Management of Electronic Media

Management of Electronic Media

Fourth Edition

Alan B. Albarran
University of North Texas

WADSWORTH
CENGAGE Learning™

Australia • Brazil • Japan • Korea • Mexico • Singapore • Spain • United Kingdom • United States

WADSWORTH
CENGAGE Learning™

**Management of Electronic Media,
Fourth Edition**
Alan B. Albarran

Senior Publisher: Lyn Uhl

Publisher: Michael Rosenberg

Assistant Editor: Megan Garvey

Editorial Assistant: Rebekah Matthews

Marketing Manager: Erin Mitchell

Marketing Coordinator: Darlene Macanan

Marketing Communications Manager:
Christine Dobberpuhl

Project Manager, Editorial Production:
Kristy Zamagni

Art Director: Linda Helcher

Print Buyer: Susan Carroll

Permissions Editor: Deanna Ettinger

Production Service: Pre-Press PMG

Cover Image: Chad Baker/Photodisc/
© Getty Images

Compositor: Pre-Press PMG

For product information and technology assistance, contact us at
Cengage Learning Customer & Sales Support, 1-800-354-9706

For permission to use material from this text or product,
submit all requests online at **www.cengage.com/permissions**
Further permissions questions can be e-mailed to
permissionrequest@cengage.com

Library of Congress Control Number: 2008942257

Student Edition:

ISBN-13: 978-0-495-56942-8

ISBN-10: 0-495-56942-9

Wadsworth
20 Channel Center Street
Boston, MA 02210
USA

Cengage Learning products are represented in Canada by Nelson Education, Ltd.

For your course and learning solutions, visit **www.cengage.com**.

Purchase any of our products at your local college store or at our preferred online store **www.ichapters.com**.

Printed in Canada
1 2 3 4 5 6 7 8 9 12 09 08

Dedicated to the memory of
my former professor, mentor, and friend,
Dr. Clarence A. "Ace" Kellner

Contents

1 Managing in the Electronic Media 1

2 The Media Marketplace: Markets, Mergers, Alliances, and Partnerships 25

3 **Ethics of Management** 51

4 Theories of Management 77

5 Financial Management 97

8 Programming: Strategy and Distribution 167

11 Regulatory Influences and Electronic Media Management 241

Preface

The electronic media industries continue to experience sweeping changes due to a confluence of technological, economic, regulatory, global, and social forces. Contemporary electronic media managers face a unique and rapidly changing environment. Competition is intense. Technology has created multiple digital platforms to distribute content and engage audiences. Mergers and acquisitions have altered the makeup of the key players who operate networks, station groups, and multichannel providers like cable, satellite, and telecommunication providers. The elimination of regulatory barriers, the growth of alliances and partnerships among media companies, and a global marketplace for entertainment and information have all contributed to the changing managerial environment.

Managers no longer oversee a single operation. In many markets, electronic media managers are responsible for multiple stations and even regional hubs. Versatility and multitasking have become common characteristics of media managers. Structural changes, along with the evolving composition of the workforce, have led management to modify its treatment of individual employees in many ways. The workforce is leaner, more diverse, more gender balanced, and relies more heavily on part-time employees than ever before.

This textbook is designed to help you understand the complex contemporary world of electronic media management. Though targeted primarily toward undergraduate and graduate students, this book will also be useful to media managers and practitioners. It focuses on domestic (U.S.) managerial topics, but where applicable, global issues are introduced. Every effort has been made to make the information not only relevant and timely but also understandable.

The Fourth Edition has been thoroughly updated to include all the latest information on management approaches and challenges found in managing electronic media enterprises and their digital platforms, along with controversies such as the debate over indecency and the XM-Sirius merger. All chapters in this new edition have been updated to reflect the latest industry standards

and includes many new and revised cases. Every chapter features new material regarding the development of digital platforms, new business models, and regulatory changes.

Chapter Review

Management of Electronic Media begins with an overview of electronic media in society. Chapter 1 introduces you to the main industries that make up the electronic media and presents the various functions, skills, and roles of electronic media managers.

Chapter 2 examines the contemporary media marketplace with a discussion of the different types of markets, alliances, and partnerships found across the electronic media and factors influencing the media industries.

Chapter 3 centers on ethics in electronic media management. This chapter examines types of ethics, ethical norms, and situations in which ethics are challenged in the management of electronic media organizations.

Chapter 4 provides a discussion of management theory by examining the three schools of management thought. Contemporary managerial theories and their application to the electronic media are presented in this chapter, as are differences between management and leadership.

Chapter 5 details the importance of financial management in an electronic media organization. The chapter includes sections on budgeting, financial statements, financial ratios, and financial analysis.

In Chapter 6, you will learn about personnel management by looking at recruitment, selection, orientation, and termination of employees. This chapter also covers the use of performance reviews and the legal aspects of managing people.

Audience and audience research is the focus of Chapter 7. Readers will gain an understanding of the different types of audience research and other methods used to evaluate and measure audiences.

Programming strategies and distribution are discussed in Chapter 8 in the context of the radio, television, and multichannel industries, at both the national and local levels.

Marketing, an important business skill, is presented in Chapter 9. There is an introduction to basic marketing principles and strategies, along with information on marketing to advertisers and the role of promotion in marketing campaigns.

Chapter 10 is devoted to news and newsroom management. News plays an increasingly important role in the electronic media, and this chapter examines the importance of news and topics related to managing the news department.

Chapter 11 reviews the role of government regulation on the electronic media. While the Federal Communications Commission remains the single greatest influence on telecommunications policy in the United States, all three branches of government and a host of other federal agencies impact the regulatory process.

Chapter 12 details the role of public relations in electronic media management. The chapter discusses the different publics encountered in the electronic media and some of the major public relations issues management often addresses.

Chapter 13 examines the impact of technology on management. The chapter examines changes in distribution and consumer technologies, the impact on media content, new business models for the electronic media, and concludes with a discussion of key issues associated with technology.

Each chapter begins with an overview summarizing its contents. At the end of each chapter are case studies to stimulate thought and discussion on various management topics. Several case studies in this edition are new, along with a number of the most popular cases from previous editions. All of the cases put you in the role of manager in a decision-making environment. A glossary of key terms used in the text is also included for easy reference.

Acknowledgments

The fourth edition of this book is similar to the previous editions in that it is a product of years of experience and interactions with a variety of media practitioners—first as an employee, then as a manager, and finally as a media educator and consultant. In my professional career, I have been fortunate to work with many good managers, first in the radio industry and later in television. Each of them helped influence my ideas about media management.

In addition to the professionals who contributed to the earlier editions, this edition drew insight from a number of other media managers. For this fourth edition, my thanks go to Becky Munoz-Diaz and Martha Kattan (Univision), Jose Valle (Telemundo), Dan Bennett (Cumulus Radio), Kevin Jenkins (Service Broadcasting), Amy Yates-Garmatz and Brian Hocker (NBC Universal), and Dave Muscari and Kathy Clements (Belo Corp.).

A number of reviewers examined various chapters and made valuable suggestions that improved this book. My sincere thanks to Richard Carvell, Arkansas State University; John Allen Hendricks, Southeastern Oklahoma State University; and Ann Jabro, Robert Morris University.

I am blessed with my wife, Beverly, and daughters Beth (and son-in-law Michael Lloyd) and Mandy, who have supported my research and writing over the years. During the writing of this edition I lost my mother, Jean Albarran, who was always unconditional in her love and support. I'm also very appreciative of the support of the faculty, staff, and students in the Center for Spanish Language Media and the Department of Radio, Television, and Film at the University of North Texas.

In conclusion, this book is dedicated to the memory of the man who taught me the most about electronic media management—my former professor and mentor at Marshall University, Dr. C. A. "Ace" Kellner. Ace passed away in November 1996, shortly before his beloved wife, Toni, who passed just after Christmas that same year. Beverly and I cherish their memory. We grew to be close friends after his retirement and visited the Kellners several times in their Florida home during the 1980s and 1990s. One of the greatest joys in my life was having him see the first edition of this book. He was proud and honored to have the book dedicated to him. My continuing hope is that the fourth edition of this book will be helpful to students and inspire them to reach their full potential in life just as Ace inspired me to do.

Alan B. Albarran
University of North Texas

Abbreviations and Acronyms

ABC—American Broadcasting Company
ACT—Action for Children's Television
AE—Account Executive
AM—Amplitude modulation
AQH—Average quarter hour
AR&D—Audience research and development
AT&T—American Telephone & Telegraph
AWRT—American Women in Radio and
 Television
BCFM—Broadcast Cable Financial
 Management Association
CAB—Cable Advertising Bureau
CBS—Columbia Broadcasting System
 (former name)
CEO—Chief Executive Officer
CHR—Contemporary hit radio
CNN—Cable News Network
CPM—Cost per thousand
CPP—Cost per point
CW—CW Network (formerly WB/UPN)
DAB—Digital audio broadcasting
DARS—Digital audio radio services
DBS—Direct broadcast satellite
DMA—Designated market area
DOJ—Department of Justice
DSL—Digital subscriber line
DTV—Digital television
DVD—Digital video disc
EAS—Emergency Activation System
EBS—Emergency Broadcast System
EEO—Equal employment opportunity
EEOC—Equal Employment Opportunity
 Commission
ESPN—Entertainment Sports Programming
 Network
FAA—Federal Aviation Administration
FBC—Fox Broadcasting Company
FCC—Federal Communications Commission

Fin-Syn—Financial interest–syndication rules
FM—Frequency modulation
FRC—Federal Radio Commission
FTC—Federal Trade Commission
GI—Gross impressions
GM—General Manager
GRP—Gross rating points
GSM—General Sales Manager
HBO—Home Box Office
HDTV—High definition television
HD Radio—Hybrid digital radio
HH—Households
HR—Human Resources
HUT—Households using television
IAB—Interactive Advertising Bureau
ISP—Internet Service Provider
JSA—Joint services agreement
LAPS (test)—Of literary, artistic, political, or
 scientific value
LMA—Local marketing agreement
LSM—Local Sales Manager
LUR—Lowest-unit-rate
MBO—Management by Objectives
MFJ—Modified final judgment
MMDS—Multipoint multichannel distribution
 services
MP3—MP3 music player
MRC—Media Ratings Council
MSO—Multiple system operator
MSTV—Maximum Service Television
MTV—Music Television
NAB—National Association of Broadcasters
NATPE—National Association of Television
 Program Executives
NBC—National Broadcasting Company
NCTA—National Cable & Telecommunica-
 tions Association
NHI—Nielsen Homevideo Index

NHSI—Nielsen Hispanic Station Index
NHTI—Nielsen Hispanic Television Index
NMMS—Nielsen Metered Market Service
NMS—Nielsen New Media Services
NSI—Nielsen Station Index
NSM—National Sales Manager
NSS—Nielsen Syndicated Services
NTI—Nielsen Television Index
NTIA—National Telecommunications and Information Administration
P&L—Profit and loss
PD—Program Director
PDA—Personal digital assistant
PEG—Public, educational, and government channels
PICON—Public interest, convenience, or necessity
P-O-M-C—Planning, organizing, motivating, controlling
PPM—Personal People Meter
PPV—Pay-per-view
PSC—Public service commission
PTAR—Prime-time access rule
PUC—Public utility commission
PUR—Persons using radio
RAB—Radio Advertising Bureau
RADAR—Radio's All Dimensional Audience Research

RBDS—Radio broadcast data system
RBOC—Regional Bell operating company
ROR—Rate of return
RTNDA—Radio-Television News Directors Association
SBC—Southwestern Bell Corporation
SDTV—Standard digital television
SMATV—Satellite Master Antenna Television
SMSA—Standard metropolitan statistical area
SPJ—Society for Professional Journalists
SRDS—Standard Rate and Data Service
TQM—Total quality management
TSA—Total Survey Area
TSL—Time spent listening
TVB—Television Bureau of Advertising
TVHH—Television households
UHF—Ultrahigh frequency
UPN—United Paramount Network
USTA—United States Telecommunications Association
VALS—Values, attitudes, and lifestyles
VHF—Very high frequency
VIP—Viewers in profile
VNR—Video news release
WB—Warner Brothers network
WWW—World Wide Web

Managing in the Electronic Media

In this chapter you will learn

- An overview of the contemporary electronic media
- The levels of management found in the electronic media industries
- The skills, functions, and roles of electronic media managers
- The demands placed on electronic media managers by audiences, advertisers, and owners

As an introduction to the subject of electronic media management, consider the following scenarios that managers might encounter in a hypothetical top-50 market.

- The second-quarter financial statements reveal that the marketing and creative services departments are both over budget by nearly 10 percent for the year. The General Manager needs to schedule a meeting with the respective department heads to review the overage and develop the steps necessary to correct the imbalance.

- A caller is upset with the broadcast of a reality program the night before, claiming the content was offensive and not suitable for families. The Program Director is asked to respond to the complaint.

- The Operations Manager of a network-affiliate station has been renegotiating with the local union over a new contract for the engineering staff. The union is making strong demands to improve

wages and health benefits. Details need to be shared with the Personnel Director and the Station Controller before negotiations can continue.

- Conflicts continue among the department heads of a network-affiliated TV station over the role of the station's Web site. The news department sees the primary purpose of the Web site as an extension of news and information, while the promotion department sees it as a vehicle for marketing. The programming, research, and sales staffs all have their own ideas as to the role of the Web site. The conflict is expected to take up most of the day's department head meeting.

- The radio ratings are out, and for the third consecutive period the high-salaried morning show host has produced lower numbers, especially among female listeners. The Program Director faces pressure from the General Sales Manager and the GM to improve the station's ratings and boost revenues. The host is resistant to any changes in the program.

- Ratings for the 6:00 P.M. and 10:00 P.M. newscasts continue to be strong, but a new sweeps month is less than three weeks away. The News Director, Program Manager, and Promotions Manager are finalizing strategies to maintain their number-one position and will later report to the General Manager.

- Plans to launch a mobile video distribution platform for the news department are finalized at a television station. The News Director, Operations Manager, and the GM are expected to announce the plan to the rest of the staff today.

- Planning sessions are continuing between the company-owned newspaper and broadcast operations over ways to streamline newsgathering and eliminate unnecessary costs. Ultimately, the goal is to converge the news operations into a single unit.

As these examples illustrate, management in the electronic media involves a number of individuals coordinating many different responsibilities on any given day. Management can be defined many ways. In this text, **management** is defined as a process by which individuals work with and through other people to accomplish organizational objectives. This book centers on management in the **electronic media**—meaning the radio, television, cable/satellite, and

telecommunications (telephone) industries, as well as their Internet sites and other **digital platforms**. Management is not a static concept but a dynamic process involving many different skills such as decision making, problem solving, creativity, negotiation, and interpersonal relations.

This book examines electronic media management in the twenty-first century—an era marked by rapid change, convergence, industry consolidation, new business models, and a heavily competitive environment. There is nothing easy about being an electronic media manager in the contemporary market. A good manager must balance the needs of owners, employees, and the audiences they serve in a time of unprecedented challenge.

An Overview of Electronic Media in Society

The electronic media occupy an important place in American society. In addition to providing audiences with a variety of entertainment and information products, the electronic media influences culture and helps define social reality (McQuail, 1994). The electronic media also function as an important component of the economic system. In the United States and other developed nations, most firms engaged in the electronic media operate in the private sector and thus deliver their content and services for profit (Albarran, 2002). As in any other business, managers in the electronic media must maintain efficient, profitable operations to meet the expectations of owners and stockholders.

The electronic media pervade society. As consumers continue to exhibit an insatiable appetite for information and entertainment, levels of media usage reflect this trend. Television viewing, radio listening, and Internet surfing dominate leisure activity in U.S. households (see Figure 1-1). Audiences can access information and entertainment content via many different distribution platforms (e.g., broadband, wireless, terrestrial) and consumer technologies (e.g., TV and radio receivers, personal computers and laptops, cell phones, the Apple iTouch, Blackberries, and PDA devices). Media managers must respond to the needs of their customers, recognizing that their audience has many choices for entertainment and information content.

FIGURE 1-1

Annual Hourly Media Usage for U.S. Population (Estimates for 2010)

SOURCE: *Statistical Abstract of the United States* (2008).

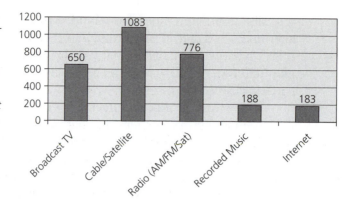

Several demands—for information and entertainment by the audience, for profits by stockholders, and for access by advertisers—place managers of electronic media facilities in a challenging position as they try to serve the needs of the market along with the needs of the marketplace. This balancing act is made all the more difficult by constant changes in competitive pressure, technology, regulatory issues, social issues, and consumer tastes and preferences.

Electronic media companies engage in similar activities. Sherman (1995) identifies four separate but interrelated activities: development, production, distribution, and exhibition. **Development** is concerned with new technological innovations. Technology stimulates the growth of the electronic media and improves the quality of media consumption. Advances in mobile content delivery and interactive television are but two examples of recent technological innovations in the electronic media. Technology continues to change the nature of the media business and the way society uses the media.

Production consists of the manufacture of both **hardware** and **software** for the electronic media. Hardware includes television and radio receivers, satellite dishes, the compact disc (CD), DVD, DVR, and the like as well as the systems that record on these media, MP3 players, and similar devices. Software includes such products as television and radio programs, sound recordings, and advertising messages.

Distribution, the focus of Chapter 8, is concerned with getting products to consumers. Today many forms of distribution or platforms are available, ranging from the traditional broadcast networks to satellite-delivered services, the Internet, broadband, and hand-held wireless devices.

The fourth activity, **exhibition**, is where the consumer uses and engages the product. The pervasiveness and portability of electronic media hardware means that exhibition can occur at any time and place. This flexibility has added to the challenge of reaching targeted audiences, since consumption of media content can take place in the home, in the car, at work, or during a workout.

Though the electronic media share similar activities, each industry is undergoing considerable change as a result of media **convergence**. Media convergence is usually thought of as the integration of video, audio, the Internet, and computing systems, as well as distribution technologies (Steinfield, Baldwin, & McVoy, 1996). Because corporations now dominate the electronic media industries with multiple holdings in many cities, companies have been engaged in converging operations to save resources. For example, in the radio industry, a company can own a maximum of eight stations in the same market. Leading radio companies such as Clear Channel, CBS, and Cumulus have merged operations and eliminated staff overlap. In television many markets now contain *duopolies*, or two stations owned by the same company. Again, as these operations are merged, greater efficiencies can be realized, primarily in a reduction in the number of employees.

Companies with multiple media holdings that may involve combinations of radio, television, cable channels, newspapers, and Web sites, companies such as News Corporation and Media General, are taking the lead to integrate newsgathering operations, as well as back-office support, marketing, and engineering. Convergence continues to evolve and is another factor changing the face of electronic media management.

While the electronic media follow a road to convergence, the industries had distinct, separate beginnings. The following sections provide a brief overview of the development of the electronic media industries.

Radio

Radio formally began in the United States during the 1920s. The radio industry established many practices for the rest of the electronic media by introducing the sale of hardware (receivers), the marketing of commercial time (advertising), the practice of networking, and the distribution of programming to audiences. Radio broadcasting

consists of two primary types of services: AM and FM. HD radio is an extension of terrestrial radio. Internet radio and satellite radio (available via paid subscription) represent other extensions of radio.

AM Radio AM radio consists of 107 channels operating between 535 and 1705 kilohertz (kHz). AM channels are restricted to 10 kHz of channel space, which severely limits the quality of the AM signal. The actual channel assignments begin at 540 kHz and repeat every 10 kHz. Because the signals are transmitted via amplitude modulation, that is, by varying the amplitude of the radio wave, the transmissions became known as *AM radio*. In 1982 the Federal Communications Commission (FCC) authorized AM stereo service but refused to set a technical standard for receivers and transmitters (Klopfenstein & Sedman, 1990). As a result, AM stereo never really developed.

The FCC established four classes of AM service (Classes A, B, C, and D) to ensure that everyone would have access to radio broadcasting. Class A stations are the most powerful, operating as **clear channels** during evening hours, which means they have exclusive rights to their assigned frequency beginning at sunset. From a management perspective, the clear channel stations represent the best class of AM stations in the country. Class B, or secondary channels, are also strong stations but must defer to the power and direction of the more dominant Class A stations. Class C stations are best thought of as regional operations, while Class D-or local stations-are usually restricted to a local geographical area and operate at levels of transmitter power even lower than that of the Class C stations.

Approximately 38 percent of all the radio stations in the United States are commercial AM radio stations. Research indicates that AM listeners are, for the most part, older than FM listeners and that AM listening accounts for a smaller share of all radio listening. The most popular formats on AM radio include news and talk, sports, and niche music and ethnic formats.

FM Radio FM radio operates at a much higher frequency than AM, between 88 and 108 megahertz (MHz). Each channel is allocated 200 kHz for broadcasting, 20 times the capacity of an AM channel, giving FM the potential for outstanding quality.

FM channel assignments begin at 88.1 MHz and continue through 107.9 MHz. **FM** stands for *frequency modulation*, meaning

the frequency of the radio wave is varied while being transmitted. FM broadcasting also differs from AM in that the signals follow the curvature of the earth. The height of the station's antenna and the power of the transmitter affect the range of coverage.

The FCC also uses a classification system (Classes A, B, C, and D) for FM stations, based on the height of the antenna and the transmitter's power. Class A stations are limited to a power of 3 kilowatts (kW) and a range of 15 miles. Class B stations can operate up to a power of 50 kW and a 30 to 40 mile range. Class C, clearly the most attractive from an ownership perspective, can broadcast up to 100 kW with a range of 60 or more miles. Class D stations were originally classified as low-power (less than 10 watts) radio stations usually assigned to universities or religious organizations. In 1980 the FCC began eliminating Class D stations by forcing them to raise power or share frequencies with others.

One other interesting aspect of the FM band is the portion of the service reserved for educational and noncommercial use. All stations assigned a frequency between 88.1 and 91.9 MHz operate as noncommercial stations. These stations are typically licensed to a college, university, religious organization, or, in some cases, a high school. Though these stations are not permitted to accept advertising, they may engage in underwriting for programming and on-air fund drives. Here you will find programming from National Public Radio (NPR), as well as the alternative music formats found on most college radio stations.

FM came of age during the 1970s and surpassed AM in total listeners. Today the FM band is dominated by music formats (adult contemporary, country, urban, hip-hop, and contemporary hits), although sports and talk programming have an increasing presence on FM channels.

The major radio group owners for both AM and FM radio include Clear Channel, CBS, Cumulus, Citadel, Entercom, Emmis, and Cox. Annual listings of the top radio groups can be found in *Broadcasting and Cable* and *Radio Ink*, two industry trade publications.

HD Radio HD radio debuted in 2006 to enable terrestrial stations to extend their programming options in a digital environment. Existing radio stations can offer additional channels on the HD band but the new service is not compatible with existing radio receivers—forcing

consumers to purchase new radios. Further, HD radio still must be fully embraced by the automobile industry as either a standard or optional feature of new cars to continue to grow. Nevertheless, HD radio promises new programming channels and the hope for additional revenue streams to broadcasters. At the end of 2007, there were approximately 1,700 HD stations on the air, according to the HD Radio Alliance.

Satellite Radio In 1994 the FCC authorized **satellite-distributed digital audio licenses**, which would provide several channels of programming to consumers on a national basis. Over the next few years, these services became known simply as satellite radio, with two providers, XM Radio and Sirius, offering a subscription service for a monthly fee. Both services initially offered 100 channels of music and information, most commercial-free. Both XM and Sirius spent millions of dollars signing key talent like Oprah Winfrey (XM) and Howard Stern (Sirius) to attract listeners, but the total number of satellite subscribers only reached about 14 million in 2007. With soaring costs, XM and Sirius announced plans to merge in 2007 and, in the summer of 2008, received approval by the Federal Communications Commission to proceed with the merger. The combined entity was renamed Sirius XM Radio.

Television

Although the television industry began in the postwar years of the 1940s, it did not grow significantly in the United States until the 1950s. In 1952, the FCC ended a 4-year moratorium on television licensing known as the "TV freeze." The freeze allowed the nascent industry to solve technical problems and geographical station assignments. An important outcome of the freeze was the addition of 70 channels (from 14 to 83) in the **UHF** (ultrahigh frequency) band to complement the existing **VHF** (very high frequency) band of 12 channels (from 2 to 13). Unfortunately, the UHF signals required higher power and were more subject to interference problems than their VHF counterparts.

The UHF stations languished for several years because the FCC failed to require manufacturers of television receivers to include the UHF reception technology until 1964. For that reason VHF stations dominated TV for many years in much the same way FM dominates AM radio today. As cable television emerged in the 1970s, UHF stations found parity with VHF signals in cable households. Both types of service (VHF and UHF) could be received with ease by cable with no differences observed in the quality of the signal.

Networks developed quickly in television after years of refinement in the radio industry. The three big networks—ABC, CBS, and NBC—each acquired TV stations to form the basis for their network TV operations. These stations are known as *network owned and operated stations* (**O&Os**) and are the most profitable TV stations in the world. Other stations that carry network programs are called **affiliates**. ABC, CBS, NBC, and Fox serve approximately 200 affiliates each. The other networks (CW and MyTV) have a smaller affiliate base. There are also several Spanish language networks that operate similarly to their English-language competitors: market leaders Univision, Telemundo, Telefutura, followed by smaller networks Azteca America and LATV. Affiliates play an important role in the network through the **clearance** or acceptance of network programming and advertising. Initially, the networks provided **compensation** (cash payments) to affiliates to carry programs, but over the years the evolving economics led to compensation being eliminated for most stations.

Consolidation in the television industry escalated with the passage of the 1996 Telecommunications Act, which increased the percentage of national audience reach from 25 to 35 percent. This allowed TV groups to acquire more stations. The networks were particularly aggressive buyers, adding several new stations to their existing portfolios. Another increase occurred in 2004 when the cap increased to 39 percent of the national audience. With NBC's acquisition of the media assets of Vivendi Universal to become NBC Universal in 2004, all of the major broadcast networks were aligned with the major Hollywood studios, enabling synergies and economies of scope between film and television program/film production. In addition to the networks, major television groups operating in the United States include Sinclair, Gannett, Belo, and Hearst-Argyle.

Multichannel Video: Cable, Satellite, and Telcos

Multichannel video services are available through monthly subscription services to cable, satellite, and telecommunications (*telco*) providers. In the United States, over 90 percent of all television households subscribe to one of these three types of services. In heavily populated markets, the services engage in fierce marketing and pricing competition, and the cable operators and telcos offer "triple play" bundles of discounted telephone, Internet, and video services. All the services provide a menu of local broadcast channels and popular networks, HD channels, premium services, and *pay-per-view* (PPV) services. Cable systems usually designate a few channels for public, educational, and governmental use as part of their community franchise requirements. These are called **PEG channels**.

The cable industry produces a variety of revenue streams: monthly subscriber fees offering different tiers of service, the selling of local insertion advertising, high-speed Internet services, equipment rental (set-top boxes, HD and regular digital video recorders), and premium/PPV programming. The larger cable operators (Comcast and Time Warner) also offer telephone services. Cable consolidation escalated during the 1990s. Larger companies began **clustering** systems together as companies sought to group large numbers of subscribers and potential subscribers together geographically.

Satellite service is available through two national operators: DirecTV, owned by News Corporation (parent of Fox), and Dish Network, owned by Echo Star. Satellite offers a digital environment with their channel lineup but lacks the multiple revenue streams that cable generates. Satellite pricing is very competitive, enabling the services to acquire new subscribers, often at the expense of cable operators.

The primary telco competitors are Verizon and AT&T. Verizon offers a service called FIOS that is built on a fiber optic backbone. AT&T offers a broadband service that uses a hybrid fiber and co-axial cable structure. Both companies also offer cell phone services in addition to a triple-play package.

Telecommunications Industry

Over the years **telecommunications** became a blanket term for enterprises engaged in communication-related activities involving

the telephone, telegraph, data services, switching equipment, and terminal equipment. The telecommunications industry, like the electronic media industries, has undergone considerable consolidation and change.

For decades, little competition existed in the telecommunications industry. In 1982 American Telephone & Telegraph (AT&T) settled a long-standing antitrust suit with the Department of Justice, resulting in the breakup of the **regional Bell operating companies (RBOCs)** in 1984. Since then, mergers and acquisitions have reduced the number of operators each year, to where there are now two major operators, Verizon and AT&T. Qwest, which serves the northwest, is a third operator.

Management in the Electronic Media

Having detailed the contemporary state of the electronic media industries, the remainder of this chapter examines management in closer detail. This section begins with a discussion of the levels of management found in the electronic media, followed by an analysis of the skills, functions, and roles managers play in their daily activities.

Levels of Management

A common misconception many individuals have regarding management is that there is one person—THE MANAGER—who leads an organization. Overused clichés such as "The buck stops here" suggest a single leader makes all the decisions in an organization. In reality, managers perform at many levels within organizations, and this is true for the electronic media industries. Different managers serve to complete a variety of tasks within an organization.

Consider a single radio station cluster in a local market with five management positions. The Program Director is responsible for the on-air sound of the stations. The General Sales Manager is charged with the responsibility of advertising sales. A Traffic Manager coordinates the scheduling of commercial advertisements and other program material. The Chief Engineer makes sure everything works properly from a technical standpoint. The General Manager (or Market Manager, as they are often called) monitors and continually evaluates the entire operation and reports to the station owners.

As managers, each individual has specific areas of responsibility, supervises coworkers, and contributes to the overall performance of the organization.

While titles vary, there is wide agreement that most organizations support three levels of management. A study involving over 1,400 managers found that the responsibilities of first- or lower-level managers, middle managers, and executives at equivalent levels were similar, regardless of the type of organization (Kraut, Pedigo, McKenna, & Dunnette, 1989). For example, **lower-level managers** center on supervising others and monitoring individual performance. Such would be the case with a Program Director who evaluates the on-air staff of a radio station, or a Local Sales Manager who monitors advertising sold by local account executives. **Middle managers** typically plan and allocate resources and manage groups of people. An example of a middle manager in the electronic media would be a General Sales Manager, who must coordinate the activities of the sales department at both the local and national levels. Top-level or **executive managers** monitor the entire organizational environment, identifying internal and external factors that impact their operation. General Managers for TV, radio, cable, and telecommunications facilities must keep pace with such diverse factors as local business economics, social trends, the regulatory climate in Washington, and the internal activities of their respective operations. As these examples illustrate, one encounters different responsibilities at different management levels. Although tasks and duties vary as a manager moves through these levels, all managers share certain skills, functions, and roles. *Management skills* refer to the basic competencies needed by electronic media managers. *Management functions* refer to the tasks that managers perform. *Management roles* refer to the different roles managers adopt as they interact with different constituencies, such as employees, owners, consumers, and peers. Figure 1-2 charts the various skills, functions, and roles of managers in the electronic media.

Management Skills

Management theorists (e.g., Hersey, Blanchard & Johnson, 2008) identify three broad areas of skills needed in the management process: technical, human, and conceptual. To this list two other skills crucial to successful media management are added: financial skills and marketing skills.

FIGURE 1-2

Management Skills, Functions, and Roles

Skills	Functions	Roles
Technical Human Conceptual Financial Marketing	Planning Organizing Motivating Controlling Facilitating Communicating Negotiating	Leader Representative Liaison

Technical Skills Electronic media managers need to understand the technical aspects of their operations, for technology and innovation constantly impact the communication industries. While technological advancements make it impossible to keep up with all the changes taking place, managers still need basic competencies in such areas as equipment operation, signal transmission, program distribution, and computer applications. The ability to provide hands-on training is an important managerial skill, since employees usually have greater respect for managers with technical expertise.

Human, or People, Skills Employees see no other area as clearly as a manager's people skills. Most managers identify this area as the single most important skill in the process of management (Hersey, Blanchard & Johnson, 2008). Successful managers in the electronic media exhibit strong interpersonal skills and are particularly adept at leading and motivating employees. Electronic media managers need to be dynamic, visionary, and motivated in order to lead their operations effectively and create a spirit of cooperation and participation among all employees.

Conceptual, or Problem-Solving, Skills Managers must understand the complexities of the internal and external environment and make decisions based on sound judgment. Because change is constant in the electronic media, managers must be able to respond quickly to changes in the environment—whether the changes concern audience tastes and preferences, technology, or employee relations. Electronic media managers must deal with a variety of issues and solve problems efficiently.

Financial Skills Industry consolidation, staff turnover, and a heavily competitive environment place incredible demands on media managers to be increasingly conscious of the bottom line. Managers need strong financial skills to establish and maintain budgets, meet revenue projections, and deal with budgetary contingencies. Understanding how to interpret financial statements, ratio analysis, depreciation and amortization methods, and break-even analysis is critical (see Chapter 5).

Marketing Skills With so many options available for the content of entertainment and information, managers need a strong understanding of marketing. They must know how to position their product(s) effectively and know what vehicles to use to create awareness. Understanding how to use the four Ps of marketing—price, product, promotion, and place—in interactions with consumers as well as advertisers is an invaluable management skill (see Chapter 9).

Though these skills are common across the electronic media, the degree of skill required at different managerial levels varies. For example, at the entry level of management technical skills are needed daily, while executives are likely to use conceptual and financial skills more regularly. Human skills are crucial at every management level. Figure 1-3 illustrates how these skills vary across levels.

Managers can develop skills via continuing education, experience, and attendance at managerial seminars and workshops

FIGURE 1-3

Skills across Managerial Levels

(Bigelow, 1991). Regardless of how they learn, managers in the electronic media need *some* knowledge in all five areas. Finding individuals with this range of expertise is a continuing challenge for the electronic media industries, as well as identifying managers that understand other media industries in a time of consolidation and convergence.

Management Functions

A frequently asked question in the study of management concerns management functions: What exactly do managers do? One of the earliest investigations into management functions came in 1938 with Chester Barnard's (1968) book, *The Functions of the Executive*. Barnard identifies three managerial functions: (1) providing a system of organizational communication, (2) procuring proper personnel, and (3) formulating and defining the purposes and objectives of the organization.

Henri Fayol was another major influence in the study of management functions. Fayol (1949) was a French theorist who specified the functions of planning, organizing, commanding, coordinating, and controlling referred to as the *POC3 model*. Later management scholars replaced commanding and coordinating with motivation, thus forming the *P-O-M-C model* of management (see Figure 1-4).

FIGURE 1-4

The P-O-M-C Managerial Model

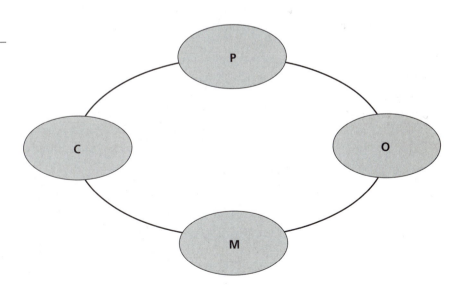

Many management books show a heavy bias toward the Fayol model (Carroll & Gillen, 1987). But do managers spend most of their time planning, organizing, motivating, and controlling? Many studies have examined management functions to determine if the classical functions theorized by Fayol still exist.

Mintzberg (1975) found that most of the P-O-M-C functions form part of the folklore that inaccurately describes management; the author identified 10 distinct managerial functions. Other studies (Hales, 1986; Kotter, 1982) question the validity of the classical management functions. Kanter (1989) claims that acquisitions and divestitures, reductions in personnel and levels of hierarchy, and an increased use of performance-based rewards creates a new managerial work environment with different management functions.

These studies present conflicting views of management functions. Which functions actually occur in the daily activities of electronic media managers? An integrated approach, combining both classical and modern perspectives, is the most reasonable way to describe management functions in the electronic media.

Media managers are involved in planning, organizing, motivating, and controlling, but they also exhibit three other important functions in managing their organizations: facilitating, communicating, and negotiating.

Planning Planning involves establishing organizational objectives and providing others with the resources needed to accomplish their tasks. Both short- and long-term objectives need to be established in the planning process. Both managers and employees should share in the creation of objectives. The contemporary electronic media management environment leans heavily on strategic planning as an important management tool (Gershon, 2000).

Organizing The organizing function addresses who is responsible for completing company objectives. Most electronic media operations maintain specific units or departments (such as operations, sales, engineering, and news) to handle individual responsibilities. Individual departments need their own planning objectives, budget, and staff to meet necessary goals, which then allows upper-level

managers to concentrate on other activities. Managers of individual departments are linked to the overall structure of the organization to create a holistic environment. Tensions may arise between individual departments over the best way to address problems. When this occurs, managers must mediate and resolve conflicts.

Motivating Motivating employees to a high level of performance directly helps any organization accomplish its goals. On the other hand, if motivation is low, productivity suffers. Certain positions in the electronic media need less management than others in this regard because the incentives are built in. For example, audience feedback, ratings, and public recognition drive talent positions, while commissions motivate account executives. For other areas such as production, research, and engineering, motivation can be an important managerial function. Numerous theories on motivation exist (see Chapter 4), but many studies yield similar findings: Employees want managers to recognize them for their individual achievements and contribution to the organization, and they want opportunities for continued growth and advancement (Buckingham & Coffman, 1999; Herzberg, 1987).

Controlling As a management function, control involves several areas of responsibility: (1) giving feedback to other managers and employees, (2) monitoring the progress toward completion of organizational objectives, and (3) making changes as situations demand. Feedback takes many forms: written, verbal, and electronic (e.g., text messaging, e-mail). A common criticism of managers is that they do not offer enough feedback to employees to let them know how they are performing. Positive feedback also helps motivate employees.

Monitoring is another essential control function. Managers must keep tabs on the progress of organizational objectives and help solve related problems. Finally, the ability (and at times courage) to make changes is an important control mechanism. Ultimately, such changes impact other personnel and perhaps even lead to their termination. While managers must be sensitive to the needs of their employees, they must also keep the goals and objectives of their operations in mind.

Facilitating As facilitators, managers must empower their employees with the needed resources to complete organizational tasks. These resources may include personnel, money, or equipment. The facilitator function is most prominent at the executive and middle levels of management. For individual units to function, managers must provide more than just moral support. They must articulate the needs of their unit when they develop a budget (see Chapter 5) and seek additional resources as needed on an ongoing basis.

Communicating A function that permeates all areas of management is communication. Managers in the electronic media have many ways to communicate with employees, who need and expect managers to keep them abreast of information important to their jobs. Formal lines of communication include newsletters, memos, and performance reviews. Informal lines of communication, however, are also important. As in any field, managers should not stay isolated in an office on the phone or in front of a computer during working hours. Managers who regularly visit employees in studios, offices, and other workstations establish a participatory climate beneficial to the organization (see Chapter 4). Managers encourage communication from employees by granting access in diverse ways—through voice and e-mail, regular meetings in which ideas and concerns are shared, and an open-door office policy as opposed to visiting with employees only by appointment.

Negotiating All electronic media managers serve as negotiators in a variety of situations. For instance, negotiation with employees may involve salary and benefit packages, contracts for talent, bargaining with guilds or unions, and requests from low- and mid-level managers for new personnel. In program acquisition, the fees for copyrighted material, license fees, news services, and local productions are all negotiable. Equipment needs often constitute a third area of negotiation. Managers must often bargain for the price of expensive items such as transmitters and production equipment. Similarly, advertising prices are determined by the available supply of commercial inventory and the demand by advertisers. Other forms of negotiation may involve owners, regulators, community leaders, business organizations, and audience members. In all types of

negotiation, managers attempt to seek the best possible solution for their operations.

Management Roles

Management roles are those behaviors associated with or expected of managers. In the electronic media, managers perform a variety of tasks and wear many hats in completing these tasks. One classic study identified three types of roles managers adopt in their daily environment: interpersonal, informational, and decisional (Mintzberg, 1975). Interpersonal roles are concerned with leadership, while informational roles address communication. Decisional roles, as expected, involve decision making. Three roles best exemplify contemporary electronic media managers: leader, representative, and liaison. Each role is discussed below.

Leader Managers are expected to provide effective leadership for their individual department and organization. Being a good leader involves accepting responsibility for the organization as well as for its employees. Adapting to change, making decisions, maintaining open lines of communication, and leading others to the completion of goals are essential qualities of strong leaders.

Representative Managers in the electronic media serve as representatives in many settings. To the public and local community, electronic media managers serve as figureheads in a variety of contexts. The General Manager may serve on community boards. The News Director may be asked to speak to a high school or college class. The Sales Manager represents the station to a number of clients. Managers also represent various trade and professional organizations, such as the National Association of Broadcasters (NAB), the National Cable & Telecommunications Association (NCTA), the National Association of Television Program Executives (NATPE), and the Radio Television News Directors Association (RTNDA), to name a few. Tasks in these organizations may involve serving on committees, consulting with regulators, and working with lobbyists.

Liaison Because of increasing consolidation in the media industries, the majority of the radio, television, cable/satellite and

telecommunications operations in the United States are owned by groups or corporations. Executive-level managers serve as important liaisons to the parent company. Accountable to the parent organization, managers regularly report on progress and problems in their operations. In turn, managers filter information from the parent company back to their individual staffs. As expected, this role demands strong communication and negotiating skills.

This discussion of management levels, skills, functions, and roles indicates that electronic media managers are unique and talented individuals who work with and through other professionals to accomplish organizational objectives.

Summary

This chapter began by introducing two terms used throughout the book: (1) *management*, defined as a process through which individuals work with and through other people to accomplish organizational objectives, and (2) *electronic media*, used in this text to represent the radio, television, cable/satellite, and telecommunications industries. Electronic media management functions in an era marked by rapid change, emerging philosophies, and a competitive environment.

The electronic media occupy an important place in society through the dissemination of information and entertainment. Electronic media managers attempt to balance the needs of the marketplace with the public's insatiable appetite for media content amid changes in technology, regulatory issues, and social trends.

Though electronic media companies all engage in development, production, distribution, and exhibition, each industry has unique characteristics. The radio industry consists of AM and FM broadcasting as well as HD and satellite radio. Television continues to be dominated by the broadcast networks, which provide programming to their affiliates. Cable, satellite, and telecommunications operators offer multichannel programming consisting of broadcast signals, satellite-delivered networks, premium services, and pay-per-view, as well as ancillary services like DVRs and telephone service. The telecommunications industry offers a range of communication services ranging from traditional telephone to Internet access in addition to video distribution.

Consolidation has brought about a more clustered ownership environment in many local markets in hopes of gaining better economic efficiencies and increased revenues. In radio, many management positions oversee several different stations and formats, while in television, duopolies prevail.

In the electronic media, management occurs on different levels and involves a variety of skills, functions, and roles. Management requires unique and talented individuals who can work with and through other people to accomplish organizational goals.

CASE STUDY | ## A Management Opportunity

Jill Preston had distinguished herself as a detail-oriented and relentless television reporter for three different stations in various-sized markets. While in college earning a degree in electronic journalism, Jill wrote for the campus newspaper and interned at the local newspaper, working primarily with print reporters covering city hall. After graduation, Jill landed a position as an entry-level reporter at a small-market TV station, where she remained for two years. She then moved on to a medium-market position that lasted one year.

Jill's career moves took her to markets of increasing size, until she took a job as an investigative reporter in a top-20 market. Her talents for reporting caught the attention of her current News Director, and when the Assignments Editor's position opened 18 months after her arrival, Jill was given the opportunity to move into management.

Jill jumped at the chance to accept a managerial role, knowing she could influence the style and breadth of coverage at the news department. As Jill began her duties, she soon found herself in conflict with most of the news staff. She wanted to be thought of as a manager, but she could not ignore her instincts as a street reporter. She found herself trying to be too controlling over her reporters, failing to give them the freedom she had valued as a reporter.

Frustrated, Jill sought the counsel of her News Director and immediate supervisor, John Williams. "What you are experiencing is not that unusual," said Williams. "Moving into management takes time to adjust. Most of us were never trained to be managers. It is something we grow into. The best advice I can offer is to think about the type of manager you want to be and how you want to relate to your fellow employees. Then work on improving your managerial capabilities."

Jill realized she had not really thought about the type of manager she wanted to be before assuming her new role. She vowed to think more seriously about her new role and the type of leader she aspired to become.

Imagine yourself in Jill's predicament. Picture yourself in a similar situation. What type of manager do you think you would be if given the opportunity to move into a managerial role? What management skills do you currently have? Which skills need improvement? What management functions are you ideally suited for? Which functions are you least suited for? What managerial roles are you the most—and least—comfortable with?

CASE STUDY	**Management versus Leadership**

A great quote from Retired Naval Admiral Grace Hopper is that "managers manage things, while leaders lead people." Management and leadership are interwoven in most business enterprises, yet it raises some interesting questions. For example, if you are a good manager, won't you be a good leader? And if you are a good leader, doesn't that mean you will be a good manager? Assess your own skills, as a manager and as a leader. Be prepared to share these in a small group with other members of your course.

References for Chapter 1

Albarran, A. B. (2002). *Media economics: Understanding markets, industries, and concepts* (2nd ed.). Ames, IA: Blackwell.

Barnard, C. I. (1968). *The functions of the executive* (30th anniversary ed.). Cambridge, MA: Harvard University Press.

Bigelow, J. D. (Ed.). (1991). *Managerial skills: Explorations in practical knowledge.* Newbury Park, CA: Sage.

Buckingham, M., & Coffman, C. (1999). *First, break all the rules: What the world's greatest managers do differently.* New York: Simon & Schuster.

Carroll, S. J., & Gillen, D. J. (1987). Are the classical management functions useful in describing managerial work? *Academy of Management Review, 12*(1), 38–51.

Fayol, H. (1949). *General and industrial management* (C. Storrs, Trans.). London: Pittman.

Gershon, R. A. (2000). The transnational media corporation: Environmental scanning and strategy formulation. *Journal of Media Economics, 13*(2), 81–101.

Hales, C. P. (1986). What do managers do? A critical review of the evidence. *Journal of Management Studies, 23*(1), 88–115.

Hersey, P., Blanchard, K. H., & Johnson, D. E. (2008). *Management of organizational behavior* (9th ed.). Upper Saddle River, NJ: Pearson Prentice Hall.

Herzberg, F. (1987). One more time: How do you motivate employees? *Harvard Business Review, 67*(5), 109–117.

Kanter, R. M. (1989). The new managerial work. *Harvard Business Review, 67*(6), 85–92.

Klopfenstein, B. C., & Sedman, D. (1990). Technical standards and the marketplace: The case of AM stereo. *Journal of Broadcasting and Electronic Media, 34*(2), 171–194.

Kotter, J. P. (1982). What effective general managers really do. *Harvard Business Review, 60*(6), 156–167.

Kraut, A. J., Pedigo, P. R., McKenna, D. D., & Dunnette, M. D. (1989). The role of the manager: What's really important in different management jobs. *The Academy of Management Executives, 3*(4), 286–293.

McQuail, D. (1994). *Mass communication theory* (3rd ed.). Newbury Park, CA: Sage.

Mintzberg, H. (1975). The manager's job: Folklore and fact. *Harvard Business Review, 53*(4), 49–61.

Sherman, B. (1995). *Telecommunications management* (2nd ed.). New York: McGraw-Hill.

Steinfield, C., Baldwin, T. S., & McVoy, D. S. (1996). *Convergence: Integrating media, information and communication.* Thousand Oaks, CA: Sage.

The Media Marketplace: Markets, Mergers, Alliances, and Partnerships

In this chapter you will learn

- The product and geographic dimensions that form electronic media markets
- The four types of market structure and their characteristics
- How economic, technological, regulatory, global, and social forces are driving change across the electronic media industries
- What a strategic alliance is and the types of strategic alliances found in the electronic media industries
- Why there are so many mergers and acquisitions across the communication industries
- How strategic alliances and partnerships affect the process of management

The first chapter—a micro perspective—introduced you to various functions, skills, and roles required from contemporary media managers. This chapter examines the media marketplace from a macro perspective, a complex system impacted by various market forces, mergers, alliances, and partnerships. Such a perspective is critical to your understanding electronic media management because the media industries seen as a whole and part of a larger business picture are in a constant state of evolution and transition.

Electronic media managers must understand basic market economics and the markets in which they compete for audiences and

advertisers. Understanding the characteristics of the market helps management develop content, advertising, and branding strategies. Mergers, acquisitions, and a variety of strategic partnerships and ventures are common to companies participating in the media industries. A competitor in one market may be a partner in another market. Chapter 2 considers these changes and how they are affecting the electronic media industries. This chapter begins with a discussion of how to define a market, with a particular emphasis on media markets and their unique characteristics, or market structures.

Electronic Media Markets

In the electronic media, the terms *target market* and *target audiences* are sometimes used interchangeably. Though not exactly synonymous, both terms reflect the goal of reaching a type of audience. Specifically, media outlets try to attract enough of an audience to obtain a dominant share of a particular market. But what exactly is a market?

Defining the Market
The term *market* is often associated with the study of economics. Economists define a **market** as a place where consumers and sellers interact with one another to determine the price and quantity of the goods produced. A market consists of sellers, buyers, and products. In the electronic media, the sellers are the actual radio and television stations, cable and satellite operators, and telecommunication providers who offer similar products or services to the same group of buyers, typically consumers or advertisers. The products consist of programming or content and other services offered by the sellers.

Dual-Product Markets
Media firms function in a **dual-product market** (Picard, 1989). That is, while media companies produce one product, they participate in separate goods and services markets. In the first market, the good may be a radio format, a television program, or a cable channel. The content is targeted to consumers, and consumption is measured in different ways. For instance, some types of media content, such as a premium cable subscription or DVD rentals, require the consumer

to make a purchase. TV and radio broadcast content is available to anyone with a receiver.

The second market, in which many media companies operate, involves the selling of advertising. Advertisers, both local and national, seek access to audiences by purchasing time and space in various forms of media content such as radio and television programs or newspapers and magazines. As the demand for advertising rises, companies charge higher prices to increase revenues and profits. On the other hand, a drop in audience ratings or other media usage often causes a decline in advertising expenditures and a reduction in revenues. For example, TV network rating periods, or *sweeps*, as the industry refers to them, are vital in determining advertising revenues. At the national level, each rating point represents millions of dollars of advertising. The network that wins a sweeps period (held in February, May, July, and November) can charge more for future advertising than the network that finishes in third or fourth place. Local affiliate stations also benefit from a strong performance during the sweeps.

Geographic Markets

In addition to operating in a dual-product market, electronic media companies operate in specific **geographic markets**. Some firms, such as radio, television, and satellite networks, operate in a national market; other companies, such as local radio and television stations, compete within a regional area.

For radio and television stations, the FCC mandates the geographical market by granting licenses to specific areas where markets are ranked according to the size of the population served (1–New York, 2–Los Angeles, 3–Chicago, etc.). Though labels for media markets are somewhat arbitrary, major markets are usually ranked 1 to 50; medium markets are 51 to 100; and small markets are above 100. In the cable industry, local municipalities award franchises that define areas of operation. In both cases, the potential audience is limited to the geographic boundaries of the market.

Many electronic media firms operate in a range of product and geographic markets. For example, News Corporation owns the Fox network and several television stations. News Corporation also has interests in cable programming (FX, Fox News, Fox Sports, Fox Business Channel), newspaper and magazine publishing (*Wall Street Journal*, *The Weekly Standard* and many others), motion pictures

FIGURE 2-1

**Product/Geographic
Market**

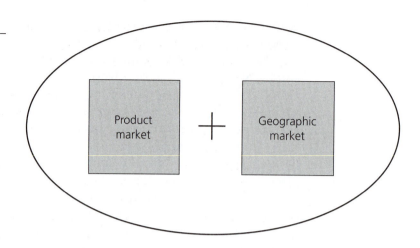

(20th Century Fox), and the social networking site, MySpace. A major player in several media markets, News Corporation encounters different competitors in each market, as well as different consumers.

Defining a media market involves combining the product and geographic aspects of the market (see Figure 2-1). This process identifies a specific market in which a media firm offers some or all of its products to advertisers or consumers. The number of sellers in a particular market—as well as the extent of the competition among suppliers for buyers—is affected by the characteristics of the market. Media economists refer to these characteristics as **market structure**.

Market Structure

Though the structure of a market depends on many factors, several important criteria help identify the type of market structure (Scherer, 1980). These criteria include the concentration of buyers and sellers (producers) in the market, differentiation among products, barriers to entry for new competitors, cost structures, and vertical integration.

Concentration in the Market The number of producers, or sellers, in a market explains a great deal about the degree of **concentration** in the market. A market is considered concentrated if revenues, or circulation, are controlled by a limited number of companies. For many years, the big three broadcast

networks (ABC, CBS, and NBC) dominated the network television market. As cable, other video technologies, and new networks (Fox, CW, Univision, and Telemundo) emerged, competition for viewers and advertisers intensified.

Though concentration can be measured in various ways, two approaches are common in media industries. One method, using ratings data, calculates the share of the market reached by each competitor. Ratings data provide estimates of the degree of buyer concentration in the market. Highly rated programs attract a larger percentage of the audience, leaving smaller audiences for less popular content. Another method involves calculating the percentage of revenues (sales) controlled by the top four (or eight) firms. This type of measure is known as a *concentration ratio*. A market is considered concentrated if the four-firm ratio is equal to or greater than 50 percent or if the eight-firm ratio is equal to or greater than 75 percent (Albarran, 2002).

Product Differentiation

Product differentiation refers to perceived differences among products. Because many media products can be substituted for one another, product differentiation is important in the electronic media. To establish such differentiation, radio stations offer unique formats, call letters and logos, on-air personalities, and Web sites. Marketing campaigns and technical facilities also establish differences in the minds of listeners. Television stations differentiate their local programming, especially in the area of the news, from other stations. Broadcast networks and cable services distinguish themselves through their individual program schedules.

Barriers to Entry

Barriers to entry are obstacles new sellers must overcome before they can enter a particular market. In the electronic media, barriers often take the form of capital investments. The high-quality equipment, personnel, and programming resources needed to establish or purchase an electronic media facility require a formidable financial investment, in many cases reaching millions of dollars. However, new distribution platforms require much less investment. For example, the cost to send mobile video or text messaging is marginal compared to operating a broadcast station. Web sites are relatively inexpensive to establish, but are costly to update and maintain on a 24/7 basis.

Sometimes barriers to entry involve regulatory policy. For example, the 1996 Telecommunications Act limited the number of radio stations a group or individual could own in a local market relative to the number of stations in the market. The act imposed limitations on the number of stations an owner could hold in a particular class (AM or FM) of stations.

Cost Structures

Cost structures are the expenses needed to create products in a market. Total costs represent a combination of fixed costs, those needed to produce one unit of a product, and variable costs, such as labor and raw materials, which depend on the quantity produced. Industries with high fixed costs, such as cable television, often lead to concentrated markets. **Economies of scale** refer to the decline in average cost that occurs as additional units of a product are created. Economies of scale are important to businesses in an industry with high fixed cost. As mentioned earlier, the costs to establish an Internet Web site is much lower, giving electronic media companies a relatively low-cost distribution outlet for their products and services.

Let's consider the costs associated with producing a newscast for a local TV station. To produce a single evening newscast, the station must commit to the costs of staff, equipment, and many other resources (see Chapter 10). By expanding and *repurposing* (e.g., using the same content in different forms), the news operation can provide additional newscasts (early morning, midday, early evening, and late news) throughout the day, as well as repurpose the content across different platforms. Thus, the average costs to produce each newscast declines, creating economies of scale. The station obtains more local programming with little additional investment beyond that required for a single newscast.

Vertical Integration

Vertical integration occurs when a firm controls multiple aspects of the production, distribution, and exhibition of its products. For example, a movie produced by one of the Disney film studios may ultimately be scheduled on the ABC network or the ABC Family Channel. The film can be sold as a package of feature films to other broadcast or cable networks, or even to local television stations. The Web site for the film offers opportunities for merchandise marketing. In each case, the company maximizes revenues through several stages of distribution and exhibition. One can better understand

market structure by analyzing the number of producers and sellers in a market, the difference between products, barriers to entry, cost structures, and vertical integration (Caves, 1992).

Types of Market Structure The four types of market structure are monopoly, oligopoly, monopolistic competition, and perfect competition (Litman, 1988). One can present them graphically as a continuum, with monopoly and perfect competition at opposite ends, and oligopoly and monopolistic competition occupying interior positions (see Figure 2-2).

In a **monopoly**, a single seller of a product exists and dominates the market. A true monopoly offers no clear substitute for the product, and buyers must purchase the good from the monopolist or forgo the product altogether. Although monopolists establish the price, all buyers may not demand the seller's product. If demand is weak, the monopolist achieves only limited market power. Barriers to entry are usually very high in this type of structure.

In the electronic media, cable television historically mirrored a monopoly market structure. Many of the franchise agreements between the cable operator and the local government were exclusive arrangements that only permitted a single operator to offer cable services in a given area. The advent of certain technologies, such as direct broadcast satellite systems, wireless cable operators, and broadband distribution, removed cable's monopolistic status.

As opposed to a monopoly, an **oligopoly** features three or more sellers of a product, which may be either homogeneous or differentiated. A market dominated by a few firms that hold a similar share is

FIGURE 2-2

Four Types of Market Structure

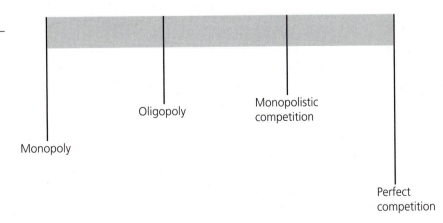

Monopoly

Oligopoly

Monopolistic competition

Perfect competition

considered an oligopoly. Such firms are interdependent; that is, the actions of the leading firm usually affect the others. As such, these firms consider their actions in light of the impact on both the market and their competitors.

Broadcast television stations operate in an oligopoly market structure, as do the networks. Though competition for audiences and advertisers is strong, the product itself is relatively homogeneous: reality programs, situation comedies, dramas, movies, news, talk programs, and so forth. Barriers to entry are significant in an oligopoly. For example, the Fox network successfully entered the national television network market despite the fact that ABC, CBS, and NBC held dominant positions with audiences, advertisers, and affiliates.

A third type of market structure, **monopolistic competition**, exists when many sellers offer similar products that are not perfect substitutes for one another. Barriers to entry are fewer compared to an oligopoly. Each firm attempts to differentiate its products to the consumer through various methods, including advertising, promotion, location, service, and quality.

In a monopolistic competitive structure, price varies with both the market and the individual firms impacting decisions. Monopolistic competitive firms often lower prices in an effort to increase revenue. Among the electronic media the market for syndicated television programming and magazines are the best examples of this type of structure.

Multiple sellers and a homogeneous product characterize the market in **perfect competition**, best exemplified by the agricultural marketplace. When no single firm dominates, barriers to entry do not exist, and individual companies operate as price takers in the market because buyers establish the price for the product. Beyond the multitude of Web sites that vie for individual attention, there is no example of a perfectly competitive market structure in the electronic media.

Forces Affecting Markets

A number of forces, functioning both independently and interdependently, have led to a state of chaotic change across the media industries during the 1990s and early into the twenty-first century.

Economic conditions, technological changes, and regulatory, global, and social forces are the converging areas driving much of the change (Albarran, 1998), as discussed in the following paragraphs.

Economic Conditions

Economic conditions refer to a number of economic factors that affect the general business cycle in both national and local geographic markets. As economic conditions fluctuate, they impact consumers, as well as businesses—including the electronic media. If the local economy begins to decline, consumers tend to spend more conservatively. If retail sales drop significantly, businesses may be forced to lower the amount of money spent on advertising, which in turn causes a corresponding drop in potential revenues for electronic media companies.

Key economic indicators include the rate of inflation, local employment trends, retail sales, measures of effective buying power, housing developments, and changes in interest rates and tax laws. Publications and Web sites from the *Wall Street Journal, Barron's,* and *Business Week* help keep us aware of current economic conditions. Managers also need to monitor the economic conditions of the local markets in which they operate and be prepared to adapt to fluctuations in the business cycle.

Technological Forces

The electronic media industries utilize technology to meet the primary functions of production, distribution, and exhibition introduced in Chapter 1. The 1990s will be remembered as the decade that fueled the transition of the media industries from an analog-based experience to a digital environment. Congress mandated that the U.S. television system move to an all-digital environment by February 2009; HD radio is another example of digital technology although not a required policy directive.

The transition to a digital environment and its potential encouraged the integration and convergence of the personal computer, telephone, and television into a single device (Steinfield, Baldwin, & McVoy, 1996). Broadband has become the term used to define the transmission of digital content over a high-speed, high-capacity network that is seamlessly linked to the Internet. Digital television will offer not only a richer viewing experience but an interactive experience as well to those who desire more than passive viewing. *High definition television* (HDTV) ushered in a new era of television production, distribution, and exhibition.

A number of trends are starting to take shape. Broadband distribution by wire, fiber optic cable, or wireless has become the norm, practically replacing dial-up connection to the Internet. With a host of portable media devices, consumers—especially younger ones—are happy to watch video via their cell phone, MP3 player, or online. Content providers have responded, making programs available either for free or for pay through services like iTunes. Today electronic media companies must think of themselves as multiplatform content providers, offering the audiences access through different distribution options.

User-generated content, where users can upload digital files through social networking services like MySpace, Facebook and YouTube have led to a new option of entertainment and information and an alternative to content delivered by the electronic media. Individual **blogs** represent yet another way to share digital content, and thousands of new blogs appear every month. User-generated content has become so important that most news operations now solicit consumer video for local news stories and other events. In addition to short videos, the Internet has become a vehicle to expose new talent and programs at a fraction of the cost of a Hollywood production

Technological forces will continue to impact the media industries as well as society. The late management theorist Peter Drucker (1999) claims no manager can manage change, but can only be prepared to respond to change. Electronic media managers must accept that technological change is a way of life and keep their efforts centered on remaining competitive and efficient in their operations. An expanded discussion on technology and its impact on media management is presented in Chapter 13.

Regulatory Forces Governmental bodies, such as Congress, the courts, and the FCC, impact the structure of media markets and marketplace activity through rulings and other actions (see Chapter 11). Because managers must be aware of potential changes in the regulatory environment, most electronic media firms employ Washington attorneys to keep abreast of significant developments. Trade publications, such as *Broadcasting and Cable* and *Television Week*, help managers monitor the evolving regulatory climate in Washington, along with membership in trade associations, like the National Association of Broadcasters (NAB), the National Association of Television Program

Executives (NATPE), and the National Cable and Telecommunications Association (NCTA).

The 1996 Telecommunications Act removed a number of regulatory hurdles from the radio, television, cable, and telecommunications industries. Since the 1996 Act, the radio, cable, and telecommunications industries have been dramatically restructured through mergers and acquisitions, resulting in a high degree of industry consolidation across many media markets and sectors (Albarran, 2002; Albarran & Dimmick, 1996; Bagdikian, 2000). Conversely, some larger companies have divested, or pursued different strategic paths. Here are a few examples:

- Viacom split into two separate companies: CBS and the "new" Viacom.

- Clear Channel Communications, Univision, and Tribune were acquired by private equity firms, removing them from public ownership.

- Belo Corp. and Scripps, former newspaper/broadcast companies, split their holdings into two separate companies.

- Southwestern Bell (SBC) acquired Bell South and AT&T, only to rename the new company AT&T.

- Citadel acquired the radio assets of the Walt Disney Company.

During the 1990s and early in the twenty-first century, regulators for the most part were more liberal in policies toward media ownership, enabling large media conglomerates to become even larger. These actions have fueled controversy and criticism from Congress, consumer groups, and diversity advocates leading to an anti-consolidation backlash and a distrust of the motives of media companies. As such, almost any regulatory review or action is likely to be met with cynicism.

Global Forces *Global forces* can best be understood by recognizing that the media industries produce products that are marketed around the globe. The growth of trade blocks, such as the European Union (EU), NAFTA (the North American Free Trade Agreement), and numerous other agreements, have opened up new markets for trade and commerce, including the electronic media.

Many domestic markets in the United States are already saturated, in that 99 percent of all households have both a radio and television receiver; 97 percent have a telephone; over 90 percent subscribe to some television service; and over 70 percent have a computer in their home. However, this is not the case in the international arena. Regions outside the United States offer tremendous opportunities for expansion and development.

A number of media powers are emerging in the regions of the world known as the triad, consisting of North America, Western Europe, and Japan/Pacific Rim (Albarran & Chan-Olmsted, 1998). Disney, Viacom, and Time Warner have become global media players. In Europe, Bertelsmann (Germany), Pearson (United Kingdom), and Telefonica (Spain) are major players, while Sony and News Corporation are the leading companies with origins in the Pacific Rim. Globalization of the media industries will continue, reflecting the fact that media companies compete in a global marketplace for content, goods, and services.

Social Forces Society is changing not only in terms of demography but also because of the converging economic, technological, regulatory, and global forces described thus far. Demography census data, for example, reveals that American society is growing older and much more diverse. The 2000 census clearly showed that the Latino population is the fastest-growing minority group in the country, surging past African Americans, and demographers expect the Latino population to equal 25 percent of the total U.S. population by 2050.

Interest and excitement about technology and lower costs have enabled more households to purchase computers and broadband Internet access, leading to a society that is very connected. Wireless access points seem to be in every public sphere possible, from public libraries and airports to fast food chains and churches. Traditional media usage has been severely impacted by the adoption of personal computers, adding to the challenge of measuring media audiences and their activities (see Chapters 7 and 13).

Individuals are using the Internet for a myriad of purposes, e-mail, e-commerce, surfing, blogging, and interactive messaging are among the favorite applications. Still, not every segment of American society—and certainly not global society—can afford a computer or Internet access. Many fear we are developing a global

society divided into two segments: one that is information rich, while the other is information poor. However, the cell phone may narrow this gap—it is cheaper and can provide a data (Internet) connection at a very reasonable price for even the most modest of budgets.

Synergy These economic, technological, regulatory, global, and social forces are driving change across the communications industry. From a management perspective, creating new alliances and partnerships among media companies has become a standard practice of doing business. These partnerships are designed to create the synergy possible between two companies (Turow, 1992). *Synergy* suggests that two different entities will operate more efficiently as one business than separately (Davidson, 1985). The remainder of this chapter provides a context for understanding these changes. First, we will look at the types of strategic alliance and partnership found across the electronic media industries, including merger and acquisition activity. The chapter concludes with a discussion on how alliances and merger activities impact electronic media management.

Alliances and Partnerships

A recurring trend affecting all businesses is the formation of strategic alliances and partnerships, especially among media companies and industries. But what is a strategic alliance? Which activities constitute strategic alliances? The following paragraphs introduce the topic.

What Is a Strategic In this text, a **strategic alliance** is defined as an association designed
Alliance? to provide benefits for each of its members. Media organizations use alliances for such purposes as sharing capital and costs, providing access to new markets, increasing shareholder value, and reducing risk. Alliances may be formed when a company wants to gain access to new geographic markets, exercise control over existing markets, or share risks in developing new products and technology (Gates, 1993; Lewis, 1990).

Strategic alliances take many forms. The most common examples are mergers and acquisitions, joint ownerships, joint ventures, and formal and informal cooperative ventures. Lorange and Roos (1992) offer a theoretical examination of strategic alliances, ranging from those involving total internalization of one company by another (such as mergers and acquisitions) to those occurring on an open, free market (such as informal cooperative ventures). An alternative approach considers the degree of interdependence among the companies involved. Informal alliances require low interdependence among firms, while mergers demand high interdependence (Lorange & Roos, 1992).

Alliances can also be formed within industries (intra-industry) or between industries (inter-industry). For example, the consolidation that has taken place since 1996 in the radio industry is representative of intra-industry activity. Conversely, the failed merger between America Online and Time Warner is an example of an inter-industry alliance, at the time joining a new media company known for its leadership as an Internet service provider with a traditional media company engaged in television, cable, motion pictures, and print.

Over time alliances between companies often prove to be unstable and many ultimately fail. For a strategic alliance to succeed, several criteria should be considered. Clearly the proposed alliance should be in a complementary business, and the companies involved must have similar business strategies (Cullen, 1999). Companies need clear expectations and agreement about the resources each company will commit, as well as compatible management styles. Alliances should be avoided if one partner would dominate the other (Gates, 1993). According to Klein (2003), many of these criteria were not in place with the AOL–Time Warner merger.

Strategic planning among all parties should drive the basis of an alliance. Such planning should involve an objective evaluation of each business activity, their target market, the competitive advantages and disadvantages drawn from the alliance, and strategies to implement the alliance. Without this comprehensive examination the alliance may suffer.

Partnerships and alliances in the electronic media continue to develop as companies reach out to one another to share rewards and risks in a variety of strategic efforts (Chan-Olmsted, 2004). The following sections identify key categories of alliances across the electronic media.

Alliances to Develop and Market Programming and Content

As the costs of producing programming skyrocketed, many companies entered into partnerships to share production and distribution costs. Increasingly, television program production companies seek partners to share costs and risks. The shared expertise that results helps create new types of content and targets programs toward specific demographic groups. Another way to look at this is the internal relationships between the U.S. broadcast networks and their subsidiary partners. In the United States all of the major broadcast networks have direct relationships with movie studios to enable sharing of costs and resources. These studios also pool together to co-produce and co-market feature films and television programs. These partnerships are also used in creating distribution agreements for different platforms, such as video distribution for cell phones, PDAs, and laptops.

Alliances for Newsgathering

Consolidation across the media has enabled opportunities in the area of newsgathering. In markets where a company owns different media properties, more and more operations are becoming integrated. Media General was one of the first companies to converge newsgathering with its properties in Tampa, Florida. CBS, NBC, and Fox have all increased newsgathering and news-sharing opportunities as well. CNN's Pathfire service provides a wide menu of news feeds to its affiliates around the country, who simply access the content they need via the Web. As a result of technology and partnerships, news operations and the content we see and hear are currently more integrated than at any other time in the history of journalism, enabling operations of any size to draw upon some of the best national and international resources available. User-generated content has also become an important component of newsgathering, giving rise to "citizen journalists."

Alliances to Expand Domestic and Global Markets

Media alliances have the goal of developing or expanding into new markets, at both the domestic and global levels. These types of alliances can occur at the production, distribution, or exhibition-stages (see Chapter 1). By expanding their market, alliance partners hope to increase brand loyalty for media products and capture a greater market share. Chan-Olmsted (2004) provides an analysis of companies pursuing strategic partnerships at a global level.

Alliances to Develop HD Radio

The HD Radio Alliance is a group of major radio companies that have pledged to work together to develop and market HD radio. Among the founding companies in the alliance were Clear Channel, Cumulus, CBS, Entercomm, Bonneville International, and Greater Media, which initially pledged $200 million each to promote HD radio. At the beginning of 2008, there were over 1,500 HD radio stations broadcasting a variety of formats in HD across the United States. There will be many more HD radio stations launching in the coming years. The big challenge for HD radio is getting consumers to buy new receivers, and working with automobile manufacturers to get HD radio as an included option in new vehicles.

Alliances to Develop Wireless Distribution

The development of wireless technology is a big hit with consumers who enjoy being able to connect to the Internet through different devices without being tethered to a wire. Originally known as *hot spots*, wireless distribution makes Internet access possible through a laptop or other mobile device. Also known as *Wi-Fi*, the access is typically free or cheaper than traditional broadband, but it lacks high capacity and has certain limits such as signal strength and security issues. There are also privacy concerns, as many of the networks are public, not encrypted, and open to monitoring and hackers. Cable and telephone companies are concerned about wireless distribution and the potential loss of customers (Yang & Green, 2004). Wireless distribution is the main driver behind partnerships to develop content for handheld digital devices, like cell phones, PDAs, media players, and gaming devices.

Alliances to Develop Interactive Television

Interactive television will someday provide the user the opportunity to engage in a variety of Web-related activities (e.g., shopping, browsing, polling, gaming, etc.) while seamlessly watching television. Interactive TV is expected to follow the debut of digital television service in 2009, but could be delayed. Numerous companies are engaged in developing interactive television, with Microsoft and Phillips among the leading players. Interactive TV continues to attract a great deal of interest over the ability to engage in many different applications, but it is unlikely to reach any critical mass until the DTV transition is complete.

As evidenced by these examples of alliances, there is a great deal of business activity across the media industries. When one ponders the development of both a domestic and a global system of

interactive, wired, and wireless broadband networks offering multiple distribution systems, the potential for media-related enterprises appears unlimited.

Mergers and Acquisitions

As with strategic alliances, corporate mergers and acquisitions have helped to redefine the media industries both domestically and globally. Several mergers have resulted in the creation of huge media conglomerates, raising concerns among citizen groups and regulators over issues like concentration of ownership and the free exchange of ideas (Bagdikian, 2000).

Following is a brief chronology of key transactions involving media companies that have taken place just since publication of the previous edition of this book in 2006:

- In the radio industry Clear Channel was acquired by a group of private equity firms, taking the largest radio company in the nation out of the public sector. Citadel completed its acquisition of most of the stations held by the Walt Disney Company.

- In the television industry, the biggest transactions involved the acquisition of Univision and Tribune to private equity firms. While not a merger per se, both the UPN and WB networks combined to create a new network, the CW. MyTV was launched as a new network under the Fox (News Corporation) umbrella.

- Comcast and Time Warner continued their dominance in the cable television arena with Cablevision attempting to become a private company.

- In the telecommunications industry SBC acquired the assets of Cingular and AT&T, but kept the name AT&T for all of its corporate activity.

- News Corporation started the Fox Business Channel, but more importantly, acquired Dow Jones and its premiere assets, the *Wall Street Journal* and *Barron's*, to their portfolio. Both will contribute to the development of the Fox Business Channel.

Why So Many Mergers?

Why have there been so many mergers and acquisitions over the years involving media companies? Several factors have contributed to this phenomenon. Ozanich and Wirth (2004) identify a combination

of strategic and financial factors that have contributed to the large volume of media mergers and acquisitions since the 1980s. In terms of strategic factors, Ozanich and Wirth (2004, p. 95) identify convergence, the ability to leverage content, barriers to new competitors, and globalization as key drivers. Regarding financial factors, the authors cite valuation, tax advantages, and a surplus of available capital as the basis for mergers.

Further concentration of ownership is possible in selected areas of the media economy. The FCC liberalized the cross-ownership regulations in December 2007, allowing for newspaper and television combinations in the top 20 markets if certain conditions are met. We can expect clustering of cable systems and radio stations in certain markets, but only for strategically targeted properties.

Implications for Management

Partnerships and strategic alliances are routine ways of doing business for many media companies as a way to expand market share while minimizing financial risk. But how do these strategic alliances and partnerships affect the process of day-to-day management? The final section of the chapter considers this question.

Changes among the media companies have many implications for the process of management. As a result managers in all media industries should have the following traits: (1) a working knowledge of more than one industry; (2) the ability to effectively multitask; and (3) sensitivity toward balancing the needs of the marketplace and the public.

The rise of strategic partnerships requires managers to know not only their own specific operation but also that of their partners'. This is particularly true in cross-industry partnerships, such as Internet alliances and distribution platforms. To keep up with rapidly changing technology, managers will need to process new information quickly, using a variety of means—from reading their partner's trade publications to attending conferences and workshops for continuing education.

Handling the range of responsibilities resulting from strategic partnerships will particularly challenge managers in the electronic

media. They must be willing to delegate responsibilities to other parties and carefully monitor progress. Multitasking requires managers to have excellent organizational and communication skills. Successful managers will need to handle the pressures of work, family, and other personal activities in an orderly manner.

Electronic media managers must continue to balance the needs of the marketplace with those of their audience in new ways. This dichotomy has long existed in the mass media because all electronic media enterprises operate to produce profits for owners and stakeholders. At the same time, the responsibility to serve the public remains an important principle. By nature many alliances require heavy investments of time and money by the companies involved. There is substantial pressure to generate profits with new alliances. Managers who can successfully balance the relationship between multiple ownership and the public's needs and wants will be extremely valuable to their operations.

While these changes apply to all the electronic media, each of the major industries discussed in this book presents unique characteristics in terms of how strategic alliances will impact their stations and systems. To provide some specific information on how management may be affected by strategic alliances, we will focus on the impact on managers of radio, television, and multichannel video systems (cable/satellite/telcos) using possible scenarios.

Radio Managers overseeing a cluster of radio stations in a single market have a great deal of responsibility in trying to manage each individual station. In a large market, a single General Manager may be responsible for as many as eight stations (Loomis & Albarran, 2004). No doubt, a major challenge lies in differentiating stations from one another to attract a wide range of listeners and advertisers. By appealing to different demographic groups, stations can strategically position themselves in the marketplace, serve different audiences, and maximize market share.

Another challenge lies in generating revenues from each operation to not only meet but also to exceed expenses. Management must carefully monitor revenue projections on a weekly and monthly basis for each station. In larger markets revenue data is supplied on a daily basis, even broken down by hours of the day. If the station is not producing its quotas, management must be willing

to take the necessary corrective action to return the station to a profit-producing mode.

Coordination among the various departments represents yet another challenge for managers. A single department may have to handle duties for several different formats—local talent or satellite. Managers must make certain each area has an adequate staff with the necessary resources to complete their tasks. Proper managerial coordination works hand in hand with clear lines of communication among the various units.

Finally, the manager must monitor the relationship of each department to the audience and community it serves. This is accomplished in many different ways, from reviewing research collected via Arbitron (which estimates listener activity), focus groups, and the station's Web site to responding to listeners' phone calls, letters, e-mails, and face-to-face interactions. Only by understanding the audience and its needs can a manager effectively run radio stations, be it a single entity or a cluster.

Managing radio stations is challenging and time-consuming. Radio managers must be skilled in many areas, delegate tasks and responsibilities to middle managers, and effectively coordinate operations to meet their many challenges.

Television TV station managers also face many challenges as the result of strategic alliances and partnerships. Since 1999 television stations can be part of a duopoly, provided that the combinations were VHF-UHF. The change in the television duopoly rule has led to numerous TV duopolies across the country. These combinations allow one management team to operate two television stations, giving the stations additional leverage in dealing with advertisers and program suppliers. Plus, the stations can count audiences derived from both operations as opposed to a single outlet. However, duopoly management means merging staffs and different operating philosophies, similar to what their radio counterparts face when managing multiple stations. In reality, most TV duopolies have few employees dedicated to the second station; most employees are focused on sales and marketing.

The FCC-mandated move to DTV will occur in February 2009. The new digital environment will pose many changes for local television stations, with most switching to digital channels different from where they had operated analog channels. The move to a digital

world offers opportunities for TV broadcasters to engage in multi-casting of "standard" digital (SDTV) signals. With a digital channel, it is possible to send one high-quality HDTV channel and a number of SDTV channels (currently 2-4 based on available digital compression techniques), some of which could be devoted to services like paging, text-based information, or other specialized applications. Datacasting offers an additional revenue stream for TV managers who find themselves in fierce competition for local advertising dollars and declining network compensation (Ducey, 1999).

Audience fragmentation continues to be a major challenge for TV managers, and new technological advances pose both opportunities and challenges. Stations must rethink how to package content for different distribution platforms and find new ways to generate audiences and revenues.

Cable, Satellite, and Telco

The cable industry finds itself in a very strong position compared to the rest of the broadcast industry, primarily because of its ability to generate multiple revenue streams. For years the cable industry has drawn revenue from subscriptions, equipment rental, premium services, and pay-per-view events. Cable has added new revenue streams with digital cable, cable modems, and telephone service. Yet cable is in a dogfight for subscribers with satellite and telco operators. In markets across the country price wars are raging between the three entities.

Cable subscriptions have likely peaked, so the industry will need to make up lost revenue from subscribers switching to satellite or telcos in the form of ancillary services such as digital tiers, cable modems, and telephone service. The triple-play packages offered in competition by cable and telephone companies should benefit consumers to keep prices lower. Satellite may have a more challenging time keeping up because of the inability to offer telephone services and high-speed Internet except through a partner.

Summary

Electronic media managers need an understanding of market economics, market structure, and product and geographic markets in order to effectively understand the competitive environment in

which they are engaged. This macro perspective helps managers recognize the challenges and opportunities they face as the media industries change and evolve. Managers must also understand how market, technological, economic, and social forces are affecting the electronic media industries and their relationship to the audiences and advertisers they serve.

Strategic alliances and partnerships also offer opportunities and challenges for the electronic media, their managers, and the public. Strategic alliances take many forms. Among the most common are mergers and acquisitions, joint ownership, joint ventures, and formal and informal cooperative ventures. Companies often form alliances in order to gain access to new geographic markets, exercise control over existing markets, and share risks in developing new products and technology. Mergers and acquisitions significantly changed the makeup of many media industries during the 1990s.

In the radio industry, mergers have led to clustering of radio operations in many local markets. In the broadcast television industry, duopoly ownership and the transition to DTV/HDTV have set the stage for numerous partnerships. The cable, telco and satellite operators will continue to compete heavily as they try to lure consumers with various bundles of services.

Strategic alliances have expanded the role of managers, who need orientation and understanding of the other industries in which they are engaged in order to build strategic relationships. The ability to handle multiple tasks in different distribution environments is an important requirement. Finally, managers must be able to balance the needs of owners and stockholders with those of audiences.

CASE STUDY | Local Alliances

Mark Elliott became the new group manager of a cluster of six radio stations in a top-30 Midwestern market when his company acquired four other stations in the same market. Elliott's company, Jerome Broadcasting, now owns four FM and two AM stations in a market of 23 total stations. More important, Elliott's combined stations control about 35 percent of the radio advertising revenue in the market, with four stations targeting the important 18–34 age demographic.

Elliott and his aggressive sales staff want to link up with retailers through-out the market to offer a number of opportunities for the retailers to reach new customers and for the stations to create new listeners. Several projects are underway, including joint sponsorship on-air as well as on the station's Web sites, a cooperative venture with the local newspaper to promote joint newspaper-radio marketing efforts, and seminars on radio advertising to educate businesses that are not advertising on any radio station.

At the weekly staff meeting, Elliott praised the efforts that had been taken to date but encouraged his staff—especially the programming, promotion, and sales managers—to identify potential partnerships with local television stations and local cable operators. "We are missing some opportunities here," said Elliott. "With five television stations in this market, and none of them owned by any of our radio competitors, let's figure out some cooperative arrangements that might benefit both of our operations. And don't forget about the cable operators that have nearly 70 percent of the TVHH (television households) as customers. I want you to brainstorm and see what sort of ideas you come up with regarding potential partnerships that we could use to enhance both parties."

Working individually or in small groups, generate ideas on possible strategic alliances and partnerships your station group and the TV and cable operators might consider that would enhance each operation at the local level. Ideas could be related to programming, advertising, or promotional alliances.

CASE STUDY Developing New Markets

In 1995 a San Antonio television station started a local 30-minute program highlighting the many interesting and unique aspects of the state of Texas. *Texas Trails and Tales* became such a popular program that it was syndi-cated on several stations across the state.

Two years ago, your company decided to expand the program into other states in which you owned television stations. To date, clones of *Texas Trails* can be found in the states of California, Florida, Georgia, and Virginia—each of course with a separate name and host. Overall, the programs have been gaining strength in each market, and in California and Florida the local programs are starting to be syndicated among other stations in the states.

Recognizing the value of the program and its local nature, station managers have now focused on expanding ancillary markets for the programs in each

state. At a recent planning session, three potential ventures seemed to offer the most potential:

1. Begin a partnership with a professional designer to develop a dynamic Web site that would feature excerpts from past programs and clips not seen in the original broadcasts, as well as a blog from the host and interactivity with the audience. Also develop a social networking site like MySpace featuring the program.

2. Market the program to cable systems within each state, particularly those with local-origination channels. This would expand the reach of the program and provide more exposure.

3. Enter a partnership with a specialty manufacturer to develop a companion book, DVD, and other merchandise (e.g., T-shirts, caps, and maps) to market to retailers in each state. Link these efforts to the station's Web site to develop an additional revenue stream.

Discuss the types of strategic alliances possible for each of these ideas. For example, would it be better to enter a joint venture with a proven marketing company, or simply hire a consultant to create the site, thereby retaining full ownership of the product? Which types of alliances would work best with each situation? Explain how you made your decision in each case.

References for Chapter 2

Albarran, A. B. (1998). The coalescence of power: The transformation of the communication industries. In R. G. Picard (Ed.), *Evolving media markets: Effects of economic and policy changes* (pp. 8–24). Turku, Finland: Economic Research Foundation for Mass Communication.

Albarran, A. B. (2002). *Media economics: Understanding markets, industries, and concepts* (2nd ed.). Ames, IA: Blackwell.

Albarran, A. B., & Chan-Olmsted, S. M. (1998). *Global media economics: Commercialization, concentration, and integration of world media markets.* Ames, IA: Iowa State University Press.

Albarran, A. B., & Dimmick, J. (1996). Concentration and economies of multiformity in the communication industries. *Journal of Media Economics, 9*(4), 41–50.

Bagdikian, B. (2000). *The media monopoly* (6th ed.). Boston: Beacon.

Caves, R. E. (1992). *American industry: Structure, conduct, performance* (8th ed.). Englewood Cliffs, NJ: Prentice Hall.

Chan-Olmsted, S. M. (2004). In search of partnerships in a changing global market: Trends and drivers of international strategic alliances.

In R. G. Picard (Ed.), *Strategic responses to media market changes* (pp. 47–64). Jonkoping, Sweden: Jonkoping International Business School.

Cullen, J. B. (1999). *Multinational management: A strategic approach.* Cincinnati, OH: South-Western.

Davidson, K. (1985). *Megamergers.* Cambridge, MA: Ballinger.

Drucker, P. F. (1999). *Management challenges for the 21st century.* New York: HarperCollins.

Ducey, R. V. (1999). Internet + DTV broadcasting = UN – TV. Retrieved September 28, 2000, from http://www.nab.org/research/topic

Edwards, C. (2005, January 31). Interactive TV: What's in the cards? *BusinessWeek, 32*–33.

Gates, S. (1993). *Strategic alliances: Guidelines for successful management.* New York: Conference Board.

Klein, A. (2003). *Stealing time.* New York: Simon & Schuster.

Lewis, J. (1990). *Partnerships for profit: Structuring alliances.* New York: Free Press.

Litman, B. R. (1988). Microeconomic foundations. In R. G. Picard, M. McCombs, J. P. Winter, & S. Lacy (Eds.), *Press concentration and monopoly: New perspectives on newspaper ownership and operation* (pp. 3–34). Norwood, NJ: Ablex.

Loomis, K. D., & Albarran, A. B. (2004). Managing radio station clusters: Orientations of general managers. *Journal of Media Economics, 17*(1), 51–69.

Lorange, P., & Roos, J. (1992). *Strategic alliances: Formation, implementation, and evolution.* Cambridge, MA: Blackwell.

NCTA. (2000, June 13). *Cable television year end review.* Retrieved October 24, 2000, from http://www.ncta.com

Negroponte, N. (1996). *Being digital.* New York: Knopf.

Nielsen/NetRatings. (2004). U.S. broadband connections reach critical mass, crossing 50 percent mark for web surfers, according to Nielsen/Netratings. Retrieved December 29, 2004, from http://www.nielsen-netratings.com/pr/pr_040818.pdf

Ozanich, G. W., & Wirth, M. O. (2004). Structure and change: A communications industry overview. In A. Alexander, J. Owers, R. Carveth, C. A. Hollifield, & A. N. Greco (Eds.), *Media economics: Theory and practice* (3rd ed., pp. 69–84). Mahwah, NJ: Erlbaum.

Picard, R. G. (1989). *Media economics.* Beverly Hills, CA: Sage.

Scherer, F. M. (1980). *Industrial market structure and economic performance* (2nd ed.). Chicago: Rand McNally.

Steinfield, C., Baldwin, T. S., & McVoy, D. S. (1996). *Convergence: Integrating media, information and communication.* Thousand Oaks, CA: Sage.

Turow, J. (1992). The organizational underpinnings of contemporary media conglomerates. *Communication Research, 19*(6), 682–704.

Yang, C. (2004, September 6). Commentary: Behind in broadband. *Business-Week*. Retrieved December 29, 2004, from http://www.businessweek.com/@@BIYJqocQvOlwcBcA/magazine/content/04_36/b3898111_mz063.htm

Yang, C., & Green, H. (2004, October 6). Welcome to broadband city. *BusinessWeek*. Retrieved December 29, 2004, from http://www.businessweek.com/@@3Cr9DYcQv@lwcBcA/magazine/content/04_40/b3902057_mz011.htm

Ethics of Management

In this chapter you will learn

- The role ethics plays in managerial decision making
- Norms consulted in making ethical decisions
- How organizations and individuals use ethical codes of conduct and mission statements to define ethical principles
- Common ethical issues faced by media management
- How to implement an ethics program in an electronic media organization

Electronic media managers make numerous decisions every working day. Their decisions often involve routine activities such as budget approval, personnel matters, and marketing and promotion plans. However, not all decisions can be made easily. Certain situations force managers to confront their own system of morals and values. Consider the following examples based on actual events over the past few years.

- Radio shock jock Don Imus uses a racial slur to describe the Rutgers University women's basketball team. Imus is fired only to resurface on the air several months later with a new employer.

- The halftime show of the 2004 Super Bowl turned into one of the most controversial moments in live television history when singer Janet Jackson's costume was torn, revealing one of her breasts. The incident led to strict new guidelines on indecency, new fines by the FCC, and managers perplexed to try and sort out what is and is not acceptable content.

- Several car chases caught live by television news crews across the country end in tragedy. In one incident the suspect took his own life. In another incident police shot a suspect after brandishing a weapon at officers.

- Several on-air news personnel have lost their jobs due to poor personal judgment, ranging from driving while drunk, caught soliciting for prostitution, and keeping pornography on their computers.

- The morning team of a popular radio station broadcast a couple having sex in a prominent New York cathedral. The outrage from the stunt resulted in the announcers eventually being fired, and the station was threatened with the possible loss of their license.

- News reporters overstep their bounds in a rush to get a story and report inaccurate information. The person impacted suffers undeserved humiliation.

These examples illustrate just a few of the challenging ethical situations confronting electronic media managers. Obviously, there are several possible solutions to each of these situations, and a discussion would yield many different answers. But how would you handle each of these situations if you were the manager? Chances are you would depend on your own understanding of what is right and wrong, consider the alternatives, and respond accordingly. The study of ethics can help us by providing the means to make difficult moral choices that confront us in our professional and personal lives.

What Is Ethics?

Derived from the word *ethos*, the study of ethics began nearly 2,500 years ago in ancient Greek society. Ethics is concerned with basic questions about what is right and what is wrong, and it involves the character and conduct of individuals and institutions (Jaska & Pritchard, 1994). Day (2006) defines ethics as a branch of philosophy dealing with the moral aspects of life. Ethics reflects a society's norms about what is morally right and wrong. On an individual level, ethics provides one's own understanding of proper conduct based on principles and rules that one considers important. Many laws in

a society are derived from the ethics and ethical values regarding acceptable behavior (Limburg, 1989).

There are many ways to study ethics (Jaska & Pritchard, 1994). One approach employs empirical methods to describe the particular moral values of a group or society. Another area of study, known as normative ethics, is concerned with understanding which values are the most relevant to a society. Ethics can also be examined in terms of organizations and the codes of ethics they adopt. Finally, one may also study personal ethics. This chapter is most concerned with the role of ethics in decision making among electronic media managers, an area bridging organizational ethics and personal ethics.

Ethical Decision Making in Electronic Media

There is no universally accepted code of ethics in the electronic media. An organization may adopt its own code of ethics, which may be written or simply implied. Wherever group or organizational ethics codes exist, conflicts may arise between the organization's approach and the individual's moral beliefs. Furthermore, the types of ethical situations vary by departments. For example, in newsrooms the ability to address decisions quickly and responsibly is an important skill. Marketing, promotions, and public relations personnel face different ethical situations because they must be creative as well as competitive in dealing with audiences and advertisers. Programmers, producers, writers, and directors reveal their own sense of ethics through the production of media content. The General Manager attempts to balance the needs of the market (owners, stockholders, and other competitors) and the public in the ethical situations electronic media organizations face on a daily basis.

Christians, Rotzoll, Fackler, McKee, and Woods (2005) identify five ethical duties of mass media employees at all levels of management and nonmanagement, as well as all types of institutions:

1. *Duty to self.* Media professionals need individual integrity and the strength to follow their conscience. Balancing career objectives with other duties can be challenging.

2. *Duty to the audience.* When deciding on a particular course of action, the audience, subscribers, or other supporters must be considered. How will the decision affect the audience?

3. *Duty to employer or organization.* Responsible employees have a sense of obligation to their employer. Duty to the firm may outweigh individual duty in certain situations. What is the impact of one's decision on the organization?

4. *Duty to professional colleagues.* We often consider obligation and loyalties to professional colleagues when we make ethical decisions. To what extent does duty to professional colleagues affect such decisions?

5. *Duty to society.* Many issues call into question our duty to society. In news, individual rights to privacy and confidentiality often arise. Media content that contains scenes of sex and violence also directly concerns society. To what extent does duty to society affect other professional duties and loyalties?

Hosmer (1996) explains that though the ethical problems management faces are thought to be simple, in most cases they are complex. Decision making is a challenging process for many reasons. Hosmer lists six factors that complicate the making of ethical decisions by managers:

1. *Ethical decisions have extended consequences.* Managerial decisions go beyond immediate or first-level consequences. Decisions affect others throughout the organization and society.

2. *Ethical decisions have many alternatives.* Few decisions involve a simple yes or no. Managers must consider all options when making an ethical decision. For electronic media managers, the pressures of time and deadlines can limit a careful analysis of each possible alternative.

3. *Ethical decisions often have mixed outcomes.* Ethical decisions often produce both benefits and costs that managers may or may not foresee. The easiest ethical decisions involve only one outcome but are rare.

4. *Most ethical decisions have uncertain consequences.* Rarely are managerial decisions free of risk or doubt, with clear-cut alternatives. Usually managers cannot foretell the full consequences of an ethical decision.

5. *Ethical decisions have personal implications.* Ethical decisions are intertwined with the values, beliefs, and other personal qualities of managers. In most cases, managers face personal benefits and costs in the ethical choices they make.

6. *Ethical norms provide a means of making informed decisions.* In the following section, several ethical norms used in making moral decisions are presented.

Norms Used in Moral Decision Making

Ethical norms form the basis of many of our individual and societal beliefs. One can define ethical norms as a set of theories derived from the study of ethics and ethical principles. Ethical norms are useful because they provide a philosophical foundation from which to analyze ethical situations and make intellectually defensible judgments (Day, 2006).

Seven ethical norms are widely used in the study of ethics (Christians, Rotzoll, Fackler, McKee, & Woods, 2005; Day, 2006; Jaska & Pritchard, 1994). These norms are the golden mean, the Judeo-Christian ethic, the categorical imperative, utilitarianism, egalitarianism, relativism, and social responsibility theory (see Table 3-1).

The Golden Mean The Greek philosopher Aristotle suggested the *golden mean*, which stresses moderation as opposed to extremes or excess. Aristotle believed that an individual could achieve strong moral character, but he or she would necessarily face difficult choices. By adopting a middle position, one could avoid both excess and deficiency (Day, 2006).

Principles of the golden mean are evident today, especially in journalistic practices in the media. For instance, the principles of balance and fairness in reporting are built on the golden mean. Maintaining objectivity in covering and reporting the news is another way to practice the golden mean.

The Judeo-Christian Ethic The Judeo-Christian ethic appears in phrases from the Jewish and Christian scriptures such as "Do unto others as you would have them do unto you" and "Love thy neighbor as thyself." The

TABLE 3-1

Comparison of Ethical Norms

NORM	SOURCE	MAIN IDEA
The Golden Mean	Aristotle	Avoid excess and extremes, seek moderation.
The Judeo-Christian Ethic	The Bible	Respect and dignity for all persons.
The Categorical Imperative	Immanuel Kant	Act on those principles that can be applied universally.
Utilitarianism	John Stuart Mill	When faced with a moral decision, seek the solution that will bring the greatest happiness to the greatest number.
Egalitarianism	John Rawls	Adopt a veil of ignorance when making ethical decisions. The veil will allow unbiased and impartial decisions.
Relativism	John Dewey Bertrand Russell	Each individual determines his or her own course of ethical decisions as each encounters different situations. (Gave rise to the study of situational ethics.)
Social Responsibility Theory	The Hutchins Commission	Journalists generally make decisions that serve society in a responsible manner. Decisions are made with good intentions.

NOTE: Compiled by the author from various sources.

Judeo-Christian ethic illustrates respect and dignity for all people based on a universal love for God. In making ethical decisions based on this norm, one would consider how the decisions would impact others.

Programming that degrades or demoralizes certain groups, especially women and minorities, violates the Judeo-Christian ethic. For instance, studies of television programming (e.g., Gerbner, Gross, Morgan, & Signorielli, 1994) confirm that the television world differs greatly from the real world, with certain segments of society overrepresented (e.g., police officers, doctors, and lawyers) and others almost nonexistent (children and the elderly). For decades

minority groups have pressured the major broadcast networks to provide greater diversity among the characters in primetime television programming and to add more minorities in such critical job functions as writing and producing.

The Categorical Imperative

The eighteenth-century German philosopher Immanuel Kant believed that ethical decisions are derived from a sense of moral duty, or the *categorical imperative*, based on principles underlying individual actions. Therefore, in making moral decisions, we must seek what would be acceptable to all members of society. That is, those principles we can apply comfortably to all situations will lead us to the right decision.

The categorical imperative is concerned more with the process of making an ethical decision than with the outcome. In using this norm, electronic media managers must determine which course of action would be the most morally defensible to the most people.

Utilitarianism

The writings of John Stuart Mill established the philosophy of *utilitarianism* during the nineteenth century. Mill claimed that when faced with moral decisions, one must consider which actions will result in the most happiness for the greatest number of people. This maxim is often referred to as "the greatest good" approach to decision making. Unlike Kant's categorical imperative, utilitarianism is more concerned with the consequences of an ethical decision than with the process of decision making. Democratic societies often identify with Mill's ideas, in that the concept of a majority rule also emphasizes the notion of the greatest good for the greatest number of people. Given this norm, managers would consider which type of content and platform would best serve the needs of the majority of the public. News Directors would focus on stories the public needs or wants to know about. Sales Managers might approach clients whose products and services provide a benefit to audiences.

Egalitarianism

Based on the work of John Rawls, *egalitarianism* asserts that everyone must be treated equally and fairly when we form ethical judgments. Rawls introduced a concept known as the *veil of ignorance* to illustrate his ideas. The veil of ignorance is a hypothetical construct.

By "wearing" a veil when considering a decision, an individual can eliminate possible biases or discrimination and therefore treat all persons in an equal manner. Without the veil of ignorance, minority viewpoints and those representing weaker points of view may be ignored or overlooked. The veil allows decisions to be made impartially, without cultural biases (Day, 2006).

You could apply this norm to electronic media management in several ways. For example, in the presentation of news, all sides should be presented fairly and accurately. Employment practices must maintain employee diversity and mutual respect. Relationships with advertisers should be conducted fairly without showing preference to larger clients.

Relativism The works of John Dewey and Bertrand Russell best exemplify the philosophy of relativism. Relativists believe that what is best for one is not necessarily what is best for another, even under similar situations. Each individual decides what is best from his or her viewpoint and does not judge others' decisions. The relativist position has given rise to the study of *situational ethics*, which examines ethical decisions in individual situations.

Program Directors (PDs) are among the practitioners most likely to follow situational ethics. In radio, the PD must decide the types of music to be played on a station. Questionable lyrics or content should be carefully scrutinized, rejected, or restricted, if necessary, depending on the audience. In television, managers determine which types of syndicated programs to acquire, as well as which types of network programs to clear. When confronted with a potentially controversial program, the manager must evaluate it and its impact on the local audience.

Social Responsibility Theory During the 1940s the Hutchins Commission on the Freedom of the Press examined the American mass media (Day, 2006). The commission found that journalists and other practitioners generally make responsible decisions that serve society (Tucher, 1998). The commission's findings gave rise to the theory of social responsibility. The commission recognized that though individuals in the media cannot correctly determine the exact impact of their decisions, they make them with good intentions.

Though social responsibility theory originated in the newspaper industry, it easily applies to the electronic media. All managers who engage in responsible behavior and expect the same type of behavior from all employees act on this norm. Exhibiting responsible behavior through programming and other areas can also enhance the spirit of trust between an electronic media facility and its audience.

Deontological and Teleological Ethics

Ethical norms often fall into two broad categories of philosophical thought: those concerned with the *process* of making decisions based on established principles and those concerned with the *actions* or *consequences* of decisions. The former category is referred to as **deontological ethics**, the latter as **teleological ethics**.

Deontological ethics is best reflected in the works of Kant, who emphasized the idea of duty in making ethical judgments. In fact, the prefix *deon* is derived from the Greek word meaning duty. Because deontological theories are not concerned with outcomes, followers of those theories are often referred to as nonconsequentialists (Day, 2006). Deontological theories examine both the intent and the motives of actions.

On the other hand, teleological theories are primarily concerned with consequences and the ability to make the best possible decisions. Ethically correct decisions are those that produce the best consequences. Utilitarianism, with its maxim of "the greatest good," is the best example of a teleologically (i.e., purpose-) based ethical theory. Though teleological theories do not ignore the process of making decisions, they do emphasize efforts to produce the best possible decisions through a careful examination of each alternative and its impact on others.

Ethical Codes and Mission Statements

Ethical codes of conduct and mission statements are two ways electronic media practitioners and companies publicly identify their business values. Codes of ethics tend to be associated with professional organizations such as the Radio-Television News Directors Association (RTNDA) and the Society for Professional Journalists

(SPJ). Mission statements are created by companies to define exactly what the company does (the "mission") and to reflect the organization's sense of values.

Codes of Ethics Codes of ethics are written statements, often presented as creeds of conduct for an organization and its members. These codes are usually controversial. Proponents claim that codes of ethics avoid the problems of individual interpretations of matters of moral judgments, while opponents assert that codes are a form of self-censorship and are often too vague and general to address moral issues effectively (Black & Barney, 1985–1986; Day, 2006; Vivian, 2005).

Several professional codes of ethics exist in the electronic media industries. The most prominent media-related organizations that have formulated professional ethical codes include the Society of Professional Journalists, the American Society of Newspaper Editors, the Radio-Television News Directors Association, the Advertising Code of American Business, the Associated Press Managing Editors, and the Public Relations Society of America. The National Association of Broadcasters at one time produced separate codes for radio and television stations, but the codes were declared unconstitutional in 1982 (see Limburg, 1989). The RTNDA code of ethics is presented in Table 3-2.

TABLE 3-2	CODE OF ETHICS AND PROFESSIONAL CONDUCT OF THE RADIO-TELEVISION NEWS DIRECTORS ASSOCIATION
Example of Ethical Code	The Radio-Television News Directors Association, wishing to foster the highest professional standards of electronic journalism, promote public understanding of and confidence in electronic journalism, and strengthen principles of journalistic freedom to gather and disseminate information, establishes this Code of Ethics and Professional Conduct.
	PREAMBLE Professional electronic journalists should operate as trustees of the public, seek the truth, report it fairly and with integrity and independence, and stand accountable for their actions.
	PUBLIC TRUST: Professional electronic journalists should recognize that their first obligation is to the public.
	Professional electronic journalists should:
	• Understand that any commitment other than service to the public undermines trust and credibility.

TABLE 3-2 *continued*

CODE OF ETHICS AND PROFESSIONAL CONDUCT OF THE RADIO-TELEVISION NEWS DIRECTORS ASSOCIATION

- Recognize that service in the public interest creates an obligation to reflect the diversity of the community and guard against oversimplification of issues or events.
- Provide a full range of information to enable the public to make enlightened decisions.
- Fight to ensure that the public's business is conducted in public.

TRUTH: Professional electronic journalists should pursue truth aggressively and present the news accurately, in context, and as completely as possible.

Professional electronic journalists should:

- Continuously seek the truth.
- Resist distortions that obscure the importance of events.
- Clearly disclose the origin of information and label all material provided by outsiders.

Professional electronic journalists should not:

- Report anything known to be false.
- Manipulate images or sounds in any way that is misleading.
- Plagiarize.
- Present images or sounds that are reenacted without informing the public.

FAIRNESS: Professional electronic journalists should present the news fairly and impartially, placing primary value on significance and relevance.

Professional electronic journalists should:

- Treat all subjects of news coverage with respect and dignity, showing particular compassion to victims of crime or tragedy.
- Exercise special care when children are involved in a story and give children greater privacy protection than adults.
- Seek to understand the diversity of their community and inform the public without bias or stereotype.
- Present a diversity of expressions, opinions, and ideas in context.
- Present analytical reporting based on professional perspective, not personal bias.
- Respect the right to a fair trial.

INTEGRITY: Professional electronic journalists should present the news with integrity and decency, avoiding real or perceived conflicts of interest, and respect the dignity and intelligence of the audience as well as the subjects of news.

continued

TABLE 3-2 *continued*

CODE OF ETHICS AND PROFESSIONAL CONDUCT OF THE RADIO-TELEVISION NEWS DIRECTORS ASSOCIATION

Professional electronic journalists should:

- Identify sources whenever possible. Confidential sources should be used only when it is clearly in the public interest to gather or convey important information or when a person providing information might be harmed. Journalists should keep all commitments to protect a confidential source.
- Clearly label opinion and commentary.
- Guard against extended coverage of events or individuals that fails to significantly advance a story, place the event in context, or add to the public knowledge.
- Refrain from contacting participants in violent situations while the situation is in progress.
- Use technological tools with skill and thoughtfulness, avoiding techniques that skew facts, distort reality, or sensationalize events.
- Use surreptitious newsgathering techniques, including hidden cameras or microphones, only if there is no other way to obtain stories of significant public importance and only if the technique is explained to the audience.
- Use the private transmissions of others only with permission.

Professional electronic journalists should not:

- Pay news sources who have a vested interest in a story.
- Accept gifts, favors, or compensation from those who might seek to influence coverage.
- Engage in activities that may compromise their integrity or independence.

INDEPENDENCE: Professional electronic journalists should defend the independence of all journalists from those seeking influence or control over news content.

Professional electronic journalists should:

- Gather and report news without fear or favor, and vigorously resist undue influence from any outside forces, including advertisers, sources, story subjects, powerful individuals, and special interest groups.
- Resist those who would seek to buy or politically influence news content or who would seek to intimidate those who gather and disseminate the news.
- Determine news content solely through editorial judgment and not as the result of outside influence.
- Resist any self-interest or peer pressure that might erode journalistic duty and service to the public.
- Recognize that sponsorship of the news will not be used in any way to determine, restrict, or manipulate content.
- Refuse to allow the interests of ownership or management to influence news judgment and content inappropriately.

TABLE 3-2 *continued*

CODE OF ETHICS AND PROFESSIONAL CONDUCT OF THE RADIO-TELEVISION NEWS DIRECTORS ASSOCIATION

- Defend the rights of the free press for all journalists, recognizing that any professional or government licensing of journalists is a violation of that freedom.

ACCOUNTABILITY: Professional electronic journalists should recognize that they are accountable for their actions to the public, the profession, and themselves.

Professional electronic journalists should:

- Actively encourage adherence to these standards by all journalists and their employers.

- Respond to public concerns. Investigate complaints and correct errors promptly and with as much prominence as the original report.

- Explain journalistic processes to the public, especially when practices spark questions or controversy.

- Recognize that professional electronic journalists are duty-bound to conduct themselves ethically.

- Refrain from ordering or encouraging courses of action that would force employees to commit an unethical act.

- Carefully listen to employees who raise ethical objections and create environments in which such objections and discussions are encouraged.

- Seek support for and provide opportunities to train employees in ethical decision making.

In meeting its responsibility to the profession of electronic journalism, RTNDA has created this code to identify important issues, to serve as a guide for its members, to facilitate self-scrutiny, and to shape future debate.

NOTE: Reprinted with permission of the Radio-Television News Directors Association.

Many professions use a code of ethics. Professional associations of doctors, lawyers, and psychologists have developed codes of ethics that are enforced by the associations; people found guilty of ethical misconduct can be completely removed from the profession. A distinguishing feature of codes relating to the mass media industries is their lack of enforceability. Many people criticize the lack of enforceable codes, as well as the lack of a universal code of ethics, in the media. Strentz (2002) offers four suggestions for a universal ethical standard applied to journalism that may be helpful in ethical decision making. The suggestions are to use restraint, know thyself, respect others, and be accountable for your actions (Strentz, 2002, p. 267).

Mission Statements Many electronic media organizations and their corporate parents have defined mission statements, which identify an organization's purpose and values. While not a code of ethics, a mission statement publicly displays the inherent values of an organization. Warner and Buchman (2004) explain that all media organizations should have a mission statement and encourage employees to write their own individual mission statement.

Hitt (1990) suggests that a mission statement is the responsibility of every manager in an organization. An acceptable mission statement defines the purpose of an organization, focuses on the product or service the organization provides, responds to the needs of various publics with interests in the organization, provides direction for making decisions and taking other actions, and energizes all employees. Finally, mission statements should be enduring but not resistant to change.

Ethical Issues in Media Management

Many ethical issues arise in electronic media management. This section will focus on four areas that clearly affect managerial decision making.

Serving the Market or the Marketplace Natural conflicts arise over the ability of electronic media firms to serve the market as well as the marketplace (McManus, 1992). Radio and television stations are required to serve the public interest, without benefit of the guidance provided by the rules and guidelines that existed pre-deregulation. Thus, the burden is on management to define what is in the public's interest. The removal of requirements for community ascertainment (gathering of information on issues of concern to the community), the Fairness Doctrine, and requirements for news and public service programming quotas give broadcast managers more latitude in determining their own course of action in serving the public.

Critics of deregulation contend the media are no longer concerned with meeting the needs of the audience, and this criticism is valid with some media facilities. But many broadcasters are involved in serving their communities through various types of outreach

programs, recognizing that localism is the major difference between their service and that of competitors. Even so, broadcasters have an obligation to their owners and stockholders to maintain a profitable business. Electronic media companies are not in business to lose money. The push for profits, however, can create pressures that may override the needs of the audience. Ethical issues arise when business interests eclipse other obligations (Day, 2006).

Dan Halyburton, a radio executive with Emmis Communications, claims that a good manager can effectively serve the needs of the public and the needs of the market, although it is a delicate balancing act. According to Halyburton, the key is to stay actively involved with the community in a variety of different ways—and to act responsibly toward the audience.

Controversies over Programming

Managers in the electronic media are often confronted with ethical questions related to programming because it is the most visible activity of electronic media companies (see Chapter 8). Most programming controversies in television relate to sex, violence, and children's programming.

Sexual Content The amount of sexual content in television programs has long generated concerns from audience members, religious organizations and educational groups. Programs such as *NYPD Blue* in the 1990s were among the first to feature partial nudity. Sexual situations remain a regular part of many daytime soap operas and Spanish language *telenovellas*. Cable networks tend to be much more liberal in their use of sexual content compared to the broadcast networks. Renewed concerns over indecency, following the 2004 Super Bowl halftime show incident, tempered broadcasters from pushing the limit regarding sexual content. As a result, Congress enacted expensive fines for presenting indecent material in 2006 to $325,000 per occurrence.

Loomis (2008) surveyed General Managers of network-affiliated television stations to gauge their perceptions of the indecency issue. The author found many GMs felt the FCC was holding them responsible for programming done at a national level of which they had no control. Further, the study indicated even the managers had very mixed views on the topic of indecency.

Violence A number of academic studies have shown that television programming contains excessive violence (e.g., Gerbner, Gross, Morgan, & Signorielli, 1994). While the networks have moved away from programs that feature gratuitous violence, violent content remains, especially via cable/satellite and telco programming. Ultimately, managers must determine which programs the audiences they serve will accept. Violence in society, such as tragic school shootings at schools and universities, refocus attention on television and film violence and its potential effects on adolescents and young adults.

Children's Programming Advocates for quality children's television have bemoaned the lack of good children's programming since the 1960s. In spite of the Children's Television Act of 1990, controversies continue in the twenty-first century. Programming controversies may cause conflicts between a manager's personal ethics and those of the organization. For example, a manager of a network-affiliated TV station may have personal moral objections to a program offered by the network. However, the station will in many instances air the program to remain in good standing with the network and advertisers who have purchased time during the broadcast. In such a case, the manager has chosen duty to the organization and customers over his or her own personal duty.

Ethics in News and Public Affairs In the reporting of news and public affairs, many types of ethical concerns confront news managers and GMs (Steele, 2004). As in the case of serving both the needs of the market and the needs of the marketplace, a great deal of pressure exists to remain competitive and be the first to report a major news event, especially at a time where technology enables the presentation of material in almost an instant manner. Economic pressures come into play for news departments as they strive to win the news ratings wars against other stations. Here are some of the most common areas of ethical questions.

Questions of Truth and Accuracy One of the most important virtues of a society, telling the truth, is reflected in many ethical codes and creeds. Truth establishes trust, credibility, and integrity among media institutions. Because every effort must be made to present accurate coverage in all news and public affairs programming, reporters and

editors must carefully verify all facts. The staging of news events or other dramatic recreations can mislead the audience, and many news organizations avoid dramatizations. The American media is often charged with being too biased in its presentation of news and public affairs, creating questions of credibility with the audience (Goldberg, 2002, 2003).

Questions of Privacy The public's right to know should not impinge on another person's right to privacy. News managers must be certain that coverage of individuals occurs because of its newsworthiness. Several areas of news reporting are routinely given special treatment by the media; for example, instances of sexual assault (a generally accepted code of ethics prohibits the naming of victims), sexual orientation of potentially newsworthy individuals, identity of people affected by certain diseases, details of suicides, identity of juvenile offenders, and treatment by the media of people suffering from personal tragedies. Managers should also question the use of secret cameras and other recording devices to get a story.

Technology and Citizen Journalists Technology has made it possible for anyone with a camera, cell phone, or laptop with Internet access to share video content and photos with the world. Media organizations initially resisted consumer-made content, but since 2006 have begun to embrace the concept, even encouraging submission of material for on-air/on-web consideration. We won't debate whether or not the people who provide such content for news purposes are journalists or not, but we can say many lack any formal knowledge of media ethics. Managers must be very careful in the utilization of such material to verify not only its authenticity but to maintain the integrity of their news operations as well.

Conflicts of Interest Journalists should avoid situations that produce a conflict of interest, compromising their ability to cover a story properly. Managers may face situations where reporters are offered gifts or other considerations that could impair their ability to report a story accurately. Personal relationships may develop with news sources in a way that creates a conflict of interest. The practice of

news organizations paying sources for information, or "checkbook journalism," raises similar concerns (Day, 2006).

Confidentiality of Sources　When a reporter promises anonymity to a source, confidentiality becomes a concern. Reporters are sometimes asked to reveal their sources of information; in extreme cases, reporters have been jailed for refusing to divulge the names of their sources. Many states have adopted provisions known as *shield laws*, which protect reporters from having to reveal the names of confidential sources to either courts or investigative agencies. News managers are sometimes caught between a reporter's effort to maintain confidentiality and external forces demanding the information.

Pressures from Advertisers　In news stories, corporations and businesses often receive attention. In some cases, such businesses are also advertising clients of the station or network. Advertisers typically object if a story is presented in a negative manner. For example, the infamous NBC *Dateline* program that featured the rigged explosion of a General Motors truck resulted in not only a lawsuit against NBC but also in the potential loss of a major advertiser. The lawsuit was eventually dropped, NBC apologized for the incident, and GM remained a client.

Ethics in Sales

The sales or marketing department also faces a range of ethical questions. In an analysis of ethics in sales, Warner and Buchman (2004) offer a list of ethical responsibilities. The five areas of accountability, in order of importance, are consumers (audience), conscience, customers (advertisers), community, and the company.

Responsibility to the Audience　As with their journalistic counterparts, media sales departments must maintain the truth in all commercial announcements. The audience wants messages it can believe; to provide false messages violates trust and destroys credibility.

Responsibility to One's Conscience　Responsible to themselves, salespeople should exhibit good ethical behavior. Salespeople with strong

ethical principles will be received as professionals, enhancing their self-confidence and self-esteem.

Responsibility to Customers Sales professionals enter into a relationship of trust with the advertising clients they serve. They come to know a great deal about a client's outlook on advertising, budget, goals and objectives, and primary competitors. Such information must be considered privileged, between the client and the salesperson. Further, salespeople have an obligation to serve the needs of the client with the campaigns they propose. Finally, sales professionals should avoid making promises they cannot keep to advertising clients. An industry push towards accountability with better audience measurement tools and other means to protect clients has helped in responsibility to advertising customers.

Responsibility to Community Sales professionals are representative of many different communities, including a global community, a business community, an industry community, and a local community.

Responsibility to a Company Sales professionals represent their company to clients, and because they deal with the selling of an intangible product (time), they become the "face," or personification, of their company. Salespeople have a responsibility to their company to be loyal, to use the firm's assets wisely, and to be a professional representative at all times.

Implementing an Ethics Program

As this chapter illustrates, ethical decision making in the electronic media can be a complicated and challenging process involving many aspects of the organization and different types of practitioners. Companies that have adopted a plan or program to help guide them through ethical dilemmas deal with ethical issues better than others.

Good companies and their managers do more than simply talk about ethics. They take steps to address ethical issues routinely

and make ethical principles an integral part of their practices. For companies who have not considered implementing a program of ethics, Hitt (1990) offers a four-step plan applicable to any organization.

1. *State the mission.* Each company should have a mission statement that clarifies the purpose of the organization not only for employees but the external public as well.

2. *Clarify the values of the organization.* Good companies exemplify good values. Communicating the values that the organization considers important is just as critical as stating the mission of the organization. Whether included in the mission statement or presented separately, values should be clear and understandable because they communicate a great deal about the company's attitude toward ethics.

3. *Create a code of ethics.* A written code of ethics, ideally found in the employee handbook, clarifies the company's position on ethical principles. The code requires the commitment of the entire organization. Promoting professionalism and credibility, a code of ethics helps the company manage employee conduct and organizational change. The code should be written in everyday language with a positive tone.

4. *Develop an ethics program.* Hitt (1990) offers several pointers for implementing an ethics program. Complete the necessary basic information (mission statement, values, and code of ethics). Orient all new employees to the ethical principles of the company. Conduct ethics seminars for all levels of management, using participatory decision making. Take time to discuss ethical issues in management and staff meetings. Maintain an open-door policy with all employees regarding ethical concerns. Finally, regularly evaluate your ethics program much as you would any other managerial program (at least yearly).

Summary

Electronic media managers and practitioners are often required to make decisions that challenge their personal morals and values. The study of ethics helps by providing some means to make

difficult moral choices that confront us in our professional and personal lives. Ethics, a branch of philosophy concerned with the basic questions about what is right and wrong, is based on principles and rules that define proper conduct for both individuals and society.

In the electronic media, ethical decision making varies by managerial levels and individual units. Though no universal code of ethics exists in the electronic media, scholars have recognized that media professionals have five areas of ethical duties: duty to self, duty to the audience, duty to the employer, duty to professional colleagues, and duty to society. Ethical decisions by managers often have extended consequences, multiple alternatives, mixed outcomes, and personal implications.

Several ethical norms provide a foundation on which to make ethical decisions. These include the golden mean, the Judeo-Christian ethic, the categorical imperative, utilitarianism, egalitarianism, relativism, and social responsibility theory. Some norms examine the process of making ethical decisions, this is called *deontological* ethics. Norms concerned with the consequences of ethical decisions are called *teleological* ethics.

Ethical codes of conduct and mission statements are two ways electronic media companies publicly define their business values. Professional organizations tend to produce ethical codes while organizations or companies usually offer mission statements. Ethical issues in media management cover a range of subjects. Such issues often arise in efforts to serve both the public and the marketplace, media programming controversies, the reporting of news and public affairs, and the sale of media advertising.

Implementing an ethics program is an essential step in making ethics an important part of any organization. To have a successful ethics program, organizations should state their mission, clarify their values, establish a written code of company ethics, and formulate an active program that involves all employees and receives regular evaluation.

CASE STUDY	**Dealing with a Major Advertiser**

WCIT-TV, Channel 6, has had a strong reputation in the local market thanks to its award-winning news department. Over the years, a regular feature called the *Investigative Team* has focused on in-depth investigative reporting. Over the years the "I-Team" uncovered corruption in many different arenas: the local school board, kickbacks to local politicians, and a scam by supermarket employees to defraud companies offering coupons to consumers.

In recent weeks, the I-Team has focused on automobile repairs. Several auto dealers were targeted (based on complaints to the local Better Business Bureau) to determine if the centers were recommending unneeded repairs for vehicles.

A female reporter took a vehicle to five auto dealers. The car needed minor repairs—replacement of a spark plug and a tire with badly worn treads, and replacement of some brake fluid. A local mechanic checked out the car prior to the investigation and determined there were no other problems.

All of the dealerships determined the car needed a tune-up as well as a new tire. Three of the dealerships suggested purchasing anywhere from two to four tires to ensure proper balance and efficiency while driving. The fourth dealer noted the car needed some brake fluid. The fifth dealer claimed the car needed an entirely new brake job and replacement of the brake master cylinder. Total cost for the brake system—nearly $1,000!

As routinely done, the I-Team reporters went back to each dealer to confront the manager with video evidence. The fifth dealer, All-American, was the primary target for the investigation. The manager at All-American denied any wrongdoing and ordered the reporters to leave.

The report was scheduled to air as part of a series on customer abuses and rip-offs in auto repairs starting the following Monday. On Friday afternoon, the attorney for All-American Automotive, Tony Larson, called the station to talk to the Local Sales Manager, Paul Corey.

"Mr. Corey, I'll get right to the point," said Larson. "All-American Automotive is very concerned about the story by your news team and its impact on the business. We don't feel the station was being professional by using hidden tactics to find out about our business. In any event, the owners have terminated the manager of the shop and the mechanic who ran the estimate on your news vehicle."

Corey listened but was confused. "That's fine, Mr. Larson, but what does that have to do with my department—don't you want to talk to the News Director?"

Larson continued, "No, Mr. Corey. You see, your reporter didn't know this, but All-American Automotive is part of a larger company you know quite well—Banner Enterprises, which includes Banner Motors and the Banner Auto Parts chain of parts stores around the city. As I understand, Banner Enterprises is one of your personal accounts. Banner purchases nearly $200,000 worth of advertising each year on your station. Mr. Banner wanted me to communicate to you that if this report, which directly and publicly admonishes All-American Automotive, runs on your station, there is little chance that your station will be able to secure any more advertising dollars from Banner Enterprises. Thanks for your time, Mr. Corey." Larson hung up.

Corey quickly organized a meeting with the General Manager and the News Director to discuss the problem. What should the station do? How might the desired decision differ between the News Director and the Sales Manager? Should the station kill the I-Team report or run the story as planned? What would the loss of the client mean to the station? How would the decision to kill the report damage the reputation and credibility of the news department? If you were the manager of this station, what would you do?

CASE STUDY	**The Wrong Content**

It was a slow Saturday night at a local, small market, Western, independent television station. Working on the overnight shift, it was common practice for the Technical Director (TD) running the switcher to watch movies or other content played on a DVD. This particular evening, the TD happened to have an adult movie running on a DVD. Momentarily forgetting what he was doing, the TD accidentally punches the DVD content on the switcher instead of hitting the commercial that was expected to run. The content that airs for about 15 seconds is pure pornography with full-frontal nudity. Within minutes, voice mail and e-mail bombard the station—most condemning the content; a few wanting to see the entire movie! If you were the manager, how would you deal with this incident? How would you respond to the public? How could this incident be used to educate the staff?

CASE STUDY	**Weekend Anchor in Trouble**

Brad Hutchinson is the weekend news anchor at WWES-TV in a top-15 Midwest market. Hutchinson, a single, handsome man in his mid-30s, has anchored the weekend news at WWES-TV for 2 years. Hutchinson is extremely popular in the ratings, especially with female viewers. He has a reputation as a ladies' man, attending a number of social and community events with a variety of women. Hutchinson is also known for being a party guy when he is off-duty, enjoying nightlife at local dance clubs and bars.

One Tuesday evening, News Director Pat Albright received a telephone call from a reporter covering city hall and the police department. Brad Hutchinson had been arrested earlier in the evening in a sting operation along with another person. Allegedly, they were trying to buy cocaine from an undercover police officer. The reporter learned that Hutchinson was in the car as a passenger and the other suspect did the talking in trying to make a deal. Hutchinson was considered an accomplice in the operation, resulting in his arrest.

The next day, Albright schedules an appointment with you as GM to discuss the Hutchinson situation. How should the station handle this incident? How might it impact the community's view of the anchor and the station? What ethical principles should be considered in this case? What would you do if you were the manager?

References for Chapter 3

Black, J., & Barney, R. D. (1985–1986). The case against mass media codes of ethics. *Journal of Mass Media Ethics, 1*(1), 27–36.

Christians, C. G., Rotzoll, K. B., Fackler, M., McKee, K. B., & Woods, R. H. (2005). *Media ethics: Cases and moral reasoning* (7th ed.). New York: Allyn & Bacon.

Day, L. A. (2006). *Ethics in media communications: Cases and controversies* (5th ed.). Belmont, CA: Wadsworth.

Gerbner, G., Gross, L., Morgan, M., & Signorielli, N. (1994). Growing up with television: The cultivation perspective. In J. Bryant & D. Zillmann (Eds.), *Media effects: Advances in theory and research* (pp. 17–42). Hillsdale, NJ: Erlbaum.

Goldberg, B. (2002). *Bias: A CBS insider exposes how the media distort the news*. Washington, DC: Regnery.

Goldberg, B. (2003). *Arrogance: Rescuing America from the media elite*. New York: Warner Books.

Hitt, W. D. (1990). *Ethics and leadership: Putting theory into practice.* Columbus, OH: Battelle Press.

Hosmer, L. T. (1996). *The ethics of management* (3rd ed.). Chicago: Irwin.

Jaska, J. A., & Pritchard, M. S. (1994). *Communication ethics: Methods of analysis* (2nd ed.). Belmont, CA: Wadsworth.

Limburg, V. E. (1989). The decline of broadcast ethics: U.S. v. NAB. *Journal of Mass Media Ethics, 4*(2), 214–231.

Loomis, K. D. (2008). The FCC and indecency: Local television general managers' perceptions. *The International Journal on Media Management, 10*(2), 47-63.

McManus, J. (1992). Serving the public and serving the market: A conflict of interest? *Journal of Mass Media Ethics, 7*(4), 196–208.

Steele, B. (2004, May 18). Ethics in television news. Poynteroline. Available online at http://www.poynter.org/content/content_view.aasp?id=65894

Strentz, H. (2002). Universal ethical standards? *Journal of Mass Media Ethics, 17*(4), 263–276.

Tucher, A. (1998). The Hutchins Commission, half a century on—I. *Media Studies Journal* (Spring/Summer), 48–55.

Vivian, J. (2005). *The media of mass communication* (7th ed.). Needham Heights, MA: Allyn & Bacon.

Warner, C., & Buchman, J. (2004). *Media selling: Broadcast, cable, print and interactive* (3rd ed.). Ames, IA: Blackwell.

4

Theories of Management

In this chapter you will learn

- Why management is considered a process
- The contributions of the classical school of management
- The contributions of the human relations school of management
- The contributions of the modern school of management

In Chapter 1, management was defined as a *process* in which individuals work with—and through—other people to accomplish organizational objectives. But what does it mean to say management is a process? How has the study of management evolved over time? Has management always been theorized as a process? This chapter examines these questions by focusing on the concept of management as a process and reviews the key theories of management and their applicability to electronic media.

Management as a Process

The term **process** describes a series of actions or events marked by change. Most of the time, process is used to define a continuous operation in which many things are happening simultaneously. Management is often considered to be a process because of its ongoing state of operation. Using process to describe electronic

media management is especially appropriate. After all, electronic media enterprises operate 24 hours a day, 7 days a week, 365 days a year. Content changes constantly, as does advertising. As discussed in Chapter 1, development, production, and distribution require the many skills, functions, and roles of managers in the electronic media. Furthermore, electronic media management must deal with changing consumer tastes and preferences, as well as social, regulatory, and technological trends.

Management in the electronic media is not a static concept but a dynamic, evolving process. However, management has not always been thought of in these terms. The next section reviews different approaches to the study of management, from its formal beginnings to its most recent theories.

Approaches to Management

To understand contemporary approaches to the study of management, it is helpful to review the major historical contributions to management theory. Serious study of management began near the start of the twentieth century in the United States and abroad. This interest coincides with the development of the electronic media in American society. The characteristics of the different approaches to management are best thought of as *schools,* the earliest of which is referred to as the *classical school of management* (see Albarran, 2006).

Classical School of Management

The classical school of management that flourished from the late 1800s through the 1920s is associated with the Industrial Revolution, which marked a shift from agrarian-based to industrial-based societies. As a philosophy, the study of management, which did not yet use this word in the sense we do now, centered on practical measures, that is—on improving the means of production and increasing productivity among workers. Among the first to study what would someday be known as management was philosopher Mary Parker Follett (Follett, 1995; Tonn, 2003). Soon after graduating from Radcliffe College in 1898, Follett began authoring a series of papers and books concerned with business conflict, authority, power, the place of the

individual in society and the group. Ironically, Follett's work was not appreciated until many years after her death in 1933, but her contributions to management thought and inquiry are now widely recognized as important foundation literature for the field.

Three different approaches to management, developed in three industrialized countries, represent the classical school: scientific management in the United States, administrative management in France, and bureaucratic management in Germany.

Scientific Management Scientific management presented a systematic approach to the challenge of increasing production. This approach introduced several practices, including determination of the most effective way to coordinate tasks, careful selection of employees for different positions, proper training and development of the workforce, and introduction of economic incentives to motivate employees. Each part of the production process received careful scrutiny toward the end of greater efficiency.

Frederick W. Taylor, a mechanical engineer by profession, is referred to as the father of scientific management. In the early twentieth century, Taylor (1991) made a number of contributions to management theory, including the ideas of careful and systematic analysis of each job and task and identification of the best employee to fit each individual task.

Scientific management also proposed that workers would be more productive if they received higher wages in return for their labor. This approach viewed the worker mechanistically, suggesting that management could guarantee more output if better wages were promised in return. Later approaches proposed that workers need more than just economic incentives to be productive. Nevertheless, many of Taylor's principles of scientific management are still found in modern organizations, such as detailed job descriptions and sophisticated methods of employee selection, training, and development.

Administrative Management Henri Fayol, a French mining executive, approached worker productivity differently from Taylor. Fayol studied the entire organization in hopes of making it more efficient. As discussed in Chapter 1, Fayol (1949) introduced the POC3 model, which detailed the functions of management. To aid managers in the planning, organizing, commanding, coordinating,

and controlling functions, Fayol established a list of 14 principles of management (see Table 4-1). Fayol recognized that management principles must be flexible enough to accommodate changing circumstances. In that sense, Fayol was among the first management theorists to recognize management as a process. Fayol's management functions and principles are still widely used in contemporary business organizations.

Bureaucratic Management In Germany, sociologist Max Weber focused on another aspect of worker productivity—organizational structure. Weber (1947) theorized that the use of an organizational hierarchy or **bureaucracy** would enable an organization to produce at its highest level. Weber called for a clear division of labor and management, a strong central authority, a system of seniority, strict discipline and control, clear policies and procedures, and careful

TABLE 4-1

Fayol's 14 Principles of Management

1. *Division of work.* Work should be divided according to specialization.
2. *Authority and responsibility.* The manager has authority to give directions and demand compliance along with appropriate responsibility.
3. *Discipline.* Respect and obedience is required of employees and the firm.
4. *Unity of command.* Orders should be received from a single supervisor.
5. *Unity of direction.* Similar activities should be under the direction of one leader.
6. *Subordination of individual interest to general interest.* Interests of a single employee do not outweigh those of the organization.
7. *Remuneration of personnel.* Wages are to be fair and equitable to all.
8. *Centralization.* Each organization must find the level of centralization of authority needed to maximize employee productivity.
9. *Scalar chain.* There is a line of authority in an organization, usually from top to bottom.
10. *Order.* All necessary materials should be located in the proper place for maximum efficiency.
11. *Equity.* Fair and equitable treatment is needed for all employees.
12. *Stability of tenure of personnel.* Adequate time should be allowed for employees to adjust to new work and skills demanded.
13. *Initiative.* The ability to implement and develop a plan is crucial.
14. *Esprit de corps.* A spirit of harmony should be promoted among personnel.

Source: Adapted from H. Fayol, *General and Industrial Management* (London: Pittman, 1949).

selection of workers based primarily on technical qualifications. Weber's contributions to management are numerous, manifested in such visible practices as organizational flow charts, job descriptions, and specific guidelines for promotion and advancement.

The classical school of management concentrated on ways to make organizations more productive. Management was responsible for establishing clearly defined job responsibilities, maintaining close supervision, monitoring output, and making important decisions. Individual workers were thought to have little motivation to do their tasks beyond wages and other economic benefits. These ideas would be challenged by the next major approach to management.

Human Relations School of Management

The notion that workers were motivated only by economic factors began to be challenged by management scholars in the 1930s and 1940s, giving rise to the human relations (or behavioral) school of management. The human relations school recognized that managers and employees were in fact members of the same group and thus shared in the accomplishment of organizational objectives. Further, employees had needs other than just wages and benefits; with these needs met, workers would be more effective and the organization would benefit.

Many theories relating to the behavioral aspects of management arose in this era. A number of the theories represent a micro perspective—that is, they center on the individual rather than the organization. Important contributors include Elton Mayo, Abraham Maslow, Frederick Herzberg, Douglas McGregor, and William Ouchi. Their contributions to the human relations school are discussed in the following paragraphs.

The Hawthorne Studies Perhaps the greatest influence on the development of the human relations approach to management was the work of Harvard business professor Elton Mayo. In 1924 the Western Electric Hawthorne plant in Cicero, Illinois, was used to investigate the impact of illumination (lighting) on worker productivity. The experiments were funded by General Electric, whose real interest, of course, was selling more light bulbs to the public. Efficiency experts at the plant used two different groups of workers in an experiment. A control group worked under normal lighting

conditions while an experimental group worked under varying degrees of illumination. As lighting increased in the experimental group, productivity went up. However, productivity in the control group also increased, without any increase in light.

Mayo and his associates were called in to investigate and expand the study to other areas of the Hawthorne plant. After a year and a half of study, Mayo concluded that the human aspects of their work affected the productivity of General Electric's employees more than the physical conditions. In other words, the increased attention and interaction with supervisors led to the greater productivity. Workers felt a greater affinity to the company when they felt that managers showed interest in their employees and their work.

The term **Hawthorne effect** has come to describe the impact of management attention on employee productivity. Mayo's work represents an important benchmark in the development of management thought, that is, recognizing employees have *social* as well as physical and monetary needs. In this era new insights were developed into ways that management could identify and meet employee needs as well as motivate workers.

Maslow's Hierarchy of Needs Psychologist Abraham Maslow contributed to the human relations school in the area of employee motivation. Maslow (1954) theorized that employees have a series of needs that one can organize into a hierarchy. As one level of needs is met, other levels of needs become important to the individual; as these levels are met, the progression through the hierarchy continues.

Maslow's hierarchy comprises five areas of needs: physiological needs, safety, social needs, esteem, and self-actualization (see Figure 4-1). Physiological needs are for the essentials of physical survival—food, water, shelter, and clothing. Safety or security needs are satisfied only after the basic physiological needs are met. Safety concerns the need to be free of the threat of physical danger and to live in a predictable environment. Social needs include the need to belong and be accepted by others. Esteem can be thought of in terms of both self-esteem (feeling good about the self) and recognition from others. Self-actualization is the desire to become what one is capable of being—the idea of maximizing one's potential.

FIGURE 4-1

Maslow's Hierarchy of Needs

Self-actualization

Esteem

Social

Safety

Physiological

The utility of Maslow's hierarchy lies in its recognition that each individual is motivated by different needs. Maslow theorized that individuals respond differently throughout the life cycle. Further, some people may have dominant needs at a particular level and thus never move through the entire hierarchy. In any case, Maslow's motivational theory suggests that managers may require different motivational techniques to motivate people according to their needs.

Herzberg's Hygiene and Motivator Factors Frederick Herzberg, another psychologist, studied employee attitudes through a series of intensive interviews to determine which job variables made workers satisfied or dissatisfied. Herzberg (1966) identified two sets of motivating factors: hygiene, or maintenance factors, and motivators (Table 4-2). **Hygiene factors** represent the work environment. They include not just technical and physical conditions, but also such factors as company policies and procedures, supervision, the work itself, wages, and benefits. **Motivators** involve aspects of the job such as recognition, achievement, responsibility, and individual growth and development. Herzberg called this second set of factors "motivators" to reflect the positive impact they have on employee satisfaction.

TABLE 4-2

Herzberg's Motivation and Hygiene Factors

MOTIVATORS The job itself	HYGIENE FACTORS Environment
Achievement	Policies and administration
Recognition	Supervision
Challenging tasks	Working conditions
Responsibility	Interpersonal relations
Growth and development	Money, status, security

Source: Adapted from Hersey, Blanchard, & Johnson (2008) and Herzberg (1966).

Herzberg's hygiene factors have some similarities to the three lower levels (physiological needs, safety, and affiliation) of Maslow's hierarchy, while the motivator factors represent the two upper levels (esteem and self-actualization). From a management perspective, Herzberg's work suggests that managers must recognize a dual typology of employee needs—both the hygiene factors and the need for positive motivation—in order to maintain job satisfaction.

Theory X and Theory Y While the work of Maslow and Herzberg advanced the importance of motivation in management, industrial psychologist Douglas McGregor (1960) noted that many managers still clung to traditional managerial assumptions that workers had little interest in work and lacked ambition. McGregor labeled this style of management **Theory X**, which emphasized such tactics as control, threat, and coercion to motivate employees.

McGregor offered a different approach to management, which he called **Theory Y**. Under Theory Y, managers did not rely on control and fear but integrated the needs of the workers instead and those of the organization. Employees could exercise self-control and self-direction and develop their own sense of responsibility if given the opportunity. The manager's role in Theory Y centers on matching the talents of the individual with the proper position in the organization and providing an appropriate system of rewards.

With its emphasis on human needs, McGregor's analysis of Theory X and Theory Y further developed the ideas associated with the human relations school. Interestingly, traits of both Theory X and Theory Y are observable in many business organizations.

Theory Z William Ouchi (1981) used characteristics of both Theory X and Theory Y in contrasting the management styles of American and Japanese organizations. Ouchi claimed that U.S. organizations could learn much from the Japanese model of management, which he called Theory Z. Like Theory Y, Theory Z cites employee participation and individual development as important components of organizational growth. Interpersonal relations between workers and managers are stressed in Theory Z. However, Ouchi also drew from Theory X, in that management makes the key decisions in an organization, and a strong sense of authority must be maintained.

A common criticism of Theory Z is that it fails to recognize the cultural differences between U.S. and Japanese firms and how these differences are manifested in business organizations and management efforts. Nevertheless, aspects of Theory Z can be found in many electronic media organizations in such areas as employee training, various types of fringe benefit programs, and lines of communication with managers (which tend to be more direct).

The human relations school launched a significant change in management thought as the focus moved away from production to the role of employees in meeting organizational goals and objectives. In particular, the ideas of creating a positive working environment and attending to the needs of the employees represent important contributions of the human relations school to the management process.

Modern Approaches to Management

By the 1960s theorists began to integrate and expand elements of the classical and human relations schools. This effort, which continues in the twenty-first century, has produced an enormous amount of literature on modern management thought. This section focuses on several areas that illustrate the diverse range of the modern school of management: management effectiveness, systems approaches to management, **total quality management (TQM)**, and leadership.

Management Effectiveness The classical and the human relations schools share productivity as a common goal, although they disagree on the means. The former proposes managerial efficiency and control, while the latter endorses employee needs and wants. However, neither approach really takes into account the importance of

effectiveness, the actual attainment of organizational goals. Both the classical and human relations schools consider effectiveness a natural and expected outcome.

Some modern management theorists have questioned this assumption. The late Peter Drucker (1973), considered the "father" of modern management theory, claimed that effectiveness is the very foundation of success for an organization, much more critical than organizational efficiency. To this end, Drucker (1986) developed **Management by Objectives (MBO)**, which involves a particular type of interaction between managers and individual employees. In an MBO system, middle- and senior-level managers must identify the goals for each individual area of responsibility and share these goals and expectations with each unit and employee. The shared objectives are used to guide individual units or departments and serve as a way management can monitor and evaluate progress.

An important aspect of the MBO approach is the agreement between employees and managers regarding performance over a set period of time. In this sense, management retains external control while employees exhibit self-control over how to complete individual objectives. The MBO approach has further utility in that one can apply it to any organization, regardless of size. Critics of the MBO approach contend it is time-consuming to implement and difficult to maintain in organizations that deal with rapidly changing environments, such as the electronic media. Nevertheless, one can find traits of MBO in the electronic media, particularly in the areas of promotion, marketing, and financial planning, where performance objectives are carefully established and monitored.

Systems Approaches to Management The systems approach to management follows a **macro perspective**; that is, the entire organization is examined, and the study includes the environment in which the organization operates (Schoderbek, Schoderbek, & Kefalas, 1985). Organizations are similar to one another in that they are engaged in similar activities involving **inputs** (e.g., labor, capital, and equipment), **production processes** (the conversion of inputs into some type of product), and **outputs** (e.g., products, goods, and services). In the systems approach to management,

organizations also study the external environment, evaluating feedback from the environment in order to identify change and assess goals.

Organizations are not isolated entities; they interact interdependently with other objects and organizations in the environment. The systems approach recognizes the relationship between the organization and its external environment. Though managers cannot control this environment, they must be aware of environmental factors and how they may impact the organization. For an application of systems theory applied to electronic media management, see Covington (1997).

A related approach to systems theory is the resource dependence perspective developed by Pfeffer and Salancik (1978). An organization's survival is based on its utilization of resources, both internal and external. All organizations depend on the environment for resources, and media industries are no exception (Turow, 1992).

Much of the uncertainty organizations face is due to environmental factors. As Pfeffer and Salancik (1978) state,

> Problems arise not merely because organizations are dependent on their environment, but because this environment is not dependable. . . . [W]hen environments change, organizations face the prospect either of not surviving or of changing their activities in response to these environmental factors. (p. 3)

Organizations can alter their interdependence with other organizations in one of two ways: (1) by absorbing other entities or (2) by cooperating with other organizations to reach mutual interdependence (Pfeffer & Salancik, 1978). Mergers and acquisitions, vertical integration, and diversification are strategies organizations use to ease resource dependence.

Systems theory and the resource dependence perspective help one understand the relationship of the electronic media to other societal systems. The media industries do not operate in isolation but form part of a larger system that also includes political, economic, technological, and social subsystems. Because systems approaches are concerned with responding to and interpreting environmental influences on the organization, electronic media managers at the executive level (General Managers) may find these approaches to management useful.

Total Quality Management Another modern approach to management theory is TQM, which one might best describe as a series of approaches to emphasize quality in organizations, especially in regard to producing products and serving both external and internal customers (Weaver, 1991). In TQM, managers combine strategic approaches to deliver the best products and services by continuously improving every part of an operation (Hand, 1992). While management implements and leads TQM in an organization, every employee must be responsible for quality. Used effectively, TQM helps an organization maintain a competitive edge.

A number of management scholars have contributed to an understanding of TQM, which is widely used. Considered the pioneer of modern quality control, Walter Shewart originally worked for Bell Labs, where his early work focused on control charts built on statistical analyses. Joseph M. Juran (1988) and W. Edwards Deming (1982) contributed to Shewart's early work, primarily with Japanese industries. Deming linked the ideas of quality, productivity, market share, and jobs; Juran contributed a better understanding of planning, control, and improvement in the quality process. Other important contributors to the development of TQM include Philip Crosby, Armand Feigenbaum, and Karou Ishikawa (Kolarik, 1995).

The popularity of TQM in the United States increased during the late 1970s and early 1980s, when U.S. business and industry were suffering from what many industrial experts labeled declining quality. Organizations adopted quality control procedures and strategies to reverse the negative image associated with poor-quality products. TQM is still used as a way to encourage and demand high quality in the products and services produced by organizations. TQM has many areas of potential application in the electronic media, from the actual production of media content and advertising to the use of mission statements and public relations activities.

Strategic Management Strategic management is primarily concerned with developing tools and techniques to analyze firms, industries, and competition, and developing strategies to gain a competitive advantage. Perhaps the most significant scholar in the area of strategic management is Michael Porter, whose seminal works

Competitive Strategy (1980) and *Competitive Advantage* (1985) represent the foundation literature in this area.

In terms of application to the media industries, strategic planning is one outgrowth of strategic management that has found wide application. In its simplest form, strategic planning involves a scanning of the external and internal environments by focusing on a firm's individual strengths, weaknesses, opportunities, and threats (a SWOT analysis). Gershon (2000) offers one of the few scholarly reviews of strategic planning for media companies. Chan-Olmsted (2005, 2006) authored comprehensive reviews of strategic management, as well as a separate book detailing the application of strategic management to media firms.

Leadership The relationship between management and leadership represents further refinement of modern management thought. Leadership, according to Hersey, Blanchard and Johnson (2008, p. 6) "occurs whenever one person attempts to influence the behavior of an individual or a group, regardless of the reason." There is wide agreement that the most successful organizations have strong, effective leaders. Most organizations contain both formal and informal leaders, both those in recognized managerial positions and those not in such positions but who show wisdom and experience.

A number of authors study leadership. Warren Bennis (1994) has spent much of his life studying leadership in organizations. Bennis claims leadership consists of three basic qualities: vision, passion, and integrity. In terms of vision, leaders have an understanding of where they want to go and will not let setbacks or obstacles deter their progress. Passion is another trait of a good leader: a person who loves what he or she does. Integrity is made up of self-knowledge, candor, and maturity (Bennis, 1994, pp. 40–41). Bennis adds that good leaders also exhibit curiosity and daring. Curious leaders never stop learning about their organization. They also are willing to take risks and are not afraid of failure. Leaders look upon mistakes as a way to learn.

Bennis makes several distinctions between someone who is a manager versus someone who is a leader. To Bennis, the leader innovates, while a manager administers. Leaders offer a long-range perspective, while managers exhibit a short-range view. Leaders originate, while managers imitate. The author argues that most business

schools—and education in general—focus on narrow aspects of training rather than on development of leadership qualities.

Another area of leadership studies involves transactional and transformational leadership. Transactional leadership assumes people are motivated by rewards as well as punishment, and that systems work best with a defined chain of command. Transactional leaders make clear to their subordinates what is required of them and rewards or punishes as needed. Transformational leadership ideally follows transactional leaders; the difference between the two being transactional leadership is more focused on management practices, while transformational leadership involves vision and passion, and subordinates accept the vision of the leader. Transformational leaders must constantly sell their vision and lead the change needed in an organization. Some of the early works in this area include books by Bass (1985, 1990) and Burns (1978).

Max De Pree (1989) defines leadership as an art. De Pree claims that liberating people (employees) to do what is required of them is the most effective type of leadership and management possible. De Pree also identifies the leader as a servant in that the person removes obstacles that prevent employees from reaching their objectives. To De Pree the leader enables followers to realize their full potential. Other prominent authors in the area of leadership are Edgar Schein, John Maxwell, and Rudolph Giuliani, to name just a few.

Management in the Twenty-First Century How will management thought continue to evolve in the twenty-first century? Perhaps one of the best sources for insight is from the late Peter Drucker, the preeminent management scholar of the past century. Drucker called for a new management model, as well as a new economic theory to guide business and industry (Drucker, 2000). Drucker claims that schools have become antiquated, failing to prepare people for the new managerial environment.

In examining management challenges for the twenty-first century, Drucker (1999) argues that, given the sweeping social, political, and economic changes affecting the world at the end of the twentieth century, there are few certainties in management and strategic thinking. Drucker states that "one cannot manage change . . . one can only be ahead of it" (1999, p. 73). Drucker claims managers must

become change leaders, seizing opportunities and understanding how to effect change successfully in their organizations.

Clearly, electronic media managers would agree with Drucker that in order to be successful, the ability to cope with and use change as a competitive advantage is critical. The challenge is how to embrace change successfully. A critical change issue for managers in the twenty-first century is determining when to focus on the external environment and when to focus on the internal environment.

At the end of the day, management is still concerned with working with and through other people to accomplish organizational objectives. In a sweeping study of some 400 companies and 80,000 individual managers across many industries, Buckingham and Coffman (1999) identified four key characteristics of great managers. Great managers were those who were particularly adept at selecting the right talent, defining clear expectations, focusing on each individual's strengths, and helping them find the right fit in the organization. The authors' findings have particular implications for electronic media management, helping to focus attention on the importance of quality employees in meeting organizational objectives.

Management and the Electronic Media

The different approaches to management reflected in the classical, behavioral, and modern schools all have limitations regarding their direct application to the electronic media industries. Although the classical school emphasizes production, its understanding of management functions, skills, and roles remains helpful. The human relations school makes an important contribution by emphasizing the needs of employees and proper motivation. And the modern approaches clarify managerial effectiveness and leadership while recognizing the interdependency of media and other societal systems.

The changing nature of the communication industries, however, precludes the adoption of a universal theory of electronic media management. The complex day-to-day challenges associated with managing a radio, television, cable, or telecommunications facility make identifying or suggesting a central theory impossible. Further,

the variability of electronic media firms in terms of the number of employees, market rankings, qualitative characteristics, and organizational culture requires individual analysis of each operation to discern what style of management will work best.

At best, a synthesis of approaches drawn from the classical, behavioral, and modern schools of management seems the most beneficial. Management is a constant, ongoing process subject to refinement and change.

Summary

In this chapter, the term *process* is used to describe a series of actions or events marked by change. Management is often considered to be a process because of its ongoing state of operation. However, management has not always been conceptualized in dynamic terms. Three schools of management thought have evolved. Some approaches center on the organization as a whole (macro approaches) while others focus on interaction between individual managers and employees (micro approaches).

The classical school of management was concerned with improving the means of production and productivity of workers. The major contributors to this school were Frederick W. Taylor, who developed scientific management; Henri Fayol, the founder of administrative management; and Max Weber, who developed bureaucratic management.

The human relations (behavioral) school focused on the needs of employees in meeting organizational goals. The important contributors include Elton Mayo (Hawthorne studies), Abraham Maslow (hierarchy of needs), Frederick Herzberg (hygiene and motivator factors), Douglas McGregor (Theory X and Theory Y), and William Ouchi (Theory Z).

The modern school of management appeared in the 1960s and continues today. Contributions to the modern school include studies on managerial effectiveness and management by objectives (Peter Drucker), systems approaches to management in the form of general systems theory and the resource dependence perspective, total quality management, strategic management, leadership, and management thought early in the twenty-first century.

The changing nature of the electronic media industries and their complex structures preclude the use of a general theory or set of guidelines for management. At best electronic media managers draw from all three schools in developing their own management styles and adapt as new situations and experiences warrant change.

CASE STUDY Management and Leadership

Management and leadership are often treated as separate concepts. Yet, to be a good manager, you should be able to lead people. Likewise, to be a good leader, you should be able to manage things. What do you see as the key differences between management and leadership? Offer some examples based on your own work experiences and observations.

CASE STUDY Just What Kind of Manager Are You?

It has been eight years since you graduated from college with a degree in communications. During that time you worked for several radio stations in a variety of programming and production positions before moving into sales as an account executive. You became one of the station's strongest account executives, always meeting your quotas and goals on time. During the past three years, you achieved the highest billings of any AE at the station. Life has been good, but it is about to change.

Gene Michaels, your supervisor and Local Sales Manager, invited you to lunch, where he informed you that he has accepted a position as a General Sales Manager with another radio group and has recommended that you be named the new Local Sales Manager. "I realize that a position in management was not what you thought this lunch was about," he tells you, "but it is a great opportunity for you to apply your skills as an AE in more of a mentoring role to develop other strong salespeople like yourself."

Flattered by the recommendation, you nevertheless are apprehensive about a move into sales management. You have experienced various management styles in your career, but never before have you been asked to develop one of your own. Based on your understanding of the different schools of management you have encountered in this chapter, how would you describe your managerial philosophy? Would it be more representative of the classical, behavioral, or modern school? What sort of expectations would you have about yourself—and the people who report to you? Finally, how would you measure your success as a manager in your new role?

| CASE STUDY | **Different Management Styles** |

As the Operations Manager for a small, local cable operator, all of the department heads (programming, engineering/technical, sales, and office) report to you on a regular basis. You have just received the initial budget request for next year from each unit, which also includes a summary of employee productivity in each area. The difference in employee evaluations caught your attention, noted by the following excerpts:

Jane Sadler, Programming. "The employees are hard-working individuals, but they could function better as a team. The level of detail needed in our unit is not as sharp as it could be. Our primary goal is to develop more of a team approach to our work and make sure the left hand knows what the right is doing."

Ralph Winslow, Technical/Engineering. "We have dealt with unusually high turnover in our area. New employees think they know everything, but they really know very little. They lack motivation. We offer a good salary and benefits, but it doesn't seem to matter to these people. Next year I would like to identify a stronger group of employees who care more about their jobs."

Ruth Cook, Sales. "Our staff is small, but we have had a great year. Our incentive-based marketing program has created a lot of friendly competition among the sales staff, and local advertising is up 60 percent over last year. I am confident that if we can add two more people to our staff they will pay not only for their salaries but add to our bottom line as well. Our staff understands that when they are successful, everyone here is successful."

Carol Gaines, Office Manager. "Our employees, most of them in the customer service area, deal with a number of frustrated customers every day. It can be a demanding and negative experience, but our staff is handling it very well. The regular training workshops offered by the company on new strategies to deal with customer service issues have really paid off. Work on developing employees in other areas, such as accounting, traffic, and general administrative, is also paying good dividends. The quality of our unit continues to improve, and we hope to build upon our success next year."

Reviewing these comments, how would you characterize the management philosophies exhibited by each of these midlevel managers? If you were Operations Manager, what suggestions would you offer on ways to improve their units?

References for Chapter 4

Albarran, A. B. (2006). Historical trends and patterns in media management research. In A. B. Albarran, S. M. Chan-Olmsted & M. O. Wirth (Eds.). *Handbook of media management and economics* (pp. 3–22). Mahwah, NJ: Lawrence Erlbaum Associates.

Bass, B. M. (1985). *Leadership and performance beyond expectation.* New York: Free Press.

Bass, B. M. (1990). From transactional to transformational leadership: Learning to share the vision. *Organizational Dynamics, 18*(3), 19–31.

Burns, J. M. (1978). *Leadership.* New York: Harper & Row.

Bennis, W. (1994). *On becoming a leader.* Reading, MA: Addison-Wesley.

Buckingham, M., & Coffman, C. (1999). *First, break all the rules: What the world's greatest managers do differently.* New York: Simon & Schuster.

Chan-Olmsted, S. M. (2005). *Competitive strategy for media firms.* Mahwah, NJ: Lawrence Erlbaum Associates.

Chan-Olmsted, S. M. (2006). Issues in strategic management. In A. B. Albarran, S. M. Chan-Olmsted & M. O. Wirth (Eds.). *Handbook of media management and economics* (pp. 161-180). Mahwah, NJ: Lawrence Erlbaum Associates.

Covington, W. G. (1997). *Systems theory applied to television station management in the competitive marketplace.* Lanham, MD: University Press of America.

De Pree, M. (1989). *Leadership is an art.* New York: Dell.

Deming, W. E. (1982). *Out of crisis.* Cambridge, MA: Productivity Press.

Drucker, P. F. (1973). *Management: Tasks, responsibilities, practices.* New York: Harper & Row.

Drucker, P. F. (1986). *The practice of management.* New York: Harper & Row.

Drucker, P. F. (1999). *Management challenges for the 21st century.* New York: HarperCollins.

Drucker, P. F. (2000, January 1). Interview. *Wall Street Journal,* p. R34.

Fayol, H. (1949). *General and industrial management* (C. Storrs, Trans.). London: Pittman.

Follett, M. P., Pauline, G., & Graham, P. (1995). *Mary Parker Follett: Prophet of management* (P. Graham, Ed.). Boston: Harvard Business School Press.

Gershon, R. A. (2000). The transnational media corporation: Environmental scanning and strategy formulation. *Journal of Media Economics, 13*(2), 81–101.

Hand, M. (1992). Total quality management—one God but many prophets. In M. Hand & B. Plowman (Eds.), *Quality management handbook* (pp. 26–46). Oxford: Butterworth-Heinemann.

Hersey, P., Blanchard, K. H., & Johnson, D. E. (2008). *Management of organizational behavior* (9th ed.). Upper Saddle River, NJ: Pearson Prentice Hall.

Herzberg, F. (1966). *Work and the nature of man.* New York: World Publishing Company.

Juran, J. M. (1988). *Juran on planning for quality.* Cambridge, MA: Productivity Press.

Kolarik, W. J. (1995). *Creating quality.* New York: McGraw-Hill.

Maslow, A. H. (1954). *Motivation and personality.* New York: Harper & Row.

McGregor, D. (1960). *The human side of enterprise.* New York: McGraw-Hill.

Ouchi, W. G. (1981). *Theory Z: How American business can meet the Japanese challenge.* Reading, MA: Addison-Wesley.

Pfeffer, G., & Salancik, G. (1978). *The external control of organizations: A resource dependence perspective.* New York: Harper & Row.

Schoderbek, P. P., Schoderbek, C. D., & Kefalas, A. G. (1985). *Management systems: Conceptual considerations* (3rd ed.). Plano, TX: Business Publications.

Taylor, F. W. (1991). *The principles of scientific management.* New York: Harper & Brothers.

Tonn, J. C. (2003). *Mary P. Follett: Changing democracy, transforming management.* New Haven, CT: Yale University Press.

Turow, J. (1992). *Media systems in society: Understanding industries, strategies, and power.* New York: Longman.

Weaver, C. N. (1991). *TQM: A step-by-step guide to implementation.* Milwaukee WI: Quality Press.

Weber, M. (1947). *The theory of social and economic organization* (A. M. Henderson and T. Parsons, Trans.). New York: Free Press.

Financial Management

In this chapter you will learn

- Basic aspects of financial management
- The process of budgeting in an electronic media organization
- An approach to analyzing common types of financial statements
- Analytical tools used in financial analysis

All firms that own electronic media enterprises operate with a common financial goal—to earn a profit on the products and services they offer. Even noncommercial entities, such as public broadcasting stations, must keep revenues ahead of expenses. Commercial radio and television stations, multichannel video systems, telephone companies, multimedia companies, and online companies are businesses. And in business, success is measured primarily by the **bottom line**—the amount of profit or loss that remains after one deducts expenses from revenues. Owners of electronic media enterprises want to protect their investment and receive a favorable return. To do this, owners turn to managers for assistance and expertise in meeting fiscal goals.

Probably no other management task is more universal than the administration and decision making associated with creating budgets and controlling revenues and expenditures. While many tasks and responsibilities are delegated, the manager remains directly responsible for financial matters. In most electronic media facilities, this person is the General Manager (GM) or some other senior manager

who makes the important decisions that affect profit or loss. Those preparing for a career in management—or any business—must understand the role of financial management.

What Is Financial Management?

To properly manage the finances of an organization, managers use **financial management**, which involves systematic planning, monitoring, and control. Though *planning* involves many areas, it mainly concerns developing budgets based on revenue history and expense projections. In planning, one also plans for new personnel positions and establishes timelines for the upgrading and replacement of expensive items, such as equipment, vehicles, and computer systems.

Monitoring takes place through managerial review of financial statements and other reports that measure the efficiency of an organization. Later in the chapter, you will learn more about financial statements—such as income statements and balance sheets—that are commonly used in business. Managers need to be familiar with the content of financial statements and how to interpret and evaluate them.

Finally, *control* can take many forms, from authorizing purchases to establishing internal policies and procedures. Control of fiscal policy helps eliminate ambiguity in an organization's financial matters. GMs work together with middle managers to administer individual budgets and evaluate performance.

Meeting Financial Goals

Financial management is needed not only to maintain fiscal control but also to meet the expectations of owners and investors. Setting financial goals is a complicated process affected by many factors beyond the control of managers and owners. Managers must consider (1) the state of the economy (both local and national); (2) technological change; (3) regulatory issues; and (4) audience tastes and preferences. Change in any one of these areas can influence the financial performance of an electronic media facility.

Take a television station, for example, that is faced with many challenges to its financial planning. First, given a flourishing local economy, competition for local advertising is generally strong. But as the economy falters, the station will be affected since advertising is one of the first things many businesses reduce or eliminate to control costs. Second, the need to upgrade key equipment may mean a sizable increase in the operating budget. Third, if the FCC should enact new policies requiring broadcasters to offer free commercial time for political candidates, this reduces the amount of commercial inventory available to advertisers. Finally, the audience may respond negatively to a new anchor or redesigned morning show. If the audience erodes significantly, change will be necessary.

One can establish financial goals in many different ways, ranging from revenue projections to cost-cutting methods. Ideally, the process involves both senior-level management and owners, with some flexibility needed from both for unknown contingencies. Financial success can be measured in many different ways—via profit or loss, profit margins, or investor appreciation. Every organization needs financial goals in order to maintain growth.

Implementing Financial Growth

The manager works closely with other personnel in administering the finances of an electronic media facility. The number of personnel involved varies, depending on the size of the organization. In small firms (fewer than 15 employees) a bookkeeper or traffic manager may handle most of the financial transactions. Medium-sized firms may have an accounting or business department employing several people. Larger firms (more than 50 employees) often have a Controller—a midlevel manager who, along with his or her staff, supervises all accounting functions and prepares reports and other materials for the General Manager. Regardless of the size of the unit, other duties beyond basic accounting functions include banking, billing, collections, payroll, personnel, tax modules, and purchasing.

Traditional electronic media enterprises are capital-intensive, consisting of a number of expensive resources. The amount of

equipment, personnel, and other materials (such as content) needed to operate a radio, TV, cable, or telecommunications facility represents an investment of hundreds of thousands of dollars. The money that flows into a media organization, through advertising and other types of revenue, can reach staggering proportions. To maintain control over the constant flow of revenue and expenses, businesses use accounting systems to keep track of all financial transactions.

Sophisticated accounting systems help in monitoring financial performance. Before high-powered desktop computers, accounting was handled through manual entry. Contemporary accounting software systems offer many features and options. Many programs combine enterprise systems (purchasing and personnel operations) data management (database functions) and supply chain management. Among the systems used by electronic media firms are Oracle/PeopleSoft, SAP, and Optimal Solutions Inc. These systems track revenues and expenses, coordinate commercial inventory and billing (commonly known as *traffic*), provide forecasts, and produce different types of reports. The radio industry uses some of these products, but also has its own specialty programs that are known as revenue management systems. Among the systems are Wide Orbit, RadioTraffic, Merketron, VIERO, VCI Solutions, and Specialty Data Systems. Managers should understand the features of the accounting system and how to access information, making computer literacy an important skill needed for pursuing a career in management.

Budgeting

Managers need budgeting in order to achieve established financial goals and objectives. Budgeting is usually an annual process in which management projects anticipated revenues and expenditures for the firm for the following 12 months. For example, to start a new budget year in January, most of the actual budgeting process will take place over the summer months of the preceding year. Once the final budget is approved, managers monitor performance at regular intervals (weekly, monthly, and quarterly) using various types of financial statements. Keep in mind that the business

year may differ from the calendar year because companies are allowed to designate their own fiscal year for tax purposes; that is, a company's fiscal year does not necessarily go from January through December.

Creation of the actual budget follows a specific organizational procedure, and all managers usually participate in budgeting. By clearly understanding the financial goals of the corporate owners, managers at all levels can work as a team toward the completion of specific financial objectives.

Setting Priorities and Goals in Individual Departments

Department heads (middle and some lower-level managers) normally submit an initial budget for approval to the Controller and General Manager based on the individual department's priorities and goals. Some departments have similar needs (such as upgrading technology); others have unique needs. Engineering may require diagnostic equipment while marketing may request new sales assistants for the following year. Each manager conducts a careful review of past performance of his or her individual unit, considering revenues and expenses as well as equipment, personnel, and other needs.

Departmental budgets are usually established with some parameters provided by the Controller and General Manager. Depending on the economy and the financial condition of the organization, managers may be asked to limit the overall increase of their budget requests to a certain percentage or to cut expenses by a certain percentage of the previous year's budget. The submission of a departmental budget is usually accompanied by a report that summarizes the budget and justifies each expense.

Capital Budgeting

Major expenses, such as the replacement of equipment, involve a separate budgeting process called **capital budgeting** (Eckhart, 1994), defined as the long-range planning, evaluation, and selection of projects covering more than one fiscal cycle. Managers use capital budgeting techniques to evaluate large purchase decisions. Most firms have more opportunities than resources for investing in long-term projects. Capital budgeting allows management to systematically evaluate projects that increase the value of the firm.

Compiling the Budget

The General Manager, working with the Controller and other financial managers, compiles the budget requests from each department. These unit requests often exceed company goals. If this is the case, the GM will often ask for a revised budget and the process continues. The GM can reject any budget items deemed unreasonable. In compiling the overall budget, the General Manager should explain to the department heads what areas of their proposed budgets are being cut or modified.

The General Manager must also evaluate any capital expenditures requested by individual departments. The GM prioritizes these requests and, through the use of capital budgeting techniques and other analysis, determines which projects (if any) can be pursued over the next calendar year. Once the budget is finalized and approved by the General Manager, it becomes the blueprint for monitoring financial performance. Department heads and the General Manager meet regularly with the Controller and other financial managers to determine steps to curb overspending and encourage savings.

Budgetary Flexibility

Successful budgets contain a degree of flexibility. The uncertainty associated with any business or industry, particularly the electronic media, requires such flexibility. Most managers address this uncertainty by designating a percentage of the budget as a reserve account to cover emergencies or unexpected contingencies.

Forecasting

Budgets also help management project estimates of future revenues and expenses. This part of financial management, known as **forecasting,** usually covers longer periods of time such as 3, 5, or 10 years. Forecasting can be challenging because many unknown factors influence business conditions such as the strength of the local economy, competition, changes in technology, regulatory decisions, changes in demography, and social trends. Despite these limitations, internal forecasting remains an important tool in long-term financial planning.

Monitoring Financial Performance

To monitor and evaluate the financial performance of a business, management uses different financial statements and reports. Where does this information come from? All financial transactions are recorded in accounting software that mimics journals and ledgers; this information

is then summarized and reported in financial statements. The individual entries or **postings** are completed using a software program.

Typical journals include a cash receipts journal, cash disbursements journal, sales journal, and general journal. Ledgers usually consist of accounts receivable, accounts payable, the payroll ledger, and the general ledger. See Table 5-1 for a description of each of the journals and ledgers used in financial accounting. Information from the general ledger is used in preparing the main types of financial statements: the balance sheet, the income statement, and the statement of cash flows.

TABLE 5-1

Journals and Ledgers

JOURNAL	DESCRIPTION
Cash receipts journal	Record of all moneys received; identifies the payer and type of account.
Cash disbursements journal	A record of all moneys paid out by the organization; should include expense categories. Totals posted to the general ledger on a regular (monthly) basis.
Sales journal	Record of all advertising sales, including name of client, contract number, date, amount, and name of advertising representative.
General journal	Record of all noncash transactions not included in any of the other journals. Includes such items as depreciation, amortization, accruals, etc.
Accounts receivable	Record of all moneys owed the organization by clients. Dated entries indicate which accounts are paid on time and which are delinquent.

LEDGER	DESCRIPTION
Accounts payable	Record of all payments to creditors for both short- and long-term liabilities.
Payroll ledger	Record of all payroll disbursements for both hourly and salaried employees.
General ledger	Record of all transactions posted from other journals and ledgers for entry into appropriate accounts. Transactions to general ledger usually posted monthly.

Balance Sheet The **balance sheet** summarizes the financial condition of a firm at a particular point in time, allowing a manager to compare its condition at different intervals. It consists of three sections: assets, liabilities, and owner's (or stockholders') equity (see Figure 5-1). It is called a *balance* sheet to indicate that a firm's assets are equal to the total liabilities plus the owner's equity:

Assets = Liabilities + Owner's Equity

Assets represent the value of anything owned by a firm. **Liabilities** represent obligations to others, or money the firm owes. **Owner's equity,** or net worth, refers to the financial interest of the firm's owners. Each of these terms is further detailed in the following subsections: assets, liability, and owner's equity.

Assets Assets fall into three categories: current assets, fixed assets, and other assets.

Current assets are usually considered first when one discusses assets because they represent items that one can convert quickly into cash. Sometimes thought of as liquid assets, current assets include cash, money market accounts, marketable securities, accounts receivable, notes, and certain types of inventories (including some equipment items like cable modems and converter boxes and unsold advertising time, and programming).

Fixed assets are assets held for a long time that one cannot convert to cash as quickly as current assets. Land, buildings, and property are the best examples of fixed assets. All types of equipment found in offices and studios, vehicles, and even transmission systems at broadcast stations represent fixed assets.

Other assets are primarily thought of as intangible assets. For most businesses, other assets consist of such things as patents, trademarks, copyrights, goodwill, and any prepaid expenses, such as taxes, interest, or insurance. In the electronic media, several important assets fall into this category, including the FCC station license, network contracts for affiliated stations, and the franchise agreement for cable systems. Programming and advertising contracts are also considered assets. Finally, **goodwill** deserves separate mention because of the importance of the electronic media to society. Goodwill refers to an organization's public record. Electronic media organizations increase their goodwill by becoming involved in the community and maintaining a positive public identity.

FIGURE 5-1

Balance Sheet

SOURCE: *Reprinted courtesy of the Media Financial Management Association (MFM).*

BROADCASTING COMPANY
Balance Sheet
As of _____

ASSETS	This Year	Last Year
Current Assets:		
Cash and cash equivalents		
Marketable securities		
Accounts receivable, less allowances		
Program rights—current		
Prepaid expenses & deferred charges		
Other current assets	_____	_____
Total Current Assets		
Property, plant, and equipment at cost		
Less: accumulated depreciation		
Net Property, Plant, and Equipment		
Program rights—long-term		
Other non-current assets		
Intangible assets, net of amortization	_____	_____
Total Assets	======	======
LIABILITIES AND STOCKHOLDERS' EQUITY		
Current Liabilities:		
Accounts payable		
Notes payable		
Accrued expenses		
Income taxes payable		
Program rights payable—current		
Other current liabilities	_____	_____
Total Current Liabilities		
Long-term debt		
Deferred income taxes		
Program rights payable—long-term		
Other non-current liabilities		
Total Liabilities		
Stockholders' equity:		
Capital stock		
Paid-in capital		
Retained earnings		
Treasury stock	_____	_____
Total Stockholders' Equity	_____	_____
Total Liabilities and Stockholders' Equity	======	======

Tax regulations require all companies to dispose of the value of their fixed and other assets over time through **depreciation** and **amortization**. Fixed assets are depreciated; intangible assets are amortized. Both methods allow firms to deduct a portion of the overall cost of the asset over the life of the asset. These concepts are discussed more fully later in the chapter.

Liabilities The second part of the balance sheet reflects the various financial obligations of the organization. Liabilities that can be eliminated in one year or less are considered current liabilities; long-term liabilities represent obligations of one year or more.

Current liabilities include accounts payable, taxes (including franchise fees for cable operators), payroll expenses (including Social Security, Medicare, and other types of taxes), and commissions. Yearly program contracts and music licensing fees, if applicable, are also considered current liabilities. Long-term liabilities include loans and mortgages on properties and structures.

Owner's Equity The third and final component of the balance sheet consists of the owner's equity or net worth. Besides the owner's initial investment in the firm, owner's equity includes earned income (also called *retained earnings*) that has not been disbursed. This part of the balance sheet reports the amount of common and preferred stock held by the owners of the company.

Income (P&L) Statement The income or **profit and loss (P&L) statement** (also called an operating statement) charts a firm's financial activities over a set period of time—usually a week, month, or quarter. The P&L statement differs from the balance sheet in that **revenues** and **expenses** are reported along with the appropriate profit or loss. While the balance sheet compares how a firm operates from one time period to the next, the P&L statement identifies where changes in the financial condition of the firm took place. See Figure 5-2 for a sample P&L statement.

Revenues vary among electronic media organizations. For radio and television stations, most revenues come from advertising sales (local, regional, national, and political as well as online ad sales) and network compensation (if applicable). Cable systems derive revenues from several sources, including subscriber fees for different tiers of service, premium channel subscriptions, PPV events, advertising,

BROADCASTING COMPANY
Statement of Operations

As of_____
(Date)

MONTH:_____ YEAR-TO-DATE

Actual	Budget	Last Year		Actual	Budget	Last Year
			OPERATING REVENUE			
			Local			
			National			
			Network			
			Production			
			Other Broadcast			
___	___	___	Misc. Revenue	___	___	___
			Gross Revenue			
			Less:			
___	___	___	Commissions	___	___	___
			Net Revenue			
			OPERATING EXPENSES			
			Technical			
			Programming			
			News			
			Sales and Traffic			
			Research			
			Advertising			
			General & Admin.			
___	___	___	Depr. & Amort.	___	___	___
___	___	___	Total Op. Expenses	___	___	___
			Op. Profit (Loss)			
___	___	___	Before Taxes	___	___	___
___	___	___	Provision for Taxes	___	___	___
═══	═══	═══	Net Income	═══	═══	═══

MODEL STATEMENTS II-2

FIGURE 5-2

**Statement of
Operations (P&L)**

SOURCE: *Reprinted
courtesy of the Media
Financial Management
Association (MFM).*

and equipment rental in the form of modems, converter boxes, and DVRs. Telecommunication facilities draw revenues primarily from business and consumer users, as well as from local and regional advertisers (e.g., the yellow pages).

Expense categories vary among the media industries. Broadcast stations cluster expenses into the following categories: general and administrative, programming and production, news, sales, engineering, and advertising and promotion. Cable and satellite systems report expenses in areas that include general and administrative, capital equipment, programming, technical expenses, and marketing. Similar to those of cable, the major expense groups of telecommunication companies include general and administrative, capital expenses, technical expenses, and marketing. Other expense categories found in all electronic media organizations include Internet hosting and marketing, depreciation, amortization, and interest expenses.

Statement of Cash Flows

Maximizing cash flow is an important goal of all businesses (Capodanno, 1994). Managers use a **statement of cash flows** (Figure 5-3) to track the flow of money in an organization. This statement summarizes the sources and uses of the cash flows in an operation and presents the beginning and ending cash balances. Notice in Figure 5-3 that a statement of cash flows falls into three sections: (1) cash flows from operating activities; (2) cash flows to or from investment activities; and (3) cash flows to or from financing activities.

Managing cash flow is difficult. Several strategies are used to enhance cash flow. Increasing revenues while controlling expenses produces more cash for an organization, as will efficient collection of outstanding client accounts, lowered taxes, and efficient management of accounts payable (Capodanno, 1994). Cash planning also helps maximize cash flow. By planning cash needs in advance, managers can shift excess cash into interest-bearing accounts (e.g., a money market account). For example, if a station has cash available in another account, transferring the money to an interest-bearing account produces additional cash and larger cash flows.

In the electronic media, cash flow is also used to determine the value of a broadcast station or cable system; that is, as cash flow increases, so does the value of the business. Sales prices for electronic media properties are routinely based on some multiple of annual cash flows. For example, if a radio station has an annual cash flow of $3 million, a multiple of 8 to 10 would suggest the station is

FIGURE 5-3

**Statement of
Cash Flows**

SOURCE: *Reprinted courtesy
of the Media Financial
Management Association
(MFM).*

STATEMENT OF CASH FLOWS

Years Ended . 20_____ 20_____

Cash Flows from Operating Activities:

Net Income

Adjustments to Reconcile Net Income to Net Cash
Provided by Operating Activities:
 Depreciation & Amortization
 Deferred income taxes
 Decrease/(increase) in receivables
 Decrease/(increase) in inventories
 Decrease/(increase) in deferred costs
 Decrease/(increase) in accounts payable & accruals
 Payments for program rights*
 Additions/(reductions) to other deferred items _____ _____

Net cash provided by operating activities _____ _____

Cash Flows from Investing Activities:
 Purchase of property, plant, and equipment
 Proceeds from sale of property, plant, and equipment
 Purchase of marketable securities
 Redemption of marketable securities
 Reductions/(additions) to other assets _____ _____

Net cash (used) provided by investing activities _____ _____

Cash Flows from Financing Activities:
 (Decrease)/increase in short-term debt
 Proceeds from long-term debt
 Payments to retire long-term debt
 Proceeds from common stock issued
 Purchase of treasury shares
 Dividends paid _____ _____

Net cash (used)/provided by financing activities
Net increase/(decrease) in cash and cash equivalents
Cash and cash equivalents at beginning of year _____ _____

Cash and Cash Equivalents at End of Year ========= =========

Supplemental Disclosures of Cash Flow Information:
 Cash paid during year for:
 Interest (net of amounts capitalized)
 Income taxes

 * Program rights may alternatively be treated as follows:
 • Program rights amortization—Operating (add back to net income)
 • Purchases of program rights—Reduction of cash (may be either operating
 or investing)

MODEL STATEMENTS II-3

valued at $24 to $30 million. Albarran and Patrick (2005) offer an examination of valuation models used in the radio industry.

Other Financial Statements

In addition to the widely used balance sheet, income statement, and statement of cash flows, firms use other financial statements to monitor their financial condition. These include the statement of changes in owner's equity, the statement of retained earnings, the statement of changes in financial position (also called the *funds flow statement*), and statements related to specific projects, such as special programming. Extensive discussion of these financial statements lies beyond the scope of this chapter. For further information, consult accounting textbooks or better yet consider taking some basic coursework in accounting.

Sarbanes-Oxley Act

One of the biggest changes to impact the financial reporting of all publicly traded corporations in the United States was the passage of the Sarbanes-Oxley Act in July 2002. Rocked by a number of well-publicized corporate scandals from infamous companies such as Enron, WorldCom, and Tyco, Congress took the strongest action since the passage of the Securities Act of 1933 and the Securities Exchange Act of 1934 to rein in corporate malfeasance. Sarbanes-Oxley imposed significant changes and protocols on different segments of corporate financial reporting and on the role of corporate auditors, and it required a certification process that each Chief Executive Officer "sign off" on the truth and validity of their financial statements or face criminal prosecution. (The Public Company Accounting Oversight Board provides a downloadable copy of the Sarbanes Oxley Act of 2002 at its Web site, http://www.pcaobus.org/.)

What does Sarbanes-Oxley mean for electronic media organizations? Since many companies are publicly traded, compliance with the new legislation is required. The implementation of the Act's requirements was initially very costly to electronic media companies. One company, wishing to remain anonymous, speculates that the total costs exceeded $1 million for each corporation. The Act has also meant more work for financial departments and puts Chief Executive Officers (CEOs) on notice that any improper reporting will not be tolerated.

To fully understand financial management, you should have a basic knowledge of the primary tools used in financial analysis. Concepts presented in this section include ratio analysis, break-even analysis, and an expanded discussion of depreciation and amortization.

Ratio Analysis

Ratio analysis refers to the **financial ratios** and margins management uses to compare their firm's financial history to that of other companies or to industry averages (Albarran, 2002). Ratios measure liquidity, debt, and capitalization, all of which one can usually calculate with data drawn from financial statements.

 Liquidity refers to a firm's ability to convert assets into cash. **Liquidity ratios** include the quick ratio, the current ratio, and the acid test ratio. Ideally, liquidity ratios should measure a 1.5 to 1 ratio of assets to liabilities. *Debt ratios* measure the debt of a firm, and in all cases, the lower the better. The leverage ratio is calculated by dividing total debt by total assets. Another common debt measure, the debt-to-equity ratio, comes from dividing total debt by total equity. Debt ratios should be no larger than 1. *Capitalization ratios* deal with the capital represented by both preferred and common stock. Two ratios are common: dividing preferred stock by common stock and dividing long-term liabilities by common stock. Table 5-2 lists

TABLE 5-2

Common Financial Ratios

LIQUIDITY RATIOS	
Current Ratio	$\dfrac{\text{Current Assets}}{\text{Current Liabilities}}$
Acid Test Ratio	$\dfrac{\text{Liquid Assets}}{\text{Current Liabilities}}$
DEBT RATIOS	
Leverage Ratio	$\dfrac{\text{Total Liabilities}}{\text{Total Assets}}$
Debt-to-Equity Ratio	$\dfrac{\text{Total Liabilities}}{\text{Total Equity}}$
CAPITALIZATION RATIOS	
	$\dfrac{\text{Total Shares of Preferred Stock}}{\text{Total Shares of Common Stock}}$
	$\dfrac{\text{Long-Term Liabilities}}{\text{Total Shares of Common Stock}}$

TABLE 5-3

Common Growth Measures

Growth of revenue

$$\frac{(\text{Current Period [mo, qtr, yr] Net Revenue}) - (\text{Previous Period Net Revenue})}{\text{Previous Period Net Revenue}}$$

Growth of operating income

$$\frac{(\text{Current Period [mo, qtr, yr] Net Income}) - (\text{Previous Period Net Income})}{\text{Previous Period Net Income}}$$

Growth of net worth (owner's equity)

$$\frac{(\text{Current Period [mo, qtr, yr] Net Worth}) - (\text{Previous Period Net Worth})}{\text{Previous Period Net Worth}}$$

Growth of assets

$$\frac{(\text{Current Period [mo, qtr, yr] Total Assets}) - (\text{Previous Period Total Assets})}{\text{Previous Period Total Assets}}$$

the formulas for the ratios most commonly used to evaluate electronic media firms and industries.

Growth measures calculate the growth of revenue and assets over time; they also document historical trends. For each growth measure, the previous time period is subtracted from the current time period, whereupon this number is divided by the previous time period (see Table 5-3). Financial growth is important to any business, and the stronger these measures, the better for the firm or industry examined. These measures include growth of revenue, operating income, assets, and net worth. *Operating income,* a variable used in both growth and performance ratios, refers to the operating profit (or loss) of a firm before allocating money for taxes.

Performance or *profitability measures* measure the financial strength of a company or industry. Low profitability measures indicate high liabilities, low revenues, or excessive expenses. Among the key measures are the return on sales, return on assets, return on equity, the price-earnings ratio, and profit margins (see Table 5-4).

Break-Even Analysis

All companies operating for profit ask themselves how much revenue they need to break even. Stated another way, how many units of a good (such as advertising time) must they sell to earn a profit? To answer these questions, managers need a clear understanding of the cost structures of their business.

TABLE 5-4

**Performance
and Profitability
Measures**

PROFITABILITY MEASURES	
Return on Sales	$\dfrac{\text{Net Income}}{\text{Total Revenues}}$
Return on Assets	$\dfrac{\text{Net Income}}{\text{Total Revenues}}$
Return on Equity	$\dfrac{\text{Net Income}}{\text{Owner's Equity}}$
Price-Earnings (PE) Ratio	$\dfrac{\text{Market Price of a Share of Common Stock}}{\text{Earnings per Share}}$
PROFIT MARGINS	
Cash Flow Margin	
$\dfrac{\text{Cash Flow (After-Tax Net Income + Interest, Depreciation, Amortization)}}{\text{Net Revenue (Revenues − Operating Expenses)}}$	
Net Profit Margin	$\dfrac{\text{Net Income (Revenues − Expenses and Taxes)}}{\text{Net Revenue (Gross Revenues Less Commissions)}}$

There are two types of costs. *Fixed costs* represent fixed inputs, such as buildings, land, and equipment. *Variable costs*, such as the cost of labor, programming material, and supplies, necessarily change over time. Fixed costs and variable costs added together equal total costs.

For example, assume a network-affiliated television station in a top-50 market has total costs of $500,000 in an average month. In order to just break even, the station must generate $500,000 per month through the sale of advertising and network compensation. If the station receives approximately 3 percent of this amount, or $15,000, in the form of network compensation, then advertising must provide the remaining $485,000. If national advertising through the station's representative firm (see Chapter 9) generates another $75,000 in an average month, then $410,000 must be generated through local advertising. If the station's local inventory (number of unsold units) consists of 500 commercial announcements, each slot must be sold at an average price of $820 in order to break even. If inventory falls to 250 spots per week, the average price will have to double to $1,640 per spot.

Break-even analysis is easier to understand when presented graphically. Figure 5-4 illustrates the break-even point for a firm.

FIGURE 5-4

Break-Even Analysis

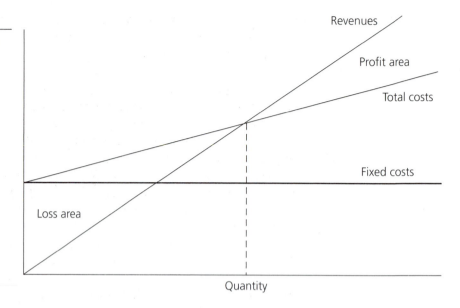

Notice that the point where revenues and total costs intersect is the break-even point. The area below this point represents a loss for the firm, while the area beyond it represents a gain. The break-even point, usually referred to as a *quantity* (Q), may represent something different for different kinds of businesses, such as the number of advertising units sold for a radio or TV station or the number of subscriptions for a cable system.

Break-even analysis must be conducted within a particular time frame (month, quarter, or year) to have meaning. As a tool for managers, break-even analysis is useful in setting projections for sales and other revenue-producing streams.

Depreciation and Amortization

Earlier in this chapter you were introduced to the concepts of depreciation and amortization as a way to deduct the costs of certain assets. The Internal Revenue Service allows companies to depreciate over time, the costs of tangible assets such as equipment, buildings, automobiles and land. Assets are depreciated according to particular categories that represent the life of the asset. Tax laws allow the taxpaying

entity to depreciate assets over 3, 5, 7, 10, or 15 years. However, tax laws are modified regularly, so always check to see if new regulations have altered depreciation methods.

Amortization is similar to depreciation, with one important exception: It deals with a firm's intangible assets, such as programming contracts. Two common methods used in amortization are the *straight line method* and the *declining value method* (Von Sootsen, 2006). In the straight line method, the same value is deducted for each run of a program series. If a station paid $200,000 for five runs, 20 percent, or $40,000, will be amortized each run through the end of the contract. The declining value method assumes most of the value of the program is found in the initial runs; in this case the first run is charged a higher percentage than the second, third, and later runs. Table 5-5 illustrates the differences between the straight line and the declining value methods. Recognize that each method results in the same amount of money being amortized; the difference lies in how fast the asset is deducted. Straight line offers a fixed deduction every year, while declining value deducts the costs at a faster pace. Tax strategies dictate which method to use; if a firm needs additional tax deductions in the near term, it would use the declining value method.

Depreciation and amortization represent noncash expense items on the P&L statement (Figure 5-2). On the statement of cash flows, depreciation and amortization are added back to net income to determine the cash provided by operating activities (Figure 5-3).

TABLE 5-5

Comparison of Amortization Methods

In the following example, a television station has paid $200,000 to use a program series for five years. Using the straight line method, the same value is deducted each year. The declining value method assumes that most of the value of the program is found in the initial runs, so the first year is charged a higher percentage than later years. The same amount of money is amortized regardless of the method used.

YEAR	STRAIGHT LINE	DECLINING VALUE
1	$40,000	$80,000
2	$40,000	$60,000
3	$40,000	$40,000
4	$40,000	$20,000
5	$40,000	0
Total	$200,000	$200,000

As you can see, financial analysis utilizes a number of analytical tools to provide various types of information. By understanding the concepts used in financial analysis, managers are better equipped to make decisions that will ultimately benefit their firms.

Reporting Financial Performance

Owners and stockholders of electronic media companies need timely information on the financial performance of their investments. Reporting financial performance is the final step in the cycle of financial management. Reports to owners and stockholders vary by company; the most common reports are executive summaries, quarterly reports, and annual reports.

Executive summaries are concise reports that one can read quickly to gain an overview of a firm's financial progress. An executive summary is a condensed version of a larger report, usually prepared by management for owners and members of the board of directors. Rather than containing detailed financial statements, it consists of a narrative that explains the financial condition of a firm.

Quarterly reports, provided for both owners and stockholders, highlight progress from the previous quarter and explain any changes in the financial stability of the firm. Such reports contain financial statements, the most common being the P&L statement for the quarter. Stockholders may receive quarterly reports along with any dividends paid by the company.

Annual reports are provided for owners and stockholders, as well as public and university libraries and potential investors. Though it is ultimately the responsibility of the Chief Executive Officer to certify the financial statements as part of Sarbanes-Oxley, annual reports are compiled from all segments of the firm and thus involve all levels of management. Of the three reports, the annual report offers the most detailed information about a company, and thus it is prepared with care and precision.

Another important aspect of reporting financial performance concerns the role of auditors. Certified Public Accountants (CPAs) operate as auditors to verify the accuracy of the financial data provided by a firm. An auditor's statement of verification is found in every annual report and some quarterly reports. Again, the Sarbanes-Oxley

Act has also impacted the role of auditing firms and requires separation of financial and consulting responsibilities.

Summary

Managers of an electronic media facility must know how to handle its finances. Such management involves planning, monitoring, and control in order to meet financial goals. Managers work with other personnel, such as a Controller in large firms, to administer financial management.

Budgeting, one of the most important components of financial management, should involve the General Manager, Controller or other financial officers, and other managers. Budgeting consists of establishing revenue and expense projections as well as capital budgeting needs.

Monitoring of financial performance is accomplished through the posting of individual transactions in various journals and ledgers and the compiling of different financial statements and reports. Widely used financial statements include the balance sheet, the income or P&L statement, and the statement of cash flows.

In financial analysis, managers use a variety of tools to gain additional insight into the financial performance of a firm. Managers should be familiar with several concepts, including ratio analysis, break-even analysis, and depreciation and amortization.

Reporting on financial performance is the final step in the process of financial management. Reports vary by company, with the most common reports consisting of executive summaries, quarterly reports, and annual reports. Auditors are used in the preparation of quarterly and annual reports. The CEO of each company must certify all financial statements prepared by auditors as required by the Sarbanes-Oxley Act of 2002.

CASE STUDY	**Purchasing a Radio Station**

As a group owner of a number of small-market stations, the Helzberg family is always looking for opportunities to grow the family's radio business. Several offers have been tendered from larger groups to buy the family company, but the Helzbergs have resisted the offers. Through a business acquaintance, John Helzberg, the President and CEO, has learned of a station

that may be for sale in a market about 75 miles away. Helzberg asks you, the group's Controller, to check out the financials of the station.

Mr. Helzberg arranges a meeting in his office. "I believe I can buy this station at 10 times cash flow along with taking over the debt. Cash flow is about $500,000 per year, and they owe another $250,000 in debt, so the station will go for about $5.5 million, maybe less, depending on negotiations." Helzberg adds, "They won't let me see all the books until I make a contract offer. I do have a recent balance sheet from the station's accounting firm. Will you review this statement and give me your thoughts on the financial condition of this station?"

KBNR-FM
BALANCE SHEET,
MAY 31, 20XX

ASSETS	THIS YEAR	LAST YEAR
Current Assets:		
Cash/Marketable Securities	$27,000	$29,000
Accounts Receivable	12,000	18,000
Prepaid Expenses	15,000	15,000
Total Current Assets	$54,000	$62,000
Property, Plant, Equipment		
Less Depreciation	35,000	40,000
Intangible Assets	5,000	5,000
Total Assets	$94,000	$107,000

LIABILITIES AND OWNER'S EQUITY		
Current Liabilities:		
Accounts Payable	$18,000	$21,000
Notes Payable	5,000	4,000
Income Taxes Payable	11,000	11,000
Total Current Liabilities	$34,000	$36,000
Long-Term Debt	50,000	60,000
Total Liabilities	$84,000	$96,000
Owner's Equity:		
Common Stock	7,000	8,000
Retained Earnings	3,000	3,000
Total Owner's Equity	$10,000	$11,000
Total Liabilities and Owner's Equity	$94,000	$107,000

Using the following balance sheet, calculate liquidity and debt ratios, as well as a growth-of-assets ratio and return on sales measure, using the formulas in Tables 5-2, 5-3, and 5-4. Using the data from your calculations, offer Mr. Helzberg your evaluation of the station. How would you describe the financial condition of this station? What factors may have contributed to KBNR-FM's successful bottom line for the year?

| CASE STUDY | **Analyzing an Income Statement** |

From the following sample income statement, calculate five ratios using the information in Chapter 5. What does this information tell you about the financial condition of this television station?

**KAAA-TV
DECEMBER 31, 20XX
YEAR-TO-DATE**

	ACTUAL	BUDGET	LAST YEAR
Operating Revenue			
Local	$28,500	$26,000	$20,500
National	17,080	15,000	12,290
Network	4,800	3,600	2,400
Political	200	250	1,000
Production	170	160	190
Misc. Revenue	550	600	600
Gross Revenue:	$51,300	$45,610	$36,980
Less Commissions	(5,140)	(4,600)	(3,690)
Net Revenue	$46,160	$41,010	$33,290
Operating Expenses			
Technical	$2,058	$2,400	$1,600
Programming	4,870	5,000	3,000
News	4,720	4,800	3,800
Sales and Traffic	5,300	5,400	4,800
Research	1,004	1,250	1,008
Advertising and Internet	1,500	2,000	1,600
General & Administrative	5,972	6,600	6,300
Depreciation & Amortization	1,550	1,550	1,752
Total Operating Expenses	$26,974	$29,050	$23,860
Operating Income before Taxes	$19,186	$11,160	$9,430
Provision for Taxes	(5,512)	(3,248)	(2,640)
Net Income	$13,674	$8,612	$6,790

NOTE: All figures in thousands.

Ratios to be calculated:

1. Return on sales

2. Cash flow margin

3. Net profit margin

4. Growth of revenue

5. Growth of operating income

References for Chapter 5

Albarran, A. B. (2002). *Media economics: Understanding markets, industries and concepts* (2nd ed.). Ames, IA: Blackwell.

Albarran, A. B., & Patrick, W. L. (2005). Assessing radio station value: A review of academic literature and analysis of contemporary industry models. *Journal of Radio Studies, 12*(1), 3–13.

Capodanno, B. (1994). Cash flow measures and reports. In A. Gordon (Ed.), *Understanding broadcast and cable finance* (pp. 109–116). Northfield, IL: BCFM Press.

Eckhart, R. (1994). Capital expenditure budgeting and controls. In A. Gordon (Ed.), *Understanding broadcast and cable finance* (pp. 102–108). Northfield, IL: BCFM Press.

Von Sootsen, J. (2006). Domestic and international syndication. In S. T. Eastman & D. A. Ferguson (Eds.), *Media programming strategies and practices* (7th ed., pp. 80–120). Belmont, CA: Wadsworth.

CHAPTER **6**

Managing Personnel

In this chapter you will learn

- All aspects of personnel management, from recruitment of employees to termination of employment
- Key federal laws designed to protect employees
- The role of unions in the electronic media
- How demographic changes affect the makeup of the workforce
- How organizational structure is changing in many media organizations

At the beginning of this book, management is defined as a process in which individuals work with and through other people to accomplish organizational objectives. Personnel management is an essential part of the management process of any industry, but particularly the electronic media, which employs people with a wide variety of creative and technical talents.

The quality of personnel at an electronic media facility often determines its ability to achieve success. Indeed, employees represent the most important asset of any organization. Through careful selection, orientation, training, compensation, and benefit programs, and by providing a diverse as well as safe and responsible working environment, managers can directly impact the success of their organization. Managers who fail to properly manage human resources are constantly forced to deal with problems related to turnover, low morale, inefficient performance, and litigation.

This chapter begins with a discussion of personnel management, including aspects of recruitment and hiring, training, performance reviews, and promotion and termination. The second section discusses legal issues involving personnel. The chapter concludes with a discussion of changes in organizational structure and their impact on communication between management and employees.

Personnel Management

Several individuals manage personnel in an electronic media organization. Department heads or middle managers responsible for individual units recommend the number of individual positions needed to accomplish their unit's tasks. One technique, **force field analysis**, developed by social psychologist Kurt Lewin (1951), can help managers determine this number.

Force field analysis considers driving and restraining forces as variables that impact effectiveness (Hersey, Blanchard, & Johnson, 2008). Briefly, *driving forces* are positive forces, such as increased earnings, praise from a supervisor, and competition. Restraining forces inhibit the driving forces. They can range from employee apathy and hostility to outdated equipment. Used in the electronic media, force field analysis is a tool that helps managers properly diagnose their environment.

Department heads recommend hiring (or terminating) individual employees, determine wages, consider vacation and other leave requests, and conduct performance reviews at least once a year. Department heads also coordinate any ongoing training and development of employees within their unit.

In most operations, the General Manager reviews and approves personnel recommendations, such as hiring and termination, salary levels, and other departmental priorities as requested by the department heads. The GM also makes sure the organization adheres to all legal guidelines regarding personnel, especially in the areas of hiring, diversity, and compliance with all applicable labor laws. Where required, management handles negotiations with various craft guilds and unions that represent employees. Most medium- and large-market organizations will have a Personnel Manager or

Human Relations (HR) Manager whose office maintains records on all employees. The Personnel Manager's responsibilities may include monitoring recruitment for individual positions (deadlines, interview schedules, and so forth), arranging job training, establishing benefit programs, monitoring changes in labor laws and collective bargaining agreements, educating employees on issues, such as diversity and sexual harassment, and working with the GM on setting wages and salaries for the organization as part of the budgeting process (see Chapter 5).

As new positions are created and existing positions turn over, managers must identify and properly select qualified new personnel. One of the most important tasks in personnel management, that of hiring, must be handled efficiently and in compliance with federal, state, and local employment guidelines to avoid any problems of litigation.

The Hiring Process

To hire an employee for a new or replacement position, managers need effective recruitment strategies to identify a qualified pool of applicants. Finding potential new employees involves a variety of internal and external approaches. Here are a few of the more common means of recruitment:

- *Recruiting internally.* One of the fastest and easiest ways to recruit personnel is through internal job postings via company bulletin boards, newsletters, electronic mail, or by other forms of communication. Recruiting from within helps build morale among existing employees by showing that management wants to help employees grow and advance.

- *Career and job fairs.* Career and job fairs have become an increasingly efficient way to gather a large number of applicants for nontalent positions. Fairs can be conducted on a local, state, or national basis, and can easily be tied to a conference or trade show. Prospective candidates attend career/job fairs for free and can interact with representatives involved in hiring.

- *Applications on file and unsolicited applications.* Most electronic media organizations maintain application files for several months from candidates who were not hired for a previous opening or who submitted unsolicited applications.

- *Advertising.* Job announcements in local newspapers and advertisements on industry websites work well to fill certain types of positions. Advertisements in trade publications, such as *Broadcasting and Cable, Television Weekly, Radio and Records*, and *Cablevision*, offer positions requiring particular skills and training. Many media corporations list openings on their corporate websites. Another good source is state broadcasting associations and other local trade groups.

- *Employment agencies.* Normally found locally, these agencies can be a good source for a number of positions requiring clerical, technical, and general business skills.

- *Consultants and headhunters.* Commonly used to find upper-level managers, executives, and talent, these firms usually charge substantial fees for their services.

- *Colleges, universities, and other educational outlets.* Excellent sources for internships and entry-level positions include two- and four-year colleges and universities with programs in broadcasting, radio/TV/film, telecommunications, journalism, and so forth, and graduate programs emphasizing communications, business administration, marketing, and engineering.

- *Word of mouth.* Personal contacts within an organization can alert a potential employee to an opening. *Networking*, the practice of establishing contacts with media professionals, is a common practice in the electronic media. There are free professional networking Web sites such as Plaxo (http://www.plaxo.com) and Linkedin (http://www.linkedin.com) that are excellent ways to build your own network. If you have not begun building your own professional network, then get started now.

- *Internships.* Another important source for information on entry-level positions, college interns are usually near graduation and may show promise for full-time employment. Liability laws for many states usually require that students enroll and receive credit in order to be an intern. Successful internships often lead to offers of employment.

- *Other sources.* Recommendations from other employers, situation-wanted ads in trade publications, and advice from professional organizations and local civic organizations can all help managers

fill positions. As part of the equal employment opportunity (EEO) guidelines established by the Federal Communication Commission (FCC), media organizations are also required to provide information on job openings to any institution (e.g., university, trade associations, and other entities) that requests information in writing. These typically take the form of mailings, faxes, or e-mail. (The EEO guidelines as well as other legal issues are discussed later in this chapter.)

Once the recruitment process has been completed, the selection process begins. Often, a potential candidate will express interest in a position by providing a brief cover letter and resume as well as an audition tape for a talent position. Companies may also require an applicant to complete a formal application for employment. Such applications usually ask for current information (such as address and phone number) as well as the candidate's educational background, employment history, skills and qualifications, and personal references. They also may inquire about immigration status, criminal records, or pending criminal or civil charges. Policies concerning nondiscrimination are also provided in the formal application.

Prior to the interview stage, employers often seek out additional information on the top applicants, or what is commonly called a "short" list. This may involve verifying educational and employment histories and contacting personal references. Applicants sometimes overstate their qualifications on the application; a check to verify dates and responsibilities will determine if the applicant has provided accurate information. Increasingly, companies are conducting background checks, credit checks, and even searching social networking Web sites such as MySpace (http://www.myspace.com) and Facebook (http://www.facebook.com) for information on individuals they are considering hiring. Especially for younger people, be very careful what types of photos and blogs you post on the Web; you don't want to lose out on a job or an interview because of what could be deemed by a potential employer as unprofessional behavior or immaturity.

The high mobility of personnel in the electronic media due to downsizing and consolidation may hamper efforts to gather information about former employment, particularly if previous managers have moved on to other positions. Employers may hesitate to divulge much information about former employees. Because of possible liability issues, some companies refuse to provide any details of

previous employment beyond the basics: job title, dates of employment, and responsibilities.

Finally, diversity is a critical, overarching component related to hiring. The workforce must reflect the local community in regards to opportunities for women and people of color. The broadcast industry offers a number of different programs and incentives through organizations like the National Association of Broadcasters Educational Foundation (NABEF) to help increase the number of women and people of color in the workforce. Maintaining diversity is a huge management challenge, but one that is critical—and expected—in the twenty-first century.

Interviewing

After managers select the top candidates for a position, they normally arrange interviews between the candidate(s) and the company. For the applicant, the interview process provides an opportunity to visit the facility, meet prospective coworkers and managers, get a better understanding of the position and its responsibilities, and learn about the philosophy of the organization. For the employer, the interview provides the important interpersonal link to the hiring process (see Table 6-1). Resumes, tapes, personal Web sites, references, and other sources of information can only tell you so much about an applicant. Meeting an applicant face-to-face can resolve many questions about the applicant's personal qualities, motivation, and interest in the position.

Time-consuming for both parties, interviewing can also be expensive. Some companies use highly structured interview procedures, while others may use a semistructured or completely unstructured process (Kaiser, 1990). The employer should clarify the type of interview procedures that will be used as well as the time required. When an applicant is brought in from out of town, the company should pay or reimburse the candidate for all travel expenses associated with the interview.

More than one interview may be required. The initial interview may be conducted with the Personnel Manager, followed by another interview with the actual supervisor for the position. Interviews may be arranged with other appropriate personnel as deemed necessary, especially for managerial and talent positions. For example, in the hiring of on-air news personnel for a TV station, most General Managers prefer to interview the final candidates for key anchor/reporter positions along with the News Director and other news managers.

TABLE 6-1

**A Few Common
Interview Questions**

QUESTION	WHAT THE EMPLOYER HOPES TO LEARN
1. What do you know about our company?	Did you prepare for the interview? Did you do your homework?
2. Why should we consider you for this position?	Are you confident in your abilities? What does the company gain by hiring you?
3. What are your strengths and weaknesses?	Companies expect honesty in answering this question. You should be able to articulate what you are best at and areas you are working to improve.
4. What do you want to be doing five years from now?	Are you goal directed? Or will you be satisfied with an entry-level position?
5. What other job experiences have you had?	Have you held a job before? How long have you been working? Did you get along with others?
6. What people have been important influences in your life?	People quick to credit others often work well with others and are not driven by ego.
7. Are you a self-starter?	Can you work alone and without direct supervision? If not given a task, are you the type of person who will take the initiative to find something to do?
8. What are your interests apart from work?	Hobbies, activities, and other interests indicate people who are well rounded and can manage time and work.

Some openings may require a skill assessment as part of the interview process. This assessment is especially needed for office and production-related positions. Many companies also evaluate a candidate's communication skills (both verbal and written) and conduct other types of performance and aptitude examinations as well. Regardless of the type of interview, the employer should explain clearly the details regarding the interview and the time required. If the employer does not volunteer this information, the candidate should ask for the information in order to be properly prepared. By law, companies cannot ask questions related to age, religion, race, or sexual orientation. It is not uncommon for companies to require a drug test before an offer of employment can be made.

The interview process concludes when a candidate accepts an offer of employment. Negotiating the terms of employment often forms part of this final step, particularly for talent positions and

managerial openings (Pinkley & Northcraft, 2000). Generally, the higher the pay, the more extensive the negotiations over salary and other perks offered to the employee, depending on the type of position. These may include a number of possible perks: the use of a company car, profit sharing or stock options, extra vacation time, travel allowances, or membership in a local health or country club, although many companies have reduced these extra benefits for all but the highest-paid positions. An agent or attorney may represent high-salaried performers during final negotiations. Regardless of the type of position, both the employer and the candidate should maintain a professional manner throughout the negotiation process.

Orientation Introducing the new employee to company policies and other personnel is commonly referred to as the *orientation process*. Orientation should occur during the initial days of employment. The amount of time needed varies depending on the type of position. A new Account Executive's orientation period may last a month or more, while orientation for a clerical employee may only take a day or less.

As with interviews, orientation procedures differ from company to company. A Personnel Manager may instruct the new employee on various policies and procedures concerning such matters as office hours, overtime compensation, sick leave, leave of absence, vacation, substance abuse, and personal appearance. The Personnel Manager or Business Manager will also take care of all paperwork necessary to enroll the new employee in company-sponsored benefit programs, such as health and dental insurance and retirement plans, as well as payroll deductions for state and federal taxes, insurance, and so on. Many companies also require new employees to sign a form claiming they will not accept *payola* or *plugola*, which is the illegal compensation from an outside source to promote a particular good or product such as a recording by a particular music artist.

Many companies provide an employee handbook or similar document that explains in detail company policies and procedures regarding personnel. This document should include specific information on nondiscrimination in employment, promotion and advancement, performance reviews (discussed later), benefit programs,

disciplinary actions, and formal grievance procedures. All employees should become familiar with the contents of the employee handbook, and employers should provide updates as necessary when company policies or provisions are modified.

The Department Manager or supervisor is responsible for orienting the new employee to the specific tasks associated with his or her position. Ideally, the interview process has already offered a realistic preview of the job, thus minimizing the time needed for orientation. In fact, when new hires have not been fully informed of the duties and expectations associated with the position, frustration usually occurs. Academic studies refer to this experience as an *unrealistic job preview* (Jablin, 1984; Wanous, 1980). Unrealistic job previews hurt the organization because they tend to place new employees in a negative environment, affecting their motivation and outlook on their new job. Companies should make sure all employees clearly understand their positions before they begin work.

Managers may need to include training in the orientation process. When new employees have little direct experience with a specific task or must work with new equipment, their training needs are obvious. Veteran employees who accept a new position may also need training, particularly if they move to a new department. One professional trainer (Rollins, 1991) offers managers the following points for a proper training experience.

- *Approach training with a proper attitude.* Too many managers look negatively on training.

- *Plan out the new employee's first day.* Careful planning will ease the transition for the new hire.

- *Consider using a training outline.* This ensures that all relevant points will be covered during the session.

- *Allocate enough time for training of the new employee and avoid interruptions.* Let other staff members know you will be involved in training.

- *Discuss company philosophy, not just policy.* New employees want to know the reasons behind company policy, and training is the best time to discuss them.

- *Utilize outside training resources.* Use as needed to supplement internal training activities.

Managers should also promote ongoing development activities for all employees, such as in-house workshops and seminars; meetings of professional associations, both local and national; and credit courses at educational institutions. Development activities provide continuing education and growth for the workforce, as well as many benefits to management. However, as budgets have become tighter and tighter, many companies have cut back on development opportunities for their employees. While this may save travel dollars and registration fees, it is short-sighted in the sense that companies are failing to provide continuing development and growth to their staff.

Performance Reviews

An important part of each employee's overall growth and development is the **performance review**, which should be conducted at least once a year. The department supervisor usually conducts this review; department heads have their reviews with the GM or other immediate supervisor. Review procedures vary from company to company. The performance review allows the employer to identify areas where the employee is particularly weak or strong. It also allows the employee to give candid feedback to the employer. A review evaluates not only job performance but also serves as the basis for salary adjustments, merit pay, and promotion.

Employers should initiate performance reviews. Employees may be asked to provide a written self-evaluation of their performance during the past year, highlighting important information concerning particular projects and outcomes. The actual review is conducted in person, and written copies of each evaluation should be offered to the employee, with the original placed in the employee's file.

At the review, the supervisor will discuss the employee's job performance during the past year, noting relevant strengths and weaknesses in an open and honest exchange. The employee should be allowed to discuss his or her feelings about the evaluation given by the supervisor, particularly as to areas of disagreement. At all times, the review should focus on the specifics of the job and the actual performance of the employee. Further, managers should establish ample time for each review and enough privacy to avoid interruptions.

Employees who believe they have been evaluated improperly or unfairly should be offered an appeal process through which they can challenge the review. These procedures should be outlined in

the employee handbook. The employer must make sure all performance reviews are conducted with proper procedures and focus on relevant task-oriented responsibilities. Failure to do so can result in litigation by the employee against the manager and the company. Here are some management guidelines for successful performance reviews.

- *Allow enough time for the review and eliminate interruptions.*

- *Stay calm and be objective.*

- *Be helpful to the employee. Point out areas where performance is poor and offer ideas for improvement.*

- *At all times be honest.*

- *State opinions clearly, and do not confuse opinions with facts. As a supervisor your opinions are not relevant in a review.*

- *Avoid using other employees as an example of positive performance.*

- *Concentrate only on the employee's performance and expectations.*

- *Do not stress deficiencies that are hard to overcome.*

- *Make sure any discussion of behavior is job related.*

- *Offer specifics and avoid euphemisms. Examples can help clarify important points.* (Reising, 1991, p. 18)

Amy Yates-Garmatz, HR Manager for NBC Universal/ Telemundo in Dallas-Fort Worth, offers five points of advice for new hires in the industry to help them grow in their profession:

- Don't ever say "that's not my job"

- Develop a proactive initiative

- Dress for the job you want, not the job you have

- Become a subject matter expert (SME) in your job

- Everyone should have a healthy fear of losing their job (Personal Communication, March 6, 2008).

Promotion Positive performance reviews and good working habits often pave the way for promotion. For example, a news reporter with a strong track record may be offered promotion to a weekend anchor position.

Internal promotion is common in the electronic media, both within the immediate organization and the larger parent company. Promotion is critical to advancement in the electronic media; most professionals find it necessary to move from market to market to achieve their career goals.

Given the high degree of corporate ownership in the electronic media, it is also common for individuals to be promoted to other stations/operations within the company. Many promotions, especially among managerial positions in larger markets, involve individuals moving from market to market. For example, a TV station's General Manager may be promoted from one of the parent company's medium-market stations to a larger market. One often finds that managers in the top markets have served in smaller and medium markets with the same company.

Increasingly, electronic media organizations continue to reduce the number of personnel to operate more efficiently. Typically, this takes one of two forms. In **downsizing**, tasks associated with positions that are eliminated are combined and reassigned to existing staff. **Outsourcing** involves hiring an outside firm or individual to handle specific functions. Some of the more common areas of outsourcing in electronic media involve Web site design and maintenance, computer repair, engineering support, and office and custodial staffing.

Retaining good employees is a continuing priority for managers. Providing adequate training and promotion from within the company will help promote an atmosphere of loyalty to the organization, which in turn can help reduce the high costs associated with job turnover.

Termination

One type of turnover that occurs regularly in any organization is termination. Employees may voluntarily leave a company to work for another facility or to pursue a different vocation. In some cases, they may be asked to leave.

Managers use disciplinary action to correct employee behaviors detrimental to the organization. The employee handbook should clearly spell out behaviors detrimental to the employee's performance. Common problems include failing to be at work on time, excessive absences or tardiness without excuse, engaging in employment with another company without permission, inability to follow

instructions, and contributing to a work environment that is hostile to other employees.

Whenever taking disciplinary action, management must document all charges in writing and notify the employee of the action. Managers have an obligation to try to prevent disciplinary problems by keeping open lines of communication with all workers (Hughes, 1989). They should deal with problems quickly and not allow them to develop into larger problems. Some companies use a probationary period of between 30 and 90 days to address disciplinary problems with employees. It should be understood that repeated disciplinary problems would lead to dismissal. Disciplinary policies and procedures must apply to all employees and not be used unfairly or to discriminate.

Managers should take actions to encourage positive performance rather than to create a threatening work environment. However, in some situations, managers may have to fire employees. Though grounds for termination vary among organizations, certain actions often result in immediate dismissal. These include possession, use, or sale of illegal drugs; unauthorized alcohol consumption; possession of a weapon or firearm; theft; insubordination; indecent behavior; repeated acts of sexual harassment or racism toward other employees; any crime resulting in a felony charge; and any continuous disciplinary problems.

The decision to terminate an employee must be made carefully. To avoid possible legal ramifications, managers must carefully follow all proper procedures. They should review the employee handbook as well as the employee's personnel file to be certain that the reasons for termination follow company policy and have been clearly documented. It is crucial for managers to document all notices, warnings, and other actions involving the employee, as well as areas where the employee has performed positively (Pardue, 1990). This written record becomes important if the company is forced to defend its action regarding a termination.

Termination often follows consolidation. Changes in ownership usually results in some turnover in the workforce. A drop in ratings or changes in the local economy may also lead to personnel cuts. Ideally, companies facing layoffs will help former employees find new employment, not just provide them with a severance package. Employers may help arrange for new job training, employment counseling, and other programs as a part of the termination process.

Part-Time Employees

Electronic media enterprises usually employ a number of part-time employees in a variety of capacities requiring production, clerical, or technical skills. Important to the success of an organization, part-timers represent a challenge for managers. Because part-timers usually receive an hourly wage, as opposed to a salary, and receive few benefits, they may not feel like a true part of the organization. Managers should try to respond to the needs of part-timers with the same attention given to full-time employees and see that part-timers are integrated into all company-sponsored activities. Part-timers desiring advancement should also be considered for full-time positions as appropriate.

Job sharing among part-time employees is also becoming a common practice. In such cases, an organization might have two people working 20 hours a week, one in the mornings, the other in the afternoon, providing the equivalent of a full-time employee but without the expense of providing full-time benefits. Job sharing is particularly attractive for certain groups in the workforce such as mothers with small children, retirees, and students.

Interns

A large majority of electronic media companies offer internship opportunities through local colleges and universities. In most cases, interns work a limited number of hours for course credit alone, but some are paid. Like part-timers, interns make an important contribution to the operation and present another personnel challenge to management. Three ideas to facilitate a good internship program follow.

First, interns should not be selected haphazardly. Departments should develop selection procedures that focus on actual tasks. So the intern is not reduced to mundane tasks, such as filing paperwork or making coffee, the company should offer specific responsibilities, making the experience positive for both parties. Second, interns should be evaluated similarly to other employees so the intern supervisor can point out strengths and ways to improve performance. This feedback can help students achieve their career goals. Third, only students enrolled in an actual credit course should be allowed to intern. Regular contact should be maintained with the educational institution regarding the intern's performance. In facilities that use a number of interns, management should designate one person as the contact for internship information and record keeping.

Working with Personnel

Because of demographic and other changes, managers in the electronic media deal with a diverse workforce. In the past, the electronic media workforce tended to be dominated by white males. Now, women and people of color make up an increasing percentage of employees in many contemporary electronic media organizations. The baby boom generation continues to age and exit the job market. But many retirees continue or need to work at least on a part-time basis. The way people work and what they work at will continually change as a result of social conditions.

How might these demographic changes impact managers? Consider the following situations. Many entry-level positions are likely to be filled by younger workers who have varied cultural backgrounds and who may speak English as a second language. Downsized workers continue to compete for existing openings, often for positions in which they exceed minimum qualifications. Mothers with school-aged children and older citizens in early retirement continue returning to the labor force, many seeking part-time hours with flexible schedules. As mentioned earlier, job sharing is much more prominent in many organizations. Employee training and development are ongoing activities, especially in the area of diversity and multiculturalism. Managers have to adapt to the changes in the labor force and sensitively address the needs of a diverse group of workers.

Successful managers need strong leadership skills to cope with diversity and change among employees. As opposed to someone who just gives orders, the best managers can motivate employees to achieve quality performance. A flexible attitude and approach to managing people with a variety of backgrounds are critical.

Legal Issues in Personnel Management

Electronic media organizations must comply with many laws and regulatory guidelines regarding the hiring and treatment of their employees. One of the most important areas of responsibility concerns issues of equal opportunity and nondiscrimination in employment

practices. Managers need to be familiar with the requirements of equal employment and affirmative action programs.

Equal Employment Opportunity Guidelines

Employers are required by federal law to provide equal employment opportunities to all qualified applicants without regard to race, color, gender, religion, or national origin. The Federal Communications Commission oversees policies regarding EEO rules for broadcasting and cable. Over the years, the FCC's EEO rules have been continuously challenged and modified. The most recent version of the FCC's EEO rules went into effect on March 10, 2003, and at the time of publication no major challenges or modifications have affected the policies.

In short, these rules require broadcasters and MVPDs (multichannel video programming distributors such as cable and satellite TV operators) to adhere to three main provisions:

- widely distribute information concerning each full-time (30 hours or more) job vacancy, except for vacancies that need to be filled in demanding or special circumstances;

- provide notice of each full-time job vacancy to recruitment organizations that request notice; and

- complete two (for broadcast employment units with 5 to 10 full-time employees or that are located in smaller markets) or 4 (for employment units with more than 10 full-time employees located in larger markets) longer-term recruitment initiatives within a two-year period. These initiatives can include job fairs, scholarship and internship programs, and other community events designed to inform the public as to employment opportunities in broadcasting (Federal Communications Commission, 2002).

The rules specify detailed record-keeping and reporting requirements and require the Commission to review the broadcasters' compliance at both midterm and license renewal. The FCC may also conduct periodic audits of broadcasters and MVPDs as further enforcement. EEO polices have changed several times, so it is always best to review the latest rules and any changes to the policies at the FCC's Web site (http://www.fcc.gov).

Sexual Harassment Another type of discrimination in the labor force involves sexual harassment. Awareness of sexual harassment became more common during the 1990s as a result of media coverage of high-profile sexual harassment cases. One must understand that sexual harassment can target men and women equally.

The U.S. Equal Employment Opportunity Commission (EEOC) offers guidelines that clarify the many different forms harassment can take. Unwanted sexual advances, requests for sexual favors, and other conduct of a sexual nature (either verbal or physical) constitute sexual harassment under one or more of the following conditions:

1. When submission to such conduct is either explicitly or implicitly a term or condition of an individual's employment.

2. When submission or rejection of such conduct by an individual is used as the basis of employment decisions affecting the individual.

3. When such conduct has the purpose or effect of unreasonably interfering with an individual's work performance or creating an intimidating, hostile, or offensive work environment. (Code of Federal Regulations, 2003)

Sexual harassment is a serious problem not only for individuals but also for employers. In 1993 the Supreme Court ruled that employers may be held liable for monetary damages as a result of sexual harassment, even if employees suffer no psychological harm. The reason is simple—sexual harassment is against the law. Electronic media enterprises may be held responsible for acts of sexual harassment committed by supervisory personnel or its agents even if the company has a written policy forbidding such conduct. Employers can also be held responsible if the conduct in question takes place between employees "when it knew, or should have known, of the conduct, unless it can show that it took immediate and appropriate corrective action" (Code of Federal Regulations, 2003, 1604.11(d)).

Because of the detrimental impact sexual harassment has on the work environment, managers must do their best to prevent harassment from happening in the first place. In short, management must (1) develop clearly defined policies that define and prohibit sexual harassment; (2) establish a communication program by which all employees are made aware of their rights; and (3) establish procedures

for employees to report any violations or abuses of those rights (Pardue, 1992). Additionally, the employer should have a system for promptly investigating complaints, usually with the complainant's permission. Outcomes of the investigation should be properly documented, reported to both parties in question, and retained in case of legal action.

Managers need to recognize that victims of sexual harassment need courage to come forward and report such conduct. Many acts of sexual harassment are believed to go unreported in the workplace because of embarrassment or fear of retaliation from the employer (Pardue, 1992). Likewise, managers must make sure that all allegations can be substantiated before committing to any action regarding an employee accused of such conduct. Dealing with sexual harassment demands careful, sensitive, and responsible actions on the part of management.

Other Labor Laws

Managers need a familiarity with a number of other labor laws. These laws are briefly reviewed in this section of the chapter.

- *Fair Labor Standards Act.* Requires employers to pay the federal minimum wage to employees. Exempt from the provisions of this act are executive, administrative, and professional personnel, as well as outside salespeople. This act addresses overtime compensation; however, Congress adopted new guidelines on overtime in August 2004 (see U.S. Department of Labor, 2004).

- *National Labor Relations Act.* Enacted to establish workers' right to organize and engage in collective bargaining, and to create the National Labor Relations Board.

- *Equal Employment Act.* Prohibits discrimination based on race, color, gender, religion, or national origin in regard to employment. Established the EEOC and amended the Civil Rights Act.

- *Age Discrimination in Employment Act.* Prohibits discrimination with respect to employment for citizens between the ages of 40 and 70.

- *Equal Pay Act.* Guarantees that all employees with similar skills and qualifications will be paid the same wage. Prohibits wage discrimination under similar working conditions.

- *Americans with Disabilities Act.* Targeted to employers with 15 or more employees, prohibits discrimination against qualified individuals with disabilities who seek employment, promotion, compensation, training, and so forth. The law requires employers to provide reasonable accommodations for a disabled employee's needs.

- *Family and Medical Leave Act.* Companies with 50 or more employees must allow employees to take up to 12 weeks of unpaid leave on an annual basis to care for family members (children, parents, or other close relatives). This act requires the employer to hold the employee's job until return from leave of absence, without loss of benefits or seniority.

Laws and regulations relating to employment frequently change. Managers must keep abreast of new laws, amendments, and other modifications and how they will impact the organization.

Labor Issues: Working with Unions

Historically, laborers and employers have not always enjoyed a harmonious working relationship. Unions were initially organized to give workers a representative voice in dealing with management over issues related to salary, benefits, and safe working conditions. The numbers of workers who are members of labor unions have declined dramatically over the years. Unions still exist for much the same purpose—to represent workers in negotiations with management and to procure fair and equitable wages and benefits for their members. The dues paid by its membership fund the union.

One can find many kinds of labor organizations throughout the electronic media. In general, guilds represent creative personnel while unions represent technical and engineering workers. The industry also refers to these distinctions as "above the line" (creative) and "below the line" (craft). Table 6-2 identifies the major trade unions and guilds in the electronic media.

Much union activity centers on the major networks and large markets, such as New York, Chicago, and Los Angeles. However, unions may also exist in other areas, allowing employees to join a union or guild if they do not work near a major media center.

TABLE 6-2

Examples of Unions and Guilds in the Electronic Media

MAJOR UNIONS AND GUILDS	TYPES OF MEMBERS
National Association of Broadcast Employees and Technicians (NABET)	Radio and television station employees in many areas
International Brotherhood of Electrical Workers (IBEW)	Broadcast and cable technicians as well as members in fields outside of electronic media
Communication Workers of America (CWA)	A number of technical employees in the cable and telecommunications industries
International Alliance of Theatrical and Stage Employees (IATSE)	Some radio and television technicians and engineers
American Federation of Television and Radio Artists (AFTRA)	Performers in live or taped radio and television programs and commercials
Screen Actors Guild (SAG)	Performers in motion pictures, television series, and commercials
Directors Guild of America (DGA)	Directors and assistant directors in radio, television, and stage performances
Writers Guild of America (WGA)	Writers for radio and television news, promotion, and continuity; graphic artists; researchers; and editors
American Federation of Musicians (AFM)	Radio and television musicians in live or recorded performances

Production technicians and engineering employees are often members of local unions.

Management's involvement with unions and guilds focuses mainly on negotiations over economic issues (e.g., wages and benefits) and working conditions (e.g., recognition of the union by management, grievance procedures, and job responsibilities). The heart of the negotiations, the union contract, binds union members and management for a specified period of time.

Collective bargaining describes the process of negotiation between union and management. Normally, each group uses a team of individuals to handle negotiations. In large markets, a General Manager and corporate officials may be part of the management negotiation team, along with the station's legal counsel and other key members. Both local and national representatives and their attorneys represent the union.

Ideally, negotiations will lead to a new agreement mutually satisfying to both parties. When an agreement is not reached after a certain amount of time has passed, both parties may agree to accept either mediation or arbitration. The differences between mediation and arbitration are simple to understand, though the procedures used are often complex. Alhough a mediator suggests alternative solutions or proposes new approaches to resolve the conflict, his or her advice is not binding. On the other hand, arbitrators produce final decisions to which both parties must adhere. This is called *binding arbitration.*

Unions and management have an interdependent relationship. Management must recognize the needs of workers regarding wages and working conditions and respect the workers' right to organize. The union must recognize the responsibilities of management and respect management's obligations to its shareholders and the public. By working together in an atmosphere of mutual respect, unions and management can achieve common goals.

Unions and guilds can be disruptive to the electronic media when they engage in a strike or work stoppage. The 2007 strike by the Writer's Guild shut down most of the programming and movie production in the United States, except for reality television and the like. The strike severely impacted programming, which led to a decline in audience ratings, which in turn led to problems attracting advertisers.

Structure, Communication, and Personnel

This final section explores changes in the hierarchical structure within media organizations and examines how these changes impact communication between management and employees.

Historically, media management texts have devoted considerable space to discussing the formal structure of a radio, television, or cable system through the use of a flow chart, similar to the one found in Figure 6-1. A flow chart graphically illustrates the superior and subordinate relationships among units, workers, and managers, and suggests specific lines of demarcation in terms of duties and responsibilities.

Many companies have recognized that hierarchical structures no longer serve the efficient management of organizations. This phenomenon is known as **flattening**. Management consultant and author Tom Peters (1992) explains that organizational work has evolved this way because of advances in technology, the emergence of a global marketplace for goods and services, and the need for efficiency in operations.

Peters predicts that many organizations would resist changing to a more ambiguous and open structure; however, such change becomes necessary for survival. Leaner structures, a continuing development and educational program for employees, and a move toward self-generated projects as opposed to departmental tasks are all traits of organizations that have moved beyond hierarchy.

Technology has forced many changes in organizational structure, easing communication and interaction between managers and employees. E-mail, instant messaging, text messages, and blogs have eased divisions between upper-level managers and employees, facilitating information exchange and prompt feedback. Employees have

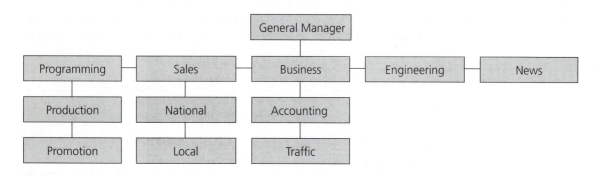

FIGURE 6-1

**Example of a Simple
Flow Chart**

instant access to managers without having to arrange formal appointments. Similarly, e-mail, voice mail, and cell phones, and other wireless devices with Internet capability have opened access between electronic media enterprises and the public. Information can flow up, down, and sideways in an open structure, eliminating the top-down flow of communication visualized in flow charts.

Though technology has eased employees' access to management, it will never replace the need for interpersonal relationships. Managers still need to take the time to get to know their employees; interact with them informally during coffee breaks, lunch, and other venues; publicly recognize them for their accomplishments; and work to develop a sense of camaraderie among all employees.

Nor will changing and more flexible organizational structures eliminate the need for promoting healthy employee relations through personal notes, company newsletters, bulletin boards, special recognition, company sports teams, annual picnics, and other traditional activities. Successful managers will integrate people skills and technological access for the benefit of all employees and the organization.

Summary

Employees are the most valuable assets of any organization, and also the most expensive. In the electronic media, the quality of the personnel directly affects the quality of the organization.

In most organizations personnel management is accomplished through several managers; larger operations may employ a personnel manager or human resources director. Personnel management involves many functions, including recruitment, selection, interviewing, hiring, training, performance reviews, promotion, discipline, and termination. Managing people involves dealing with wages, compensation, benefits, and other employee programs. Companies should provide an employee handbook that explains clearly all policies and procedures pertaining to employment.

Managers need to be familiar with current labor laws, especially those dealing with equal employment opportunities, diversity, and sexual harassment in the workplace. An understanding of unions and guilds is also critical for managers in the electronic media.

Changes in demographic trends and organizational structure will continue to impact the management of personnel. Workers will represent ever more diverse backgrounds and cultures and will require nontraditional schedules. Organizations continue to evolve from a hierarchical structure to one that is more flexible and ambiguous.

Technology has made communication easier for employees to interact with management. Nonetheless, interpersonal skills and traditional communication methods remain important in promoting good employee relations.

CASE STUDY **Attracting New Talent**

As the Director of Human Resources for a television duopoly in a medium-size market, Madison Murphy pondered how to get better-qualified people for entry-level positions in the television stations. The stations had been experiencing difficulty attracting younger people, who had many career options in terms of media-related professions, into television. Their company offered competitive pay and benefits but local television did not hold the attraction compared to areas like entertainment productions, video games, or even documentary production opportunities.

Murphy called a meeting for some of the newest employees to the station who were on board less than a year. Murphy began by explaining the challenge of attracting more qualified applicants for positions and was hopeful for some new ideas beyond the traditional things like job fairs and internship programs. "What I need for you are some ideas. Think creatively, and let's brainstorm on some ways we can make people interested in this dynamic industry and want to be a part of it."

Take the role of a recent employee at the station and generate at least three ideas on ways to find and recruit new talent beyond existing strategies. Discuss these with other members of the class or in small groups.

CASE STUDY **Personnel Problems at KMDT-TV**

KMDT-TV is a television station located in a top-30 market. Part of a group ownership of nine stations, KMDT-TV has operated since 1957, having enjoyed a long and successful relationship as a CBS affiliate. You were appointed Vice President and General Manager of KMDT-TV about a year ago.

During the past year you have come to know most of the employees and other managers. Overall you have a good rapport with the station's managerial team (some 10 members) and you feel good about your relationship with the employees (a total of 45, including both full- and part-time employees).

Following your regular Tuesday morning meeting with the managers, Jane Stovall, the Personnel Manager, asks to speak with you privately in your office. Stovall has been with the station for six years in a variety of capacities and in charge of personnel for the past two years.

"We have two separate personnel complaints that have come up, and both are serious and need immediate attention," she says. "One of them concerns the Chief Engineer and his lack of sensitivity toward other employees; the other concerns conduct that may be related to sexual harassment."

Stovall presents the available facts of each problem. Otis Wilson, who is Anglo, has been Chief Engineer for over 30 years. Otis is particularly gruff with new people. KMDT's position as a middle-market station has caused a lot of personnel turnover as employees join KMDT and then move up to larger markets. Otis does not deal well with change. Despite being an engineer, he is gregarious and likes to share off-color jokes loudly with other employees. "The complaint received about Otis concerns the jokes, which often deal with women and minorities. The complaint said Otis regularly uses phrases, such as "spades," "spics," "slant eyes," and "fags." We have a diverse staff, largely because of your commitment to hiring more women and minorities. In fact, 46 percent of our employees are women, and 24 percent represent various ethnic groups, including African Americans, Latinos, and Asian Americans."

The second problem concerns the Programming Department. "As you know, last week we appointed Bill Campo from our sister station to the position of Assistant Program Director, in line with Mike Hayes's recommendation. Well, it seems that Monica Davis, the programming staff assistant, is bitter that she did not get the position, suggesting that Mike passed her over because of a personal relationship that went sour." Puzzled by the comment, you ask what Stovall means.

"About 18 months ago, Mike and his wife were having problems, and they separated. During the separation, Mike and Monica had an affair. Monica was and still is single. As far as I know, she has had no other relationships with anyone at the station. In fact, the only reason the Mike and Monica affair became so well known was that they were observed by several staff members hugging and touching one another, and word moved around

quickly. The affair soon ended. Mike and his wife reconciled and began counseling. Monica seemed to take things in stride after the affair ended. Apparently Mike's marriage is holding up pretty well," says Stovall.

"Mike came into my office late yesterday, claiming that Monica is threatening to file a sexual harassment complaint against him and the station because she says that during their affair he suggested to her he would help her get a promotion in the department—and now she has been passed over. Mike denies that he ever made any sort of promise to Monica about a promotion during the affair. Further, he said that their affair only lasted about a month, and work was rarely discussed. It is interesting that until now, there has been no problem with either Mike or Monica in working together despite the affair and Mike's reconciliation. I am afraid, though, the fact that Monica is Anglo, Bill is Latino, and Mike is African American could somehow become an issue."

Stovall concludes her report. "Obviously, these matters need attention. Because of the damaging nature of these complaints, we could be faced with two separate legal actions. My feeling is that both problems can be resolved with some decisive action. How do you want to handle these situations?"

As the Vice President and General Manager, you need to take action for each of these personnel problems. Offer a specific plan of action. Explain what you will do with each of these personnel matters, and how you will determine if the solutions you propose are working. Justify your responses.

CASE STUDY ## Dealing with an Employee's Illness

As the Program Director for KKZZ-FM, Carrie Miller is responsible for the on-air staff and the overall sound of the radio station. KKZZ's afternoon drive personality, Lee Thomas, has been with the station for nearly three years and has produced steady and stable numbers.

During the past year, Thomas went through a nasty divorce, which brought about changes in his work habits. He frequently arrived at the station just prior to his 3:00 P.M. shift. Fellow employees found him to be moody at times; some days he would be happy and energetic, other days he would be surly and appear angry.

On Monday, midday announcer Sean Fuller stopped at Carrie's office after his shift. "Carrie, I don't want to talk about other employees, but Lee was

in a bad mood when he arrived a few minutes ago. I am pretty sure he has been drinking heavily. And this is not the first time this has happened."

Miller immediately went to the control room to confront Thomas. "Yeah, Carrie, I have been drinking. I'm sorry. Guess I have been hitting the bottle pretty heavy lately. I just can't seem to stop."

If you were Miller, how would you handle this situation? Should Thomas be terminated? Does the station have an obligation to help Thomas deal with his drinking problem? What would you suggest?

References for Chapter 6

Code of Federal Regulations (CFR). (2003). Title 29, Section 4. *Guidelines on discrimination because of sex*. Part 1604.11. Washington, DC: U.S. Government Printing Office.

Department of Labor. (2004). Fair pay. Retrieved January 16, 2008, from http://www.dol.gov/esa/regs/compliance/whd/fairpay/main.htm

Federal Communications Commission. (2002, March 28). Broadcast and cable EEO rules and policies. Retrieved September 29, 2004, from http://ftp.fcc.gov/cgb/consumerfacts/EEORules.html

Hersey, P., Blanchard, K. H., & Johnson, D. E. (2008). *Management of organizational behavior* (9th ed.). Upper Saddle River, NJ: Pearson Prentice Hall.

Hughes, B. (1989, November–December). Employee discipline. *Broadcast Cable Financial Journal*, pp. 36–40.

Jablin, F. M. (1984). Assimilating new members into organizations. In R. N. Bostrom (Ed.), *Communication yearbook 8* (pp. 594–626). Newbury Park, CA: Sage.

Kaiser, B. (1990, November–December). Hiring smart. *Broadcast Cable Financial Journal*, pp. 30–31.

Lewin, K. (1951). *Field theory in social science*. New York: Harper & Brothers.

Pardue, H. (1990, November–December). Legal and practical implications of employee termination. *Broadcast Cable Financial Journal*, pp. 32–33.

Pardue, H. (1992, March–April). Managing the sexual harassment problem. *Broadcast Cable Financial Journal*, pp. 12–13.

Peters, T. (1992). *Liberation management: Necessary disorganization for the nanosecond nineties*. New York: Knopf.

Pinkley, R. L., & Northcraft, G. B. (2000). *Get paid what you're worth*. New York: St. Martin's Press.

Reising, B. (1991, January–February). Tips for successful performance reviews. *Broadcast Cable Financial Journal*, p. 18.

Rollins, B. (1991, January–February). Don't miss the train. *Broadcast Cable Financial Journal*, pp. 8–10.

U.S. Department of Labor. (2004). Fair pay. Retrieved January 16, 2008, from http://www.dol.gov/esa/regs/compliance/whd/fairpay/main.htm

Wanous, J. P. (1980). *Organizational entry: Recruitment, selection and socialization of newcomers*. Reading, MA: Addison-Wesley.

Audiences and Audience Research

In this chapter you will learn

- The important role of research in the electronic media industries
- The sources and types of audience research data used by electronic media managers
- Key terminology used in analyzing audience data

All forms of electronic media share the goal of generating audiences. Radio stations use a variety of music and information formats to target different demographic groups. The way television stations approach audiences depends on many factors such as the type of station (network affiliate versus independent) and decisions to offer certain types of programming and available types of programming, such as news. Cable channels target audiences through niche programming, such as *Spike* and *Oxygen*, and air mass-appeal channels, such as *TNT* and *USA*. Even telecommunication carriers such as Verizon, AT&T, and Qwest target different audiences by providing communication services for mobile phones and landline phones, as well as video distribution.

To identify potential audiences, electronic media managers need a clear understanding of audience research. This includes the ability to use and interpret research data in the form of audience demographic and psychographic information. This chapter presents an overview of the terms used in audience analysis along with a discussion of how management uses audience research data to increase their competitive position in the markets in which their enterprises operate.

Audience Research and Analysis

The proliferation of media content has led to an increasing reliance on research as a tool in audience analysis. Electronic media managers, programmers, and advertisers all need knowledge of the audience in terms of uses of and preferences for media content, but they also utilize their knowledge of audience needs, motivations, and lifestyle characteristics.

Audience research is an ongoing activity among the electronic media. Radio and television stations need to know which types of programs successfully reach target audiences. Cable, satellite, and telecom companies need to understand which audiences desire particular types of services—such as HD or Spanish-language channel packages, or variations of high-speed Internet access. Advertisers monitor the effectiveness of their messages in selling products.

Managers in the electronic media industries have three types of data to assist in decision making. **Demographic** research, the most familiar type, presents quantitative information (data based) on the media habits of audiences. **Psychographic** research goes beyond numeric information to offer qualitative information about audiences, such as lifestyle and buying patterns. Supplementing demographic and psychographic data, **geodemographic** research considers neighborhood characteristics by ZIP code.

Demographic Research Data

For many years, demographic research served most of the research needs of electronic media managers. Demographic research is best represented by audience ratings data, with which one can estimate the number of viewers and listeners in a variety of age and sex categories across different time periods, or **dayparts**. Radio data measures individuals, while television data is reported in terms of households as well as demographic groups.

Though age categories reported in demographic data vary, they routinely include the following segments: 2–11 (children), 12–17 (teens), and adult categories of 18–34, 35–54, 18–49, 25–49, 18+, 35+, 50+, and 35–64. When ratings are reported in newspapers, radio, and television programs, only a single audience category (such as adults 18+) is given. Adult categories are also broken down by gender. Such categories allow for analysis of different groups by program.

Managers use other demographic categories to supplement and expand age and gender breakdowns. Ethnicity has become much more important in recent years because of the tremendous growth of key groups in the United States, especially among Latinos. African American households tend to watch more television than Anglo households (Albarran & Umphrey, 1993; Nielsen Media Research, 2000), and Latinos number among the most loyal members of the radio audience (Gerlin, 1993; Hispanic Radio Today, 2007).

Income and education characteristics also help managers target audiences, especially because the two are often correlated. Other demographic data potentially useful in defining audiences are the number of individuals in a household, household ownership status, and occupation. Demographic information is very valuable because it describes the audience and specifies how many people are estimated to be watching or listening to a particular program at a given time.

Psychographic Research Data

Psychographics offer an alternative to demographic information by focusing on consumer and lifestyle characteristics like activities, opinions, interests, values, needs, and personality characteristics. More broadly based than demographic research, psychographic research is more challenging to interpret.

One popular form of psychographic research is VALS, an acronym for *values, attitudes,* and *lifestyles* research, originally developed by SRI Associates. The VALS research is based on an extensive survey instrument designed to gauge changes in individual lifestyles and values over time. VALS groups individuals into one of nine different categories, which range from "Innovators" representing highly motivated, high-resource households, to "Survivors" representing those with lower resources and lower innovation. Scarborough is another key company engaged in psychographic research.

Psychographic research involves a range of qualitative approaches. Among the more popular methodologies are focus groups, program testing, and call-out research. In a focus group, a small number of subjects are recruited to discuss a particular topic. A moderator leads the session, which is usually taped for further analysis. Focus groups are widely used in marketing research. In call-out research, a radio station or independent research company calls households to locate individuals in key demographic groups. Once a desired respondent is secured (e.g., men 18–35), the interviewer will ask the respondent to identify which types of music they would most

likely listen to from a series of prerecorded segments. Because of its individual nature, psychographic research takes longer to gather and interpret, although the data often provide a richer source of audience information than quantitative data (Wimmer & Dominick, 2006).

Geodemographic Research Geodemographic research combines demographic and psychographic data with geographical locations or clusters (using postal ZIP codes and census data) to determine audience tastes and preferences. Developed in the 1970s, geodemographic research is used in advertising and marketing to aim messages and products at specific geographic areas. Companies specializing in geodemographic media research include Claritas (owned by Nielsen, which is part of VNU) and Tapscan (owned by Arbitron). In particular, radio stations use geodemographic information in larger markets to target specific clusters of listeners through the use of direct mailings and call-out research. Good managers will recognize the value of using all three types of research information—demographic, psychographic, and geodemographic—to help them to analyze and target audiences.

Sources of Audience Research Data

Managers can access audience research from several sources. The most widely used sources are national research services. Other sources include industry and trade associations, professional consulting firms, and local research (in-house) departments. A summary of each of these areas follows. (For further information on audience research, see Ferguson, Meyer, & Eastman, 2002, and Wimmer & Dominick, 2006.)

Nielsen Media Research In the television industry, Nielsen Media Research, owned by the Dutch company VNU, offers a variety of services to its clients. The premier television ratings service, Nielsen tracks national viewing through the National Agency, Broadcaster and Syndication Services Index (NABSS). Nielsen also estimates viewing of all types of home video with the Nielsen Homevideo Index (NHI). The NHI service includes measurement of cable and satellite services, home video, DVD, and other new television technologies.

Other services include but are not limited to, the Nielsen New Media Services (NMS), Nielsen Hispanic Television Index (NHTI), and the Nielsen Hispanic Station Index (NHSI). Local television ratings are available through the Nielsen Station Index (NSI), used by television owners and advertising agencies. Nielsen also measures Internet audiences through Nielsen/NetRatings. For the most current listing of Nielsen services, please review the company website.

Nielsen's national data is primarily collected with the Nielsen Peoplemeter, a device that monitors audience viewing using a *set-top* box and a remote control keypad (see Figure 7-1). Through extensive sampling procedures, Nielsen chooses approximately 9,000 households, called **Nielsen families,** out of the nation's 112.7 million television households (as of 2008). Each individual in the household logs in with the keypad each time he or she watches television. The data collected from the Nielsen families are used in compiling the **overnight** ratings and other reports for paid subscribers.

Nielsen's local service uses a combination of meters and diaries to collect data. This data is especially important during the sweep periods. In a diary household, every respondent completes a daily log or diary of television viewing, usually for a week. The diaries are then mailed to Nielsen, which compiles the information into a

FIGURE 7-1

Nielsen Peoplemeter and Keypad

SOURCE: *Copyright 2005, Nielsen Media Research. Reprinted by permission of Nielsen Media Research.*

summary report called the Viewers in Profile (VIP). Nielsen's Metered Market Service provides overnight ratings information to all local clients.

Nielsen's monopoly status as the only provider of ratings in the United States puts the service in a challenging position with the television industry. Industry executives and policymakers often criticize Nielsen's power and control along with the high costs of their services (Bianco & Gover, 2004). Nielsen remains in a dominant position as the television ratings leader.

National Research Services for Radio

In the radio industry, local audience ratings come primarily from Arbitron. A former local television ratings competitor to Nielsen, Arbitron dropped out of television measurement in 1993 to focus on radio. Arbitron reports ratings for every radio market in the country at least once a year, with major markets measured as many as 48 weeks out of a year. Ratings are delivered electronically to Arbitron's clients.

Arbitron has long used diaries to gather listening data from a carefully selected sample of the audience in each radio market. Respondents log their listening activity for one week and then return the diary to Arbitron for analysis. The usable information is compiled into a local market report or book, which is distributed to Arbitron's clients, most of whom are radio station owners, advertising agencies, and radio representative (sales) firms.

Arbitron developed a new technology known as the Portable People Meter (PPM) to measure radio audiences, beginning with trials in the United Kingdom and select markets in the United States. The PPM is a passive data-gathering technology that allows a beeper-size device to monitor and record radio listening (see Figure 7-2). The device picks up encoded signals from radio stations, measuring individual time spent listening. At the end of the day, the PPM is placed in the docking station where the data is downloaded to a central computer. It is then compiled with other data and used to provide ratings analyses.

The radio industry had hoped to adopt the PPM service nationwide, but experienced a number of problems as the service was introduced into a few markets in 2007 that questioned the reliability of the data. Arbitron delayed further implementation of the PPM in 2008 until some of the problems could be resolved. Eventually,

FIGURE 7-2

**Arbitron Portable
People Meter**

SOURCE: *Reprinted by
permission of Arbitron Inc.*

Nielsen is partnering with Arbitron to introduce the PPM for use in measuring television ratings.

Ratings for the national radio networks are reported by RADAR (Radio's All Dimensional Audience Research), a subsidiary of Arbitron. National advertisers and programmers use the RADAR report to determine the audiences of network radio services and nationally syndicated radio programs.

**Industry and
Trade Associations**

Another useful source of audience research data is industry and trade associations. Organizations such as the Radio Advertising Bureau (RAB), Cable Advertising Bureau (CAB), Television Advertising Bureau (TVB), and the Interactive Advertising Bureau (IAB), offer many types of audience information. Each of these entities provides basic research data to help its members sell advertising.

The National Association of Broadcasters (NAB) provides several research sources for its clients. For instance, it publishes various types of research in the form of books, pamphlets, and reports through its Research Department. The National Cable and Telecommunications Association (NCTA) offers information on cable audiences and other industry statistics. Station representative

firms, such as Interep and Katz Media Group, as well as major advertising agencies, such as Universal McCann, also provide some types of public data. A useful publication for marketing research, *Standard Rate and Data Service* (SRDS) compares advertising rates and other information among various segments of the communication industries. SRDS is also part of the Nielsen umbrella of research services.

Consulting Firms Many companies and individuals provide independent research and consulting. Some offer relatively specialized services, such as Audience Research and Development (AR&D), which focuses on television branding. While expensive to retain, professional research and consulting firms offer considerable expertise to their clients. A good source that lists all of the current major research companies and serves the electronic media is the annual *Broadcasting and Cable Marketplace* yearbook.

Internal Research Local or in-house research departments also have a presence in
Departments the electronic media, especially in larger markets. An in-house research department is generally used in conjunction with the sales department to generate data for presentations to current and prospective clients. In-house research departments are usually quite small; maybe just one or two people. They work with a variety of data from Nielsen and Arbitron, as well as local market trends and patterns.

The increase in the number of individuals with education and training in research methods and data analysis has aided the creation of local research departments. Research remains an important growth area for employment in the electronic media industries. The Broadcast Education Association has been working to develop a certification program in audience research to provide an important industry-recognized credential for this growing area.

Using Audience Data

Research helps managers identify key strengths and weaknesses of their content, as well as those of their competitors. To make the best

use of the many sources of audience research at their disposal, managers must understand ratings terminology and, perhaps more importantly, the ability to interpret the data.

The two most common terms used in audience research are *rating* and *share*. A **rating** is an estimate of the number of people or households viewing or listening to a particular program, based on some universal estimate. This universal estimate could be the entire national audience (as in the case of a broadcast network or cable/satellite channel) or a sample of a larger population in a local market. Regardless, the universal estimate must be clearly delineated. A common formula for a rating follows:

$$\text{Rating \%} = \frac{\text{Audience (Individuals or Households)}}{\text{Universal Estimate}}$$

Or stated another way,

$$\text{Rating \%} = \frac{\text{Number of Viewers or Listeners}}{\text{Total Viewer or Listener Population}}$$

A single rating point represents 1 percent of the population under examination. If a particular television program has a rating of 10, this means that 10 percent of the population is estimated to have watched the program.

Share differs from a rating in that a share measures the percentage of the viewing or listening audience, based on the actual number of viewers or listeners, such as all television households (called Households Using Television, or **HUT**) or listeners (Persons Using Radio, or **PUR**) at a given time. Shares indicate how well a particular program or station is performing against the competition:

$$\text{Share \%} = \frac{\text{Audience (Individuals or Households)}}{\text{HUT or PUR}}$$

To see the difference between ratings and share, consider the following simple example. A three-station TV market has a population of 10,000 *households* (HH). A sample of 1,000 HH was used to estimate viewing of the local (6:00 p.m.) newscast. The sample found 200 HH viewing WAAA's newscast, while WBBB's audience comprised 150 HH and WCCC only drew 50 HH. Ratings and shares were calculated as follows.

In this example, the HUT level is derived by adding the number of households for each station together (200 + 150 + 50 = 400). That is, 400 HH out of 1,000 HH were watching television, while the remaining 600 HH, or 60 percent, were not watching television. Note that the rating and share numbers are usually expressed as whole numbers rather than percentages. Calculating the rating for WAAA yields .20 (200/1,000 = .20), but the percentage is always converted to a whole number (.20 × 100) when reported as ratings information.

Ratings are smaller than corresponding shares because ratings consider the entire population with sets on or off, but shares take into account only the actual households or individuals using a particular medium. As such, share totals will usually equal 100 percent of the available audience; ratings will not. Interpreting the data is simple. For WAAA, a rating of 20 indicates that 20 percent of the total audience was estimated to be watching the WAAA newscast. However, for the time period, WAAA draws 50 percent of all available viewers to its newscast, indicating a strong position in the local news rankings.

Rating and *share* are the two most common terms used to understand audience data. Other terms used in radio estimates include average quarter-hour persons, rating, and share; *cume* (cumulative) persons and rating; exclusive cume rating; time spent listening; and turnover.

- **Average quarter-hour (AQH) persons** estimates the number of people listening to a radio station for at least 5 minutes in any given quarter hour. An AQH of 15,000 from 6:00 A.M. to 10:00 A.M. would mean that a radio station is estimated to reach an average audience of 15,000 persons during any quarter hour in that time period.

- **Average quarter-hour rating** is the AQH persons expressed as a percentage of the total population. Using the previous data, if there are 300,000 potential listeners in the market, then the AQH rating would be 15,000/300,000 = 5 percent, or 5 as it is usually reported.

- **Average quarter-hour share** is the AQH persons expressed as a percentage of the total audience actually listening. If there are 150,000 people listening to all radio stations between 6:00 A.M.

and 10:00 A.M., then the AQH share would be 15,000/150,000 = 10%, or 10.

- **Cume persons** represent a radio station's cumulative audience, or the estimated number of individuals reached by a radio station. Cume persons count the total number of different listeners that tune in for at least five consecutive minutes during a given week. A high number of cume persons indicates strong penetration or reach in a market.

- **Cume rating** is an estimate of a station's reach, or the cume persons expressed as a percentage of the total population in a given week. If there are 60,000 cume persons out of a population of 300,000, the cume rating would be 60,000/300,000 = 20 percent, or 20.

- **Exclusive cume rating** is an estimate of the percentage of the total population that listens to only one station over a period of time. For example, if 5,000 out of 60,000 cume persons listened to only one station, the exclusive cume rating would be 5,000/60,000 = 8.3 percent, or 8.3. Exclusive cume is a measure of audience loyalty.

- **Time spent listening (TSL)** estimates the amount of time the average person listens to radio. To calculate TSL, use the following formula:

$$TSL = \frac{\text{AQH Persons} \times \text{Number of QH in Time Period}}{\text{Cume Persons}}$$

- **Turnover** is an estimate of how many times the audience completely changes during a particular time period. You calculate turnover with the following formula:

$$Turnover = \frac{\text{Cume Persons}}{\text{AQH Persons}}$$

Ratings information is also used by sales and marketing professionals to calculate other measures in determining advertising placement and effectiveness. These measures include *gross rating points* (GRP), *gross impressions* (GI), reach, frequency, *cost per thousand* (CPM), and *cost per point* (CPP). These terms and formulas are discussed in more detail in Chapter 9.

Market Terminology

Another set of terms represents the physical market for the radio and television industries. Arbitron and Nielsen both use the terms DMA and Metro to define media markets geographically. These terms are detailed as follows:

- **Designated Market Area (DMA)** consists of those counties where the heaviest concentration of viewing or listening of stations in the Metro area takes place. Each county can be included in only one DMA. Market rankings by Nielsen and Arbitron are based on the number of households in the DMA and are revised annually.

- **Metro** is the geographical area corresponding to the U.S. Office of Management and Budget's standard metropolitan statistical area (SMSA).

A Word Regarding Samples

Ratings information is obtained by gathering data from a **sample** of the audience or population. Because time and expense prevent gathering information from every member of a population, a sample is used to represent the larger group. Most companies involved in media research use probability or **random sampling** procedures to select a sample, which means every member of the population under study has an equal chance of being selected and represented in the study (Wimmer & Dominick, 2006). With data generated from a random sample, companies can estimate the viewing or listening preferences of the larger population.

Though the random sample is used regularly in audience research, nonprobability samples are often used for focus groups, auditorium testing, and call-out music research. A **nonprobability sample** means that not every member of the population under study has an equal chance of being selected, which limits generalizing the data to a larger population.

Standard Error and Confidence Intervals

All ratings are only estimates of audience viewing and listening and are subject to a certain degree of error from sampling procedures

(Beville, 1988). Research companies normally refer to this concept as standard error or *standard error of the estimate*. Always expressed as a percentage, standard error is directly affected by the size of the sample and must be interpreted within a particular confidence interval, usually set at 95 percent.

A *confidence interval* of 95 percent means that 95 out of 100 times one can be sure the results will fall within a certain range. For example, if a television show has a rating of 11, with a standard error of 1.5, this means the true rating in the total population from which the sample was drawn would fall between 9.5 and 12.5 every 95 out of 100 times. Generally speaking, using a large sample size and a high confidence interval (such as 95 percent or .05) will result in lower standard error. Information on standard error and confidence intervals is always explained in detail in a ratings report, usually near the end of the report.

Ratings Accuracy

Managers must be concerned about the accuracy of the audience data to which they subscribe, as well as any research conducted for their facility by a professional research firm or consultant. Research vendors obtain accreditation from the **Media Rating Council (MRC)**, an organization of research professionals drawn across several media-related fields. To ensure that the data are accurate and objective, the MRC examines the methodologies and procedures used in their collection.

If a firm or individual consultants are not members of the MRC, managers should take care before contracting research services. Before hiring a firm or individuals to conduct research, managers should check references and previous clients. In this regard, knowledge of ratings, research methodologies and procedures, and research terminology is helpful in scrutinizing research firms.

Research is expensive. Nielsen and Arbitron, the leaders in the television and radio industries, charge millions of dollars for their services to clients in major markets. Even smaller-scale projects, such as focus group research for local markets or local call-out music research, can run several thousands of dollars per study. In short, managers must compare the cost of research with the anticipated benefits derived from the process.

Research Application

Research can be used in many creative ways. While most research data is naturally tied to programming and sales efforts, research also can be used very effectively in marketing and branding efforts (see Chapter 9).

Research can be misused as well. Inflating or misrepresenting the actual numbers, usually in efforts to secure advertising, is a serious ethical breach as well as grounds for legal action. Managers should stress the importance of using research data accurately and fairly at all times, especially in communication with clients and the general public.

Management must carefully analyze research results and then make decisions on how best to use the data in reaching audiences as well as the advertisers who desire those audiences. Used properly, audience research complements managerial decision making across the electronic media.

From Mass Media to Personalized Media

The proliferation of media choices and a host of new consumer technologies present a major hurdle for electronic media managers and the companies they serve. Research across all media illustrates a fragmented landscape, with audiences spending less time with traditional media and more time with other digital technologies (Arbitron, 2008; Bianco, 2004). Today's audiences can access information from the Internet, listen or view content on their iPods/MP3 players or cell phones, use a DVR or the Web to watch their favorite programs as their schedule permits, and share information through their social networking sites. Media usage has become more personal and individualized and scheduled by the consumer rather than controlled by the distributor.

All of these options create havoc in terms of gathering audience data, not to mention the challenges advertisers have in reaching these audiences—especially younger people (Baker, 2004). Advertisers have responded creatively by trying new approaches, such as product placement within television and film, and trying new media alternatives. Television and radio stations are also experimenting and

looking for new ways to reach audiences. Today's electronic media manager must think of how to reach audiences using a variety of digital platforms, and which platforms to invest in—everything from cell phones to PDAs to the Internet.

Clearly, research somehow must rise to this challenge in order to have utility for management. Research will need to identify not only new usage patterns and behaviors but also provide reliable information. Audience research has assumed an even greater importance in the twenty-first century and will demand continuing innovation and experimentation to meet the challenges of rapidly changing technology and distribution systems across multiple platforms.

Summary

All companies in the electronic media are involved in generating and maintaining audiences. Radio, television, cable, satellite, telcos, and Internet-based companies attract audiences through different types of content. Advertisers gain access to these audiences through the purchase of time and space.

Media managers need to be familiar with different types of audience research data and tools of analysis. To understand audiences, electronic media companies use a combination of demographic, psychographic, and geodemographic data. Audience research data is available from national research services, industry and trade associations, professional firms, and local or in-house research departments. Because research is expensive, managers must consider the costs against the perceived benefits. Managers also need to be familiar with the various ratings terminology and concepts and how to interpret data. Used effectively, audience research augments managerial decision making involving programming, marketing, and promotional strategies.

Digital technologies and a wide number of viewing and listening options have created a very fragmented audience environment, posing even greater challenges for research in the twenty-first century as consumption has moved towards a more individual and personalized model. Good research will become even more important to strategy and decision making as we move forward in this very competitive and fragmented marketplace.

CASE STUDY	**Local Research**

Jessica Lynn is the Director of Research for a TV duopoly in a medium-size southeastern market. Lynn has access to a variety of research data, including the Nielsen local market report as well as qualitative reports from Simmons and VALS. Yet Jessica was convinced they were missing data from the reports, so she scheduled a meeting with her Station Manager, Mark Schwartz, to discuss the matter.

"I'm not suggesting we drop any of these efforts, but that we consider putting some resources into doing our own local research," she began. "According to Nielsen, we have few younger people in the 18- to -25 demographic watching any television outside of prime time. As such, several key advertisers targeting this demo are reluctant to buy time in other dayparts."

Schwartz trusted the instincts of his research director; she had proven to be a valuable asset in her five years with the stations. "Ok, I'll find some funds to get you started but it won't be much—maybe around $10,000 max," said Schwartz. "You are going to have to do this on the cheap until we see some tangible results. What's your plan?"

Take the role of Lynn and generate some ideas to collect some low-cost research for the stations that could tap into the viewing preferences of the 18–25 demographic. What are some possible options? What methodologies might be considered to obtain some data? How could the Internet and other digital platforms be used to acquire the data the manager is interested in?

CASE STUDY	**Acquiring a Station**

Umphrey Broadcasting owns 26 radio stations, mostly in medium-size markets. The company has decided to expand its holdings by targeting stations among current markets for possible acquisition. You are the manager of WZBR AM/FM, located in a top-40 southeastern market. WZBR-AM plays a traditional country-and-western format that draws audiences ages 50 and older, while the FM station programs a country format featuring more contemporary artists, attracting adults ages 35 through 54. There are seven other AM stations and seven other FM stations, for a total of 16 stations. Under FCC rules, in markets with 15 to 29 stations, a single owner may operate up to six stations, with a limit of four in the same class. The owners of Umphrey Broadcasting are interested in adding up to three FM stations to their station portfolio.

The owners have asked you to take a good look at the local market, the audience, and the FM stations that are possible targets for acquisition.

The owners want you to prepare a report on which FM stations Umphrey Broadcasting should consider acquiring, ranking the stations in order of preference.

Use the following tables and the material in this chapter to analyze the market. Be sure to consider such factors as demographic composition of the market and competition from other stations.

Existing Stations: Characteristics from Recent Ratings Report

AM STATIONS	FREQ.	FORMAT	AQH (00)	CUME P (00)	KEY DEMO
WABL	550	Sports Talk	140	410	M 25–54
WCDD	810	Country	45	101	M 50+
WDDG	930	Oldies	55	88	W 35–49
WGRC	1060	C/W	100	330	W 45+
WMMG	1420	Religious	23	51	W 35–49
WSST	1530	Country	33	44	M 45+
WXYV	1610	Gospel	26	47	W 35–54

FM STATIONS					
WABL-FM	92.7	Classic Rock	150	370	M 25–49
WGEO	94.1	Hip-Hop	101	350	M 18–35
WGRC-FM	98.7	Country	210	620	W 35–54
WMMG-FM	99.5	CHR	168	490	Teens
WRST	103.9	Soft Rock/AC	60	101	W 18–49
WXYV-FM	104.1	AC	75	100	W 25–34
WXXR	106.7	Mexican Regional	38	67	W 18–34

Market Characteristics

POPULATION ESTIMATES	WOMEN	MEN	TOTAL
Total population	57,500	54,800	112,700
18–34	17,600	16,985	34,585
18–49	21,200	20,750	41,850
25–34	11,000	10,800	21,800
25–49	9,400	9,500	18,900

POPULATION ESTIMATES	WOMEN	MEN	TOTAL
35–54	7,600	7,300	14,900
55+	7,200	4,200	11,600
Teens 12–17	4,000	4,050	8,050
Children 2–11	2,300	2,100	4,300

(continued)

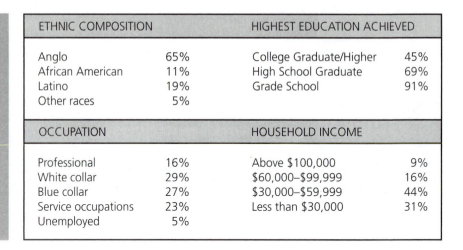

ETHNIC COMPOSITION		HIGHEST EDUCATION ACHIEVED	
Anglo	65%	College Graduate/Higher	45%
African American	11%	High School Graduate	69%
Latino	19%	Grade School	91%
Other races	5%		
OCCUPATION		**HOUSEHOLD INCOME**	
Professional	16%	Above $100,000	9%
White collar	29%	$60,000–$99,999	16%
Blue collar	27%	$30,000–$59,999	44%
Service occupations	23%	Less than $30,000	31%
Unemployed	5%		

References for Chapter 7

Albarran, A. B., & Umphrey, D. (1993). An examination of television viewing motivations and program preferences by Hispanics, blacks, and whites. *Journal of Broadcasting and Electronic Media, 37*(1), 95–103.

Arbitron. (2008). *The infinite dial: Radio's digital platforms.* Presented by B. Rose and J. Lenski. Available from http://www.arbitron.com/downloads/digital_radio_study_2008.pdf

Baker, S. (2004, July 12). Channeling the future. *Business Week,* pp. 70–72.

Beville, H. M. (1988). *Audience ratings: Radio, television and cable* (2nd ed.). Hillsdale, NJ: Erlbaum.

Bianco, A. (2004, July 12). The vanishing mass market. Special Report. *Business Week,* pp. 61–68.

Bianco, A., & Glover, R. (2004, September 20). How Nielsen stood up to Murdoch. *Business Week,* pp. 88–90.

Ferguson, D. A., Meyer, T. P., & Eastman, S. T. (2002). Program and audience research. In S. T. Eastman & D. A. Ferguson (Eds.), *Broadcast/cable programming: Strategies and practices* (6th ed., pp. 35–73). Belmont, CA: Wadsworth.

Gerlin, A. (1993, July 14). Radio stations gain by going after Hispanics. *Wall Street Journal,* pp. B1, B8.

Nielsen Media Research. (2000). *2000 report on television.* New York: Author.

Wimmer, R. D., & Dominick, J. R. (2006). *Mass media research: An introduction* (8th ed.). Belmont, CA: Wadsworth.

8

Programming: Strategy and Distribution

In this chapter you will learn

- The responsibilities of the program director in an electronic media facility
- Differences in the types of programming and strategies used in the radio, television, cable, and telco industries
- Issues of concern for program managers across the electronic media

Programming is a critical component of successful media management. Radio and television stations would have little attraction without the entertainment and information content they deliver to audiences. Similarly, satellites and cable channels would be useless without programming. Like management, programming in the electronic media is an ongoing process, reflecting changes in audience tastes and preferences and in distribution technologies.

The Program Director

The person actually responsible for programming in a radio or television station is the Program Director or Program Manager, a mid-level manager who reports directly to the General Manager. In the cable industry, the title Operations Manager identifies the person responsible for programming the system. In this chapter, the names

Program Director (PD) and *Program Manager* are used to represent the person responsible for programming across the electronic media.

In most cases, only a few employees work in a programming department. Radio stations in smaller markets may have only a single employee, the actual Program Director, while larger markets may also employ a program assistant. TV stations and cable systems employ an average of two to four people in their departments. Consolidation has limited the number of programming-related positions in the broadcast industry. In television, much of the buying process for syndication now occurs at the corporate as opposed to the station level. In radio, market clusters demand that programming functions become the responsibility of a market program manager or market manager.

Most Program Directors have several years of experience, as well as a college degree. The paths to programming vary; many programmers have previous experience in a related area, such as production or promotion. Program Directors are responsible for many management tasks, the most common of which are the following:

- *Budgeting.* As discussed in Chapter 5, programming represents a major expense in the electronic media. Program Directors need skills in creating and administering budgets, amortizing programming, and conducting break-even analysis for acquired and scheduled content.

- *Acquisition.* Programming comes from various sources. The PD's job is to acquire programs, usually in consultation with other managers and corporate executives. Programming can be acquired from a network or other production company, acquired in trade or barter, or produced internally. Acquisition involves negotiating with producers and distributors.

- *Scheduling.* Scheduling is the process of arranging programming to meet strategic goals and objectives. Numerous strategies and considerations are used in scheduling programming, the most important being how well the program will attract audiences and advertisers. Scheduling becomes less critical as more content moves to the Internet and other forms of distribution where it is not necessary to adhere to a linear schedule.

- *Evaluation.* Program managers use research data (see Chapter 7) and other audience feedback to evaluate programming. The evaluation

process determines whether or not a radio station will change format or a television show will be moved to another time period or even canceled.

- *Interpersonal skills.* The PD's many responsibilities involve interaction with other managers and station personnel, as well as the public at large. Strong verbal and written communication skills are needed, as well as the ability to work with others.

Because of the structural differences among the radio, television, and cable industries, programming and the strategies used to reach audiences differ across the electronic media and its various platforms. The following sections discuss the specific ways each industry handles programming, beginning with radio.

Radio Programming

Audiences commonly identify radio stations by the type of format they broadcast. Popular radio formats across the United States include country, oldies, classic rock, adult contemporary, news/talk, and those targeting ethnic audiences (e.g., Spanish, Hip-Hop, Urban). Popular radio formats are listed in Table 8-1.

TABLE 8-1

Popular Radio Formats

What are the most popular radio formats in the United States among station owners? While popularity of formats varies from region to region and from one demographic group to another, one benchmark is looking at the number of stations that program a certain format. Listed here are the top five formats by number of stations programming that format.

FORMAT	NUMBER OF STATIONS
Country	2,037
News/Talk	1,359
Latin/Hispanic	721
Oldies	720
Adult Contemporary	631

SOURCE: *Radio Advertising Bureau* (2007–2008). The data change over time, so consult the Web site at http://www.rab.com for the most current information.

Selection of a station format should begin with a careful analysis of the marketplace. A good market analysis examines such factors as the number of other radio stations in the market and their formats, ratings of competing stations, demographic characteristics (also called *demographics* or *demos*), and retail expenditures. Ultimately, format decisions often take one of two approaches: (1) Stations attempt to capture an existing audience from another station, or (2) stations develop a format to reach an audience not being targeted by a competitor.

Target Existing Audiences

Advertisers desire certain types of audiences more than others. In radio, the 18–49 demographic is considered ideal. If one station has a large share of a key demographic group, such as women 18-49, another station may attempt to draw female listeners away by using a similar format. Radio audiences tend to be fickle; they rotate stations in much the same way as television viewers. One challenge in radio programming, besides identifying and targeting an audience, is maintaining that audience.

Develop a Niche

An alternative approach to capturing another station's audience is to target an audience not currently being served by an existing station. Niche formats come in many different flavors, ranging from sports talk to ethnic formats on AM to jazz and classical on FM. Niche formats also represent challenges in terms of marketing and promotion; to be successful, niche formats are found most often in large (top 50) markets where multiple stations compete. Take, for example, Spanish language radio; what originally was primarily a music format has evolved in to many variations of music, and even ventured in to Hispanic talk radio (Speyer, 2008).

Format Variables

In selecting a format, management must consider many other variables. Among the most important are:

- *Technical aspects*. FM stations are best suited for music formats, while AM stations tend to emphasize talk and information programming, as well as niche or specialty formats. HD offers superior sound quality to both AM and FM, but offers limited distribution due to low adoption of HD receivers.

- *Local-air staff, syndicated distribution, and voice tracking*. Formats can be built around local personalities or provided by a

syndication service. A PD must weigh the costs and benefits of using local talent against those of a syndicated service. Another option is voice tracking, a concept originally developed by Clear Channel, where top radio talent in one market records an entire shift for stations in other markets. This controversial practice takes away jobs and creates challenges at maintaining localism.

- *Commercial matter.* Stations must carefully determine how many minutes will be allocated to the sale of commercial time in both drive and nondrive time periods. Enough time must be provided for the station to meet expenses as well as hold listeners. Ideally, most music formats should limit commercial matter to 8 to 10 minutes per hour.

- *Marketing and promotion considerations.* A format should have strong marketing and promotion potential, regarding both advertisers and audiences. Today, managers use *branding,* a marketing technique discussed in the next chapter, to help establish an identity for each station. Labels such as "classic rock" and "news radio" are used in tandem with station call letters and frequency location to help build brand identity. Over time, the Internet has emerged as a critical marketing tool for the radio industry, along with "text" messaging to cell phones.

- *Wheel or "hot clock."* The PD is responsible for creating the actual format wheel or clock used as an on-air guide by station personalities. The wheel contains various categories of music, all commercial matter, and other programming material such as weather, traffic, and time announcements.

- *News and public affairs programming.* What (if any) is the station's commitment to providing news and public affairs programming? When and how will these elements be programmed? News content help meet the public interest requirement of a licensee. A common criticism at radio in the postconsolidation era is that too few stations offer any substantive news and public affairs programming.

- *Selection of a network.* Though not required, many radio stations are affiliated with a national network so they can provide news and other program features. Network material is tailored to reflect the station's format and on-air sound. Table 8-2 provides a listing of the major radio networks.

TABLE 8-2

Examples of National Radio Networks

ABC RADIO NETWORKS
ABC News Radio ABC Sports ABC Music Radio ABC Radio Networks en Español ESPN Radio ESPN Desportes
CBS/WESTWOOD ONE
CBS Radio Network Marketwatch.com Radio Network CNN Radio NBC News Radio CNBC Business Radio The Wall Street Journal Radio Network
CLEAR CHANNEL COMMUNICATIONS
Premiere Radio Networks
SATELLITE RADIO NETWORKS[a]
Sirius XM Radio

[a] Satellite radio services are available through subscription service and are not part of over-the-air broadcasting.

SOURCE: Compiled by the author from various sources.

Station management regularly evaluates format variables and modifies them as conditions warrant. Generally speaking, the greatest concentration of radio listening takes place in the morning drive time hours of 6:00 A.M. to 10:00 A.M., followed by afternoon drive time (3:00 P.M. to 7:00 P.M.). Midday (10:00 A.M., to 3:00 P.M.) ranks third in terms of listeners, followed by nighttime (7:00 P.M. to midnight). Because of this, a radio station's highest-paid personalities are found during the morning hours. Stations build on the success of their morning program to attract audiences throughout the day.

Structurally, the radio industry continues to evolve. The 1996 Telecommunications Act removed all national limits on radio station

ownership, leading to the formation of radio clusters in local markets. This has also impacted programming positions in local markets. If a group owner controls the maximum of eight stations in a local market, a single programming department can coordinate the formats across the group's stations. This eliminates the need for a separate PD for each station, saving expenses for the owner.

Satellite radio services finally debuted in 2001 (XM Radio) and 2002 (Sirius) after years of anticipation. Satellite radio is a subscription-based service, available for a monthly fee. Both services offer multiple radio formats in a digital environment, with many of the services commercial-free. By 2007, XM and Sirius had an estimated 14 million combined subscribers, yet neither service had ever produced a profitable year, leading to the two companies seeking a merger to reduce costs. The FCC allowed the companies to merge in August 2008, renaming the new entity Sirius XM Radio.

Though the industry continues to change, radio remains an important medium for both audiences and advertisers. Radio is a daily companion for thousands of adults, yet many studies suggest radio is losing younger audiences who prefer their MP3 player or Internet radio (see Albarran, et al., 2007). Advertisers use radio as a cost-efficient medium to supplement other marketing efforts. From a management perspective, radio still has the ability to generate positive profit margins for stations with clear target audiences, good technical facilities, and solid brands.

Television Programming

In the broadcast television industry, it is helpful to differentiate between network-affiliated stations and independent stations. Network affiliates enter into contractual agreements with a network. Historically, this relationship was based on compensation the networks paid affiliates to carry network programs. As programming costs have skyrocketed and audiences continue to fragment, the nature of compensation has been eliminated in all but the top markets.

Where network compensation used to account for as much as 5 percent of the revenue of a large market station or 15 to 25 percent for small markets, actual compensation has dwindled to single digits to reflect the changing economics of network television.

Efforts to further reduce compensation are ongoing between the networks and their affiliates. In a few cases, affiliates entered long-term agreements with networks in which affiliates pay the network—a practice called **reverse compensation**. But this practice did not become widespread. Some networks negotiated with their affiliates to give back local advertising time to the networks in exchange for compensation.

Independent stations are not affiliated with a broadcast network, and they are few in number given the growth of the big four networks and the smaller networks, or "netlets," such as the CW and MyTV. Independents generate the bulk of their schedule through syndication, barter (discussed later in the chapter), and local production, such as news.

Program Directors in any kind of station can acquire several types of programming through first-run syndication, off-network syndication, ad hoc networks, and local production. Each of these areas is examined in the following sections.

First-Run Syndication

As the name suggests, **first-run syndication** involves programs offered directly to local television stations, thus bypassing the national broadcast networks. When programs are successful, the penetration rate can quickly exceed 95 percent of all U.S. TVHH. Successful distributors of first-run syndication programming include Paramount (*Entertainment Tonight*) and King World (*Wheel of Fortune, Jeopardy,* and *Oprah*).

First-run syndication is often produced at a lower per-hour cost than network programs because of the high license fees required for the latter. Still, first-run programming contains a lot of risks. Success depends on many factors, including the national penetration of TVHH, marketing and promotion, and audience interest in the series. Despite these concerns, popular series, such as *Oprah* and *Entertainment Tonight,* clearly prove first-run syndication is an attractive option for programmers.

Off-Network Syndication

Unlike first-run syndication, off-network syndication represents those series that have had a previous run on a network schedule. Ideally, a series should have a minimum of 100 to 150 episodes prior to entering the syndication marketplace, which allows a local station to run the series on a strip basis (five days a week) with a minimum of two

runs per year. Prices for off-network syndication have soared, with former network hits such as *Everybody Loves Raymond* and *Friends* earning millions in syndication. The most popular off-network programs usually attract many bidders in local markets, increasing the costs for a profitable syndication product. Major markets have been known to pay millions of dollars for off-network products; as market size drops, the cost declines.

Most program producers will finance programs at a deficit in order to gain a position on a network schedule, with the hope of eventually recapturing the losses in the syndication marketplace (Von Sootsen, 2006). Situation comedies are one of the most attractive types of off-network syndication, as evidenced by the success of series such as *Seinfeld, Friends, Frasier,* and *Everybody Loves Raymond.* Sitcoms are popular because of their half-hour format, which can be used in a variety of dayparts. Dramatic programs such as *ER* and the various flavors of *CSI* and *Law and Order* have found the best opportunities for syndication on cable, as opposed to local television stations, because the programs are longer and can target specific demographic groups cable channels want to reach. Reality programs have not fared as well in syndication.

Production companies providing first-run and off-network syndication depend heavily on barter in negotiations with local stations and cable networks. **Barter** refers to the practice of a program being acquired for broadcast with some commercial time already packaged (presold) in the program. For example, a number of programs are offered with several minutes of barter time included. The use of barter allows the distributor to be assured of an additional return on the program beyond the license fee. Though the buyer of the series (a TV station or cable channel) gives up some commercial inventory when accepting barter, the practice usually results in lower programming costs. In most cases, programs must clear approximately 85 percent of all TVHH to make barter advertising successful (Moscow, 2000).

Ad Hoc Networks

Programming of interest to a state or region may be produced as part of an **ad hoc network**; an ad hoc network consists of stations that affiliate in order to receive certain programming. For example, college sports events may be found on various regional networks that carry football or basketball games. Telethons, beauty pageants, and an occasional special series or production are other types of programming available through ad hoc networks.

Local Programming

Local programming varies from station to station. Most local programming consists of news, sports, children's programming, programs targeting minority audiences, public affairs programs, and an occasional series or special. In general, network affiliates are most likely to have local news operations, although some independent stations also provide news. Local programming can be expensive to produce and, except in the case of news or sports, may not easily attract audiences and advertisers.

Networks and Programming

The three major networks (ABC, CBS, and NBC) provide the greatest part of the program schedule of their affiliates—on average, 15 to 18 hours per day. Fox provides approximately 15 hours a week of prime-time programming, but no daytime hours. CW and MyTV offer a limited prime-time schedule to their affiliates.

The increase in the number of networks symbolizes the importance of distribution, economies of scale, and group ownership in delivering television programming. The elimination of the financial interest and syndication rules allowed the networks to own and distribute more of their own programming. All the major networks are aligned with film studios to provide a continuous source of programming for distribution (ABC–Disney, Fox–20th Century, CBS–Paramount, NBC–Universal, and CW–Time Warner). The marriage of production studios and networks creates a perfect union: The studios provide the programming (software) to be distributed through the networks (hardware).

To reach a large enough audience, networks need an affiliate base capable of reaching at least 90 percent or more of all TVHH. As more audience members are reached, the overall costs to produce and distribute programming decline. The networks engage in cooperative behavior, characteristic of an oligopoly market structure (Litman, 1993). Advertising inventory and prices, compensation agreements, and license fees for programming acquired from production companies reflect areas of conduct agreement among the networks. Television ratings, promotional activities, and program quality represent areas that differentiate networks.

Network Program Strategies Television program managers use many strategies in the placement and scheduling of programming in different dayparts (Eastman & Ferguson, 2006). In prime time, particular

strategies are commonly used. The **lead-in** program strategy simply places the best program at the beginning of the prime-time schedule, in the hope that the audience will remain for other programs. **Hammocking** involves placing a new or weak television program between two established programs, at either the half-hour or the hour interval. The opposite of hammocking, **tent-poling** is a strategy to place a strong program between two new or weaker programs to generate more of an audience before and after the middle program.

Counterprogramming involves targeting a different audience from that of competitors. On Sunday nights in the fall, NBC draws male viewers with *Sunday Night Football*, while ABC and CBS counter with programs geared toward women. **Stunting**, a practice usually limited to the sweeps, involves a deviation from the regular schedule. A series may air one or more times a week, feature crossover guests from another series, or be packaged as a movie or special. **Blunting** is where a network chooses to target a competitor by scheduling a program with the same demographic appeal. **Seamlessness** was developed in the late 1990s to counter the impact of the remote control; by providing a **seamless transition** between the end of one program and the beginning of another, programmers hope to maximize audience flow and ultimately increase ratings.

These network strategies have been used for decades, although their value has come into question. With cable, satellite, and telco systems delivering hundreds of channels in 90 percent of all *television households* (TVHH), and with DVRs and VCRS and remote control devices common in many households, it is impossible to control audience flow.

Recognizing the environment had forever changed, the major broadcast networks slowly began to make programming available on their Web sites, experimenting with a number of different models. At first, nightly newscasts became available online. Now, most popular series are available online the next day and can easily be watched via a laptop or desktop computer with a high-speed connection.

Yet another key move was the partnerships the networks engaged with Apple to offer programs available via iTunes for downloading for a fee. With the diffusion of the popular iPod and other hand-held media players, audiences are free to watch programs whenever they want. Of course, in addition to the paid iTunes services, there are many peer-to-peer web sites offering illegal downloads of programs that users can access as well.

The next wave of new technology will center around the cell phone for the distribution of mobile video—which is expected to be a multimillion dollar business over the next decade. Most cell phones are capable of receiving video; it is just a matter of users subscribing. As price points for subscriptions drop—and look for eventually a great deal of content to be available for free—mobile video will become more commonplace and widespread.

Local stations will also respond to this trend but will likely focus their efforts on programming they own, such as news and sports and other local content. Many local stations struggle in determining which of the many available digital platforms to pursue and- perhaps more importantly—which can be profitable.

Other Network Dayparts Dayparts outside of prime time are very important to a network, especially in terms of revenues. Daytime programming is much cheaper to produce than that of prime time. Although advertising rates and audience ratings are lower, the networks still generate strong profits from their daytime schedule. During nonprime-time hours, the networks generally strive for parity; that is, they try to equal one another in terms of audience ratings and affiliate reach (Walker & Bellamy, 2006).

Overall, nonprime-time network programming consists of the following segments and approximate time periods:

- *Early morning* (7:00 A.M. to 9:00 A.M.). This period is normally reserved for morning news and information programs, such as *Today*, *Good Morning America*, and *CBS This Morning*. These programs have fairly wide appeal to adults ages 18-49, especially women.

- *Daytime* (10:00 A.M. to 4:00 P.M.). This time period features three main types of programming—talk, game shows, and soap operas—all targeting female viewers.

- *Late night* (11:30 P.M. to 1:00 A.M.). This has become a fierce battleground with David Letterman and Jay Leno fighting for younger audience members (18–35) and *Nightline* attracting older, more serious audiences (25–54) who want an alternative to talk shows.

- *Overnight* (1:00 A.M. to 7:00 A.M.). This daypart consists of some additional late night talk programs and a combination of news programming.

- *Weekend mornings and afternoons.* Mornings have historically been devoted to children's programming, although NBC adopted a different strategy several years ago with a push toward programming for young teens. Afternoons usually program sports or sports magazine programs. The news departments for the networks carry a number of public affairs and discussion programs on Sunday mornings; sports programs dominate the afternoon when in season.

Local Affiliate Programming Because they receive the bulk of their schedule from the network, local affiliates actually have very few hours of programming decisions to make. Still, the hours programmed by the local station are critical in terms of audience ratings and the ability to draw local revenues. The major time periods that must be filled are as follows:

- *Early morning* (6:00 A.M. to 7:00 A.M.). Stations with a news department use this time for an early newscast; stations without news may offer either children's or religious programming.

- *Morning* (9:00 A.M. to 10:00 A.M.). Talk programming has become the norm during this hour, either a syndicated talk show or a locally produced version.

- *Noon* (12:00 P.M. to 1:00 P.M.). Stations in medium and large markets will likely program news in this time period.

- *Early fringe* (4:00 P.M. to 8:00 P.M.). The most critical time period for the local station, this daypart encompasses both local and national news and leads into prime time programming. Depending on market size, news may take up as much as 90 to 120 minutes of this daypart. Typically 4:00 P.M. to 5:00 P.M. is reserved for talk programming, first-run syndication, or off-network series, but many stations in larger markets begin afternoon news at 4:00 P.M. The prime access period of 6:30 P.M. to 8:00 P.M. consists of game shows, court programs, entertainment news programs, and more talk programs.

- *Late fringe* (11:00 P.M.–11:30 P.M.). This has been a traditional time period for late news or, in some cases, an off-network series.

- *Overnights* (varies). Stations carry a variety of programs overnight. In addition to network offerings, you may find syndicated

programming, repurposed newscasts, more talk shows, movies, or even infomercials.

- *Weekends.* Building around a network schedule can be tricky; local stations use movies, sitcoms, infomercials, locally produced programs, and barter programs to fill in hours between network programs.

Local affiliate programming decisions are often made by the Program Director in conjunction with other department heads, such as sales and news, and the General Manager. In all dayparts, the PD attempts to maximize the size of the audience with the programming and provide a strong lead-in to other shows. To accomplish this challenging task, PDs work several months in advance to acquire programming and to provide enough time for proper promotion and marketing of new material.

Independent Programming and Strategies Independent PDs face far greater obstacles than network PDs in attracting audiences. While the network provides many hours a day for programming, the independent, with fewer financial resources, must generate an entire schedule of programming. Most independents try to position themselves with a particular type of programming or counterprogram against network affiliates. Most independent programming consists of a combination of syndicated programs, movies, and sports.

Some independent stations have built a schedule around talk shows. This strategy is referred to as **stacking,** or programming a block of time with the same genre. Stacking can be used effectively with movie packages, situation comedies, and dramatic programs, in addition to talk shows. It can also be used as a counterprogramming strategy to attract key demographic groups.

In larger markets, an independent station will often attempt to secure local broadcast rights for professional baseball, basketball, or hockey games. Sports programming can be expensive, and it carries risk. If a local team does well in the standings, good ratings may follow; if the team falters, ratings often fall. Labor issues and strikes sour fans' interest and create a scramble for programming to fill the time slots, such as the problem ABC and ESPN experienced when the National Hockey League cancelled the entire 2004–2005 season.

Some independents also program local news, although many stations have alternatively presented news at an earlier hour than

other stations in the market. In the Eastern Time zone, this may mean offering a local newscast at 10:00 P.M. versus the traditional 11:00 P.M. start for network affiliates.

Independent stations will usually generate far lower ratings than network affiliates, but with a combination of successful positioning and counterprogramming strategies, the independent can usually generate enough audience to interest advertisers and earn profits. The fate of independent stations is not promising; with many broadcast networks to choose from, there are now fewer than 100 true independent stations in the United States, down from about 500 in the pre-Fox television era.

Opportunities through Multicasting The transition to digital television in February 2009 will allow all television stations—whether network O&Os (for owned and operated), network affiliates, or independents—to engage in multicasting, the programming of additional standard digital television (SDTV) channels in addition to its main channel. Using digital compression technologies, TV stations will have the ability to offer up to two to three channels of SDTV to complement their main broadcast channel. In large markets, some stations are already programming some digital channels.

One industry article (Romano, 2008, March 10) discusses some of the early multicast options available to TV stations for their digital channels. Among the services and the formats identified: LATV (Bilingual English-Spanish programs for young audiences); Retro TV (Classic programs from the 1960s to 1980s); .2 Network (Entertainment channel offering movies); Weather Plus (Service from NBC Universal); AccuWeather (another weather service); Blue Highway TV (family entertainment); CoLours TV (diversity channel); Fan Vision (local sports); Funimation (Anime); Mexicana (Spanish language news and entertainment); Motor Trend TV (automobiles); Ultra Latina (Spanish language entertainment); and World Championship Sports Network (less televised sports).

All of this sounds great in theory, but there are many challenges with multicasting. First is distribution. Cable, satellite, and telco providers are not required to add digital subchannels to their system, meaning the only way consumers could access the services is through an antenna. Second, how will companies pay for these new services, or as the industry puts it, how to "monetize" the digital spectrum. Finally, there is the

issue of splitting your main audience. By programming additional channels, will it actually pull viewers away from your main channel?

Multicasting holds opportunities and challenges, and we certainly will not have a clear idea as to how it will unfold until the digital transition is complete in February 2009. Electronic media managers are hopeful that multicasting will ultimately deliver new revenue streams and audiences.

Multichannel Programming

Cable, satellite, and telco systems deliver a series of services available to consumers at different **tiers** and prices. For example, "basic" cable service normally consists of local broadcast channels; public access, educational, and governmental (PEG) channels; and a limited number of other networks. Expanded tiers feature many popular cable services such as ESPN, CNN, MTV, Nickelodeon, USA, and TNT. There are also tiers devoted to high definition (HDTV), sports, Latinos, children, and other specialized programming. The top satellite networks are listed in Table 8-3. Premium services, such as HBO and Showtime, are individually priced on a monthly basis. Pay-per-view programming involves paying for material per event; popular genres include championship boxing, wrestling marathons, movies, and special events.

All of the cable programming services discussed in this section also apply to other multichannel distributors: satellites, MMDS and SMATV operators, and telephone companies. Because cable is the dominant distributor with nearly 68 percent of all households subscribing to cable, that term is used to describe the programming in a multichannel environment.

Programming among multichannel carriers differs from broadcast television. At the system level, the provider (cable, satellite, telco) negotiates with individual networks for carriage and arranges the various tiers of service offered to consumers. The provider normally pays each network a set fee per subscriber to carry the programming. Fees vary and depend on the services obtained. Cable TV programmers must also allocate shelf space for local program services, PEG channels, and local origination channels as needed or required by the franchise agreement. These services may or may not be included on satellite or telco systems.

TABLE 8-3

Top Cable Networks, Ranked by Number of Subscribers, 2008

1	Discovery	98,000,000
1	TNT (Turner Network Television)	98,000,000
2	ESPN	97,800,000
4	USA Network	97,500,000
4	CNN (Cable News Network)	97,500,000
6	Lifetime	97,300,000
6	TBS	97,300,000
6	Nickelodeon	97,300,000
6	The Learning Channel (TLC)	97,300,000
6	The Weather Channel	97,300,000
11	ABC Family Channel	97,000,000
11	ESPN2	97,000,000
13	C-SPAN (Cable Satellite Public Affairs Network)	96,500,000
13	HGTV (Home and Garden Television)	96,500,000
15	Food Network	96,300,000
15	MTV	96,300,000
17	Cartoon Network	96,000,000
17	Comedy Central	96,000,000
17	Fox News	96,000,000
17	VH1 (Music First)	96,000,000

SOURCE: From Top 20 Cable Program Networks, available online at http://www.ncta.com.

At the network level, programming decisions are made much in the same way as at a broadcast network, save for one key difference. Some networks are known for mass appeal programming (e.g., TNT, TBS, USA) while other services are targeted toward various niches and smaller audience segments (e.g., HGTV, Food Network, History Channel). Cable networks will put their strongest programming in prime time but will also look at counterprogramming opportunities and positioning strategies against the broadcast networks. For example, HBO found success with several critically acclaimed original series (*The Sopranos, Sex and the City, Six Feet Under*). ESPN has obtained rights to numerous leagues and sporting events. CNN airs *Larry King Live* every weeknight. Programming strategies vary by each network and type of service (advertiser supported, premium, or pay-per-view).

The proliferation of networks has created a tremendous need for new and recycled programming. For example, mass appeal channels such as USA, TBS, and TNT use both first-run and off-network syndication programs to fill their schedule. Channels geared toward specific audiences have also generated demand for programming.

ESPN and ESPN2 feature some first-run programming, as well as programs devoted to fishing, auto racing, and running.

These networks also have a strong presence in the international market. A number of programming brands have extended into international markets. MTV has been very successful offering global versions of music television targeted to young audiences in Europe, Asia, and Latin America. CNBC launched European and Asian extensions of its business news services. CNN International helped establish the network as the world's most recognized news brand.

New programming tiers of service continue to debut. Operators offer digital service to customers with specialty tiers devoted to HD programming, Spanish-language programming, children, and sports. Comcast became the first major cable operator to offer a video-on-demand service, with many hours of free and premium content available to audiences who subscribe to digital cable. Time Warner and other major providers have followed suit.

Management Issues in Programming

An examination of programming in the radio, television, and multi-channel sectors illustrates the common concerns shared by program managers in acquiring, scheduling, and evaluating program content. These concerns about the future are discussed in the following sections.

Intense Competition for Audiences

Today audiences have multiple choices for listening and viewing. These include traditional distribution (e.g., broadcasting, cable, satellite, telco), alternative distribution systems (wireless and Internet), storage devices (VCR, DVD, DVR), and hand-held devices (cell phones, PDAs, etc.). Audience shares continue to fragment as new competitors emerge. These new services provide a digital quality experience for consumers. Given this increasingly competitive environment, electronic media managers will have a tougher job maintaining existing market share.

Demand for More Research

Increasing emphasis is being placed on audience research so that managers can better understand the audiences they serve. Audience

fragmentation is increasing, necessitating data more detailed than just demographic ratings and shares. More lifestyle and psychographic research (see Chapter 7) is needed to pinpoint specific attributes of the audiences served by individual programs. This will provide not only better efficiency for advertisers but also better targeting and program strategies.

As discussed in Chapter 7, companies engaged in audience research are also revamping their data collection technologies, such as the introduction of the PPM for radio (with television eventually to follow suit). Nielsen now measures out-of-home television viewing (hotels, sports bars, etc.) and began C3 ratings to measure programs on the day of broadcast plus three additional days—designed to capture viewers who watch programming via their DVR or other storage devices.

Brand Development and Brand Extension

Audiences watch programs, as opposed to channels. Programs that attract and hold audiences become key brands for the channels or platforms on which they are distributed. All programmers are interested in building brand recognition for their content, in extending those brands into other time periods, and in finding other opportunities to build audiences.

Rising Costs of Programming

High-quality programming is expensive to produce and distribute, especially as television transitions in to high definition. Managers share concerns about maintaining and controlling the costs of programming at both local and national levels. As costs increase, programming bears greater pressure to generate profits. This pressure is a common concern for local news operations, which often struggle to produce enough revenue to cover their expenses.

One reason why reality programs, talk shows, and newsmagazines dominate television fare is that they are relatively cheap to produce compared with sitcoms or dramas. Likewise, fees for professional and local sports rights rise annually. In the radio industry, satellite music formats can often be acquired at a lower cost than employing an entire on-air staff. In general, increasing programming costs represents an area of common concern.

Regulatory Concerns

Regulators continue to express concern over certain types of media content, particularly programs featuring sexual and violent content.

The introduction of V-Chip technology, a provision in the 1996 Telecommunications Act, was delayed for a number of political and logistical reasons. Voluntary program ratings have met with controversy as well, with NBC the last network agreeing to participate. As a result of the 2004 Super Bowl halftime show where Janet Jackson's costume experienced the so-called "wardrobe malfunction" that exposed her right breast, the FCC and Congress increased fines for indecency to $325,000 per incident. Further, regulators have frustrated producers, directors, and writers over the definition of what constitutes indecent material and the fear of facing fines.

Tragic school shootings and their resultant news coverage raised questions regarding journalistic standards and practices, ethics, and concerns over media content. Many critics feel television broadcasters have failed to live up to the programming requirements of the 1990 Children's Television Act. With the advent of digital channels, policymakers and broadcasters continue to debate what specific public interest requirements for television is needed in a digital world.

Because of its pervasive nature, programming will no doubt continue to be scrutinized by the public and by politicians. Managers must be cognizant of the programming provided by their operations and ideally maintain the community's interests and needs at all times.

The Multiplatform Environment

There is no question that electronic media outlets are evolving in to multiple platform enterprises offering various types of media content to consumers. A listing of the many digital distribution platforms available for electronic media enterprises is found in Table 8-4. The challenge for management is to determine which platforms to offer content and, perhaps more importantly, how to financially support or monetize these efforts through the creation of new business models.

Traditional electronic media companies find themselves not only in competition with each other but with a plethora of user generated content available from services such as YouTube and social networking websites. You can even find new programming targeted specifically for broadband audiences on the Internet that will never be seen on broadcast television.

Radio has been impacted as well, not only by the iPod/MP3 phenomenon but also by thousands of Internet radio stations, which

TABLE 8-4

Digital Distribution Platforms

SDTV/HDTV	Wi-Fi/Broadband
Multicasting (TV)	DVRs (TiVo, generics)
Video on Demand (VOD)	Video Game Consoles
MP3 Players	Blogs
Podcasts	User Generated Content
Satellite Radio	Social Networks
Mobile Phones	Personal Digital Assistants
SMS Services (messaging)	Slingbox/Apple TV

offer the ability to establish your own favorite music and playlists, not to mention a growing number of podcasts offering a variety of content. We are in an era where traditional media and "new" media platforms will coexist with one another, and the winner will be consumers, who have more choice and control over what they access in the way of entertainment and information. We will not see traditional media like broadcast radio and television die, nor will we see new media completely dominate. But we will see programming and distribution platforms continue to evolve and change as we move forward, adding to the challenges of today's managerial environment.

Summary

Programming is vital to the success of an electronic media facility. The Program Director or Manager plays a major role by acquiring, scheduling, and evaluating programming in consultation with the General Manager, other department heads, and corporate executives (where applicable).

Among the electronic media, programming strategies differ. Radio stations build their programming around a specific format or type of presentation in combination with other programming elements. FM stations tend to be more music oriented while AM stations offer more information and niche formats.

Broadcast television programming consists of network programs, first-run syndication, off-network syndication, ad hoc networks, and local programming. Network affiliates program only a few hours a

day, while independents must organize an entire schedule. Affiliates try to maintain audience flow between network offerings; independent stations use positioning and counterprogramming strategies to gain market share.

Cable, satellite, and telco programming services occur on two levels. At the system level, the operator arranges programming among various tiers of service, using a combination of local broadcast channels, cable networks, PEG channels, and local origination channels. Basic, expanded, premium, and pay-per-view are the typical tiers of many systems, with digital services the norm. At the national level, these networks tend to position themselves as either a mass appeal service or a niche service, targeting specific audiences.

Across the electronic media, program managers face similar concerns. Increasing competition means smaller audiences for many services and a greater reliance on accurate and improved research data. The number of potential digital platforms to distribute content continues to expand. Rising programming expenses represent another area of concern, along with the possibility of future governmental regulation of programming. All programmers are wrestling with the challenges brought by new technology and increasing platforms and the opportunities it provides for increased program distribution and marketing.

| CASE STUDY | **Morning Drive: Local Talent or Syndication?** |

Shaun Stevens, Program Director of WKCQ-FM, a classic rock station (one of 15 stations) in a medium-size market (rank = 47), was faced with a difficult programming decision. Market consolidation had reduced the number of station owners in the market to four, with his station the only one maintaining a local ownership presence. For years WKCQ had retained a strong audience in the market, much of its success due to a stable staff of air personalities, among them morning man "Jumbo" Jim Elliott.

Elliott's numbers had started to slip during the past couple of Arbitron measurement periods, and while he still led in the important 18–49 female demographic, other demos were on the decline. Elliott had surprised Stevens the week before by announcing he was leaving the station to take an on-air position with a larger company in a top-25 market. Replacing Elliott with an existing staff member was not an option as far as Stevens was concerned. While the rest of the staff was good, they were better suited to their respective time

periods. Replacing Elliott would be a challenge, not only in finding the right personality, but also in attracting someone with the salary limitations imposed by the station's owner.

Stevens had collected information on the growing number of syndicated morning radio programs available in recent years. Going with a syndicated morning program had several advantages—and disadvantages. A syndicated show would bring a professional sound to the station at an affordable price. It would be cheaper than hiring a new morning talent. There were some very good personalities offering a classic rock show via syndication, and with no other syndicated morning shows in the market, Stevens felt he could build on the opportunity.

But going with the syndicated program would mean giving up local control. Yes, it was still possible to provide local news, weather, and traffic inserts, but the sound of the four-hour morning shift would definitely not reflect the local community. Further, there was no guarantee the syndicated program—or for that matter a local replacement—could match or exceed Jumbo Elliott's numbers in morning drive. Yet another option was to voice track the morning show, using some of the corporate talent available in other markets. Voice tracking also eliminated localism, and there were no guarantees future ratings would grow.

Take the role of Shaun Stevens in this case. Consider the implications of staying with local talent versus adopting a syndicated program or going with voice tracking. Analyze the issues involved and render your decision.

CASE STUDY | ## Independent to Network Affiliate

KLWT-TV, channel 29, began operation in the Pacific Northwest during the late 1960s as an independent television station. The station's signal reached an estimated 135,000 TVHH. The market was predominantly Anglo, with a median household income of $38,000, but there was a growing Latino audience estimated at about 20 percent of the market population. The area was primarily rural, with forestry and agriculture the primary drivers of the economy. KLWT's transmitter was about 100 miles from the nearest large market, with little media competition save a suburban newspaper and three radio stations that served the region.

When the Fox Television network debuted in the 1980s, management had considered becoming part of the new network but passed at the opportunity. KLWT was primarily known for showcasing movies on its schedule, along with several older, off-network programs. The station carried no

first-run syndication products or news. The station's owners, Great Pines Broadcasting, had received several offers to sell the station, but the family-owned company did not want to sell. With programming costs continuing to rise, profit margins at the station began to shrink as more and more financial resources were allocated to prime time.

Dan Byers, the station's Program Manager, convinced upper management it was time for KLWT to pursue network affiliation, which would provide a much-needed prime-time schedule and allow the station to spend more money on other dayparts. Byers had the luxury of selecting from five networks (CW, MyTV, Univision, Telefutura, and Telemundo) for affiliation. All five were interested in affiliating with KLWT. None of the nets were offering any compensation, but they were providing much-needed programming and an affiliate presence. Byers was concerned that there was enough of a Latino market to support a Spanish-language station, but for now, all options had to be considered. Byers faced two distinct challenges. The first was to recommend to management which of the networks to affiliate with. The second challenge was to determine the best strategy for building a programming strategy with KLWT-TV.

Take the role of Byers, and conduct an analysis of the programming currently offered by CW, MyTV, and the Spanish-language networks Univision, Telefutura, and Telemundo. Make a recommendation as to which network would be the best choice for affiliation. Next, develop a weekday daytime schedule in conjunction with the planned network prime-time lineup. Think about what audience strategies you could use to help maximize audience flow and build the station's profit margins.

CASE STUDY | **A Cable Programming Dilemma**

Cathy Washburn serves as Operations Manager for Metro Cable in a southeastern medium market with a population of 350,000 TVHH. Metro Cable was established in 1973 and currently has a 48 percent subscriber rate. Metro's physical plant had completed an expensive upgrade to digital and now offered over 160 channels on several tiers of service, as well as cable modems. Still, the company faced strong competition from satellite and telco providers that were successful in attracting nearly 25 percent of the market's subscribers. The satellite services—both DirecTV and Dish—were engaged in fierce cost-cutting and anticable messages to draw new subscribers. Verizon announced plans to begin offering its fiber-based FIOS service within a year's time.

Walt Connell, the system General Manager, asked Washburn to rethink the programming on the basic and expanded tiers of service, as well as a

video-on-demand (VOD) service as a way to counter the competition. "We need to stop this churn of subscribers to satellite, and we can do that with a repackaged lineup that showcases our digital capabilities, HD options, and other services. With VOD, we should be able to do a lot of creative programming. Get to work on a plan and bring me some ideas."

Taking the role of Washburn, develop new tiers of service for the Metro customers. To obtain a comprehensive list of potential cable channel listings, consult the National Cable Television Association's Web site at http://www.ncta.com, as well as trade publications and local newspaper listings. Be prepared to explain why you chose certain services over others in establishing your system's programming. Also, explain how you would program the VOD portion of your digital service.

References for Chapter 8

Albarran, A. B., Anderson, T., Garcia Bejar, L., Bussart, A. L., Daggett, E., Gibson, S., Gorman, M., Greer, D., Guo, M., Horst, J. L., Khalaf, T., Lay, J. P., McCracken, M., Mott, B. & Way, H. (2007). "What happened to our audience?" Radio and new technology uses and gratifications among young adult users. *Journal of Radio Studies, 14*(2), 2–11.

Eastman, S. T., & Ferguson, D. A. (2006). *Media programming strategies and practices* (7th ed.). Belmont, CA: Wadsworth.

Litman, B. R. (1993). Role of TV networks. In A. Alexander, J. Owers, & R. Carveth (Eds.), *Media economics: Theory and practice* (pp. 225–244). New York: Erlbaum.

Moscow, S. (2000, January). Remarks at 2000 NATPE Educational Foundation luncheon, New Orleans.

Radio Advertising Bureau. (2007–2008). *Radio marketing guide and factbook*. Retrieved from http://www.rab.com/public/MediaFacts/factbook.cfm

Romano, A. (2008, March 10). Local stations multiply. *Broadcasting & Cable*, pp. 16–18.

Speyer, P. (2008, May 5). The power of the people. *Radio Ink*, p. 13.

Von Sootsen, J. (2006). Domestic and international syndication. In S. T. Eastman & D. A. Ferguson (Eds.), *Media programming strategies and practices* (7th ed., pp. 80–120). Belmont, CA: Wadsworth.

Walker, J. R. & Bellamy, R. V. (2006). Nonprime-time network television programming. In S. T. Eastman & D. A. Ferguson (Eds.), *Media programming strategies and practices* (7th ed., pp. 159–185). Belmont, CA: Wadsworth.

Marketing

In this chapter you will learn

- The role marketing plays in the electronic media and the parties responsible for marketing
- Basic marketing strategies of segmentation, positioning, and branding
- The different types of advertising and their importance to the electronic media
- Terms and concepts used in evaluating media advertising
- How promotion is used in marketing and the different types of promotion found in the electronic media

Electronic media enterprises are constantly engaged in marketing to different audiences, advertisers, agencies, representative firms, and suppliers. In Chapter 1 marketing was introduced as an essential skill needed by electronic media managers. As a business concept, marketing can be thought of as the ability of organizations to serve consumers' needs and wants for specific products (Ries & Trout, 1986a).

A business that understands the importance of marketing has two related goals: to generate new customers and to serve current ones. To accomplish these goals, firms must be able to earn profits to stay in business. For successful marketing to occur, companies must be internally organized around common goals and objectives (Warner & Buchman, 1991). Marketing efforts follow the traditional four Ps of marketing: product, price, place, and promotion, discussed briefly in the following section.

The Four Ps of Marketing

The **product** consists of the actual good produced for customers, as well as the packaging of the product. Consumer research helps companies identify the types of products to offer. In the electronic media, test audiences regularly evaluate content (the product) before it is scheduled to air. The success or popularity of a program is assessed through the use of audience ratings (see Chapter 7). Products change over time as audience needs change, affecting program genres. In 1999 ABC debuted *Who Wants to Be a Millionaire?* in prime time with great success, only to see the program dropped from the schedule within two years. The CBS program *Survivor* ushered in a new type of reality show, where contestants face weekly elimination until there is one winner. This type of program spawned imitators using this same idea, ranging from *The Bachelor*, *The Apprentice*, and *The Biggest Loser*. Other programs such as *American Idol* and *Dancing with the Stars* follow the same idea, but focus on talent.

Because it directly impacts the sale of a product, **price** is an important consideration in marketing. If two products are similar but one is priced much higher, most customers will choose the cheaper product. In electronic media, managers make pricing decisions regarding advertising sales and charge for services offered by cable and satellite operators. Pricing decisions affect competitors, who must consider what price to charge in light of other prices available in the market.

Place is both the physical location at which the product is actually sold and the steps taken to distribute the product. Some manufacturers sell products directly to customers, while others distribute their goods through wholesalers and retailers. Decisions about place affect marketing strategy. For instance, broadcasting and cable represent traditional distribution vehicles. The Internet's presence alters place in that you don't need a bricks-and-mortar location to attract customers as Amazon, eBay, and Travelocity illustrate. The growing proliferation of other digital platforms, discussed elsewhere in this book, make the concept of place much more complicated.

Promotion is a combination of activities that promote both awareness among consumers and the actual selling of products. Advertising is a major part of promotion. The electronic media serve

the needs of many businesses by offering access to audiences through the sale of advertising. In turn, the electronic media use on-air promotion and their Web sites as well as advertising in other media (e.g., newspapers, billboards, transit media, and messaging to mobile phones) and guerilla marketing (word-of-mouth and through social communication web sites such as MySpace and Facebook) to attract audiences to their products (content).

Personnel in Electronic Media Marketing

Who is responsible for marketing in an electronic media facility? Most marketing tasks are coordinated across two units—sales and promotions—run by several individuals. The General Sales Manager (GSM), a midlevel manager, usually supervises the sales department. In some companies, other managers assigned to specific areas, such as a Local Sales Manager (LSM) and a National Sales Manager (NSM), assist the GSM. Each area has its own staff. The sales department serves primarily to market the station to potential advertising clients at the local, regional, and national levels.

Normally a single midlevel manager supervises the promotions or creative services department. Larger operations may also employ an assistant manager. The size of the promotions unit varies with the size of the market; the larger the market, the larger the promotions staff. The promotions department is responsible for marketing the business to audiences. Promotional staffs are increasingly finding creative ways to use the Internet as a key marketing tool. Text messaging has also become popular, especially in radio, with companies such as HipCricket among the first entrants in to this new market.

The sales and promotions managers work closely with the GM, programming (TV/radio stations), and operations (cable, satellite and telco systems) departments to coordinate and manage marketing activities. Because each area tends to overemphasize the importance of its individual unit, conflicts often arise, particularly between sales and programming. For example, programmers are quick to point out that it is the programs that draw audiences, which in turn attract advertisers. Sales departments argue that advertising generates the revenues that pay for content, salaries, and operations. In reality, the

two units are interdependent and must work together to mutually benefit the organization.

Marketing involves a wide range of managerial responsibilities: strategic planning, targeting of specific audiences, design of advertising and promotional campaigns, and extension of the organization's brand. Some authors claim marketing is warfare (see D'Allesandro, 2001; Ries & Trout, 1986a) requiring participants to recognize opponents' strengths and weaknesses in order to successfully exploit or defend against them. In the electronic media, the success of the warfare is usually measured in terms of audience ratings, market share, and the strength and awareness of key brands.

Marketing Strategies

Successful marketing is a product of carefully planned strategies. Marketing-oriented electronic media companies may adopt many strategies. This section reviews three of the most common strategies used by businesses to market products—segmentation, positioning, and branding—and their application to electronic media enterprises.

Segmentation Segmentation strategies target individual market segments (audiences). The goal of segmentation is to identify segments not currently served and develop products to meet their needs. To be effective, a segment must be measurable, large enough to be profitable, and reachable (Runyon, 1980).

The electronic media provide many examples of segmentation strategies. In radio, ethnic formats can reach sizable segments not served by other competitors in large markets, particularly for stations targeting these audiences (Brandes, 1995; Gerlin, 1993). Several TV programmers use segmentation, such as MTV (teens/young adults), Univision and Telemundo (Latinos), BET (African Americans), Lifetime and Oxygen (women), and Spike (men). The Internet, along with other digital platforms introduced in earlier chapters, further enhances and facilitates segmentation strategies for businesses.

Database marketing emerged as an early tool in developing segmentation strategies. Electronic media companies use database

marketing to reach specific audiences (Scott, 1995). Database marketing involves collecting data on audience members, then accessing the information as needs warrant. One can compile the actual information in the database from many sources: Web/digital registrations, promotional events, direct mail—and then supplement the information with other sources such as population and demographic data. Using database marketing in conjunction with digital platforms, advertisers and electronic media companies can pinpoint and target consumers who use particular products, channels, and Web sites. With increasing channel capacity and distribution methods, segmentation strategies are becoming more refined, leading to personalized marketing and advertising messages we experience now with the Internet. Technology continues to impact the media industries. *Business Week* devoted a 2004 special report to "the vanishing mass market," indicating that marketing efforts have undergone great change, with advertisers shifting money away from traditional venues, such as network television, to Internet, product placement, and alternative platforms (Bianco, 2004).

Positioning One of the most influential marketing strategies of the past 30 years, **positioning** is defined by Ries and Trout (1986b, p. 2) as "what you do in the mind of the prospect." In short, the product must be presented to consumers clearly. The authors contend people are saturated with too many messages, limiting their ability to accurately recall information. Being a leader is important. Ries and Trout explain that people remember who is in first place, but often forget who is second or third.

For electronic media organizations, positioning builds on a clear identity (brand) in the marketplace and establishes differences from competitors. In the electronic media, companies quickly embrace whatever top position they can, such as for certain demographic groups. For example, ESPN has positioned itself as a leader in sports programming, while CNN is widely recognized as a global news leader.

Positioning in the electronic media requires an objective analysis of many factors. Warner and Buchman (1991) suggest that positioning analysis should consider the market, the number of competitors and their marketing strategies, and a thorough internal analysis of all areas of operation.

Branding Another way to describe a product's image in the marketplace, **branding** differentiates products, goods, and services (Murphy, 1987). In branding, both tangible and intangible values work together to create an image of a product in the mind of the consumer. For instance, many people do not think in terms of soap when they need to do laundry. Instead, they may think of products, such as Tide, Cheer, or All. Any of the products will clean their laundry, yet most people would differentiate the quality of each product based simply on its brand name.

Branding triggers both emotive and rational responses in people. Brand image is influenced by many factors, including the product, packaging, name, price, advertising and promotion, and the method of distribution (D'Alessandro, 2001). To establish an effective brand image, managers must consider ways to make all these aspects work together.

Think for a minute how electronic media companies use branding. Radio stations identify their formats with phrases like "classic rock," "Mexican regional," and "hip hop." Television stations use branding to distinguish their style of newscasts. Satellite channels such as MTV, USA, TNT, and ESPN use distinctive logos and styles of presentation to create a brand for their channels. Branding is a critical marketing strategy. Large corporations like News Corp., Disney, and NBC Universal are in one sense a collection of many well-known and established media brands.

The marketing strategies presented in this section—segmentation, positioning, and branding—form the basis for a basic marketing plan in any business. Segmentation requires analyzing a market to identify underserved audiences, while positioning fills audiences' needs. Branding establishes unique selling points for the audience to differentiate one entity from its competitors.

Sales versus Marketing

Electronic media companies have long moved away from simply selling advertising time to clients. As competition for audiences has escalated, electronic media firms have recognized the need to emphasize marketing in order to attract revenues. Let's examine the differences between the concepts of sales versus marketing.

Expanding Selling to Marketing

Until the 1970s, electronic media companies concentrated most of their efforts on selling advertising time to clients, or transactional selling (Shane, 1999). Time was sold in 30- or 60-second units or as sponsorship of an entire program. Because there were fewer choices, programs attracted larger shares of the audience, and advertisers eagerly bought time. As the number of stations and channels grew, competition for audiences intensified. Broadcasters could no longer just sell advertising time to waiting clients. To maintain a competitive position, companies had to shift from a sales-oriented to a marketing-oriented philosophy.

Each industry established its own advertising bureau to help local stations and cable systems market themselves. The Radio Advertising Bureau (RAB), the Television Bureau of Advertising (TVB), the Cabletelevision Advertising Bureau (CAB), and the Interactive Advertising Bureau (IAB) provide members with many resources to aid local marketing efforts. Electronic media professionals keep abreast of the latest marketing techniques through seminars, conferences, and other educational opportunities.

The telecommunications industry also emphasizes a heavy marketing orientation, with the major players AT&T and Verizon offering bundled services for all types of communication needs and video services. These carriers fight for customers, with cable companies also competing for bundled services.

VOIP (voice over Internet telephony) has emerged as another competitor for telephone services and will continue to grow. The telecommunications industry has considerable resources to put forward in marketing, and one of the biggest opportunities for telcos lies in mobile video applications, which are expected to mushroom over the next decade. Some estimates have suggested the mobile video market good generate as much as $2 billion in revenues by 2012 (Ducey, Fratrik & Fraemer, 2008).

Understanding Clients and Their Needs

A key difference between a selling and a marketing orientation is the genuine recognition and goal of serving a client's needs. A sales-oriented approach focuses on the product (e.g., advertising time). A marketing-oriented approach is designed to help clients meet the goals and objectives of their business. To achieve this goal, many firms position their account executives as professional marketing consultants rather than just salespeople pitching packages of time units.

Recognizing the needs of clients requires a clear understanding of their business objectives. During the 1980s, the radio industry introduced consultancy interviews as a tool to learn about clients and their needs. The consultancy interview evolved into what the Radio Advertising Bureau calls the Client Needs Analysis (CNA), designed to draw out information about the client's business, which is then used to formulate a marketing plan involving radio as part of the advertising mix. Consultative selling also occurs in selling television and other types of advertising.

The General Sales Manager

In traditional electronic media enterprises such as radio and television, the General Sales Manager (GSM) oversees all operations of the sales or marketing department and reports to the General Manager. Two other middle managers—the Local Sales Manager (LSM) and the National Sales Manager (NSM)—assist the GSM. Some operations may employ someone charged with developing cooperative (or co-op) advertising that also reports to the GSM.

The GSM's primary responsibilities include the development of sales policies and objectives in conjunction with the GM. However, there are many other tasks, including coordinating sales with other departments in marketing the facility; maintaining budgets and quotas; supervising personnel; new business development, nontraditional revenues, working with advertising clients and agencies at all levels (local, regional, and national); approving copy and contracts; where applicable, consulting with and selecting the national representative firm; and working with the business department on the credit, collections, and processing of various accounts. Due to consolidation, a GSM may supervise several stations (as in radio) or two television stations (in cases of a duopoly/LMA). One of the most important managers in an electronic media facility, the GSM usually has several years of sales experience. Many General Managers have prior experience as a GSM, whose success is a direct result of the sales efforts at the local and national level.

Local Advertising

The radio, television, and cable industries depend on local advertising as part of total revenues. Of the three, the radio industry depends heavily on local advertising, as local sales account for approximately 77 percent of total radio revenues. In television, local advertising sales account for approximately 33 percent of total industry revenues. Local sales average around 22 percent of total advertising revenues in the cable industry.

The Local Sales Staff: Account Executives

In the radio, television, and cable industries, the local sales staff must generate new advertising business, also called new business development. Commonly referred to as **Account Executives**, AEs are supervised by a Local Sales Manager or a GSM. The size of the local staff varies according to market size. Larger markets tend to require larger, more specialized sales staffs than smaller markets.

Regardless of market size, account executives tend to draw higher salaries because they often receive **commissions** paid as a percentage of advertising sales. Actual commission rates vary among stations and industries. For example, accounts serviced by an advertising agency will pay a low commission (3–5 percent) compared to new business development, which pays a higher rate (10 percent or higher).

Local AEs concentrate most of their efforts on what Warner and Buchman (1991) refer to as *developmental selling*, which focuses on the customer rather than the product. Developmental selling integrates knowledge of the client's needs and business with creative approaches. In addition to finding and developing new accounts, local AEs prepare and present various types of sales presentations, provide service to existing clients, and often assist in preparing advertising copy.

Sales managers find the selection of new AEs a difficult task. Employers widely agree that AEs need experience, motivation, attention to detail, organizational ability, strong communication skills, professional appearance, integrity, creativity, imagination, and persistence. Unlike the situation in many other departments, part-time

AE positions and internships are uncommon. The sales assistant is one entry-level position that may lead to an AE job. A sales assistant helps prepare presentations, analyzes research, and serves clients. Industry consolidation has displaced many former sales managers, returning many to the ranks of AEs or forcing them out of the business altogether.

Selling media advertising is a challenging profession, primarily due to the fact that salespeople experience a great deal of rejection and the heavy competition for ad dollars. Turnover is high in sales, particularly among new AEs. Continuing education is a priority if one aspires to be an AE, not just to keep current with the industry but also to understand client needs. Electronic media firms attempt to counter AE turnover with careful recruiting and selection, followed by rigorous training programs to orient and prepare new AEs for success in their career.

The RAB, working with the radio industry, offers three different certifications for Account Executives. The Radio Marketing Professional (RMP) is an orientation of the entire sales process and is ideally suited for new AEs or those in the first year of employment. The Certified Radio Marketing Consultant (CRMC) is a more detailed program, requiring several years of experience. The Certified Radio Marketing Expert (CRME) is the most prestigious certification, requiring the most significant experience and a considerably expanded knowledge of radio marketing. More information about these certification programs is available at the RAB Web site (http://www.rab.com).

Role of the Local Sales Manager

The Local Sales Manager (LSM) is responsible for the performance of the local sales staff. The LSM usually reports to the GSM. In large markets, a single television station may employ several LSMs, with each manager responsible for a team of AEs. Local Sales Managers typically have several years of successful experience as an AE. In addition to drawing relatively high salaries, LSMs often receive additional compensation in the form of an *override,* a term used to represent a commission on total sales achieved above monthly or quarterly goals.

The LSM's duties include administering all local sales activities, supervising local Account Executives, establishing individual

projections and quotas for each AE, and evaluating individual and unit performance. Local Sales Managers may also have their own list of clients with whom they maintain regular contact. In conjunction with the GSM, the LSM establishes several important policies, such as setting revenue projections for the local sales staff and monitoring rates for advertising. In any broadcast station or cable system, the amount of advertising is limited to a certain degree and is affected by available supply, as well as demand by clients. In the radio industry, the amount of time available for advertising is referred to as **inventory**; in the television and cable industry, the term **availabilities** (or **avails**) is used as well. These terms are discussed in the following sections. However, one advantage to selling advertising on the Internet is there are no inventory considerations. On Web sites, advertising can be combined with existing database marketing to tailor messages based on the user's history and preferences.

Radio Revenue Projections and Rates

Assume a radio station has a policy of offering no more than 10 minutes of commercial matter per hour to maintain a steady flow of music to the audience. Broken into 30-second spots, the available inventory consists of 20 spots per hour, 480 spots per day (24 hours), or 3,360 spots per week. However, this figure is somewhat misleading in that stations rarely sell much advertising during the overnight time period (midnight to 5:00 A.M.) because the audience is small. Let's assume a station sells most of its advertising time between 6:00 A.M. and midnight, Monday through Sunday. With a maximum of 10 commercial minutes per hour, the total available inventory declines to 2,520 spots.

Continuing this example, let's also assume that about 20 percent of the station's inventory is reserved for national advertising (discussed in the next section). This represents 500 spots, leaving a weekly inventory of 2,020 spots for local advertising. The price for these spots depends on the demand by advertisers. When demand is high, stations can charge premium rates for advertising. Conversely, when demand is low, stations may charge the minimum amount required per spot to break even. The cost of each spot is further affected by the quantity demanded by each advertiser (clients who buy more spots usually receive a lower cost per spot), competition, and local economic conditions.

Sales Managers know exactly how many spots must be sold at the minimum price to meet all the station's financial obligations (review break-even analysis from Chapter 5). But how does a Sales Manager determine a minimum price? Again, let's assume that the station must generate weekly revenue to cover approximately $100,000 of expenses. Managers always take into account a **sellout rate** for their particular station. Sellout rate refers to the actual percentage of inventory sold over a given time. Using a conservative sellout rate of 50 percent, the station can expect to sell 1,000 spots in a week. Therefore, the minimum amount the station can offer a single spot for is $100 ($100,000 divided by 1,000 spots = $100). In other words, selling spots consistently below $100 would have a negative impact on the station's bottom line, while selling spots consistently above the $100 minimum will increase the station's profit performance.

This simple example gives you some idea of how Sales Managers determine revenue projections and department or unit quotas on a weekly, monthly, or annual basis. While rates for individual spots are always negotiable in markets of all sizes, supply and demand of inventory has the greatest impact on advertising prices. In major markets, advertising rates can even change by the hour during periods of peak demand, much like any commodity.

Television Revenue Projections and Rates

Establishing rates and revenue projections for television stations requires a similar approach, although not as simple as for radio. Several factors make inventory much more variable in the television industry. First, the number of available spots varies according to the daypart—prime-time programs naturally draw more viewers (and advertisers) than early morning or late evening. Second, television spots are tied to ratings performance—stations guarantee that a certain estimated part of the audience will see the program. If a station does not actually generate the promised audience, the station must provide a **makegood**, usually in the form of additional, free announcements as a supplement. Makegoods represent a cost to the station, not a benefit. When a station provides a makegood, it loses inventory that could be sold to other clients. A third factor is the reliance on barter in program acquisition. Recall from Chapter 8 that barter is used extensively in the licensing of syndicated programs. Though barter may provide programs at a lower cost, it also limits the available inventory stations can sell.

Television and radio stations depend on their traffic depart-
ments to help the sales staff maintain control over available com-
mercial inventory. Without coordination between traffic and sales,
chaos would reign. Fortunately, a number of software packages
are available to provide constant updates on available inventor for
scheduling.

Cable Revenue
Projections
and Rates

The cable industry approaches local advertising differently. Local
cable advertising revenues originally represented a small percentage
of the cable revenue streams, but that is no longer the case. Local
cable advertising revenues have steadily increased, according to the
NCTA Web site. In 2007 local cable advertising reached $4.7 billion,
approximately 18 percent of total cable advertising revenues accord-
ing to SNL Kagan data from *Broadband Cable Financial Databook,*
2007 (cited in National Cable & Telecommunication Association,
n.d.). Cable rates tend to be priced lower than radio and television
spots and are often offered as insertions on a package of the most
popular cable channels.

Inventory is also an issue in cable television. Local cable adver-
tising is confined to one to three minutes per hour on most of the
popular, advertiser-supported cable networks, such as CNN, MTV,
ESPN, and USA. Systems follow one of three options regarding local
cable advertising. One is to employ a local marketing staff to call on
clients in the same way that radio and television stations do. This
option is usually the most expensive for local cable systems because
of the cost of salaries and benefits for marketing personnel. These
local sales staffs tend to be small.

A second option is to outsource advertising sales to a company
that specializes in marketing insertion advertising to local businesses.
Cable systems receive a set amount of money each month, and the
company provides the necessary production and the actual tapes of
all commercials sold on a weekly basis. Local clients can advertise on
popular cable networks, usually at a rate comparable to that of local
radio stations. Clients purchase insertion advertising for a number of
weeks at a time; spots are rotated among various cable networks on
a random basis and air several times a day.

A third option involves the use of **interconnects**. Interconnects
exist where two or more operators join together to distribute ad-
vertising simultaneously over their respective systems. Interconnects

increase advertiser effectiveness by offering the efficiency of a multiple-system purchase and save time in that only one contract must be initiated. Interconnects are widely found across the cable industry in the United States. The Cabletelevision Advertising Bureau (2005) reported 106 interconnects as of 2005, with more growth expected.

National Advertising

National advertising is another important source of revenue for the electronic media industries. National advertising also encompasses regional advertising. There are two categories of national advertising—**spot** and **network**. Spot advertising represents the local inventory on a broadcast or cable outlet that is sold to clients at the national level; this type of advertising is referred to as **national spot** or just *spot* for short. Network advertising represents the advertising dollars sold by the various broadcast and satellite networks; these commercials are eventually presented during network programming.

Spot Advertising To supplement national campaigns, clients at the national level advertise in local markets around the United States. Some of the more prominent national advertisers include automobiles (Ford, General Motors, Toyota), soft drink companies (Coke, Pepsi), fast food (McDonald's, Burger King), breweries (Anheuser-Busch, Coors), airlines (American, United), and various other products (Procter and Gamble, American Home Products).

In radio, national spot accounts for approximately 18 percent of total revenues, while network advertising accounts for about 5 percent. In television, national and network spot sales account for approximately 62 percent of total revenues. The cable industry commands a small portion of national spot; most systems do not separate local sales from spot sales. Network advertising is the biggest category for the cable industry, accounting for approximately 75 percent of all advertising revenues.

**National Sales
Staff**

The national sales staff is smaller than the local sales staff. In some stations, the staff is limited to the National Sales Manager (NSM) and an assistant. To be promoted to the position of National Sales Manager, an individual usually needs several years of experience in the sales department as an AE or as an assistant to the NSM. National sales tend to be concentrated in the top 50 markets. Because smaller markets receive limited national spot revenue, there is no need for a separate NSM. In such cases, the GSM or the GM coordinates national spot sales.

**Role of the
Rep Firm**

National and regional sales are coordinated with a **national representative firm,** also known as the *national rep* or *rep firm*. Most of the transactions for national advertising occur in major media centers such as New York, Los Angeles, Chicago, and Dallas, homes of the largest advertising agencies. Because each local station cannot afford a National Account Executive in each city calling on the agencies to solicit national business, stations contract with a rep firm to handle national sales.

In representing local stations, the rep firm acts as an extension of the local sales force in the national and regional markets for advertising. Firms are usually contracted on an exclusive basis, meaning they represent only one station owner in a market. Rep firms are compensated through a commission on all advertising placed on local stations. Rep commissions vary from a low of 2 to 5 percent in television to as much as 10 to 15 percent in radio.

Here is an example of how the national sales process works. Reps build on relationships with agencies to solicit advertising for the stations they represent. Agencies specify the criteria they desire for a client. In most cases, the "buy" for a client requires a particular demographic group such as women 25–54, men 25–49, adults 18+, or teens. Usually the buy is based on quantitative requirements, such as a specific *cost per rating point* (CPP) (discussed later in the chapter) and the number of rating points required. The rep firm obtains a list of availabilities (unsold inventory) from each station able to meet the criteria desired by the client and negotiates the individual transactions for each station it represents.

Besides contracting national advertising for individual stations, the rep firm may provide other services, such as audience research,

assistance with sales and promotion strategies, revenue projections and trends for individual markets, and advice on the purchase of television programming. Key rep firms in the radio industry include Interep, Katz, and CBS. In the television industry, some established rep firms include Katz Continental, Petry Media Corporation, and its subsidiary Blair Television.

Working with the Rep Firm

For both parties to accomplish their tasks, the rep firm and the National Sales Manager need to be in close communication. To compete effectively for national ad dollars, rep firms need to be kept aware of any changes in the local station's market, programming, competition, and rate structures. An important partner in generating national sales, the rep firm should be a partner in the station's marketing planning and projections.

As in any business relationship, problems can occur between rep firms and stations. Either may switch affiliations at the end of a contract period if one is unhappy with the performance of the other. Attention to detail is important in coordinating national sales. Miscommunication, inaccurate information, and failure to follow up are other common problems encountered in rep–station relations.

Cooperative (Co-op) Advertising

Cooperative or co-op advertising is another category of advertising revenue found in the electronic media, although it works differently than local and regional accounts. In **co-op advertising,** manufacturers share in the advertising costs with local retailers. For example, Maytag manufactures appliances available at many local retailers. If the local retailers meet the specific requirements of the manufacturer's co-op plan, Maytag may reimburse them for part or all of their advertising costs.

The money available for co-op is directly related to the amount of **accruals,** or dollars credited for advertising, for each retailer. Tied to the amount of products purchased by the retailer from the manufacturer, accruals are usually subject to a dollar limitation. A simple 3 percent/$3,000 co-op plan would indicate the local retailer could request advertising dollars based on 3 percent of the products purchased from the manufacturer, up to a total of $3,000. If the retailer bought $60,000 worth of products from the manufacturer, then the maximum available for co-op purposes would be $1,800 ($60,000 \times .03 = $1,800).

It is estimated that millions of dollars of co-op advertising are left unused each year by retailers. Why? First, many retailers may not be aware of co-op opportunities. Second, many retailers tend to favor newspaper over broadcast and cable advertising. Third, retailers and stations dislike the paperwork required for co-op. Because co-op plans vary among manufacturers, stations can employ a coordinator to work exclusively on co-op plans. The co-op coordinator works with retailers to set up the individual contracts, prepares paperwork required by the manufacturer, and sees that the copy adheres to all requirements set by the manufacturer.

Internet Advertising

The Internet has become a vital component of electronic media advertising. Advertising dollars continue to transition to the Internet from traditional media outlets such as newspapers and magazines, and this trend will continue for many years. According to one report (Malone, 2008), local online advertising reached $8.5 billion in 2007, while national online advertising exceeded $10 billion. By 2008, total Internet advertising will move ahead of radio advertising in to third place behind television and newspapers.

Electronic media companies now offer online advertising options with their local and national buys, and also offer Internet-only packages. Some operations are now employing Internet-only salespeople.

One new area of development has been the growth of services such as Google Audio and eBay selling or auctioning unsold advertising revenue directly to advertisers, typically on a late or last-minute basis. Both Google and eBay started selling local advertising time in 2007 after negotiating deals with major station groups and other large clients. Bid4Spots.com is another firm specializing in selling unsold inventory; the company now is partnering with eBay to sell time (Carnegie, 2007). This practice began in radio, but has already transitioned to television, cable and newspapers.

Sales Terminology

A sales staff regularly uses audience research data to help market the station to advertisers. National sales are almost always structured around performance metrics—that is, *selling by the numbers*. Local sales may also be quantitatively driven, particularly in larger markets. Marketing professionals use many formulas to create an advantage over other competitors.

Common terms used in marketing media advertising include *gross impressions* (GI), *gross rating points* (GRP), *reach*, *frequency*, *cost per thousand* (CPM), and *cost per point* (CPP). Gross impressions, gross rating points, reach, and frequency all involve audience estimates and the number of commercial announcements in a schedule. Cost per thousand and cost per point are measures of efficiency that take into account price as well as audience estimates and commercial load. Each of these terms is discussed in more detail as follows:

Gross impressions (GI) is a measure of the total media weight and refers to the total number of people reached by each commercial in a campaign. Though GIs can represent different time periods, they must always use the same demographic group. Primarily used in radio, GIs are calculated by multiplying AQH persons by the number of spots and summing for each daypart. The following example shows the total GIs for women (W) 18–49 across three dayparts:

DAYPART	AQH	NO. OF SPOTS	GIs
6–10 A.M.	6,000	12	72,000
10–3 P.M.	2,400	6	14,400
3–7 P.M.	3,000	10	30,000
Total gross impressions			116,400

Note that you *cannot* add all the AQH estimates and multiply by the total number of spots to find the GIs; each daypart must be calculated separately as in the example.

Gross rating points (GRPs), another measure of media weight, is the sum of all rating points generated in an advertiser's schedule. GRPs are used in both radio and television, but as with GIs, the same audience base must be used. Radio GRPs are calculated by multiplying the total number of spots by the AQH rating. The next example uses hypothetical data for men (M) 25–54:

DAYPART	AQH RTG	NO. OF SPOTS	GRPs
6–10 A.M.	9.5	12	114
10–3 P.M.	3.0	6	18
3–7 P.M.	5.2	10	52
Total gross rating points			184

Like GIs, GRPs must be calculated separately for each daypart. In television, GRPs are calculated by multiplying the rating for a program by the number of spots and summing the total. Again, the same audience base (M 25–54) must be used.

DAYPART	RTG	NO. OF SPOTS	GRPs
Monday Night Football	13.5	6	81
Lost	6.0	2	12
Desperate Housewives	10.0	2	20
Total gross rating points			113

Reach is a measure of how many different people are exposed to at least one commercial advertisement. Think of reach as a measure of width in a media plan. A radio station's cume audience is equal to the size of the station's reach. Different estimates can be used for reach, such as a rating or a cume.

Frequency, used in combination with reach, can be thought of as the depth in a media plan. Frequency refers to the number of times the average person (in radio) or household (in television) is exposed to the same advertisement. Reach, frequency, and GRPs are interrelated, as seen in the following simple formulas:

$$\text{Reach} \times \text{Frequency} = \text{GRPs}$$
$$\text{GRPs} / \text{Frequency} = \text{Reach}$$
$$\text{GRPs} / \text{Reach} = \text{Frequency}$$

If 100 GRPs are purchased to reach an audience with an average frequency of 5, the reach will be 20.

Gross impressions, gross rating points, reach, and frequency all use audience estimates. The final terms discussed in this section, cost per thousand and cost per point, take into account the negotiated price for advertising as well as audience estimates.

Cost per thousand (CPM) describes the cost to reach 1,000 people; with it, one can compare competitors, advertising media, time periods, and so forth. (Note the abbreviation is CPM. The *M* is derived from the Latin word for thousand, *mille*.) CPM is calculated

by dividing the cost of the advertising plan by gross impressions (measured in thousands). For example, if the total cost of an ad campaign is $35,000 and the gross impressions total 700,000, then CPM equals $50. Some texts divide the cost of the ad plan by 1,000 and then divide by gross impressions; either way will produce the same measure.

$$CPM = \frac{\text{Total cost}}{(\text{Gross Impressions} / 1{,}000)}$$

$$CPM = \frac{\$35{,}000}{700}$$

$$CPM = \$50.00$$

Note that CPM is a comparison tool; a single CPM calculation is meaningless. In broadcast and cable selling, CPM is often used to compare advertising costs with costs of similar competitors as well as other media (e.g., newspapers).

Cost per point (CPP), another measure of efficiency, is the cost of a single rating point. CPP is calculated by dividing the total cost of the ad plan by the total GRPs. Another useful comparison tool, CPP serves as a negotiating point in the sales process. In the following example, if the total cost of an advertising plan is $35,000 and the total number of GRPs equals 630, then CPP equals $55.55.

$$CPP = \frac{\text{Total cost}}{(\text{Gross Rating Points})}$$

$$CPP = \frac{\$35{,}000.00}{630}$$

$$CPP = \$55.55$$

CPP is sensitive to the characteristics of a market. Advertisers expect to pay more money to buy rating points in Seattle or Denver than in Knoxville or Gainesville. Again, CPP must be used as a comparison measure of cost estimates.

Do not be intimidated by all these formulas and calculations. Most software packages generate many types of cost and audience analysis estimates for use in preparing client presentations. Understanding how to interpret the numbers and use them to your competitive advantage is far more important than doing the actual calculations.

Promotion as a Form of Marketing

An effective sales staff must have audiences to deliver to advertisers. Generating audiences is one of the primary functions of the promotions or creative services department. No electronic media enterprise can become complacent about its share of the market; there are simply too many alternatives available to audiences. For a total marketing effort to succeed, companies need good promotional campaigns and strategies. Promotions remain strategically important to electronic media management as competition for audiences has intensified.

Promotion takes many forms, ranging from self-promotion via the Internet, through on-air activities, to paid promotion in the form of advertising. Promotional efforts maintain both audience and advertiser awareness. The size and budget allocated to the promotions department varies according to market size and revenues. Standalone promotions departments are most common in the top 50 markets; in smaller markets, other units may pick up the duties. On average, firms allocate 3 to 5 percent of revenues back to promotion budgets; in major markets, the budget can reach several millions of dollars.

Duties of the Promotion Manager

As a midlevel manager, the Promotion Manager supervises the activities of the department and reports directly to a General Manager. The Promotion Manager works closely with the programming and sales departments in planning and coordinating activities aimed at audiences and advertisers, as well as monitoring and evaluating all campaigns.

The Promotion Manager is responsible for managing personnel in the department, supervising the budget, allocating resources, supervising graphics, evaluating research data, coordinating Internet

activities, and handling public promotional events which are usually tied to non-traditional revenue efforts. One of the most versatile managers in the electronic media, the Promotion Manager has knowledge of promotion, sales, marketing, research, technology, and regulatory policies concerning promotional activities.

Types of Promotion

Promotion Managers use many types of activities to market an electronic media facility. Most promotional efforts are aimed at either audiences or advertisers. Some of the most common methods follow:

- *On-air promotion.* One of the most effective and efficient tools available for promotional activities, **on-air promotion** in radio includes simple things such as announcing the call letters, logo, and music coming up in the next segment. In television, promotional spots or **promos** are used to attract audiences to upcoming events, especially at the network level. Local stations center promotions on the news team. Both TV stations and satellite networks use distinctive logos to maintain audience awareness. On-air promotion is not without cost; the time spent on promotional activities means time not available for advertisers. Cross-marketing promotional strategies are used by many firms, involving TV, radio, newspapers, the Internet, and other digital platforms.

- *Web.* Electronic media companies expend considerable resources on their Web pages for promotion and marketing purposes. Web sites are used for everything from streaming content to providing an important source of audience feedback and participation. Companies continue to examine ways to use the Internet to develop new revenue streams.

- *Publicity.* This refers to the free time and space made available by other media. Electronic media companies are very skilled at promoting events of interest to other media, such as newspapers. **Publicity** can range from simple activities, such as an electronic press release announcing the acquisition of a new program, to interviews or stories. The key is to design events that other media will take interest in reporting.

- *Advertising.* In this context, advertising refers to paid promotional activities, or the time and space purchased by the electronic media

facility in other media. Billboards, print advertisements, television commercials, radio commercials, Web site banner advertising, bumper stickers, and transit media placards (buses, taxis, and rail in urban areas) are vehicles for electronic media advertising.

- *Sales promotions.* Sales promotions are designed to attract new advertisers to a station. Companies may offer seminars to potential advertisers on subjects such as the advantages of radio (or television) advertising. Other campaigns may be targeted toward existing advertisers. Cable, satellite, and telco providers constantly market to existing subscribers to encourage them to try new products or services.

- *Community involvement.* Electronic media companies strive to promote goodwill in the communities they serve. Involvement with civic groups and nonprofit organizations on community projects establishes a positive image valuable to companies.

Evaluating Marketing Efforts

Media managers constantly execute and evaluate marketing strategies and campaigns. As such, they use many tangible measures of effectiveness. Advertising revenues, audience ratings, and research data all quantifiably indicate a particular marketing campaign's degree of success. Less tangible items, such as goodwill, phone calls, and e-mail and letters from audiences and advertisers are also considered when evaluating marketing plans.

Technology also affects the ability to evaluate marketing in the electronic media. Technology is providing increasingly efficient ways to measure consumers' use of individual products and services through many new innovations. At the same time, technology is also making marketing more challenging. How will marketing evolve when households are able to receive hundreds, if not thousands of channels of information and entertainment via their TV, computer, or IPTV connection? How will this affect the relationship with advertisers and audiences? Though specific marketing tools will evolve and adapt, the goal of generating advertisers and audiences remains a key challenge for electronic media managers.

Summary

Marketing knowledge is an essential skill needed by today's electronic media managers. In the electronic media, marketing is targeted toward advertisers and audiences. Marketing involves a range of responsibilities, including planning advertising and promotional campaigns and developing and maintaining the brand or identity of an operation.

Marketing strategies are an important part of any marketing plan. Segmentation, positioning, and branding are three common strategies used by businesses in marketing products and services.

The General Sales Manager and staff are responsible for generating advertisers. Most companies position advertising as part of a marketing orientation, with companies emphasizing meeting the needs of a client as opposed to selling time. Electronic media companies draw advertising revenues from local, regional, and national accounts, as well as through co-op advertising, the Internet, and other digital platforms. Different formulas measure advertising weight, breadth, depth, and effectiveness.

The promotions or creative services department serves to generate audiences and audience awareness. Promotional activities may include on-air promotion, Web and Internet, publicity, and paid promotion (advertising). Other types of promotions include sales promotions and community projects.

Across the electronic media, marketing strategies undergo continual development and evaluation. Like many areas of the electronic media, technology continues to impact marketing techniques and challenges traditional assumptions, but the basic goal of generating audiences and advertisers remains the same.

CASE STUDY **Marketing a New Newscast**

WKAR-TV is a Fox affiliate in a top-50 television market (145,000 TVHH), having signed on with Fox in 1988 after being an independent since it began broadcasting in the 1970s. There are four other stations in the market: affiliates for ABC, CBS, and NBC and a PBS station housed at a local university. Cable penetration is 54 percent; satellite penetration is 26 percent; video delivered by telcos is at 9 percent.

WKAR has made a commitment to establish a new local newscast and compete directly with other stations at 6:00 P.M. and 11:00 P.M. Until now, WKAR has been counterprogramming against competitors, occasionally winning third place in both the 6 and 11 o'clock ratings with popular reruns of series such as *The Simpsons* and *Two and a Half Men*.

The ABC affiliate, WPAT-TV, has led the market for years, emphasizing a strong theme ("First for News"), well-established anchors, and a host of familiar news reporters and numerous community activities. The CBS affiliate, WRMA-TV, has fought with the NBC affiliate, WWTC-TV, for second place at both the early and late newscasts. Most of the time, the difference in ratings between WRMA and WWTC has been a single point or two. WRMA uses a format replicated in several markets, calling its newscast "The NewsCenter." The WRMA NewsCenter features two anchors at all times (one male, one female); though they present the news in a serious manner, there is a lot of banter among the news, sports, and weather presenters.

WWTC emphasizes a fast-paced approach with an "Action News" format, which includes rotation among three anchors, regular investigative reporting featuring topics that border on titillation, and dramatic pictures of accidents, fires, and criminal activity.

As the Marketing Director of WKAR, your task is to come up with ideas for a marketing plan for the news venture. You must analyze the market and create a plan based on segmentation, positioning, and branding strategies. The final plan will be used in making decisions on the type of news personnel to hire, the format of the newscast, the design of the set, promotional strategies, and other criteria.

Note: Your instructor may wish to supplement your local television market in lieu of the hypothetical stations in this example. This case could also be applied to the national network newscasts, using the Fox, CW, or MyTV networks with plans to develop a national newscast to compete with ABC, NBC, and CBS News.

CASE STUDY | **The Tough Retailer**

Jim Robinson was the founder and owner of Robinson's Appliances, one of the largest appliance stores in the Northwest market of Rockport. Three months ago, Robinson retired, turning over the business to his daughter and son-in-law, Christine and David Applegate. Christine, who was raised in the family business, handles the sales staff, store layout, and customer

relations. David, who has an MBA, carefully studies and analyzes all the business aspects of the store, including inventory, accounting and billing, taxes, and advertising.

Julie Hawkins, an account executive for KTLK-AM/KRCK-FM, has been calling on the Robinson account for nearly five years. Julie first convinced Mr. Robinson to try radio advertising through a co-op package with some of the brand names he carried in his store. Though Robinson was skeptical, the plan proved to be a winner. Convinced of the power of radio, Robinson purchased a small monthly package to supplement the co-op efforts. Over the five years, Robinson's Appliances has experienced growth in market share and revenues, thanks in part to successful radio advertising.

Hawkins knows that David Applegate will be the new contact for advertising at Robinson's Appliances, having met David on her regular call to the store last month. The two of them have decided to meet to discuss the account.

"How is everything going with the transition?" Julie asks.

"Overall, very well," says David. "We have a lot of work to do, but we are off to a smooth start. However, at the same time, the nature of doing business is changing, and we have to be very careful we are doing what we should be doing in all areas—including advertising."

Julie senses some concern in David's voice. "The past few years in working with Mr. Robinson, KTLK/KRCK has been very instrumental in establishing Robinson's Appliances as the premier appliance outlet in Rockport, and we want to continue to assist in that effort," she says.

David responds, "Yes, I know. But at the same time, I want to make sure your station will continue to be the best deal for the money. I don't see anything in the files and contracts with your station that says anything about the GRPs generated by the advertising, the cost per point, anything. If you want to keep this account, I will need that information in considering future advertising with your station."

Julie is flabbergasted. Mr. Robinson never asked about gross rating points or gross impressions. He simply wanted to position his business in the market and get customers to visit the store. Developmental selling had always worked with Mr. Robinson. But David, with his business background, wanted numbers to review.

Julie carefully considers her response. "David, the broadcast stations and newspaper in this market rarely find retailers who need or even understand the type of data you have asked for. However, if you feel such information will help you make informed decisions, I will be happy to generate a plan that includes these figures. I will get back to you later this week."

"That will be great," David says. "I'm going to expect the same thing of your competitors, although the strength of your station in reaching our target audience of women 25 to 54 makes your operation and our business a good fit. Still, I want to see the numbers."

As Julie leaves the meeting, she makes some notes in her car. Few retailers in Rockport need the data Applegate wants, but if generating a media plan will maintain a strong client, then Julie has some work to do once she returns to the station.

Using data from the following table, construct a media plan she might present to Robinson's Appliances. In your plan, calculate the GIs, GRPs, CPM, and CPP for the retailer's target audience, women 25–54. Assume the station buys a package of 20 spots per week (:30 each), with 10 spots on the AM station and 10 on the FM station. Consider different placement of spots to determine the most efficient plan for a month.

	KTLK-AM (news/talk) W 25–54*			KRCK-FM (adult contemporary) W 25–54*		
16–10 a.m.	4,300	4.1	$325	6,400	6.1	$550
10–3 p.m.	1,100	1.0	$150	3,350	3.2	$275
13–7 p.m.	2,700	2.6	$225	4,100	3.9	$450
17–12 a.m.	800	.01	$050	1,700	1.6	$100

*Total women 25–54 in the market is estimated at 1,05,000.

NOTE: Each station lists AQH actual estimates (do not add 00) followed by AQH rating. $ refers to cost for a :30 spot.

References for Chapter 9

Bianco, A. (2004, July 12). The vanishing mass market. *Business Week*, pp. 61–68.

Brandes, W. (1995, February 13). Black-oriented radio zeroes in on narrowly defined audiences. *Wall Street Journal*, p. B8.

Cabletelevision Advertising Bureau. (2005). *Why cable*. Online presentation available at http://www.onetvworld.org/main/cab/whyCable/whyLocalCable/the-power-of-local-cable-.shtml

Carnegie, J. (2007, June 7). *eBay partners with Bid4Spots for airtime auctions.* Retrieved from http://www.rbr.com/epaper/pages/june07/07-111

D'Alessandro, D. F. (2001). *Brand warfare: 10 rules for building the killer brand*. New York: McGraw-Hill.

Ducey, R. V., Fratrik, M. R., & Kraemer, J. S. (2008). *Study of the impact of multiple systems for mobile/handheld digital television*. Retrieved April 30, 2008 from http://www.bia.com/publications_reports.asp

Gerlin, A. (1993, July 14). Radio stations gain by going after Hispanics. *Wall Street Journal,* pp. B1, B8.

Kaplan, D. (2004, June 6). *It's an interconnected world, after all*. Retrieved from http://www.broadcastingcable.com/index.asp?layout=article& articleid=CA423559&display=Special%20Report

Malone, M. (2008, January 14). New media, new newsrooms. *Broadcasting & Cable,* pp. 22–23.

Murphy, J. M. (1987). *Branding: A key marketing tool*. New York: McGraw-Hill.

National Cable & Telecommunications Association. (n.d.) Cable advertising revenue: 1985–2008. Retrieved August 6, 2008, from http://www.ncta.com/Statistic/Statistic/CableAdvertisingRevenue.aspx

Ries, A., & Trout, J. (1986a). *Marketing warfare*. New York: McGraw-Hill.

Ries, A., & Trout, J. (1986b). *Positioning: The battle for your mind* (Rev. ed.). New York: McGraw-Hill.

Runyon, K. (1980). *Consumer behavior and the practice of marketing* (2nd ed.). Columbus, OH: Merrill.

Scott, R. (1995, June 5). Radio direct marketing: Targeting the future. *Radio Ink,* pp. 30–35.

Shane, E. (1999). *Selling electronic media*. Woodburn, MA: Focal Press.

Warner, C., & Buchman, J. (1991). *Broadcast and cable selling* (2nd ed.). Belmont, CA: Wadsworth.

News and News Management

In this chapter you will learn

- How news establishes a sense of localism
- How electronic media organizations use news as a form of programming
- How news departments are organized and staffed
- Key issues in news and newsroom management

The electronic media are visible in many ways to audiences and advertisers, but perhaps they are most visible in the delivery of news and news-related programming. Over the years, society has become increasingly dependent on the electronic media for news and information. For many Americans, the electronic media are the primary source for knowledge of national and international events, whether delivered via traditional television or radio, or through the Internet, mobile phones, or alternative platforms.

News and news content are both ubiquitous and pervasive. Radio delivers traffic, weather, and local news to commuters during morning and afternoon drives. Local television stations may devote as much as one-third of their programming to news, beginning in early morning hours and extending to late night after prime time. Satellite-delivered news channels, like CNN, Fox News, and MSNBC are representative of a number of 24-hour news channels available to U.S. households 365 days a year. According to the Association of Regional News Channels (http://www.newschannels.org), over 25 regional and local all-news services are available to cable and satellite households as of early 2008. The Internet, with its ability to

both deliver and archive news content produced by electronic media organizations, has rapidly evolved as one of the primary distribution points for audiences to access news and information.

News remains one of the enduring products of electronic media organizations. This chapter examines news and news management by focusing on several topics. These topics include the importance of news as an area of content, the organization of a typical news department, and issues in news management. While news can be examined on many levels of analysis, this chapter will center its discussion on news at the local level, consistent with the direction of this text. From a career standpoint, the local newsroom of a radio or television station is the logical starting point for entry into the field of electronic journalism. Hence, an understanding of topics and issues related to local news management is applicable to most readers.

The Importance of News

Why is news so important to electronic media organizations? There are many possible ways to address this question. From a historical perspective, news has been intertwined with broadcasting since its beginnings. The first radio broadcasts to achieve notoriety were the election results of 1920, broadcast by KDKA, the nation's first licensed radio station (Albarran & Pitts, 2001). During the World War II years, radio news kept Americans informed of the campaigns in Africa, Europe, and the Pacific. The advent of television ushered in a new dimension for news with the capability of combining sound with moving pictures. Many broadcast historians rank the news coverage of the assassination and funeral of President John F. Kennedy in 1963 as a defining point for broadcast news, much in the same way CNN's coverage of the Gulf War in 1990 signified a new era of instantaneous global news coverage (Hatchen, 2000). The terrorist attacks on September 11, 2001, and the wars in Afghanistan and Iraq continued to increase American audiences' reliance on news and information from electronic media outlets.

From a cultural perspective, news serves many areas of society. News provides not only information to improve learning and understanding but also aids in awareness of our societal norms, values, and beliefs. News enables listeners and viewers to experience and

interact with cultures and peoples in other parts of the world. News and news content are targeted to different segments of the population, ranging from news that is feature oriented to news focusing on business and sports. There are many ways one can examine news. In this section, we center discussion on two important topics: localism and news as a form of programming.

Localism More than any other type of content, news establishes a sense of **localism** with both audiences and advertisers. In fact, listeners and viewers feel dependent on local news sources to help learn about topics and issues of concern. Critics may bemoan the fact that most Americans get their news from the electronic media as opposed to print media sources, but it is reality.

In fact, localism is the key feature that separates local and regional radio, television, and cable channels from their national and international counterparts. It is important to have access to the major networks and operations like CNN, MSNBC, and Fox News for key national and world events, but when people want to know what is happening locally that may impact their lives and the people closest to them, most will seek out their local news operations.

Further, audiences identify with local news personalities, often regarding the news anchors or weathercasters as trusted sources and even friends. More viewers are aware of local news and news anchors than they are of which network the station may be affiliated with. Local news personalities tend to be visible in their local communities promoting and participating in various civic causes and events. This helps establish a sense of unity, or brand, with the local electronic media, promoting greater loyalty among viewers and listeners.

With a more saturated and competitive media environment, the concept of *localism* is the single biggest advantage the electronic media offer their audiences. For electronic media organizations, news is the manifestation of localism and the most tangible way to be a visible, interacting part of a community.

In addition to establishing a sense of localism, news also helps to build a definable brand in the mind of the audience. Logos such as "Eyewitness News," "Action News," and "News Center" are utilized in conjunction with on-air and external campaigns promoting news anchors and reporters. Often this means a separate brand, or "bug," that viewers see on the lower third of their television screen that becomes recognized with news broadcasts.

This branding of the news operations helps not only in generating awareness and building audience ratings. It also helps in marketing to advertisers. In the television industry, stations with a local news operation typically hold a strong competitive advantage over independent stations in terms of both audience ratings and revenues. News is the main reason for this advantage.

News as Programming

News is critically important from a programming perspective, especially for television stations. The cost to produce a single news program would be very expensive, especially in terms of capital outlay to acquire talent, equipment, sets, and so forth. But by producing multiple hours of news, stations have a very economical form of programming. By programming multiple hours of local news, the overall costs drop considerably. This is especially true for stations in large and medium markets.

Content for the news comes from a complex internal system of assignments and reporting discussed later in the chapter, but other sources are used as well. Stations use the Internet, e-mail, telephone feedback, and other sources to help identify and select stories that interest the audience. Local blogs can be monitored to gather ideas and opinions for new stories. Town hall meetings have become increasingly popular as a way of generating community interest and helping identify the key issues on the minds of many local citizens.

Television news can be found in several dayparts. Early morning newscasts begin in some markets as early as 5:00 A.M. For network affiliates, local news is interspersed with morning programming like *Today* and *Good Morning America* (Eastman & Ferguson, 2006). The noon hour is another traditional time period for local news coverage. These earlier newscasts are among the most profitable hours of the television day. The programming is easy to sell, although talent costs for morning and noon news anchors have increased substantially for many stations rethinking what time periods represent the best place to put their strongest news talent.

Afternoon fringe time, beginning around 4:00 P.M. to 5:00 P.M., is the time when many stations will program their first news broadcast, followed by another local news block at 6:00 P.M. Late news appears directly after the conclusion of prime-time programming, at 11:00 P.M. in the Eastern and Pacific Time zones and at 10:00 P.M. in the central and mountain time zones. Many stations repeat their

late-night news at some time slot during the overnight period and resell the advertising. With the transition to digital, stations will also be able to multicast local news on one of their SDTV channels.

Companies with duopoly operations, local marketing agreements, or joint services agreements tend to rebroadcast news on a sister station but at a different time period, thereby generating even larger reach and penetration in the market. It is not uncommon for news to represent four to six hours of the broadcast day for ABC, CBS, and NBC affiliates. For example, because of the lack of daytime network programming, FOX affiliates tend to program even more hours of news. Affiliates of CW and MyTV, in contrast, broadcast much less news; in fact, some affiliates may not have a local news department, or they may buy news programs from other stations.

Local and regional television news coverage is growing across the United States. Some 25 local or regional 24-hour news channels exist, with many more channels available via broadband over the Internet. Audiences demand news more often, especially with so many demographic changes in regards to work patterns and lifestyles, leading to more opportunities to reach audiences at different time periods. Regardless, advertisers prefer reaching news audiences who tend to be the most loyal viewers with higher discretionary spending patterns.

In contrast to television programming, many radio stations have cut back or even eliminated news coverage over the past decade. Still, most music stations offer a minimum of some news headlines, local traffic, and weather during drive time hours (Albarran & Pitts, 2001). News and news/talk radio stations are found in most large and medium markets, but smaller market stations also tend to devote some resources to local news, sports, and weather. Radio networks also offer news and other programming features to their affiliates.

Finally, the Internet is a critical source for news distribution for electronic media companies. The ability to archive and expand existing news material via the Web offers new ways to increase the audience for news. Stations can also provide news access to individuals outside of traditional listening and viewing hours. News content can be repurposed for use on the Internet, as well as developing original news content found only via the Web site.

The Internet is becoming increasingly important as the primary news source for younger audiences, who are much more

likely to access the Web than to turn on the radio or television. A challenge for broadcasters is using the Web to "push" the audience back toward traditional broadcasting after sampling the news from the Internet. The ability to access news via wireless devices, like cell phones and PDAs, presents new challenges in packaging and delivering news in smaller and more compressed environments.

Organization of a News Department

News departments vary in size and composition from market to market and type of facility (e.g., radio or television) and depending on the commitment to news as a form of programming. News is under the leadership of the News Director, who has responsibility for the unit and its performance. The News Director in most markets is an upper-level manager, reporting directly to the General Manager. A number of larger markets have news managers with the title of Vice President or President of News.

In most electronic media organizations, the News Director tends to be one of the higher-paid members of the management team with several prior years of experience, often involving a work history in different size markets. News Directors usually work their way up through the ranks, with most having started as writers, reporters, and producers and having carried out general assignments. News Directors tend to have a degree in either journalism or a related field; today many News Directors may also hold an advanced degree.

According to Martha Kattan, News Director of KUVN-TV (Univision) in Dallas-Fort Worth, News Directors should have several key characteristics to be successful. These include being challenging, objective, open-minded, caring, tactful, and firm but fair (personal communication, April 8, 2008).

Staffing the News Department The News Director (ND) is assisted by a number of personnel in the newsroom. Because of the variability in the size of the news department across markets, our discussion will center on the types of representative staff found at a local television station.

Assistant News Director The Assistant ND works closely with the News Director and shares the overall responsibility of the department. At some facilities, the Assistant ND may work an earlier time

shift, with the News Director working later in the day. The Assistant ND serves in a variety of roles, usually helping producers and reporters as they progress on their individual stories. The Assistant ND typically assists in hiring as well as designing the newscast structure and format.

Assignments Editor The Assignments Editor is responsible for assigning stories to be covered by the reporters. Some operations maintain a beat system of reporting, where a particular reporter will cover topics such as education, city government, business, or the environment, while others will use a random general assignment approach. The reporters work with the Assignments Editor to determine the length of their **news package** and other criteria. The Assignments Editor seeks out story ideas by monitoring police scanners, reading newspapers and magazines, following key Web sites and blogs, and keeping in touch with reporters and producers.

Operations Manager The Operations Manager may not be found in all news departments, but the responsibilities associated with this position are critical. The Operations Manager coordinates the technical needs associated with covering stories and events such as the use of satellite time, live trucks, helicopter coverage, and other logistics.

Executive Producers Executive Producers are found in medium and larger markets and are typically considered to be part of newsroom management. The Executive Producer often supervises a team of producers and will help write and rewrite all stories that eventually air. Executive Producers in the top 25 markets have the final word on what goes on the newscast and the order of presentation.

Producers As a group, producers are responsible for ensuring that all elements of a newscast are properly arranged and organized to provide a tight, coherent production. In theory this sounds easy, but in practice it can be extremely challenging, especially in situations involving breaking news stories that can totally disrupt the best-planned newscasts. As a newscast moves closer to air, producers keep in constant contact with all members of the department, including the reporters, anchors, and production staff.

Anchors Considered by viewers to have the most visible as well as most authoritative positions in the news department, anchors deliver the news by providing an introduction to stories gathered by reporters. They also help transition different segments of the newscast. The role of the anchor varies considerably; in some stations the anchor merely is the talent that delivers the news to the audience. In other operations, the anchor is directly involved in the production of the news department, perhaps even serving as a Managing Editor of the news in consultation with the News Director. In some cases a single anchor reports the news; in others multiple anchors share the anchor desk. Most anchors have roots in reporting, and they tend to be among the highest-compensated positions in the newsroom. Anchors may also write or rewrite scripts used on-air.

Reporters Next to the anchors, the reporters are the most visible members of the news department because their work requires regular contact with the community they serve. Reporters handle a range of responsibilities, including writing stories, working with the production personnel in the shooting and editing of their package, and keeping in touch with the producers. Increasingly, reporters must also prepare Internet versions of their stories for use on the Web site and other platforms, and some reporters maintain their own blog. Stations are also investing in Web-only reporters to file stories and maintain blogs on station Web sites (Malone, 2008).

Photographers and Editors Production personnel are critical to the success of a news operation. On the television side, news photographers bring life to a news story with pictures of news events. In fact, anchors and reporters have very little on-camera time in most newscasts, because the pictures are what tell the stories. And news is about telling stories to audiences. Editors help in this process by editing together footage so packages are within their allocated time. In radio, reporters gather their own interviews and handle their own editing to produce **actualities**, or sound bites that add realism and interest to radio news stories.

Sports The importance of the sports segment depends on market size. In larger markets where professional sports are part of the community, sports takes on a much more prominent role, while in medium

and smaller markets without professional sports franchises the coverage centers on local teams (high school, college, university). Sports personnel are limited to a Sports Director and perhaps one to two reporters in most markets. In larger markets, sports may produce two to four specials for the station to air in prime time, usually at the beginning of a season. Extended Sunday night sports programs that follow local news are also popular in many large markets and allow for additional coverage and reporting beyond the limited time in nightly local newscasts. Many stations without a strong local sports connection have cut back and even eliminated sports in some markets, recognizing that "sports junkies" will find the content they want on 24-hour TV and radio sports channels like ESPN or Fox Sports, rather than try to catch the two to three minutes of a local newscast with limited information.

Weather Audience research has shown that weather is the primary reason people say they watch local news. Tools used to report weather have become increasingly sophisticated, involving a combination of graphics and radar. In areas where weather can be volatile and subject to extremes, a good weather team can mean a bonus to ratings. Weather is usually handled by a primary weather anchor, assisted by one or two other on-air talents to cover weekends and daytime. Many weathercasters have obtained degrees or certification as a meteorologist, adding another branding element to the newscast.

Budgeting and the News Department

The News Director is responsible for maintaining the budget of the news department. Like any department, the News Director negotiates the budget on an annual basis with the General Manager and the Controller. News Directors normally manage two budgets—one budget to handle regular expenses (talent and other costs that cannot be amortized) and a capital budget for capital expenditures (new equipment, vehicles, etc.).

News represents one of the more challenging areas of budgetary management, as the costs to cover live and unplanned news events can effectively kill an existing budget. The News Director is faced with the daily challenge of managing the resources for the news operation while at the same time working with other department heads to increase profitability.

Many professionals trained as journalists resent the fact that news is often expected to "pay its own way" in an electronic media facility. But as competition for audiences and advertisers has intensified, news personnel have come to grips with the realities of the marketplace and understand that ratings are critical in achieving success. By streamlining operations and cutting unnecessary costs, news managers strive to meet economic objectives for the organization while preserving journalistic integrity. Still, it is important to recognize this is a delicate balancing act to achieve. This is one reason why the News Manager reports directly to the General Manager. To some extent, the news operation can be insulated from other departments in terms of its revenues and expenses and contribution to profitability (or loss).

The most expensive component in a news department is the personnel. News personnel salaries typically account for around 60 percent of the budget in a network affiliate television station, less for independents, and significantly less for radio stations. Average salaries for selected categories of television and radio news personnel are presented in Table 10-1. Equipment represents the largest capital expense, with many operations functioning in a total digital environment. News services in the form of wire services, syndicated news sources, and subscriptions represent another expense category.

There are other expenses that are either directly or indirectly tied to the news department. Overtime tends to be a common expense in the news department when news events require keeping personnel beyond normal working hours as events evolve. Travel and satellite time represent other common expenses. Research in the form of focus groups is often used as a qualitative measure to obtain audience feedback, while ratings services provide quantitative measures of demographic reach and viewing trends. Other types of

TABLE 10-1

Average Salaries for Selected Categories of TV/Radio News Personnel

JOB TITLE	TELEVISION SALARY	RADIO SALARY
News Director	$84,900	$36,400
News Reporter	$35,600	$25,800
Sports Anchor	$52,300	$31,300
News Producer	$31,900	$29,600
News Photographer	$29,600	N/A

SOURCE: Papper (2007).

expenses include such things as fuel and vehicles, tape, sets, office supplies, and telephone expenses.

Remember that news department budgets vary across the electronic media and market size, and the budgetary items discussed in this section may not be applicable to all news operations. Regardless of the type of market, one should realize that budgetary management of a news department presents a number of challenges, and the ability to utilize resources in the most effective way directly impacts the overall performance of the news department. Given this range of experiences, News Directors make excellent candidates for a General Manager position.

Issues in News Management

News Directors deal with a number of issues in the course of leading their news operations. This section focuses on some of the more salient issues managers confront on a daily basis, as opposed to logistical issues associated with breaking news events.

Erosion of the News Audience

With the number of viewing options available for today's television viewers constantly increasing, audience levels for local television news have tended to decline in recent years. This decline in audience has placed even more pressure on news managers to control costs and try to increase ratings before advertisers balk at paying increasingly higher prices to reach fewer and fewer audience members. A national study of 500 adults conducted by NewsLab found that viewers were not uninterested in local news, but they chose to get their news from sources other than television. Newspapers were identified as the primary source of local news by 43.2 percent of all respondents, with 20.6 percent ranking television second, followed by radio at 16.8 percent (Potter & Gantz, 2000).

In an evolving digital environment, news will shift to content that is not simply scheduled but that is desired by the audience on demand (Warley, 2004). While this shift will occur over time, the fact is audiences can now access news increasingly via wired (computers, cable, satellite) and wireless devices (wireless network, a PDA, or a cell phone). According to the Warley (2004), the broadcast industry

has a unique 50+ year relationship with local audiences and must adapt to this shift as changes in audience usage patterns occur. In other words, as the audience shifts, the electronic media industry will need to shift as well to maintain the relationships they have developed with their audience.

Convergence

Electronic media newsrooms around the country are increasingly converging news operations with other mediums, notably print and Internet. This sharing of news resources, or *convergence*, began in major markets and is now moving slowly through other markets. From a management standpoint, converged news operations make a lot of sense, as it promotes efficiency within operations and lowers overall costs. Perhaps the one negative is that as newsgathering becomes more converged, there is less of an identity associated with the actual presentation of the news, and the audience must be educated about which former competitors may now be allies.

Some companies have had greater success with convergence than others. For example, Media General and Belo were two early leaders in converging news operations, integrating their television news operations with radio, print, Internet, and cable partners. But by 2008, Belo had split in to two companies and Media General experienced major job cuts across markets. One initial study on local television convergence found significant differences in opinions and expectations of convergence success between managers and reporters, with managers feeling that convergence was good while reporters and producers had many concerns (Smith, Tanner, & Duhe, 2007).

Convergence means reporters and producers need to be able to work in multiple platforms, generating content that could be used for TV, radio, print, or online. Increasingly, newsroom employees will need multitasking and multiplatform skills, as will managers.

Negotiations with News Talent

News anchors and reporters often have detailed contracts specifying the terms of service, compensation, benefits, and personal services provided by the electronic media facility. An agent often represents talent in contractual negotiations in large and medium markets. News Directors are usually involved in negotiations for news contracts along with the General Manager.

Contracts serve to protect both parties. For the talent, the contract specifies the financial commitment the organization makes to

the individual. In turn, the contract protects the electronic media facility from another entity in the market buying out an existing contract, leading to talent jumping from one operation to another. Many contracts contain what is referred to as a **noncompete clause** that specifies the length of time employees must remain off the air in the market if they leave their position. Several states (California, Maine, Massachusetts, etc.) do not allow noncompetes, so it is important to understand state regulations regarding labor and employment.

Good talent is one of the keys to a successful news operation, so management tries to do whatever it can to maintain a positive relationship with its on-air talent. This can be especially challenging with local news departments, as individuals who do find success as news talent typically have many employment options, from moving to a larger market to making the jump to a network operation.

Ratings and Sweeps

Aside from the daily pressures of presenting news that is accurate, objective, and fair, the constant pressure associated with ratings looms over the newsroom. Everyone in the newsroom, from the News Director down, knows the success of the news product is not measured by how well the news is planned and presented but by how favorably the audience responds to the news via audience ratings. Chapter 9 details the way ratings are gathered and analyzed. In this chapter, the focus is on how the ratings impact the presentation of local news.

In television news, sweeps is the critical time period for assessing viewing trends. TV sweeps are held four times a year, during the months of February, May, July, and November, but adjustments to this schedule may take place due to recurring events like major elections, the Olympics, or other significant events. During sweeps, news departments devote a block of time to "special" reports on topics that run on consecutive days. Some news operations have been criticized for presenting what many feel are merely sensational stories dealing with sex, crime, and drugs. Other news operations have been lauded for presenting series that deal with important community issues regarding education, politics, health, and medicine, as well as investigative reports detailing fraud and corruption.

Determining the type of series and other strategies (e.g., a new news set or news theme) to unveil during sweeps requires months of advance planning on the part of the news management team. Trying to coordinate materials for a sweep period that is weeks or months

away adds another layer to the responsibilities of news management personnel.

News Ethics

Ethical issues, first discussed in Chapter 3, tend to have a recurring presence in the newsroom. Ethical confrontations can occur in several areas of news gathering and delivery, as illustrated in the following paragraphs.

Technology is one such area. Live shots are a key feature of local news, but they raise the question of whether live shots are truly needed or even desired by the audience. Knowing when to engage the live shot is more important than the technological ability to provide a live shot. Live shots also have the potential of endangering the news crew in situations involving war, demonstrations, conflict, and severe weather.

The increasing use of helicopters in news operations, first designed for use in monitoring traffic problems and coverage of fires and other accidents, has expanded into an array of activities that confront news ethics. Many viewers remember how the infamous police chase of the white Bronco carrying O. J. Simpson played out on national television. TV helicopter crews have captured gunfights between the police and various suspects that have resulted in on-air gunfights and suicide.

The use of hidden miniature cameras to collect material that traditional camera crews would be unable to obtain raises another set of questions regarding news ethics. There are some instances where the use of hidden cameras may in fact benefit the public, but news managers must know the proper time to invoke such a practice (Steele, 1997). Regardless of their use, part of the public will always feel the use of hidden cameras in any situation is deceptive and unwarranted.

Presenting material fairly and accurately is a constant challenge for reporters. News Directors must demand accurate research, checking facts, and corroboration of source material before stories are broadcast. Failing to do so violates any trust developed between the newsroom and the audience.

Finally, the use of *video news releases* (VNR) that are in reality videos produced by public relations departments or government should rarely be used as a news story. One publication calls the use of VNRs a "threat to the integrity of news programs" (Westin, 2000, p. 9).

Race and Ethnicity Issues

The Freedom Forum, a nonprofit organization funded by Gannett, published a report in 2000, "Best Practices for Television Journalists," authored by former ABC News Executive Av Westin. The handbook was based on anonymous interviews conducted with news professionals at the local and network levels throughout the United States.

The research revealed a lack of sensitivity in newsrooms toward race and ethnicity, which in turn influences story content and selection (Westin, 2000). The report called for a system to create better balance in the presentation of news stories, as well as establishing in-house diversity councils to monitor and evaluate the production and presentation of the news. The issue of diversity and sensitivity is often addressed in better news operations through required seminars and other educational activities. The problem is the daily pressure to get material on-air is often apparent in descriptions of suspects that are too vague and limited to race, gender, and maybe age.

The RTNDF publishes a frequently updated guidebook to help news managers improve on diversity hiring (News Diversity Project, 2004). While the industry recognizes they need improvement in addressing race and diversity issues both within the newsroom and in the content they provide, progress has been slow. An RTNDF report concludes, "RTNDF has shown that journalists of color have made some, but not nearly enough, progress into the upper ranks of our nation's radio and television newsrooms" (News Diversity Project, 2004, p. 3). When it comes to hiring, News Directors are much more aware of balance, but the issue changes depending on the market. Newsrooms must reflect the market, and the industry must take on different hiring practices.

Dealing with Unions

As discussed in Chapter 6, labor unions are prevalent in the electronic media industries and can be found in several representative areas related to the newsroom. While actual negotiations with unions are likely to be handled by the GM or perhaps an Operations Manager, News Directors may be involved because of the importance to the overall news operation.

One clear responsibility in unionized news operations is to make sure that people do not deviate from their job responsibilities. For example, camera operators are limited to their work with the camera, while the video editors handle actual editing, studio technicians handle the studio environment, and so forth. Management must be certain that duties are clearly defined and followed in accordance with guidelines agreed upon by management and the unions.

Summary

News serves a critical role for electronic media organizations and for society. For electronic media organizations, news establishes a sense of localism with audiences and advertisers and provides an important source of programming. For society, news programming helps individuals understand and interpret events that affect their lives in a local, national, and global context.

News and news programming is ubiquitous and pervasive. In addition to the local news presented by television and radio stations, there are local and regional news operations available to cable and satellite households, as well as national and international news services like CNN, Fox News, MSNBC, and CNBC. The Internet has quickly emerged as the most important distribution medium for news at all levels.

News departments are under the direction of a News Director, who usually reports directly to the General Manager. The News Director manages the department along with the Assistant News Director and Assignments Editor. Producers, anchors, reporters, photographers, and editors round out the typical news staff, and increasingly stations are putting more resources in to Web-only reporters and producers. Salaries and duties vary across markets and type of facility.

News Directors deal with a number of issues in the day-to-day management of the news department. Among the most prominent issues News Directors face are dealing with the erosion of the news audience, negotiating with talent, dealing with ratings and sweep periods, facing ethical issues and ethnic and gender bias, and dealing with unions.

CASE STUDY **Live at 5 Takes a Twist**

WDDD-TV is a VHF station located in a top-10 market. An ABC affiliate, WDDD has a strong local news presence in the market. The first afternoon newscast at 5:00 P.M., called "Live at 5," provides a mix of soft news, weather, and traffic information, with an occasional interview feature.

It is a typical Wednesday afternoon. The station's traffic reporter is inside the station's helicopter ready to appear live to give the first of three traffic

updates to viewers. Just before going to air, the reporter observes a high-speed chase on the westbound side of a freeway involving a sports car and two police cars. The traffic reporter goes to the first segment, with sirens obvious in the background.

Once the shot has switched back to the studio, the reporter asks the station's director through an internal feedback channel whether the chopper should follow the chase to see what is happening. Almost simultaneously, new information emerges. The police radio in the newsroom provides details of the car chase. Inside the car is a suspect, with a hostage taken in a carjacking. Several witnesses saw the suspect brandishing a gun, and some audience members began to email photos of the car in pursuit by police. The victim of the carjacking has been identified via the license plate as a young mother who lives in a nearby suburb; it is possible a small child may be in the back seat.

As the News Director of the station, what do you tell your reporter and on-air team to do? Obviously the story has the potential to disrupt the entire newscast. Depending on what happens, the chopper cameras might witness a tragedy unfolding or a resolution to a dangerous situation. Clearly, you do not want the news helicopter to interfere with the work of the law enforcement officials, nor do you want to risk endangering any hostages trapped in the car.

The station newscast goes to a scheduled commercial break. The news will be back on the air in less than 90 seconds. A quick glance at the monitors in the newsroom tells you that none of the three local news competitors are on the story, at least from a "live" perspective. What do you do? How do you pursue the story? If so, what instructions will you forward to your reporter and production staff about how to cover this breaking news story? If not, what impact will this have when your competitors pick up on the story?

CASE STUDY	**Reinventing Local News**

For nearly 30 years, KNZW has been the market leader for local television news in the market of Everyport, a West Coast medium-size market. Two other stations provided local news competition, and over the years the competitive product for all three stations tended to mirror each other—especially with breaking news coverage. News Director Courtney Clay's fears were becoming reality: the station was starting to slip in its numbers for both the 6:00 P.M. and late evening news, especially for younger audiences, primarily due to audience fragmentation and fewer people watching news.

Several staff members suggested the station rethink its news product and take on a more contemporary, "edgier" look to attract younger viewers. But Clay was concerned this could backfire and alienate KNZW's loyal audience. Still, she felt something had to change rather than stay with the status quo. Clay contacted two different consulting firms and asked them to generate ideas on how to reinvent KNZW's news product, especially in regards to a strategy involving digital platforms. Take the role of a consulting firm, and present a plan on how you would reinvent KNZW news and what platforms you would emphasize to expand coverage.

CASE STUDY **Anchor Woes**

Blessed with a strong but calming voice, Bill Powers anchored television news in a top-20 market for the past 24 years. Many residents of the market associate Powers with the news, and for several years his newscasts dominated ratings at both 6:00 P.M. and 11:00 P.M. But over the past two years, the numbers have declined, in part due to the overall erosion of television news, and in part from intense competition from local competitors who offer a qualitatively different product to viewers.

Powers' four-year contract is due to expire in five months, but the station had been unable to reach a new agreement with the anchor. Powers has been serving as his own representative. News Director Jennifer Scott, in meetings with the station's General Manager, John Craig, is well aware of the need to reduce expenditures for the news department and wants to hold down salaries. Powers has been offered a 3 percent salary increase and a two-year contract extension; the anchor countered by asking for an 8 percent raise and another four-year deal.

The latest negotiating session proved to be a nightmare for the station. Scott informed Powers that the station would offer a 4 percent salary increase for two years, and if ratings improved during the next 24 months, there would be incremental bonus money that would in effect add another 3 percent increase to his salary. Powers rejected the offer, claiming he was so upset with the station's offer that he intended to move to the station's primary competitor once his contract was up. In fact, he had already negotiated a new deal with the other station.

Scott was stunned. She knew that Powers did not have a noncompete clause in his contract, primarily because he had been considered a lifelong

employee of the station. Legally, she could not keep him from going to work for another station. The question was what to do in the remaining five months of his contract.

Scott went to meet with the General Manager after the meeting to discuss options. There were really very few to consider. "He has got to go, now!" said Scott. "I don't want him on the air." Craig agreed that was probably the best thing to do, but how would the station handle the anchor chair? The weekend anchor was not an option for the full-time duties, and since Scott had been the lone anchor, there was no in-house replacement waiting in the wings. Further, the station was two weeks into a sweep period. The timing was awful from every possible angle: the effect on the news operation, the impact on the ratings, and the public relations problems this situation would create.

If you were the News Director, how would you handle this situation? What could you do to try to minimize the damage this situation might cause internally to the news operation, and externally to viewers and advertisers?

References for Chapter 10

Albarran, A. B. & Pitts, G. G. (2001). *The radio broadcasting industry.* Boston: Allyn & Bacon.

Eastman, S. T. & Ferguson, D. A. (2002). *Broadcast/cable programming strategies and practices* (6th ed.). Belmont, CA: Wadsworth.

Hatchen, W. (2000). *The world news prism* (8th ed.). Ames: Iowa State University Press.

Malone, M. (2008, January 14). New media, new newsrooms. *Broadcasting & Cable,* pp. 22–23.

News Diversity Project. (2004). *Recruiting for diversity: A news manager's guide* (7th ed.) [Electronic version]. Washington, DC: Radio and Television News Directors Foundation.

Papper, B. (2007, June). Seize the pay. *Communicator.* Retrieved December 15, 2007, from http://www.rtnda.org/media/pdfs/communicator/2007/jun/062007-16-25.pdf

Potter, D. & Gantz, W. (2000). *Bringing viewers back to local TV news: What could reverse the ratings slide?* Retrieved September 22, 2000, from http://www.newslab.org/bringback-1.htm

Smith, L. K., Tanner, A. H., & Duhe, S. F. (2007). Convergence concerns in local television: Conflicting views from the newsroom. *Journal of Broadcasting & Electronic Media (51)*4, 555–574.

Steele, B. (1997, September). Hidden cameras: High-powered and high-risk. *Communicator.* Retrieved August 6, 2008, from http://www.poynter.org/dg.lts/id.5612/content.content_view.htm

Warley, S. (2004, July 29). *We're losing our audience, but we don't have to.* Retrieved July 29, 2004, from http://www.tvspy.com

Westin, A. (2000). *Best practices for television journalists.* New York: Freedom Forum.

Regulatory Influences and Electronic Media Management

In this chapter you will learn

- How the three branches of the federal government influence U.S. electronic media policy
- Why the FCC is the main regulatory force in the electronic media
- Important FCC rules and regulations that affect the broadcast, cable, and telecommunication industries
- Other federal agencies and departments that influence electronic media policy
- Informal sources of influence on electronic media policy

This chapter examines the regulatory forces that affect electronic media management. You have read about some of these influences in earlier chapters. For example, Chapter 6 referred to equal employment and other labor laws and policies. Chapter 7 alluded to the licensing process for broadcasting and how it establishes the geographical aspects of the market. The discussion of strategic alliances in Chapter 2 illustrated how policy decisions have removed barriers limiting competition and convergence. In this chapter, you will see a more detailed analysis of regulation and policy.

Regulatory influences refers to institutional (e.g., governmental) policies that affect the daily operation and management aspects of an electronic media facility. This chapter examines regulatory influences ranging from agencies such as the Federal

Communications Commission (FCC) and the Federal Trade Commission (FTC) to informal regulatory controls. Throughout, the chapter emphasizes how these regulatory influences affect electronic media managers.

Regulatory Influences: The Federal Government

Historically, the federal government has played a major role in shaping the present electronic media landscape in the United States. The federal government includes the president, the Congress, and the Supreme Court, representing the three branches of government—the executive, legislative, and judicial. Each of these branches plays a role regarding regulation of the electronic media. Each of these areas is discussed in the following sections.

The Executive Branch

The executive branch of the government consists of the executive office of the president and other offices and councils, the departments whose heads form the president's cabinet, and several independent agencies. The president enforces the laws passed by Congress and makes appointments to agencies such as the Federal Communications Commission with the approval of the Senate. By appointing the FCC chairman and other commissioners, the president directly influences electronic media policy. The FCC chairman and two other members of the commission represent the same political party as the president; the minority party holds the other two seats.

The Legislative Branch

The legislative branch is made up of Congress and various administrative agencies. Congress consists of the United States Senate and the House of Representatives, politicians elected by the people they represent in various states and districts. Congress makes, repeals, and amends federal laws, levies taxes, and allocates funds for the entire government.

Media managers monitor congressional actions and administrative agency regulatory activities through several avenues, including trade associations such as the NAB, the NCTA, and the USTA (United States Telephone Association); Washington-based attorneys who represent electronic media owners; and trade publications.

Most regulatory action in Congress that impacts the electronic media begins in the House with the Energy and Commerce Committees and the Telecommunications Subcommittee. In the Senate, the Commerce Committee and Communications Subcommittee are the usual starting points for legislation.

The Judicial Branch The judicial branch of the government consists of the Supreme Court and other federal and district courts. The president appoints justices to the Supreme Court and federal judges, who must be confirmed by the Senate. In both cases, the appointments are for life. The courts interpret the Constitution and federal laws.

There are approximately 95 federal district courts in the United States. Above the district courts are 13 courts of appeals designated as circuit courts. A decision at the district level may be appealed to a circuit court and from the circuit court of appeals to the Supreme Court. Because it would be impossible for the Supreme Court to hear all appeals presented to it, the Court decides which cases to consider during each of its sessions. If the Supreme Court refuses to hear an appeal, the decision of the lower court stands.

Role of State and Local Law

The United States Constitution gives power to the federal government to make laws in areas of national concern, including matters pertaining to communications policy. However, state and local laws regulate certain aspects of electronic media policy in coordination with national policies. Though this chapter focuses on federal policy, wherever state and local laws pertain to the topic (such as cable television and telecommunications regulation) their role is presented as well.

Role of the Federal Communications Commission

Though several federal agencies influence electronic media policy, the FCC exerts the greatest influence (Nadel, 1991). In examining this agency, we first consider the actions that led to its creation.

The FCC: A Brief History

With the passage of the Wireless Ship Act of 1910, the government first recognized the importance of communication for both safety and commerce. Two years later, the Radio Act of 1912 established basic priorities for radio licenses. By the 1920s, radio was flourishing in the United States. Anyone could obtain a radio license through the secretary of commerce, whose office awarded licenses because radio communication crossed state boundaries. But chaos ensued when too many licenses were issued, resulting in overcrowding and technical interference.

Broadcasters attempted self-regulation through a series of national radio conferences held from 1922 to 1926, but they could not reach a consensus. In an unprecedented move by any industry, broadcasters asked the federal government to regulate radio by establishing policies for station licensing and operation. Congress responded by passing the Radio Act of 1927, which created the Federal Radio Commission (FRC). Congress recognized the scarcity principle in its legislation—the idea that more people would want to engage in broadcasting than available frequencies would permit. The 1927 act introduced the PICON principle, which stated that all broadcast licensees had to "serve the public interest, convenience or necessity," a phrase borrowed from the Interstate Commerce Act (Le Duc, 1987). Because a broadcast license represented a scarce resource, the FRC was to ensure that licensees would serve the public interest.

Interestingly, though the FRC was not intended to be a permanent agency, it could not complete its mission in just one year as originally conceived. By the 1930s, with radio thriving as a national medium and television in development, the need for a permanent agency became obvious to regulators. In 1934 Congress passed the Communications Act of 1934, which established the FCC to replace the FRC. The FCC became an independent agency with the power to regulate communication by wire and wireless—including radio, telephone, telegraph, and eventually television, as well as microwave and satellite—transmission.

The Communications Act of 1934 was the cornerstone of electronic media regulation for 62 years. In February 1996, Congress passed a new Telecommunications Act that dramatically altered many regulatory policies affecting the broadcast, cable, and telecommunication industries. The act's primary goals were to promote competition and reduce regulation in order to provide lower prices and better services to consumers and to encourage the growth of new telecommunications technologies (Messere, 2000).

Among the many provisions of the act were several important changes. National ownership limits for radio were removed, while ownership limits for television were raised. Open competition between the cable and telephone industries was stimulated, along with a requirement that television manufacturers include a V-chip device in new receivers to allow blocking out of programs containing sex and violence. The 1996 act retains the FCC as the primary regulatory body for the electronic media.

The Contemporary FCC

The FCC comprises five members, one of whom serves as chairman. Commissioners are appointed for five years and can be reappointed, although only a few commissioners have remained beyond their original term. The FCC continues its efforts to regulate telecommunications, although scholars question if this is possible given the rapid changes in the industry (Entman & Wildman, 1992).

Regardless of criticisms, the commission has responded to changes in the electronic media over the past 30 years. Beginning with the Carter administration in the late 1970s, the FCC entered a period of deregulation, eliminating a number of bureaucratic requirements for radio broadcasters under former chairman Charles Ferris. During the Reagan administration, chairmen Mark Fowler (1981–1987) and Dennis Patrick (1987–1989) further emphasized deregulation. Here are a few of the areas affected during this era.

- *Elimination of the Fairness Doctrine.* The Fairness Doctrine required broadcasters to present both sides of controversial issues (Aufderheide, 1990). Broadcasters for the most part argued that the Fairness Doctrine actually inhibited coverage of controversial topics and violated their First Amendment rights.

- *Community ascertainment requirements.* Broadcasters were once required to gather opinions from leaders in the community they served regarding issues of importance and were expected to offer specific programming (usually as news or public affairs) to address those issues. For broadcasters, ascertainment was a tedious and time-consuming requirement.

- *Programming quotas for news and public affairs.* The FCC eliminated quotas on the amount of news and public affairs programming for broadcast stations.

- *License renewal procedures.* License renewal procedures were greatly streamlined, with the length of license increased for radio and TV stations.

The first Bush administration and FCC chairman Alfred Sikes (1989–1993) advocated further marketplace regulation with a number of additional changes:

- *Elimination of the fin-syn rules.* The financial interest–syndication rules (see Chapter 8) restricted the networks from having a financial interest in the programs they broadcast or from having syndication rights. The rules expired in November 1995.

- *New technology development.* The FCC began serious efforts to develop new communications technologies by encouraging the growth of digital television, *digital audio broadcasting* (DAB), and the participation of telephone companies in distributing video programming.

The Clinton administration took an entrepreneurial approach to communications regulation under chairmen Reed Hundt (1993–1998) and William Kennard (1998–2001). The FCC has dealt with a number of changes in the aftermath of the 1996 act, including review of mergers and acquisitions, establishing a timeline for the transition to digital television, authorization for television duopolies under certain market conditions, and growth and expansion of the Internet. At the same time, the Clinton-appointed FCC frustrated broadcasters with its traditional concerns over television violence, regulations on children's programming, changes in the EEO rules, and the refusal to further modify cross-media ownership of broadcast stations and newspapers.

In 2000 the election of George W. Bush brought the Republican Party back into control of the White House and the FCC. Commissioner Michael Powell (2000–2005) became chairman, followed by Kevin Martin (2005–present). Powell attempted further marketplace reform in regards to ownership and competition policy, but was met by resistance from fellow commissioners, including some in his own party. The FCC under Powell took a tough stance on indecency following the infamous 2004 Super Bowl halftime show, featuring the "wardrobe malfunction" that resulted in singer Janet Jackson's breast being exposed before millions watching the live broadcast. The incident triggered numerous fines for networks and other broadcasters

over indecent material and left doubt concerning what exactly constitutes "indecency" (see Loomis, 2008).

Chairman Kevin Martin's tenure as head of the FCC has been controversial. Martin attempted to further relax ownership rules but was rebuffed except for a December 2007 decision to relax the newspaper and broadcast cross-ownership ban in the top 20 markets based on a variety of conditions. Congress threatened to introduce legislation removing the provision. Martin has also called for à la carte pricing on cable television options, something the cable industry has vehemently rejected, as well as imposing localism standards on broadcasters. There has been a great deal of partisanship within the Martin-FCC with Republican and Democratic members rarely agreeing on any policy.

FCC Regulatory Policies: What the FCC Does

The FCC regulates many activities of electronic media companies by establishing and evaluating policies and procedures. It also has the power to levy fines and forfeitures against these companies. The Media Bureau oversees regulatory activities for broadcasting and cable. The Wireline Competition Bureau oversees the telephone industry, while the Wireless Telecommunications Bureau handles spectrum management and access. The International Bureau addresses satellite issues. The FCC undergoes regular restructuring and organization. The other offices and bureaus that make up the FCC are presented in Figure 11-1. The following sections examine the role of the FCC in regulating the broadcast, cable, and telecommunication industries.

The FCC and Broadcasting

In the broadcast industry, the most visible and important actions of the FCC involve the licensing process. A broadcast license remains a valuable resource, as evidenced by the high prices paid to purchase radio and television stations. The price to purchase an electronic media facility in even small markets can cost millions of dollars. While equipment, land, and other assets do not warrant such high prices, the FCC license represents an invaluable asset to station owners. The license is the key asset owners acquire when they obtain a broadcast station (Bagdikian, 1997).

The FCC grants and renews licenses, but it also can take them away—something that has happened infrequently in broadcast history (see *KFKB Broadcasting Association, Inc. v. FRC*, 1931; Le Duc, 1987; *Office of Communication of the United Church of*

FIGURE 11-1 Federal Communications Commission Organization. SOURCE: *Federal Communications Commission, www.fcc.gov*

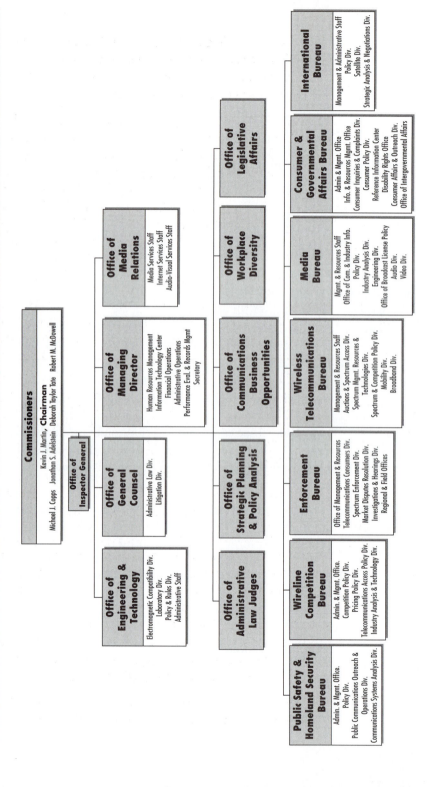

Christ [UCC] v. FCC, 1966). The FCC also approves the transfer of a broadcast license—the actual sale of a radio or television station to a new owner. Here are some of the most important FCC licensing policies that managers need to be aware of.

- *Ownership limits.* Historically, the FCC has established limits on the number of stations an individual or company may own. The 1996 Telecommunications Act eliminated national ownership limits for radio. In local markets, the number of radio stations an individual or group may control is affected by the market size and by the number of television stations owned by the same individual or group. For the television industry, no individual or group may own stations that collectively reach more than 39 percent of the national audience. The 39 percent cap was a compromise reached in 2003, after the FCC originally tried to increase the cap to 45 percent.

- *Duopoly and triopoly rules.* In 1999 the commission approved common ownership of two television stations in the same market provided eight stations (commercial and noncommercial) remained post merger. Further, no duopoly is allowed among the top four stations in the market in terms of audience share. The duopoly rule also impacts cross-ownership of other media. If two television stations are owned in the same market, it reduces the number of radio stations the same owner may hold depending on the market size and number of stations (Federal Communications Commission, August 1999). In 2003, the FCC allowed *triopolies* or ownership of three stations in a market provided there were at least 18 TV stations in the market, with only one of the three stations rated among the four highest in the market.

- *Local marketing agreements (LMAs).* LMAs were first established during the early 1990s in radio and later spread to television. LMAs allow one station to take over the programming and advertising sales for another station in the market without assuming ownership of the facility. The FCC made several minor changes to LMA policies in 1999 at the same time that it made changes in regulations regarding television duopolies. The most important change was that most existing LMAs would be allowed to become TV duopolies. Note that the term Joint Services Agreement (JSA) is also used instead of LMA.

- *License renewal.* Broadcast licenses for both TV and radio stations were extended to eight years under the 1996 act. The FCC

also eliminated certain procedures for challenging a license renewal.

- *EEO guidelines.* The most recent EEO guidelines adopted by the commission occurred in 2002. The current guidelines requires broadcasters and *multichannel video program distributors* (MVPDs or cable and satellite operators) to widely distribute information on full-time vacancies, provide notice of vacancies to recruitment organizations requesting notices, and engage in long-term recruiting initiatives such as job fairs, scholarships, or internship programs to inform the public about employment opportunities. The FCC also requires recordkeeping and reporting requirements related to EEO initiatives. Full details are available at the FCC's Web site, http://www.fcc.gov (Federal Communications Commission, 2002).

- *Cross-ownership rules.* The 1996 act allows broadcast stations to acquire cable systems, and cable operators may acquire broadcast stations but not broadcast networks. However, in March 2001 the Powell FCC decided to allow Viacom to own both CBS and UPN. In 2007 the FCC liberalized cross-ownership restrictions in regards to newspaper-TV cross-ownership, but limited it to the top 20 markets.

- *Transition to digital television.* The 1996 act requires existing analog stations to convert to digital television (DTV) transmission and move to a new digital channel by February 2009 (see Chapter 13). A key unresolved issue regards must carry of broadcasters' digital channels; so far the Commission has not required MVPDs to carry additional digital channels. With over 90 percent of American households receiving service from a cable, satellite or telco distributor, this is a huge problem as these new channels will go unseen unless consumers adopt a terrestrial-based antenna in addition to their MVPD subscription.

- *Public file.* All broadcast stations must maintain certain documents and information in a file available for public inspection during regular business hours. Stations must also handle telephone requests for information from the public file during regular business hours. Major documents required in the public file are listed in Table 11-1.

- *Operating and technical requirements.* As part of their license obligations, all broadcast stations must follow strict operating

TABLE 11-1

Public File Contents

Broadcast stations are required to maintain several types of information in the public file, in either paper or electronic form. The amount of time required to retain each item varies, depending on the length of the license term, except where indicated.

1. FCC applications, ownership documents, written agreements with community groups, annual employment reports (FCC Form 397 Statement of Compliance), and related EEO information.

2. The most recent version of the FCC publication *The Public and Broadcasting—A Procedure Manual*. Should be retained indefinitely.

3. Correspondence regarding requests for political time and information on any controversial programming.

4. A list of community issues and programs that have been afforded significant treatment by the station.

5. Letters and written comments from the public regarding station programming and other issues. Defamatory or obscene material should not be included, nor letters the authors have asked to be restricted from public access.

6. Quarterly report listing compliance with commercial limits on children's programming and a list of programs detailing the station's commitment to educational needs of children (FCC Form 398 for TV stations only).

SOURCE: Adapted from P. K. Pringle, M. F. Starr, and W. E. McCavitt, Electronic Media Management, 4th ed. (Boston: Focal Press, 1999); and Federal Communications Commission Web site (www.fcc.gov).

guidelines. The license specifies the channel for operation, transmitter power, hours of broadcasting, maintenance of antenna and tower lights, proper station identification, and compliance with the nationwide Emergency Alert System (EAS). Failure to follow these standards can result in fines for the owner.

- *V-chip requirements.* The 1996 act mandated that new television receivers must be equipped with a V-chip (short for *violence chip*) to be used in conjunction with a ratings system for television programming (see Table 11-2) that would give parents the option to block out unwanted programs. After years of deliberations on implementation and a timetable for production, the first sets equipped with the V-chip became available in January 2000.

TABLE 11-2

Voluntary Programming Code Ratings

CONTENT RATINGS	
FV	Fantasy Violence
V	Violence
S	Sexual Situations
L	Coarse Language
D	Suggestive Dialogue

AGE RATINGS	
TV-Y	Programs Created Solely for Children
TV-Y7	Directed to Older Children
TV-G	General Audiences
TV-PG	Parental Guidance Suggested
TV-14	Parents Strongly Cautioned
TV-MA	Mature Audiences Only

The FCC and Programming Policies

Another visible area of FCC policy concerns broadcast programming. Although the FCC lets broadcasters determine the types of programming to broadcast, the commission has adopted several policies that directly influence programming at local stations, such as the following:

- *Children's television programming.* The FCC has long been concerned with how broadcast programming meets the needs of children. Over the years the FCC has adopted several policies requiring broadcasters to provide responsible content. Congress passed the Children's Television Act (CTA) in 1991, with the commission adopting new rules in 1996 to strengthen enforcement (Federal Communications Commission, August 1996). The act requires broadcasters to provide at least three hours of core programming a week for children ages 12 and under.

 The FCC defines core programming as any regularly scheduled weekly programming of at least 30 minutes, airing between 7:00 A.M. and 10:00 P.M., that has serving the "educational and informational needs of children as a significant purpose" (Federal Communications Commission, August, 1996). Further, the rules require broadcasters to place quarterly programming reports in their public file on a quarterly basis, describing how they meet their obligations under the CTA. Stations are also required to file

an annual Children's Television Programming Report using FCC Form 398.

The act also imposes limitations on the amount of commercial time in children's programming to 10.5 minutes an hour on weekends and 12 minutes an hour on weekdays (Children's Television Act of 1990; Policies and Rules Concerning Children's Television Programming, 1993).

- *Television ratings system.* The prime-time television ratings system was established by the FCC following passage of the 1996 act. Networks were asked to voluntarily label their programs with codes for sex, violence, and dialogue (language) (see Table 11-2). News and sports programs are not rated. NBC initially refused to participate in the system but eventually gave in.

- *Obscenity.* Broadcasting obscene material is against the law. *Obscene material* is defined in Supreme Court's *Miller v. California* (1973). The material in question must meet three criteria: (1) The average person, applying contemporary community standards, finds that the work as a whole appeals to prurient interests; (2) the work depicts or describes in an offensive way sexual conduct specifically defined by the applicable state law; and (3) the work lacks serious literary, artistic, political, or scientific value (also called the LAPS test). By and large, broadcasters avoid any programming that one might consider obscene.

- *Indecency.* While indecent speech is protected under the First Amendment, it can be regulated. For many years, the *Pacifica* ruling regarding George Carlin's "seven dirty words" monologue served as the model of indecent speech (*FCC v. Pacifica Foundation,* 1978). In 1987 the FCC issued a new definition of indecent language: "language or material that depicts or describes, in terms patently offensive as measured by contemporary community standards for the broadcast medium, sexual, or excretory activities or organs" (New Indecency Enforcement Standards, 1987). The new standard became very controversial because it failed to clearly address the types of material that were prohibited, the hours the material could be broadcast, or the specific penalties for violation.

 In the years following the *Pacifica* decision, the FCC adopted several provisions that permitted the airing of indecent programming during certain hours, a time period that became known as

a "safe harbor." However, the courts repeatedly struck down the FCC limitations as unconstitutional. Resolution came in 1995 when the U.S. Court of Appeals ruled the commission could permit broadcasting of indecent material between the hours of 10:00 P.M. and 6:00 A.M. (*Action for Children's Television v. FCC, 1995*).

The 2004 Super Bowl halftime show again brought the question of indecent content to the forefront, with Viacom being fined for broadcasting the breast-baring incident. Viacom challenged the fine and asked for clear definitions from the courts as to what is indecent content. After years of controversy, the Supreme Court will take up the issue of indecency in 2008, hopefully bringing a conclusion to one of the most confusing standards in media regulation. Loomis (2008) offers an interesting study on GM reactions to the indecency controversy.

- *Equal time provisions (Section 315)*. Section 315 of the 1934 Communications Act requires broadcasters to provide equal broadcast time for all legally qualified candidates for public office. Today the rule primarily applies to political advertising. Participation by candidates in a newscast, politically sponsored debate, or other bona fide news event is exempt from the rule. The rule specifies that stations must sell political advertising at the *lowest-unit-rate* (LUR) charge to qualified candidates. Some networks and local broadcasters may voluntarily offer prime-time advertising (usually up to a five-minute block) to legally qualified candidates for president.

- *Broadcasting a hoax*. On-air hoaxes have long been associated with the radio industry, dating back to the 1938 CBS broadcast of *War of the Worlds,* which caused panic among many listeners. In most cases, hoaxes have been presented with no harm intended. In 1992 the FCC issued new rules regarding on-air hoaxes (Broadcast Hoaxes, 1992). Essentially, the new rules forbid broadcasting of false information if three criteria apply: (1) The sender knows the information is false, (2) the broadcast of the hoax may cause public harm, and (3) broadcasting the information does in fact cause harm. Stations guilty of broadcasting a hoax can be fined up to $10,000.

- *Lotteries*. Broadcasters may not broadcast or sponsor a commercial lottery. Managers should be particularly concerned about promotional contests and campaigns that unintentionally carry the three

elements that constitute a lottery—prize, chance, and consideration. Any contest or other activity that requires an individual to pay some sort of fee (consideration) that provides an opportunity to be selected (chance) for some award of value (prize) constitutes an illegal lottery and is subject to a fine. The lone exception to broadcasting lotteries concerns those states with voter-approved lotteries, where licensees may carry announcements and advertisements for legal state lotteries.

The FCC and Cable Television

Regulation of the cable industry differs greatly from that of broadcasting. Cable operators do not obtain a license from the FCC; instead, they are awarded a **franchise** from a local governmental authority. The franchise agreement sets forth the requirements for each local cable system regarding fees, channels, and so forth. For many years, cable franchises were considered exclusive arrangements, giving cable operators monopolistic power. In passing the Cable Television Consumer Protection and Competition Act (1992), however, Congress eliminated exclusive franchising in the cable industry.

The 1992 Cable Act was designed to reregulate the cable industry in several specific areas, including rates for basic cable service (Johnson, 1994). Cable was effectively deregulated in 1984 with the passage of the Cable Television Communications Act. However, as cable rates soared and customer service declined under deregulation, citizens pressured Congress to act.

The 1996 Telecommunications Act also affected the cable industry. Among the major provisions were the following:

- *Rate regulation for basic cable.* National rate regulation for basic cable was eliminated in 1999. The cable operator establishes local rates, subject to the approval of the franchising authority. In many cases, the cable operator and the franchising authority negotiate rate increases.

- *Must carry/retransmission consent.* This provision gives broadcasters the right to negotiate with the cable operator for carriage of their station. TV stations now have one of two options. First, broadcasters can take **must carry**, which requires the cable operator to carry the television signal on the cable system at the channel's regular or mutually agreed-on channel position. Second, broadcasters may opt for **retransmission consent** in lieu of must carry and thus negotiate individually with each cable system for

compensation and channel position. The chosen option is to be renewed every three years. Most TV broadcasters initially opted for must carry, but more and more stations are negotiating retransmission consent to obtain a new revenue stream. Must carry was challenged all the way to the Supreme Court, and the Court upheld the policy.

- *Ownership provisions*. Previously, the FCC adopted a 30 percent audience reach cap, meaning a cable operator may serve no more than 30 percent of all multichannel households (defined as national cable and satellite TVHH). In March 2001, the courts ruled that the 30 percent cap was arbitrary and capricious and effectively eliminated any cap requirement for cable television ownership (Dreazen & Solomon, 2001). Since this decision, no further action has occurred to set limits on cable system ownership, although cable operators question the constitutionality of a limit.

- *Network exclusivity*. Cable operators may neither carry nor import network-affiliated programming that duplicates the same program on a local TV station. For example, a cable operator in Washington, D.C. may not import programming from a network affiliate in Baltimore; the station must provide the local network affiliates with program exclusivity.

- *Syndication exclusivity (syndex)*. Local television stations pay high prices for syndicated programs; therefore, they want assurance that their programs will not be duplicated. The station must first engage in an exclusive market arrangement with the distributor. Once that contract is negotiated, the station must notify the cable operator, who must block out any programs in question. Syndex also applies to satellite distributors, and there have been many local stations who have challenged satellite operators for violation of the rule.

- *Program access channels*. The 1984 Cable Act established the right of franchising bodies to require that certain channels be designated for public, educational, or governmental access. PEG channels are not under the jurisdiction of the cable operator. In fact, because the operator may not censor or edit any of the material presented on the PEG channels, controversy has arisen in some communities. In 1995 a federal appeals court ruled that cable operators may place explicit public access programming on so-called

"blocked" channels, which would require individual households to notify the cable operator if they wished to receive the programming (Pearl, 1995).

The FCC and Telephone Regulation

Telephone regulation is an extremely complicated process because of different jurisdictional boundaries and market segments. It involves numerous services regulated at both the state and national levels.

The long-distance or interexchange market is overseen by the FCC's Wireline Bureau. Most regulatory activity concerns rate regulation. Historically, telephone companies were regulated under a **rate-of-return (ROR)** framework, meaning that rates were set at levels needed to produce enough revenues to cover total costs. Over time, ROR regulations did little to encourage new products or expansion in the telecommunications industry, so the FCC began to use a different method, known as *price caps,* to regulate interexchange carriers (Shields, 1991).

First introduced in 1989, **price cap regulation** limits the prices companies can charge, rather than regulating profits. This change allows companies greater flexibility in dealing with competitors and promotes greater efficiency. To maximize profits, managers attempt to streamline production activities to lower costs below established prices. Price cap regulation has benefited consumers as the cost of long-distance service has declined for several years.

Local exchange providers (LECs) are regulated in tandem by the FCC and individual states. Because the LECs derive most of their revenues from intrastate services, most importance is placed at the state level. State **Public Utility Commissions (PUCs)** or **public service commissions (PSCs)** oversee rate regulation of local telephone service within the 50 states, as well as the charges associated with ancillary services such as caller ID. Some states use ROR regulation, while others have adopted price caps. To raise tariffs and telephone rates, LECs must file requests with the appropriate state regulator for approval.

The 1996 act was designed to spur competition among local and long-distance carriers by allowing entry into each other's markets and also to allow cable companies the opportunity to provide local telephone service. But the regulation empowered the FCC to formulate specific policies regarding market entry into competitive markets. Before local exchange carriers could provide long-distance

services, they had to meet an exhaustive 14-point checklist that illustrated efforts to open the local market they served to competition.

Early in 2000, these goals were far from being realized. Bell Atlantic, later known as Verizon, was the first local carrier authorized to provide long-distance service. SBC, now known as AT&T, became the second of the former "Baby Bells" to offer long distance. Long-distance carriers have had difficulty in marketing local service, especially with the wide adoption of cellular plans that feature free long distance. Comcast, Time Warner, and Cox have been the most successful cable companies to provide local competing telephone service.

The 1996 Act led to greater consolidation in the telecommunications sector. Since passage of the act, several mergers have occurred involving a number of firms. AT&T (formerly SBC Corporation) and Verizon have been the most aggressive. AT&T acquired Pacific Telesis, Ameritech, Southern New England Telecommunications (SNET), Bell South, and SBC; Bell Atlantic acquired NYNEX and GTE and was renamed Verizon. Qwest Communications acquired U.S. West.

The telecommunications sector continues to address technological change as carriers seek to become the dominant provider of communication-related services (voice, broadband, data wireless, fiber optics and Internet telephony or VOIP) for business and home. Telcos compete with cable and satellite operators and terrestrial broadcasters, as well as with Internet service providers, to establish and build on market share. Regulating the changing and competitive telecommunications landscape will remain a challenge in the years ahead.

Other Federal Departments and Agencies

While the FCC is the federal agency that most affects electronic media policy and regulation, other federal departments and agencies also directly influence regulatory action (Nadel, 1991). This section offers an examination of other such departments and agencies.

Department of Justice The Department of Justice (DOJ), through its Antitrust Division, is concerned with anticompetitive practices in American industries, including the electronic media and telecommunication industries.

The DOJ has been called on several times in recent years to gauge the impact of mergers and acquisitions in the media industries, particularly to determine if such actions would be in the public interest.

For example, the Antitrust Division investigated the mergers of Viacom and CBS, AOL and Time Warner, and XM and Sirius to name a few examples. The agency gained considerable recognition with its high-profile lawsuit against Microsoft. Because broadcast stations are federally licensed, the DOJ also has the power to prosecute violators of the Communications Act. The department concerns itself with flagrant violations rather than routine levies and fines, which the FCC administers.

Federal Trade Commission The Federal Trade Commission oversees advertising regulation in the United States. Because the electronic media depend on advertising for their survival, managers need an awareness of FTC duties and jurisdiction. Essentially, the FTC investigates false or deceptive advertising as well as unfair trade practices.

Advertising regulation also falls under the jurisdiction of other federal agencies and departments, including the Food and Drug Administration, the U.S. Postal Service, the FCC, and the Securities and Exchange Commission (Vivian, 1999). In addition, many states have laws pertaining to deceptive or false advertising. The FTC maintains a strong interest in advertising aimed at children and has been granted authority to oversee Internet advertising.

National Telecommunications and Information Administration Operating within the Department of Commerce, the National Telecommunications and Information Administration (NTIA) serves primarily to advise the president on telecommunication issues. The NTIA was particularly active during the 1990s, recommending that telephone companies be allowed to provide video services and pushing the development of HD television in the United States, but less active in the twenty-first century.

Federal Aviation Administration Given the number of transmitting towers spread across the country and their potential risk to aviators, the Federal Aviation Administration (FAA) has a vested interest in the electronic media. Broadcast stations face tough fines for failure to maintain proper lighting of towers and antennas. Checking the tower light remains a daily operator function at all broadcast stations.

Informal Regulatory Forces

Through its various branches and agencies, the federal government is the primary regulatory body affecting the electronic media. State and local laws also play a role in regulation. In addition, informal regulatory forces also affect electronic media management. This section examines three areas of regulatory influence that lie beyond governmental boundaries: consumer groups, self-regulation, and the press.

Consumer Groups Though the Communications Act of 1934 established the importance of serving the public interest, a landmark case was needed to demonstrate that the public has the right to participate in regulatory proceedings. During the early 1960s, WLBT-TV in Jackson, Mississippi, was accused of discriminating against blacks in several areas, including refusing to sell political advertising to a local black candidate for public office (Kahn, 1984). Local groups fought the station's license renewal with legal assistance from the United Church of Christ (*Office of Communication of the UCC v. FCC*, 1966). The case dragged on for over 20 years, with the circuit court of appeals ruling in favor of the UCC petition to deny WLBT's license. Ultimately, the case established the concept of *citizen's standing*, meaning the public had the right to challenge broadcasters at renewal proceedings.

The WLBT case spawned a period of activism by citizen groups toward broadcasters. This included challenging license renewals as well as establishing media watchdog groups like Action for Children's Television (ACT). Other groups have targeted certain types of programming, advertising, and employment practices in their protests and boycotts. Consumer groups like the Consumers Union regularly challenge rate increases for cable and telecommunication services. Electronic media managers are always concerned about the impact of consumer groups and the possibility of more regulation by governmental bodies. The heavy consolidation within the media industries has rekindled several consumer groups advocating more diversity and lessening media control by major corporations.

Self-Regulation To limit possible governmental involvement, the electronic media industries engage in various types of self-regulation. For many years, radio and television stations voluntarily operated under the NAB

Codes, which specified various rules regarding programming, advertising, and promotional activities. The Justice Department challenged the codes in 1979, claiming they limited competition for advertising prices and other charges. In a 1982 settlement, the NAB Codes were eliminated.

Overall, broadcasters and cable operators take rather conservative positions regarding material that could be deemed controversial or cause public concern. Stations routinely scrutinize advertising messages and have been known to refuse commercials considered controversial. At the network level, program standards and practices departments still serve as watchdogs over network advertising and programming. Codes of ethics and conduct also influence self-regulation. These codes are discussed more fully in Chapter 3.

The Press Most major newspapers in the United States used to employ at least one media critic devoted to the electronic media, but employment cuts and downsizing have eliminated many of these positions across the country (Guthrie, 2008). Magazines, trade publications, the Internet, and numerous blogs provide forums for reviews. Criticism by the press and other agents helps not only to enlighten the public but also serves as a system of informal control.

Broadcast and cable operators are usually praised when they do something well, such as providing coverage of important news events or presenting programs that educate and enlighten the public. At the same time, critics admonish the media for promoting questionable or tasteless programming and violating their ethical and journalistic responsibilities.

Summary

Regulatory influences occur at many levels and take different forms among the electronic media. Through its executive, legislative, and judicial branches, the federal government provides the main sources of regulatory influence in various departments and agencies.

The greatest single source of regulatory influence is the Federal Communications Commission. Created by the Communications Act of 1934, the FCC regulates the broadcasting, cable, and telecommunications industries in coordination with state and local agencies.

The FCC consists of five members appointed by the President of the United States.

In the broadcasting industry, the FCC specifies criteria for broadcast licensing and ownership, along with a variety of technical and operating requirements. It also deals with a number of programming policies, including provisions for children's programming, obscene and indecent language, equal time, prime-time access, financial interest and syndication, and broadcasting of hoaxes and lotteries.

In the cable industry, the FCC regulates rates for basic service, in tandem with local franchise authorities. The commission also oversees policies in regard to must carry/retransmission consent agreements, program and syndication exclusivity, and access channels.

The FCC and individual states regulate the telecommunications industry through *public utility commissions* (PUCs) or public service commissions (PSCs). Most regulatory action concerns rate regulation. Policy makers have used rate-of-return policies along with price caps to regulate the costs of telecommunication services.

Aside from the FCC, other federal departments influence regulation. These include the Department of Justice's Antitrust Division, the Federal Trade Commission, the National Telecommunications and Information Administration, and the Federal Aviation Administration, which is concerned with broadcast and cable towers and their potential threat to aviators.

Informal regulatory influences on electronic media policy come from citizen and consumer groups, self-regulatory efforts, and criticism in the press, the Internet, and other venues.

CASE STUDY	Is It a Hoax?

Doug Graves, Julie Morrow, and Tim Sanchez host the popular "morning crew" program airing on WBCV-FM, a top-20 urban radio station located in the Northeast. The morning crew's reputation for outrageous stunts and jokes on the audience and key figures was common throughout the market. Particularly adept at doing a range of impersonations, Graves would often call unsuspecting audience members and imitate politicians and well-known actors such as Tom Cruise and Jack Nicholson.

With Halloween approaching, the morning crew decided on a skit which later proved to be damaging to the station. The crew was scheduled to do

a live evening broadcast on Halloween night at a downtown dance club's grand opening. Violence was all too common in the city, so the morning crew decided to have Graves "seriously wounded" as a result of a drive-by shooting, to play a trick on the audience. The team decided not to tell the station's Program Director about their skit, so he would be part of the joke as well. A number of sound effects were recorded in advance along with sirens, crowd noise, and other techniques to provide a realistic incident for the listening audience.

Morrow and Sanchez would continue to broadcast live from the scene, reporting on other events following the "shooting." About 30 minutes later, they would interview a "police official," played by Graves. A series of questions would determine that the fake police officer was actually Graves, that there had in fact been no shooting, and that everyone was fine. Having been "tricked," WBCV listeners could then call in for a variety of "treats" to be given away on-air to wrap up the remote.

The incident went off as planned, with some unexpected consequences. Numerous listeners proceeded to the downtown area to get a firsthand look at the crime scene. Traffic jams occurred at several major intersections, and three people were injured in separate auto accidents directly related to the incident. Many listeners hearing about the "shooting" flooded switchboards at the radio station, the police station, and local hospitals to try to find out information on Graves' condition. After it was over, the station received angry phone calls from listeners all night. The next day, several local officials threatened to notify the FCC. Only a handful of listeners found the broadcast amusing.

Is WBCV-FM guilty of playing a hoax on the audience? How would you, as the manager of the station, handle this problem? Would you report this incident to the FCC? Why or why not?

CASE STUDY **Political Advertising**

A heated race for a congressional seat was coming to an end with the election less than 10 weeks away. Three legally qualified candidates, a Democrat (Kerry Childers), a Republican (Joe Welch), and an Independent (Bart Bergman) were bitterly divided on several issues, including gun control, education, and homeland security. But the major issue dividing the candidates—and voters—was abortion.

As the only female candidate, Childers unconditionally supported abortion rights for women and garnered support from all the pro-abortion groups.

Welch believed in pro-choice but felt the local and national government should not be expected to fund abortions in any way. Bergman is a strong pro-life supporter, and his campaign had the support of all of the pro-life groups.

Five local stations serve the market, four network affiliates and one public station. You manage the smallest station, the former independent station in the market now affiliated with the WB network. The three other network affiliates garner the greatest share of political advertising, and they sold time to all three candidates. But the Bergman advertising was especially controversial, as it featured gruesome pictures of aborted fetuses. Under the political advertising guidelines, the stations cannot censor the ads, regardless of how offensive they may be.

At a midday staff meeting, Sarah Turner, the General Sales Manager, informs the department heads the Bergman group has requested advertising time on the station. "What do we do?" said Turner. "Technically, we don't have to sell advertising to Bergman's campaign, as we have not sold any advertising to the other congressional candidates. Personally, I don't want to offend our viewers and other clients as the other stations in the market have done by showing these controversial spots."

Jason Margolies, the Program Manager, spoke up. "But isn't this part of our public service responsibility—to help voters decide on who to vote for in the election? I think we have an obligation here, regardless of the concern over the content. How can we not run these ads?" Promotions Manager Julie Lewis expressed fear that the ads would hurt the audience more than they would help. "What are we supposed to tell the parents who call the station complaining about the ads and their impact on their children?"

Ultimately, the department heads failed to reach a consensus. Take the role of the General Manager in this case, carefully examine the issues and consequences, and make a decision as to whether or not your station will accept these controversial advertisements.

References for Chapter 11

Action for Children's Television v. Federal Communications Commission, 58 F.3d 654 (D.C. Cir. 1995).

Aufderheide, P. (1990). After the fairness doctrine: Controversial broadcast programming and the public interest. *Journal of Communication, 40*(3), 47–72.

Bagdikian, B. (1997). *The media monopoly* (5th ed.). Boston: Beacon Press.

Broadcast hoaxes, 70 RR 2d 1383 (1992).

Cable Television Consumer Protection and Competition Act, 47 U.S.C.A. Sec. 521 et seq. (1992).

Children's Television Act of 1990, 47 U.S.C. Sec. 303 (a)-3(b) (Supp. II 1991).

Dreazen, Y. J., & Solomon, D. (2001, March 5). Court overturns FCC's ownership caps, in victory for AT&T, AOL, cable firms. *Wall Street Journal,* pp. A3, A10.

Entman, R. M., & Wildman, S. S. (1992). Reconciling economic and non-economic perspectives on media policy: Transcending the "market-place of ideas." *Journal of Communication, 40*(3), 47–72.

Federal Communications Commission. (1996, August 8). *FCC adopts new children's TV rules.* Retrieved May 31, 2000, from http://www.fcc.gov/Mass_Media/News_Releases/1996/nrmm6021.html

Federal Communications Commission. (1999, June). *The public and broad-casting.* Retrieved December 23, 2004, from http://www.fcc.gov/mb/audio/decdoc/public_and_broadcasting.html#PIF

Federal Communications Commission. (1999, August 5). *FCC revises lo-cal television ownership rules.* Retrieved August 11, 1999, from http://www.fcc.gov/Mass_Media/News_Releases/1999/nrmm9019.html

Federal Communications Commission.. (2002) *Broadcast and cable EEO rules and policies.* Retrieved September 29, 2004, from http://www.fcc.gov/cgb/consumerfacts/EEORules.html

Federal Communications Commission v. Pacifica Foundation, 438 U.S. 726 (1978).

Guthrie, M. (2008, April 7). The disappearing TV critic. *Broadcasting & Cable,* 10-12.

Johnson, L. L. (1994). *Toward competition in cable television.* Cambridge, MA: MIT Press.

Kahn, F. (1984). *Documents of American broadcasting* (4th ed.). New York: Prentice Hall.

KFKB Broadcasting Association, Inc. v. Federal Radio Commission, 47 F.2d 670 (D.C. Cir. 1931).

Le Duc, D. (1987). *Beyond broadcasting: Patterns in policy and law* (2nd ed.). New York: Longman.

Loomis, K. D. (2008). The FCC and indecency: Local television general managers' perceptions. *The International Journal on Media Manage-ment, 10*(2), 47-63.

Messere, F. (2000, April). NAB Telecommunications Act 1996 update. Pre-sentation to the Broadcast Education Association, Las Vegas.

Miller v. California, 413 U.S. 15 (1973).

Nadel, M. S. (1991). U.S. communications policymaking: Who and where? *Comm/Ent Law Journal, 13*(2), 273–323.

New indecency enforcement standards to be applied to all broadcast and amateur radio licenses, 2 FCC Rcd. 2726 (1987).

Office of Communication of the United Church of Christ v. Federal Communications Commission, 359 F.2d 994 (D.C. Cir. 1966).

Pearl, D. (1995, June 7). Cable TV systems cleared to block "indecent" material. *The Wall Street Journal,* p. B4.

Policies and rules concerning children's television programming, FCC LEXIS 987 (1993).

Shields, P. (1991). The politics of the telecommunications policy process: The example of the FCC's price cap initiative. *Policy Studies Journal, 19*(3/4), 495–513.

Vivian, J. (1999). *The media of mass communication* (5th ed.). Needham Heights, MA: Allyn & Bacon.

Electronic Media Management: The Role of Public Relations

In this chapter you will learn

- What public relations is and the role it plays in the electronic media industry
- The different publics that are important to electronic media organizations
- Ways managers engage public relations
- Different public relations activities designed to build a favorable identity in the community
- Controversial issues that require the use of public relations

Professionals in the electronic media industry continuously interact with groups of people representing different interests. These groups include audiences, advertisers, stockholders, employees, other businesses, governmental agencies, civic organizations, and nonprofit institutions, to name a few. In the field of *public relations* (PR), these groups are referred to as **publics**. Electronic media managers recognize that their operations constantly involve public relations. But what do we mean by public relations? The phrase *public relations* is used in many ways. People sometimes misuse it to explain good or bad behavior on the part of individuals or organizations ("That's bad PR."). This chapter centers on the formal management functions of public relations: the conscious attempt by an organization to improve its standing or image with publics by enhancing their understanding of the organization.

The Public Relations Society of America (PRSA), a national organization of public relations professionals, offers this definition for PR: "Public relations helps an organization and its publics mutually adapt to each other" (Public Relations Society of America Foundation, 1991, p. 2). This definition encompasses the important functions of research, planning, communication, and evaluation used by PR professionals (Pavlik, 1987). The PRSA uses the term "organization" to keep from limiting the scope of its definition. Finally, the use of the word *publics* recognizes that organizations deal with multiple groups "from which they must earn consent and support" (Public Relations Society of America Foundation, 1991, p. 2).

This chapter examines the role of public relations by focusing on its importance in management and then moving to a discussion of how the electronic media industries interact with different publics. Later sections explore how managers use public relations to maintain an identity in the market and the types of controversial public issues electronic media managers often encounter.

The Importance of Public Relations

Organizations use public relations in many ways to gain the support of various publics. The PRSA identifies 14 activities that represent the broad range of responsibilities commonly associated with PR professionals (Newsom, Turk, & Kruckeberg, 2004; Public Relations Society of America Foundation, 1991):

- *Press agentry*. Dealing with the planning of activities and events.

- *Promotion*. Garnering support or favorable public opinion for a person, product, organization, or cause.

- *Publicity*. Disseminating planned messages through other media without payment, that is, time and space afforded by other media with no cost to the organization.

- *Public affairs*. Assisting the organization in analyzing and meeting public expectations, also serves to develop effective involvement in public policy.

- *Research*. The foundation of all public relations activities.

- *Graphics*. Conveying information through visually oriented messages.

- *Advertising*. Paying for time or space acquired in other media to promote an organization.

- *Marketing*. Building consumer-driven strategies based on product, place, price, and promotion.

- *Integrated marketing communications*. Unifying communications from an organization so they are consistent. IMC began developing in the 1990s.

- *Government relations*. Dealing with policymakers and regulatory bodies on behalf of an organization. Also involves lobbying of elected officials when necessary.

- *Financial public relations*. Creating and maintaining the confidence of investors and building relationships with the financial community (e.g., banks, lenders). Used by publicly held companies.

- *Community relations*. Activities designed to maintain and enhance the important relationship between the organization and the local community.

- *Industry relations*. Coordinating activities with other firms and trade associations within a particular industry.

- *Minority relations*. Building and maintaining relationships with individuals and minority publics through various activities.

- *Media relations*. Seeking publicity or responding to requests or interest in an organization.

- *Propaganda*. Influencing the opinions of a public in order to propagate a specific doctrine.

Who Handles Public Relations? Public relations activities may either be handled by an in-house department or coordinated by an independent PR firm. In an electronic media facility, most PR activities at the corporate level usually involve both approaches, especially for special projects and major events. Some corporations retain a professional firm for assistance on a regular basis (Kinkead & Winokur, 1992). Much like an attorney advises a client regarding legal implications, PR firms advise an organization about the public ramifications of organizational decisions.

At the local level, many electronic media firms normally handle public relations in-house. Public relations responsibilities tend to be assigned to the Promotion or Community Services Department; larger operations may have a separate PR unit. In smaller operations, PR responsibilities usually are coordinated by the General Manager. However, all personnel in an electronic media facility should understand the importance of public relations and that every employee serves as a representative of the station, regardless of position or title. Individuals or departments engaged in PR usually report to the General Manager, who serves as the figurehead for the organization. This chapter emphasizes local public relations activities and those in which managers play a major role.

Public Relations and Public Opinion

Public relations and public opinion go hand in hand. Public opinion is difficult to gauge; sometimes positive public opinion occurs naturally, while other times not as effortlessly. Depending on external circumstances, public opinion can change dramatically. You can probably recall several public relations disasters over the past few years such as the accounting scandals at Enron and WorldCom, the reporting scandals at the *New York Times*, and controversy over the Abu Ghraib prison photos released during the Iraq War. In each of these cases, the organizations involved had to try to rebuild public opinion through public relations efforts. Successful PR promotes favorable public opinion.

The electronic media industry functions in an open environment, with almost every action visible to the public. The pervasiveness of electronic media means that just about every person has opinions and attitudes about programs, personalities, and other aspects. To an electronic media manager, a positive image conveyed through successful public relations techniques helps to increase audience ratings, advertising billings, credibility, and goodwill.

How Managers Use Public Relations

The PRSA identifies eight ways that PR helps managers achieve their goals (Public Relations Society of America Foundation, 1991). The following list presents these ideas and applies them to the electronic media.

- *PR promotes the sale of products and services.* In tandem with publicity and promotional functions, PR efforts influence both audiences to consume programs and advertisers to purchase time.

Integrated marketing, involving PR, publicity, and advertising, helps accomplish these goals.

- *PR helps build morale, enhance productivity, and create a team spirit.* PR helps promote internal motivation among employees, aids in the retention of existing employees, and supports recruitment of new people. The competition inherent in the electronic media is made easier by employees working together to achieve common goals.

- *PR provides management with an early warning system.* Through its involvement with various publics, PR helps to keep managers aware of pending social and political happenings, enabling them to be more responsive to change. Departments that regularly encounter people outside the station (such as sales, programming, and promotions) are among the first to recognize changes.

- *PR provides new opportunities for organizations.* Because they interact with the greatest number of internal and external publics, PR personnel can identify new ideas, new markets, and new methods of solving problems.

- *PR efforts help to protect the present position when an organization is attacked.* Electronic media managers are often confronted by different publics about programming, advertising, or news stories. Public relations activities help to minimize or negate any impact on the firm's bottom line until a negative situation can be resolved.

- *PR helps prevent executive isolation.* Though not a common problem for many EM managers, PR forces managers to interact with not only various publics but also to remain aware of what is happening both within and outside of an organization.

- *PR helps organizations manage change.* Change can be threatening to an organization, and the electronic media industries are no stranger to change. Public relations activities help to ease transitions so companies can maintain their competitive edge.

- *PR reminds managers of the "double bottom line."* An electronic media company has a dual responsibility: to achieve economic success, while also serving the public. Successful PR strategies enable managers to balance the needs of both the market and the marketplace.

Used effectively, PR helps electronic media managers build a favorable image among audiences and advertisers. Furthermore, PR helps establish trust and maintain credibility among various publics.

Publics and Electronic Media Institutions

At the beginning of the chapter the term *publics* was introduced and discussed as a way to help define public relations. This section takes a closer look at the major publics that electronic media managers regularly encounter. Hendrix (2004) divides the publics of any organization into 10 categories: media, employee, member, community, government, investor, consumer, international, special, and integrated marketing communications.

Media Publics As part of the media system, radio, television, cable, and telecommunication companies interact with other media at the local and national levels. Newspapers and other print publications regularly carry information about the electronic media, covering everything from programming to special events. Likewise, radio and television stations will cover other media activities of interest to listeners and viewers. Additionally, there are also different specialized media (e.g., trade, industry, and business publications and special programs) that are part of the media public. Good professional relations with other media make up a necessary part of an electronic media organization's PR plan.

Employee Publics Employee publics refer to all employees of an organization, ranging from management and nonmanagement personnel to part-time and temporary personnel. Any organization concerned with PR must do its part to keep employees motivated, informed, and content. How can any company influence the public if its own employees have a poor attitude toward the organization? Review the information in Chapter 6 for more detail on motivating and developing good relations with employees.

Member Publics In Hendrix's (2004) system, member publics refer to all members of an organization, including elected officers and individual members,

state and local chapters, and other allied organizations. Applied to the electronic media, member publics represent trade and professional organizations such as the NAB, NCTA, RAB, TVB, Radio Television News Directors Association (RTNDA), American Women in Radio-Television (AWRT), and state and local associations. Member publics would also include the various guilds and unions introduced in Chapter 6 (see Table 6-2).

Active involvement in professional organizations promotes not only the personal development of individual members but also the professional image of the individual company. In the electronic media industry, member publics are an important component of PR efforts.

Community Publics

Perhaps the most critical public for electronic media managers in PR is *the* public—made up of various audiences. Because electronic media companies are community-based businesses, positive relations with the local community are an absolute necessity. While electronic media managers recognize they cannot satisfy all the people all the time, they do strive for the most positive relations possible with the local community, business leaders, and elected officials. Managers accomplish this in many ways, ranging from sponsorship of community events to generating programs about issues of concern to the public. The invitation to submit user-generated content to EM outlets, participate in EM-sponsored blogs, and other new media create additional opportunities for involvement from community publics. Overall, the community expects responsible and professional service from the electronic media companies.

Government Publics

The previous chapter introduced you to the various forms of regulatory influence media managers usually encounter at the national, state, and local levels. Regulators pay most attention to those issues their constituents bring up. Regulatory actions, such as the 1996 Telecommunications Act, the 1990 Children's Television Act, and hearings and discussions over the amount and impact of televised violence and media ownership, represent areas of active interest on the part of policymakers. Through participation in trade associations and individual efforts (letters, phone calls, lobbying), electronic media managers share their concerns with regulators and attempt to minimize the amount of governmental involvement.

Investor Publics This group consists of the individual and institutional shareholders of public companies, as well as the larger financial community as it affects these institutions. A company that loses confidence in the eyes of stockholders and financial analysts will find difficulty obtaining needed capital and lines of credit. On the other hand, a financially stable and healthy organization will attract the investment community. Part of the PR efforts of any electronic media company must be channeled toward maintaining positive relationships with investor publics. This particular area has grown increasingly important, making financial credibility an important variable.

Consumer Publics Consumer publics are perhaps best represented by groups who question and challenge the actions of the electronic media industry. Activist groups such as Action for Children's Television and the Center for Media Education regularly voice concerns with programming for children. Watchdog groups such as Accuracy in Media chastise the media for inaccuracies in reporting news events. Groups such as the Moral Majority challenge managers over programming that does not promote their moral values. The National Organization for Women (NOW) speaks out regularly on programming that debases women and minimizes their contribution to society. Ethnic groups bemoan the lack of roles for African Americans and Latinos in programming and advertising. Managers must be sensitive to the concerns raised by consumer publics and attempt to find workable solutions when conflicts arise.

International Publics The global nature of the media business and the fact that so many corporations involved in electronic media are also active on a global level elevates the importance of international public relations activities. Hendrix (2004) lists international publics as host country media, host country leaders, and host country organizations. Close synergies exist among global and local news organizations, which regularly share footage and satellite feeds of news events—just one example of international cooperation and good public relations. Increasing costs further justify the importance of these types of alliances and partnerships as discussed in Chapter 2.

Special Publics Special publics comprised of both mass and specialized media also include the leaders and organizations composing this public.

Special publics can also refer to groups that are either temporary in nature or that do not fall under any other category. Examples of special publics in the electronic media industry include advertisers and advertising agencies at the local, regional and national level, services such as Nielsen and Arbitron, syndicators, other companies that produce content, and professional consulting and engineering firms needed for specialized services.

Integrated Marketing Communications

As discussed previously, integrated marketing communications involve the unification of all forms of communication from an organization to promote consistency. Applied here, the publics for integrated marketing communications would encompass customers, employees, media, investors, suppliers, competitors, and government regulators.

The Demands of Publics

Newsom, Turk, and Kruckeberg (2004) explain that all publics place demands on PR practitioners. However, managers and their PR departments must be able to identify and prioritize the needs of the various publics. Managers should consider an action taken to address one group in regard to its effects on other publics.

For example, local TV stations occasionally refuse to carry a program offered by their network affiliate because they have concerns about the content of the program. Such a decision might be both praised by the audience for demonstrating concerns and attacked by those claiming the station is playing a form of censorship. The networks will certainly not be happy with the decision, as it means the program will not be cleared in the market and the anticipated audience will be less than promised to advertisers.

The ABC network broadcast the movie *Saving Private Ryan* on Veteran's Day 2004, yet many ABC affiliates refused to carry the program not because of the violence, but because of the offensive language in the film. *Private Ryan* producer/director Steven Spielberg, in licensing the rights to ABC to carry the movie years earlier, required the movie be shown uncut and unedited to deliver its full powerful impact. Local ABC station managers had to make a tough decision regarding the movie, knowing that one or more of their publics would not be happy with the outcome.

Maintaining an Identity in the Market

Having examined the importance of public relations, how managers use PR, and the various publics they encounter, we turn our attention to some specific activities used in PR efforts. Employees, from the receptionist to the CEO, need to be aware of and concerned with public relations (Heath, 1994). Any one employee can influence others simply by the way he or she performs tasks and responsibilities (Garbett, 1988).

Electronic media managers understand the delicate relationship with the various publics they serve. To foster a stable relationship, managers use PR activities to demonstrate the company's responsibility and commitment to the community they serve, thus fostering trust. Though practices vary from market to market, the following are some of the more common approaches used to maintain an identity in the market.

- *Graphics.* Though one might identify graphics with promotional efforts, they are also a form of public relations used to communicate an organizational identity. Electronic media logos have long served as an important part of identification and awareness on the part of audiences and advertisers. We easily recognize logos, such as the CBS eye, the NBC peacock, and the black circle enclosing the letters ABC. Other graphic designs also play an important role in PR efforts. Television stations rely heavily on graphics for their news operation and channel position. Radio stations portray call letters and formats with their logos, and cable, satellite and telecommunication systems use logos to identify their companies in all promotional efforts and correspondence.

- *Public service campaigns.* Radio and television stations and many cable systems carry out annual public service programs as a contribution to the community. These efforts often involve sponsorship and cooperation with other companies. The most common activities include food drives, holiday toy drives, health events, community blood drives, job fairs and employment workshops, financial seminars, and family/home safety campaigns. These efforts provide not only an important service to the community but also promote goodwill and positive feelings toward the media organization (Lowengard, 1989). A strong community identity helps promote favorable public opinion toward the facility.

- *Public appearances*. Employees most visible to the public (e.g., TV news anchors and reporters, radio personalities) are often in great demand for personal appearances at community events such as those sponsored by schools, churches, and civic organizations. These activities help promote goodwill for the media organization and promote a sense of the facility's commitment to the community.

- *Speaker programs*. Operating at a more formal level than public appearances, some firms provide a select group of speakers chosen from key management and staff personnel. Duties might include presentations to civic organizations (e.g., Rotary, Kiwanis, Jaycees) or speaking to a student class or a tour group.

- *Sponsorship of events*. Electronic media companies regularly sponsor various community and charitable events. Sponsorship covers an entire range of activities, from telethons to programs dealing with issues of public concern. Many of these sponsorship events also create nontraditional revenue opportunities for stations (see Chapter 9).

- *Participation in local organizations*. Managers usually encourage employees to become involved with community organizations of interest to the company. Such participation promotes individual responsibility and provides a formal source of PR activities.

- *Awards and honors*. Awards and honors won by the facility or individual employees should be properly recognized and displayed at the main business location. These displays impress not only visitors but also promote pride among employees.

- *Press releases/publicity*. Press releases and briefings detailing such things as employee promotions, new hires, programming highlights, and other matters of public interest should be provided to other media for publicity. Self-promotion and other publicity efforts are also important and should be used regularly to inform key publics. EM Web sites carry a lot of publicity information.

- *Newsletters, brochures, Web sites, blogs, and social network pages*. Initially aimed at potential advertisers, regular newsletters and other electronic and printed material inform readers of the potential of media advertising and other activities. Many media organizations also use in-house publications and electronic newsletters to promote PR activities among employees.

- *Seminars and town meetings.* Usually coordinated with sponsorship and public service efforts, electronic media companies often sponsor seminars and town meetings on matters of public concern. Usually open to the public, these events feature experts on particular subjects. Not only do these events offer the public valuable information but they also generate a lot of goodwill.

- *Tours/open houses.* Many electronic media facilities accommodate groups and individuals on tours during regular business hours as long as arrangements are made in advance. Some stations regularly provide an open house for the public.

This list includes just some of the many possible ways to engage in a successful PR program in the electronic media industry. Many creative and innovative programs occur daily across the United States, including the market where you reside.

Dealing with Controversial Public Issues

Because the pervasiveness and influence of electronic media place every enterprise in the public eye, the media often must defend or explain their actions to the public. As such, the media particularly need a strong public relations effort to maintain a positive image in the minds of the various publics.

An important aspect of successful public relations is dealing with public problems and controversies as they arise (Heath, 1994). In dealing with difficult situations, organizations usually follow either a proactive or a reactive PR strategy. As the words suggest, a proactive strategy attempts to anticipate problems in order to determine appropriate strategies for dealing with them. A reactive strategy, however, addresses problems as they arise.

While the range of controversial issues one could examine is relatively unlimited, this section focuses on three areas that tend to generate the most complaints against the media: journalistic issues, criticisms against programs, and complaints against advertising.

Journalistic Issues News departments are criticized for biased or inaccurate reporting (Goldberg, 2002). Politicians and business leaders often claim that their remarks were taken out of context or misquoted from an interview.

Failing to show sensitivity toward victims of accidents can also incite harsh feelings against the media. Editing techniques can make a person appear incompetent or untrustworthy or make a crowd appear much larger than was actually the case.

News departments may also receive criticism for the content of stories or series of stories. During sweeps, TV stations often provide week-long series, which may deal with subjects designed to titillate the audience, involving sex, drugs, or violent behaviors. Critics contend that such series are designed to influence ratings rather than provide work of journalistic merit. Managers need discretion and good judgment in determining the content of news series and other features.

News managers, reporters, and editors must make sure that their stories truly reflect events in society and are factual. Despite a system of editorial checks and balances, mistakes sometimes occur, even as we have learned with prestigious news organizations like CBS, CNN, and the *New York Times*. When confronted with mistakes, news managers must immediately deal with the issue by offering an explanation of their actions and apologies as necessary. Attempting to cover up an incident can only cause more problems. If necessary, the General Manager may need to address the problem directly in a commentary or other public forum.

Complaints over Programming

Controversial program content can also lead to complaints against electronic media facilities. In television, complaints may be directed toward a network, syndicated product, or local programming. Recall from Chapter 11 that the FCC provides few regulations on programming and for the most part avoids any content regulation outside of children's programming or indecency. The burden of responsibility falls on the local management team to determine suitable programming for its audience.

Historically, most complaints against television programming have centered on sexual content and violence. Occasionally programs may be attacked on moral grounds, and historically programs such as *Murphy Brown, Married with Children, NYPD Blue, Will & Grace, Without a Trace*, and others have been targeted by consumer groups because of their content. Talk programs on both television and radio have been criticized for the proliferation of sexual topics. Cartoons and animated programs that feature gratuitous violence

and promote the purchase of toys and other products also incur regular complaints.

In the radio industry "shock jocks" like Don Imus regularly challenge the limits of decent material—and often face fines. Howard Stern, fined more than any other radio personality in history, left traditional radio for satellite radio in 2006. Imus was fired in 2007 for racial remarks over the Rutgers University women's basketball program, only to be rehired by another company months later. Music lyrics that promote sex, violence, and drugs also trouble audiences.

Cable, satellite and telco systems also receive complaints over content. Services, such as MTV, FX, Spike, and USA, have been targeted over program content. Many local audiences criticize systems that offer adult channels, even if limited to a subscription or PPV basis.

Electronic media managers have few choices in such cases. They can remove the program schedule; reschedule the program at another, less controversial time; or simply ignore the protests. Each programming complaint should be examined and evaluated individually for both validity and merit. If complaints are few, the Program Manager or the General Manager may either telephone or write a letter or e-mail to a complainant outlining the company's position on the matter. As required by the FCC, all written complaints must be placed in the public file of a broadcast station.

Complaints about Advertising

As with programming, EM managers should consider the public when determining which advertising is acceptable for their individual operations. Certain types of advertising have led to complaints. The most controversial subjects revolve around beer and wine advertising, condom advertising, advertising for medical products, and political advertising. Infomercials, also known as program length commercials, have been criticized because of their persuasive presentation and disguise as regular programs. While not illegal, advertisements for attorneys, physicians, and medical facilities have been frowned on as inappropriate for professional occupations, yet they still exist, especially in daytime television.

Political advertising can be inflammatory or controversial for certain audience members. Recall from Chapter 11 that under the guidelines of Section 315 of the Communications Act, broadcasters are not allowed to censor or edit any political messages. This creates

a Catch-22 for broadcasters. When they accept political advertising, they may have to run controversial messages such as a candidate's stance on abortion. On the other hand, to decline any political advertising would raise the criticism of not serving the public interest and showing bias toward a particular political party.

Electronic media managers can use several strategies to deal with advertising complaints. For one, they could simply avoid all potentially controversial messages or vendors, but in reality this presents a potential economic loss. Though it is difficult to decline potential advertising clients, managers must consider the potential damage to their operation's image in allowing controversial advertising to air. A second strategy would be to use the situation as a way to educate and inform the public about controversial topics through other content, such as a news series or special program. This approach is perhaps more reasonable because the media can uphold its obligation to present diverse views and opinions to the public. As with programming complaints, written complaints to the station regarding advertising must also be placed in the public file.

Summary

Public relations plays an important role in electronic media management by helping to establish and promote a favorable identity to the various publics and audiences served by the organizations. Public relations encompasses many different activities, including press agentry, promotion, publicity, public affairs, research, graphics, advertising, marketing, integrated marketing communications, issues management, government relations, financial public relations, community relations, industry relations, and propaganda.

Activities are coordinated through an in-house department (such as promotions or community service) and/or an independent PR firm. Although the General Manager assumes the key figurehead role in representing the organization to various publics, all personnel in an electronic media facility are engaged in the practice of public relations.

Managers use PR in many different ways to gain public support among key publics. In the electronic media, these publics include

media, member, employee, community, investor, government, consumer, and special publics.

Public relations activities vary among the electronic media. The most common activities used to maintain an image in the community include graphics and logos, public service campaigns, public appearances, speaker programs, sponsorships, employee participation in local organizations, awards and honors, press releases, newsletters, Web sites, blogs and other distribution platforms, seminars, tours, and open houses.

Public relations also help companies deal with controversial public issues. In the electronic media industry, three areas generally require the use of PR techniques: journalistic issues, criticisms against programs, and complaints against advertising. In all cases organizations usually adopt a proactive or reactive strategy in dealing with public issues.

CASE STUDY	**Do You Cancel the Captain?**

For over 40 years in the small market of Pleasantown, a local television station had been known for an innovative local children's program called *Captain Cartoon.* The program began in 1968 as a half-hour, after-school program featuring a live host and child audience, along with feature cartoons. By 1970, the program had expanded to one hour in length, airing from 4:00 P.M. to 5:00 P.M.

The program evolved over the years; the live audience was dropped in the 1980s, and over time there had been four different "Captains." *Captain Cartoon* had been praised by both local and national organizations, such as the Parent-Teacher Association and Action for Children's Television, for segments within the program that promoted community events for children, encouraged reading and writing activities, and helped children understand their world. Most programs featured a 10-minute package of the Captain visiting with a guest (e.g., police officer, doctor, dentist, and veterinarian) who explained something to children or demonstrated something children needed to know.

By the late 1990s *Captain Cartoon* had grown stale. The other two television stations in the market dominated the time slot in terms of ratings; one programmed *Oprah* and the other reruns of popular situation comedies (such as *Home Improvement* and *The Simpsons*).

The *Captain* program came up regularly in the weekly manager's meeting. Steve Roberts, the General Sales Manager, complained that the sales team had major difficulty keeping sponsors in the program. "We could be making five times as much with a good syndicated program and improving our ratings at the same time," said Roberts. The News Director, Sylvia McGarry, also said, "This program provides a horrible lead-in for our 5:00 P.M. early newscast and has for years. A change can help our news ratings as well."

The Promotion Director, Pam Jones, raised the issue with her colleagues that "*Captain Cartoon* helps us in many ways. We are the only local station with an hour-long weekday program for children in the market. Don't we have some obligation to the community—to children—to keep this program on the schedule? Can't we try and revamp the program in some way—maybe even drop back to a 30-minute program from 4:00 P.M. to 4:30 P.M.—rather than just cancel the program? What kind of message does that send?"

The Program Director, Rob Fitzpatrick, was caught in the middle. "I know we continue getting killed in this time slot with this program and agree we can do better in terms of sales and ratings with just about any other effort. But I agree with Pam—killing this program could cause some strong repercussions. I'm also certain Ray Martin (the current actor who plays the Captain) will be against cutting the program to 30 minutes. If we move the program back to 4:00 P.M., we lose what audience we have because most of the children are not home by then. We could move the program strictly to the Internet and make it available on the Web site or one of our new digital channels. But that would no doubt result in a loss of audience, as well as open us up for criticism by taking a popular children's program off the air. I don't see any positives coming from a move in terms of PR."

In this sticky programming problem, you as the General Manager of this station must decide what to do with *Captain Cartoon*. In determining your response, consider how your decision will affect the publics your station interacts with and how you will implement the course of action you decide to follow.

| CASE STUDY | **Radio Station Makeover** |

Radio station KCAK-AM/FM, Catlettsville, a small-market radio station combo in the rural Midwest, had floundered for years under its former owner, Joe Sullivan. Sullivan sold the station last month to your company, Eagle Broadcasting. Eagle President Glen Henley has asked you to move to Catlettsville and revamp KCAK-FM as its new General Manager. After agreeing on terms, you accepted the offer to become a GM for the first time.

When you arrived at the new station following FCC approval of the license transfer, you were confronted with a list of problems. Technically, the station was suffering: The studios needed repair and the transmitter did not work properly. The station employees suffered from morale problems, openly referring to the station as "KCAK—Where Cows Are Kool." In the community the station had a weak image among advertisers. Local ratings were awful—the AM station ranked dead last among the four other stations in the market; the FM ranked number three. HD radio was not even under consideration. The technical problems could be solved quickly, thanks to the parent company, which maintained a good engineering firm on retainer. Repairing the damage within the station and the community would be a tougher project.

As the new General Manager of KCAK-FM, design a public relations plan to turn around the negative image and identity of these stations both within the organization and throughout the market. Establish specific goals and objectives for each area and ways to implement your ideas, including plans to eventually offer HD radio.

References for Chapter 12

Garbett, T. (1988). *How to build a corporation's identity and project its image.* Lexington, MA: Lexington Books.

Goldberg, B. (2002). *Bias: A CBS insider exposes how the media distort the news.* Washington, DC: Regnery.

Heath, R. L. (1994). *Management of corporate communication: From interpersonal contacts to external affairs.* Hillsdale, NJ: Erlbaum.

Hendrix, J. A. (2004). *Public relations cases* (6th ed.). Belmont, CA: Wadsworth.

Kinkead, R. W. & Winokur, D. (1992, October). How public relations professionals help CEOs make the right moves. *Public Relations Journal,* pp. 18–23.

Lowengard, M. (1989, October). Community relations—new approaches to building consensus. *Public Relations Journal,* pp. 24–30.

Newsom, D., Turk, J. V., & Kruckeberg, D. (2004). *This is PR: The realities of public relations* (8th ed.). Belmont, CA: Wadsworth.

Pavlik, J. V. (1987). *Public relations: What research tells us.* Newbury Park, CA: Sage.

Public Relations Society of America Foundation. (1991). *Public relations: An overview.* New York: Author.

13

Technology and Electronic Media Management

In this chapter you will learn

- New technological trends impacting the electronic media
- How technology affects media content
- The search for new business models and revenue streams
- Management issues associated with new technologies

The electronic media industries continue to face a rapidly evolving environment due to many factors, but perhaps no single force has created as many challenges and opportunities as technology (Anderson, 2006). This chapter examines key technological trends impacting the electronic media, discusses how technology will affect media content, details efforts to establish new business models and revenue streams, and summarizes the key management issues associated with new technologies.

Technology Trends

Here are a few important facts to establish a context for discussion of technology trends:

- Over 92 percent of all households in the United States pay for television to a cable, satellite, or telco distributor according to the National Cable and Telecommunications Association.

- U.S. households continue to increase their spending every year on entertainment and information technologies, and they are spending increasing amounts of their time with media, according to the U.S. Statistical Abstract.

- Over 71 percent of U.S. households have Internet access, and many of these households are spending increasingly more time with the Internet instead of traditional media, according to the U.S. Statistical Abstract.

- There are more cell phones than landline phones in the United States (United States Telecom Association, 2008).

- iPods and other MP3 players are preferred over radio listening by most young adults (Albarran, et al., 2007).

- Consumers are rapidly adopting wide-screen digital television receivers, digital video recorders, MP3 players, and "smartphones."

- Wireless technology has emerged as the preferred way to access the Internet via laptops, cell phones, PDAs, and other devices.

- User-generated content in the form of blogs and videos (e.g., YouTube) and social networking sites like MySpace, Facebook and Linkedin are redefining the Web experience for their utility to share contacts, entertainment, and news.

- Smartphones such as the iPhone and Blackberry offer a range of functions including Internet, email, MP3 player, digital camera, calendar, address book and more opportunities for media access and consumption.

As these points emphasize, technology is both widespread and changing the way consumers access media content. This intensive technological environment is posing havoc for electronic media managers, who are struggling to remain competitive in a world where the audience is increasingly fragmented.

Our discussion on technology trends centers on two broad categories: distribution technologies and digital platforms. Both areas have implications for the electronic media industries and managerial decision making.

Distribution Technologies Electronic media began by broadcasting a terrestrial signal that was received by an antenna. In television the antenna gave way to coaxial cable and satellite, while in radio terrestrial broadcasting

competes with satellite radio. This section examines the distribution technologies available to electronic media institutions and how they are evolving early in the twenty-first century.

DTV/HDTV The development and diffusion of digital television with high-definition (HDTV) capability has forever changed the television landscape (Dupagne & Seel, 1998). In the United States, the transition to DTV will finally be completed as of February 17, 2009, when the country shifts to digital from analog.

DTV offers many advantages for electronic media managers. Most stations will offer a primary HDTV channel, as well as multicasting a series of "standard" (SDTV) channels. The multicast or subchannels are used to provide a range of new services, with everything from a 24-hour local weather channel, a local 24-hour news channel, a channel in another language (e.g. Spanish), or targeting an underserved demographic group. Television GMs see these additional channels as a way to generate new revenues and monetize the digital spectrum. But distribution is a challenge, as the FCC dealt a blow to broadcasters by ruling in 2005 that cable operators are only obligated to carry one channel under must carry provisions (Federal Communications Commission, 2005).

Broadband Distribution Broadband distribution includes a number of distribution modes, including coaxial cable, Internet, *digital subscriber line* (DSL), fiber optics (e.g. Verizon's FIOS), and wireless. As detailed in Chapter 2, broadband has become the term used to define the transmission of digital content over a high-speed, high-capacity network that also links to the Internet. Broadband delivery means multiple channels of information and entertainment available to consumers via any number of potential reception technologies—the television receiver, a personal computer or laptop, a cell phone, MP3 player, or PDA.

Consumers continue to demand more choices and options, which has led to significant growth in broadband adoption; by the end of 2009, 70 percent of all U.S. households are expected to have broadband access (Green, 2005). EM companies will need to negotiate carriage on broadband platforms so their content can be accessed by these different audiences and consider joint partnerships as a way to secure access. Television operators must negotiate with cable, satellite, and telco providers to make more channels available for

their multicast signals. TV broadcasters continue to engage in retransmission consent with cable operators to generate additional revenues for their signals, arguing that their channels are just as valuable as those provided by distributors such as CNN or ESPN.

While broadcasters are challenged by broadband distribution, cable and telecommunications operators are energized by the revenue and business potential associated with broadband services. Intense competition is the norm, with major cable companies (Comcast, Time Warner, Cox, and Cablevision) competing with telecommunication companies (AT&T and Verizon) to offer triple-play services to consumers. Satellite providers can offer digital radio and television signals but must partner with local telephone companies to add a telephony/Internet component.

Internet Consumers access the Internet in one of three ways: traditional dial-up, high-speed broadband, or wireless. Dial-up is in rapid decline as more consumers and households have moved to broadband. High-speed access, driven by cable modems, DSL, and fiber, continues to grow as does wireless.

Wireless While we have always had wireless distribution in the electronic media via terrestrial broadcasting, contemporary wireless technology enables Internet access—and growing broadband or high-speed Internet access, without being tethered to a telephone line or coaxial cable. This has allowed businesses and households to set up wireless network access using a simple router and networking cards in laptops and desktops from any point within the range of the home network (usually limited to a maximum of 100 to 150 feet).

Wireless or Wi-Fi technology has become an expectation for consumers. Wireless **hot spots** first appeared in airports, hotels, schools, and universities; today Wi-Fi public networks can be found just about everywhere except remote rural locations. Wireless distribution makes it possible to send Internet-related content to cell phones, MP3 players, PDAs, and other enabled devices.

HD and Satellite Radio Hybrid digital or HD radio is growing in the United States, as more and more stations move to offer the new service to listeners. Complicating the diffusion of HD is the need to buy

new receivers, and the fact that most new automobiles will not offer HD radio as an option before 2009 or 2010. Radio managers hope to generate new audiences and revenues through their HD channels, much in the same way as their counterpart TV managers with DTV. HD is also hoped to thwart the competition from satellite radio.

Satellite radio, which began as two services (XM and Sirius) merged in to a single entity in 2008, Sirius XM. Both XM and Sirius failed to turn any profits during their initial years of operation, and without the merger one of the services was likely to fail.

Consumer Technologies While there are increasing distribution options available to electronic media firms, consumers now have even more ways to use and receive media content aside from the traditional methods of terrestrial, coaxial, satellite, and tape/video. This section reviews key consumer technology that poses more challenges and opportunities for electronic media management.

Smartphones (Mobile Phones) There are more mobile phones in use in the United States than land lines, and there is no doubt the mobile phone is emerging as the primary consumer communications device with its many capabilities. The same scenario is true for numerous other countries. With the introduction of *smartphones* like the Blackberry, created by Research in Motion, or the iPhone, developed by Apple, more and more consumers are adopting phones with many capabilities: MP3 player, Internet, e-mail and messaging, digital camera, GPS, and so on. And the mobile phone is becoming a critical distribution platform for Internet, video, and audio applications. Chan-Olmsted (2006) was among the first to review management strategies for mobile video distribution. One report by BIA Financial Network estimates that mobile/handheld video distribution could reach as much as $2 billion by 2012 (Ducey, Fratrik, & Kraemer, 2008).

The portability and ease of the mobile phone means growing numbers of consumers will access entertainment and information via a mobile phone, but that doesn't mean they will abandon their large-screen TVs or laptops. The mobile phone adds utility and connectivity for people on the go, especially business users. Electronic media companies need a clear strategy targeting mobile phone users and must recognize the important value of this growing segment of users.

Digital Video Recorders (DVRs) DVR technology allows consumers to record and store content on a hard disk, and the user can play back the material whenever needed. DVRs also allow the user to skip commercial messages (much to the chagrin of advertisers) and offer a number of interesting features, such as the ability to watch one program while recording another; stop and restart a recorded program in real time; and seek out similar content based on preferences and desires. A growing number of DVRs can download content directly from the Internet.

The DVR revolution was sparked by TiVo, the first brand name associated with DVRs. However, cable, satellite, and telco operators provide generic DVRs to customers as well. Electronic manufacturers will offer television sets with built-in DVR technology, as well as a built-in DVD recorder to easily archive recorded content. DVRs are estimated to be in 25 percent of all U.S. television households by 2011 (The Carmel Group, 2007). Consumers with DVRs rate the technology very highly for performance and ease of use.

Wireless Reception Devices As mentioned previously, the proliferation of a number of consumer reception technologies, including wireless-enabled Internet and broadband devices, are leading a new era of media consumption. In addition to smartphones, PDAs, new and improved versions of iPods, and other MP3 players offer wireless reception. Other devices will follow suit. Products such as Apple TV and the Slingbox enable households to store and send video and Internet content to other rooms in a household.

As more and more consumers—especially younger people—adopt these wireless devices, there is potential for even greater fragmentation of the audience. While these technologies will be a boon to consumers, they represent yet another challenge for existing electronic media organizations trying to capture and hold an audience and advertisers seeking access to those audiences.

Interactive Television Interactive television was expected to be a force by the beginning of the twenty-first century, but the technology has yet to debut to a critical mass despite a lot of ongoing research and development. Interactive television will come of age within the next decade. Numerous companies are working on interactive television,

including key technology players such as Microsoft, Hewlett Packard (HP), Yahoo!, and Oracle. What it will mean for consumers will be an enhanced viewing experience where the television experience will be coupled with Internet access to allow for all sorts of interactive applications, from shopping and leisure activities to sports and news (Lieb, 2004).

This environment will create new demands regarding how media content is created and packaged for consumers. Not every program will have interactive capabilities, but the possible applications and innovations appear endless. For example, you could be watching a prime-time drama and have an opportunity to participate in the program by "voting" on which character might be the potential criminal in the show, or what you think the outcome will be. Like what a particular actor is wearing? Click on a link to take you to a shopping site where you can buy the clothing, or store the site for review later. During a newscast, you could click on an alternate link located on the lower third of the screen or on either side to learn more about a country's population, culture, and geography. Sports programming offers endless opportunities to engage fans. Interactive television will also open numerous possibilities for educational programming. It may someday be possible to design individual curriculums for students in grades K–12 to enhance traditional classroom learning.

Media Centers Microsoft, HP, and other computer and software manufacturers have developed devices capable of integrating traditional computing and entertainment options. These products, referred to as the Media Center, combine a number of technological options for the consumer. The Media Center becomes the control point in the household that enables the user to access digital photos, music, television (both standard and high definition), movies, and games from a single control point. Furthermore, when coupled with a high-speed home network, the device allows content to be displayed on a computer (with an appropriate video and sound card) or television in other rooms of the house.

With the appropriate software and hardware, a user can pause and play back live TV or radio, digitally record an entire TV series or program category, watch DVDs and videos, burn CDs and DVDs, organize and play music, and show digital photo slide shows.

Not all households want or need TV-PC integration. However, as households add more technology, we can expect they will look to simplified ways to integrate and manage their reception technologies and content, as well as integrate their media center activities with other "smart" household devices such as lighting systems, security systems, and climate control.

Media Content

Technological innovations pose new challenges for electronic media managers as they grapple with how their content products must change and adapt. Three areas that are drawing the most attention involve HD considerations, repurposing and repackaging content, and user-generated content.

HD Transition With the transition to a full digital environment, HDTV is now a reality in most local markets. HD has brought many challenges to management, most notably for news production. Stations have had to adapt to larger and wider options for sets and reconfigure sets and graphics. HD also means more investment in preparing talent for on-air presentation. Talent must give more attention to hair, makeup, and clothing considerations, as all appear much clearer and sharper in an HD environment.

Repurposing and Repackaging Content Repurposing is not a new trend, but technology enhances repurposing possibilities. TV broadcasters will be able to integrate and expand existing content through duopoly/LMA/JSA agreements (as applicable), via multicasting of SDTV signals, and integration with their local Web sites. News packages designed for broadcast can be much longer in a repurposed environment, whether on another channel, over the Internet, or sent to a mobile phone. It will take creative, new approaches to determine how repurposing content could generate new revenue streams for stations. Electronic media companies must also consider how to repackage content.

The Internet is readily accessible on a number of wireless devices. As television moves to transmit signals to smaller devices, the content will need to be condensed and repackaged to fit the specific

application and distribution modes. This raises many questions. What types of content (e.g., news, weather, stock market updates, sports scores) will be demanded by users? How long should the content be? How often will it need to be updated? Will it be possible to "broadcast" in the same sense to a wireless device? How will the programming need to be condensed and repackaged? How much advertising should be included?

All of these considerations require a new wave of professionals with considerable skills in computing and engineering, as well as creative and innovative programming and marketing ideas. Traditional TV stations will have to expand their distribution options in order to take advantage of the growing number of distribution platforms.

User-Generated Content

As media content morphs into other forms and formats, users not only have more and more control over individual consumption and usage; they are creating and distributing their own content. User-generated content, also referred to as *social media*, consists of social networking sites (such as MySpace and Facebook) where users share personal information (photos, text) as well as preferences and tastes for music, movies, and television programs. Growth in social networks has been unprecedented; as of 2008, MySpace was just five years old, yet accounted for 82 million users in the United States and another 117 million globally (Baker & Green, 2008). Social networks, first resisted by electronic media companies, are now an important part of any entities' digital strategy.

In addition to social networks, YouTube demonstrated consumers' willingness to share original video content with one another. The phenomenal growth of YouTube forced electronic media companies to seek out content from their viewers for possible use in their broadcasts. No one is guaranteed that any content they upload to CNN or any other media organization will be aired, but user generated content is an important way to connect with the audience and is now openly encouraged.

Blogs, or "blogging," has also risen in popularity. Media organizations were slow to respond to blogging, but now most journalists and other key personnel offer blogs via the company website. Blogs have also emerged as an important source of news and information, especially outside of the mainstream media. There are well over an

estimated 120+ million blogs, with thousands more added every day. Blogs not only carry text, but can also be used for audio (podcasts), images, and video.

Business Models

Historically, the electronic media industries have been heavily dependent on advertising for the majority of its revenues. This simple business model—selling advertisers access to audiences—continues to sustain the electronic media industries, but advertisers are very concerned about audience fragmentation and the difficulty of reaching new audiences with their messages, and many advertisers are increasingly moving money into digital/online media from traditional media.

Technology creates opportunities for new business models and revenue streams beyond traditional media advertising. Advertising will continue to be the mainstay for revenues for the electronic media industry through both spot placement and strategic product placement, but there are hopes that new business models will deliver new sources of revenues, especially through the Internet and other digital platforms (see Ha & Ganahl, 2007). Three areas are discussed in the following section: multicasting, subscriptions, and pay for play.

Multicasting The ability for television broadcasters to deliver a number of standard DTV signals raises the potential for new revenue streams. Using digital compression technologies, it will be possible for most TV stations to broadcast between two to four different SDTV channels. As mentioned in earlier chapters, these additional channels could be used to launch a 24-hour local news service, a 24-hour local weather channel, or other types of programming (local sports or children's programming). However, most of these channels would likely be dependent on traditional advertising for revenues.

There is also the potential to use part of this spectrum to transmit specialized information, such as business and information services, either as simple text or as video and audio streams. Users for these types of services will certainly be more specialized in their

orientation, and these services will have to appeal to those users. Some potential opportunities exist in fields like business, medicine, law, real estate, and education.

Multicasting will create an even greater demand for content due to the additional channels in use by electronic media firms. It will also take creative marketing and promotional strategies to get these new services off the ground, create awareness—and need—among potential users. No one can predict the income potential multicasting will offer television broadcasters, but there is great hope among television managers that these additional channels will translate in to much-needed additional revenue streams.

Subscriptions The electronic media industries will continue to develop subscription-based services sold directly to consumers. And history tells us consumers are willing to pay for the services they need and want. Consumers are used to paying monthly fees for television services through cable and satellite, as well as for premium services like HBO.

New subscription opportunities continue to emerge. Netflix changed the model for renting home video, forcing industry leader Blockbuster to adapt. iTunes has changed the way people purchase music. Satellite radio is another example of users' willingness to pay for media content.

As media use becomes more personalized, subscriptions will become even more prominent. Over time, we may move to an environment where the majority of our media consumption is on a pay-as-you-go or à la carte basis. Consumer groups have been advocating this model for years, claiming it is in the best interest of consumers. Electronic media companies will need to identify new opportunities for subscription-based services, whether they are in print, broadcast, online, or multimedia—and develop marketing strategies to attract customers. As with multicasting, the potential for subscription services is unknown but offers another potential revenue stream for EM companies.

Pay for Play Pay for play can be thought of in much the same way as pay per view. Instead of a monthly or annual subscription, users simply pay for the actual content they consume. This model is prevalent on the Internet and will continue to grow as a business option. Price point becomes an important issue in developing pay for play content.

Companies need a pricing strategy that is attractive to consumers but still profitable.

Historically, most electronic media content has been "free" in the sense that if you had a TV or radio receiver you could access the content without any charges. Pay per play will be challenging for older audiences to accept, while younger demographics will be more open to the concept because they do a lot of commerce in an online mode.

Management Issues

The growth and diffusion of technology poses many challenges for electronic media management, involving numerous areas of oversight and administration. This section examines the key issues associated with technology and their overall impact on electronic media organizations. These issues include personnel, fragmentation, and creating value in an increasingly technology-driven society.

Personnel Chapter 1 defined management as the process of working with and through other *people* to accomplish organizational goals. Employees, associates, workers, or any other term used to describe personnel represent the most important component of any organization. Technology impacts personnel in many ways and places evolving requirements on the types of skill sets needed to be successful in electronic media firms.

Increasingly, personnel must be able to adapt to a widely changing technological landscape. In addition to basic computer skills (word processing, spreadsheets, database, and presentation programs), electronic media personnel need a wider range of technical skills depending on their job function and department they call home. Departments like sales and marketing, engineering, business administration, and production all demand expertise with different types of software programs and other equipment. One key challenge is not only finding new personnel with the requisite skills but continually retraining and retooling for existing employees. Management will need to invest more resources into their existing staff to keep them trained for new applications and technologies that impact their job function.

Electronic media firms will continue to demand workers who are versatile and able to adapt to different situations and who are willing to learn new processes and ways to do business. In order to serve the needs of electronic media firms, existing workers and people planning to enter the electronic media (such as majors in communications, broadcasting, journalism, or related fields) must develop a variety of skill sets from a technical standpoint to better position themselves for the best job options. Finding the best people is a constant management challenge. Finding the best people with the right technology skills will be even more demanding for management.

Fragmentation

The fragmentation of the audience, brought about by increasing options for entertainment and information, as well as a host of consumer-level technologies, is a killer management issue for electronic media companies (Anderson, 2006). Managers can't stop fragmentation; they can only try to somehow minimize its impact.

As discussed earlier, electronic media managers will have to develop a comprehensive digital strategy, focusing on the key platforms demanded for their specific business enterprise. Managers will need to rethink packaging and distributing content beyond traditional methods. At the same time, compelling content, especially related to a local audience, provides the best means to limit the impact of fragmentation. These new efforts will require creativity, as well as enhanced marketing efforts to properly target consumers.

Advertisers are also impacted; as the audience shifts away from traditional media, reaching consumers becomes more difficult and more expensive (Bianco, 2004). Advertisers continue shifting more dollars to online and product placement at the national level in order to reach fragmented audiences, especially younger people who are less likely to read a newspaper, watch broadcast TV networks, or listen to regular radio (Rose, 2004). Of course, this also impacts the electronic media as they must seek new clients—and ultimately new revenue streams—to counter these defections.

Fragmentation is yet another basic reason behind media consolidation and conglomeration. By expanding and promoting economies of scale and scope, EM companies have some leverage by buying into new markets. NBC acquired Telemundo to reach the rapidly growing Spanish-language audience, while Viacom purchased ownership interests in videogame maker Electronic Arts to bolster its reach to

younger audiences. The big corporations can withstand the impact of fragmentation much easier than the smaller media properties that may only own a few outlets. For these operations, fragmentation is another economic threat that poses considerable challenges.

Creating Enterprise Value

All businesses operate to earn profits and continually try to increase the value of their firms, not just for stockholders and owners but to provide the resources needed to function in a competitive environment. Another key management issue is building value for their enterprise. For each of the electronic media industries covered in this text, there are a number of economic challenges that could negatively impact each area.

In the radio industry, audiences have multiple alternatives for music and information from satellite radio, online or Internet radio, and podcasting (Albarran, et al., 2007; Green, 2005). For traditional radio broadcasters, much hope is placed on the future of HD radio. HD radio will offer increased value to existing radio companies, giving them the opportunity to offer niche services such as satellite radio and even DVR-like storage and playback functions for audio. But listeners will have to buy new receivers, which are expensive but should decline in price over time.

Broadcast television, cable, and satellite services will continue to siphon viewers away, and advertisers are following. Programming costs continue to rise, and the cost of converting to a digital environment is expensive, with no way to recapture the investment in the short time. The FCC gave broadcasters a tough challenge by not yet requiring digital must carry for multicast services. TV broadcasters hope multicasting will generate new audiences and revenues but recognize it will be a slow process.

The cable and satellite industry will continue to battle head-to-head for consumers, but they face a growing threat together from Verizon and AT&T as the big telecom giants bundle telephone and video services to consumers such as cable operators (Clark, 2005). Cable is well positioned in its ability to draw revenues from many different areas and new services, like an HD tier and video on demand, clearly adding enterprise value for cable operators (Lieberman, 2005). Satellite will remain a strong number-two service, constrained by not being able to offer high-speed Internet service. Both services will face increasing price pressures as the telecom companies target subscribers.

The consolidation in the telecom industry gives tremendous economic clout to giants such as AT&T and Verizon that bundle a range of communication services to the home. However, this doesn't mean the telecom operators will necessarily win the battle. Consumers will have to be won over by more than just price, and some may not be comfortable with one company controlling all of their communication activities. While the future for services like smartphones, high speed access, and mobile video are still very lucrative—traditional wired telephone and long-distance services are no longer demanded by many consumers.

In summary, significant management issues related to increasing enterprise value run across the electronic media industries. No industry offers a clear competitive advantage over the others, and each area will be fighting for audiences, advertisers, and their own economic future.

Summary

The electronic media industries continue to face a rapidly evolving environment due to technology. This chapter examined the key technological trends impacting the electronic media, reviewed how technology impacts media content, discussed new business models and revenue streams, and summarized the key management issues associated with new technologies.

Distribution technologies are growing for the electronic media industries through a variety of digital platforms targeting home and wireless devices. Consumer technologies are also expanding through smartphones, digital video recorders, wireless devices, interactive television, and household media centers. Together, this environment of expanded distribution and consumer technologies offers more control to consumers and allows for greater individual and personalized services for users. In terms of media content, three areas are garnering attention of media firms. These include considerations of production involving high definition, the ability to repurpose and repackage content, and the emergence of user-generated content through social networking, blogs, and sites such as YouTube.

Regarding business models, electronic media organizations are constantly searching for new revenue streams. Multicasting holds

the most promise for television broadcasters in a totally digital environment. Subscriptions are becoming more prominent across the electronic media, as consumers pay for new or specialized content. Pay for play is another emerging business model.

Finally, in terms of management issues three key areas were discussed. People or personnel remain the most important part of any EM organization. Increasingly, technology will demand employees with a variety of technical skills. Fragmentation is a huge problem for traditional media firms, as audiences shift to other content providers and advertisers follow suit. All managers must be concerned with raising the value of their enterprise, and in a competitive and rapidly changing landscape there are significant challenges for each industry covered in this text.

CASE STUDY	**Multicasting: A Brainstorming Session**

Community Broadcasting, a privately held company, owns 24 television stations in 12 different markets, strategically acquiring duopolies in each market. Community has fully completed its transition to a digital environment, and each station broadcasts some HD programming on their new digital channels.

Wayne Walker, Group Television President, has set up a conference call with the 12 market managers to discuss multicasting options. An e-mail from Walker states: "With compression technologies enabling us to currently offer at least four channels of SDTV for each channel, we have an opportunity to program up to eight channels in each of our markets. We should strive for some consistency to enable economic efficiency, but we can certainly tailor some of our channels to match your local needs. The key question is what are our options? What do you and the staff identify as some opportunities for multicasting for our group? Please arrange to have a brainstorming session with your senior management, and let's share ideas on our conference call next week."

Taking the role of one of Community's 12 market managers, identify at least 10 possible options for multicast channels for your local market. Be creative and develop names for each of your options with a clear identifiable brand.

CASE STUDY	**An HD Radio Strategy**

Mary Fuller is a market manager for Carlyle Radio. She oversees five radio stations in a midsized southwestern market. Fuller has been very concerned by the continuing encroachment on radio audiences by satellite radio, Internet radio, and the iPod revolution, and the topic of technology's impact on local radio was discussed at almost every weekly management meeting.

"We need a plan for HD Radio for each of our stations in the cluster," began Fuller. "We have already decided on the formats: two will be Spanish language (Mexican Regional and Oldies), with the others devoted to classic Rock, Soft Rock, and Country." Our challenge is going to be encouraging the audience to buy the new HD receivers, and how we can market these new services cheaply with our existing web sites. I need your input on the best way to market and promote these new HD channels, and any and all ideas are welcome."

If you were one of Fuller's department heads, how would you respond to this challenge? What are some ways you could market the new HD services? How will you measure success? Develop two to three potential ideas for consideration.

References for Chapter 13

Albarran, A. B., Anderson, T., Garcia Bejar, L., Bussart, A. L., Daggett, E., Gibson, S., Gorman, M., Greer, D., Guo, M., Horst, J. L., Khalaf, T., Lay, J. P., McCracken, M., Mott, B., & Way, H. (2007). "What happened to our audience?" Radio and new technology uses and gratifications among young adult users. *Journal of Radio Studies, 14*(2), 2–11.

Anderson, C. (2006). *The long tail.* New York: Hyperion.

Baker, S., & Green, H. (2008, June 2). Beyond blogs. *BusinessWeek,* pp. D45–D50.

Bianco, A. (2004, July 12). The vanishing mass market. *BusinessWeek,* pp. 61–69.

Carmel Group. (2007). *White papers and studies.* Retrieved: June 1, 2008, from http://carmelgroup.com/publications/white_papers_and_studies/digital_video_recorders_time_in_a_magical_box_present_trends_future_project/

Chan-Olmsted, S. M. (2006). Content development for the third screen: The business and strategy of mobile content and applications in the United States. *The International Journal on Media Management, 8*(2), 51–59.

Clark, D. (2005, January 3). A new tech battle for the home. *Wall Street Journal*, pp. B1, B4.

Ducey, R. V., Fratrik, M. R., & Kraemer, J. S. (2008). *Study of the impact of multiple systems for mobile/handheld digital television.* Retrieved April 30, 2008, from http://www.bia.com/publications_reports.asp

Dupagne, M., & Seel, P. B. (1998). *High definition television: A global perspective.* Ames: Iowa State University Press.

Federal Communications Commission. (2005, February 10). *Second report and order. Carriage of digital television broadcast signals: Amendments to Part 76 of the Commission's Rules.* Retrieved March 12, 2005, from http://hraunfoss.fcc.gov/edocs_public/attachmatch/FCC-05-27A1.doc

Green, H. (2005, March 7). Internet radio 101. *BusinessWeek.* Retrieved March 6, 2005, from www.businessweek.com/print/technology/content/mar2005/tc2005037_3846_tc024.htm

Ha, L., & Ganahl, R. (2007). *Webcasting worldwide: Business models of an emerging global medium.* Mahwah, NJ: Lawrence Erlbaum Associates.

Lieb, R. (2004, April 23). Interactive's sea change. Retrieved April 25, 2005, from http://www.clickz.com/experts/brant/buss/article.php/3344381

Lieberman, D. (2005, January 23). Cable could rule if it plays its cards right. *USA Today.* Retrieved January 25, 2005, from http://www.usatoday.com/money/media2005-01-23-cable-outlook_x.htm

Rose, F. (2004, August). The lost boys. *Wired*, pp. 115–119.

Glossary of Key Terms

Account Executives Electronic media professionals who sell advertising to clients at both the local and the national level.

accruals Used in co-op advertising; accruals refer to the dollars credited to local retailers for co-op plans.

actualities Term used to define audio clips used in radio news.

ad hoc networks Networks formed for certain broadcasts of television programming such as special events or sports.

affiliates Stations that carry network programs.

AM Amplitude modulation; a type of radio broadcasting.

amortization Method used in deducting the costs of intangible assets.

assets Items on a balance sheet that can be converted into cash. Examples of assets include cash, checking and savings accounts, accounts receivable, land, and equipment.

availabilities (avails) In television advertising, refers to the number of spots available for sale to advertising clients.

average quarter-hour (AQH) persons Estimates the number of people listening to a radio station for at least five minutes in any given quarter hour.

average quarter-hour rating The AQH persons expressed as a percentage of the total population.

average quarter-hour share The AQH persons expressed as a percentage of the total audience actually listening.

balance sheet Summarizes the financial condition of a firm at a particular point in time; used for comparison purposes. It consists of three sections: assets, liabilities, and owner's equity.

barriers to entry Normally thought of as obstacles new sellers must overcome before entering a particular market.

barter Used in selling programming; a barter program comes packaged with presold advertising.

blog A website maintained by an individual posting commentary, audio and video material, and links to other sites.

blunting Programming term where the same demographic group is targeted at the same time by two competitors, thus "blunting" each other.

bottom line Slang term used to represent the net profit or loss for a firm; taken from an income statement.

branding A commonly used marketing strategy whereby products, goods, or services are identified by their brand name. For example, customers often ask for a brand name such as Kleenex (instead of a tissue) or Coke (instead of a soft drink).

break-even analysis The amount of revenue needed to cover total costs in a business; how many units of a product must be sold in order to make a profit.

bureaucracy A group with a hierarchical structure and a division of labor between workers and managers. Attributed to the German theorist Max Weber.

capital budgeting Process by which one determines major purchase decisions that cover more than one fiscal year.

clearance Occurs when a local affiliate accepts programming and advertising from its network; in most stations, clearance decisions are made by the Program Director in consultation with the GM. In return for clearing the program, the affiliate may receive compensation from the network.

clear channels Stations that have exclusive right to their assigned frequency at sunset. Clear channel radio stations can be heard over hundreds of miles and are considered valuable assets by managers.

clustering Movement across electronic media whereby larger firms acquire smaller firms in geographical groupings.

collective bargaining The negotiation process between union and management over contracts.

commission In terms of sales, refers to the amount of compensation paid to account executives on advertising contracts. Commissions paid vary depending on type of advertising sold.

compensation Refers to cash payments made by broadcast networks to affiliate stations for carrying or clearing network programs.

concentration Variable used in defining market structure; the number of producers or sellers in a given market.

convergence Combination and integration of the broadcast, cable, telecommunication, and computer industries to develop and market information and entertainment products.

co-op advertising This type of advertising involves shared costs between local retailers and manufacturers.

cost per point (CPP) Calculated by dividing the total cost of the advertising plan by the number of rating points generated in a media buy, CPP is a comparison tool used to compare the cost per point of one radio station or one television program to another.

cost per thousand (CPM) The cost to reach 1,000 people; a comparison tool used in media buys.

cost structures The costs of production in a particular market.

counterprogramming Strategy in which one station or network offers alternative programming to attract audiences.

cume persons An estimate of the number of different listeners to a radio station for at least five minutes in any given quarter hour within an entire week.

cume rating An estimate of a station's reach; the cume persons expressed as a percentage of the total population for a given week.

current assets A group of assets that can be quickly converted into cash.

datacasting Where TV stations use their digital sub-channels to send text and data services to customers, usually for subscriptions.

dayparts Time periods analyzed in audience research in both the radio and TV industries.

demographic Term used for descriptive characteristics of the audience regarding age, sex, and time spent viewing/listening.

deontological ethics Field of ethics concerned with the process of making decisions based on established principles.

depreciation Method used in deducting the costs of tangible assets. Tax laws specify the various classes of assets and types of depreciation schedules that can be used in business.

Designated Market Area (DMA) Ratings term used by Nielsen and Arbitron to identify the heaviest concentration of audience members in a given market.

development The engagement of electronic media firms in creating and implementing new technological innovations.

digital platforms Term used to describe digitally-based ways to distribute information and entertainment to audiences, such as mobile phones, video on demand, or satellite radio.

distribution A common activity of electronic media firms; distribution is concerned with linking different products to consumers.

downsizing The efforts by businesses to reduce expenses by eliminating excess personnel; also known as *flattening*.

dual-product market A unique characteristic of many media industries. Media companies produce one product but offer the product to different markets. Most electronic media programming is targeted to two markets, advertisers, and audiences.

duopoly A type of ownership whereby one company can own two stations within the same geographical market; duopoly rules have been relaxed for both radio and TV.

economies of scale The decline in average cost that occurs as additional units of a product are produced.

electronic media Used in this text to represent the radio, television, cable television, and telecommunication (telephone) industries.

ethical codes Guidelines on behaviors and practices; many professional organizations adopt a formal code of ethics media practitioners are expected to follow.

exclusive cume rating An estimate of the percentage of the total population that listens to only one radio station over a period of time.

executive managers Also referred to as *General Managers,* people who monitor the entire organizational environment, identifying internal and external factors that affect their operation.

exhibition A common activity of electronic media firms whereby the consumer uses the product.

expenses Part of the operating statement that lists all relevant expenses for a firm.

feedback A concept of systems theory; information drawn from the environment in order to identify change and assess organizational goals.

financial management The planning, monitoring, and controlling of a firm's finances.

financial ratios Used in analyzing the financial status of a business, ratios compare many different characteristics such as liquidity, debt, growth, and performance.

first-run syndication Original television programming marketed directly to stations as opposed to being broadcast by a network.

fixed assets A group of assets usually held for a long time.

flattening Term used to describe elimination of managerial layers in an organization.

FM Frequency modulation; a type of radio broadcasting.

force field analysis Developed by Kurt Lewin as a diagnostic tool to determine the number of employees needed to complete a task effectively.

forecasting Projecting revenues and expenses; usually covers longer periods of time such as 3, 5, or 10 years.

format The programming of a radio station.

franchise In the cable industry, signifies the awarding of a geographical area to a cable operator by a local government for the purpose of providing cable television service.

frequency Used in advertising; refers to the number of times an individual is exposed to the same advertising message.

General Managers See *Executive Managers*.

geodemographic Research that classifies neighborhoods with common characteristics by zip code; also incorporates demographic and psychographic information.

geographic market Commonly found in the electronic media; broadcast stations and cable systems operate in defined geographic markets.

goodwill An intangible asset; refers to a firm's public record in a community.

gross impressions (GI) A measure of media weight; refers to the total number of people reached by a media plan.

gross rating points The total of all rating points generated in an advertising plan; measure of media weight.

hammocking Programming strategy that places a new or weaker program between two established programs.

hardware Includes television and radio receivers, satellite dishes, and compact disc players.

Hawthorne effect Used to describe the impact of management attention on employee productivity; resulted from studies by Elton Mayo.

high-definition television (HDTV) High-resolution, digitally enhanced TV.

hot spots Term used to describe a location for wireless Internet access in public places, like airports, libraries, universities, and hotels. Entire communities are setting up wi-fi networks to enable wireless access for citizens.

Households using television (HUT) a term used in TV measurement.

hygiene factors Theorized by Herzberg to represent the working environment in an organization.

income statement Also called an *operating statement* or *profit and loss statement,* charts a firm's financial activities over a set period of time—usually a week, month, or quarter.

inputs In systems theory, refers to variables needed for processing (e.g., labor, capital, equipment).

insertion advertising Local advertising inserted into popular cable channels during commercial breaks.

intangible assets Programming and license agreements are examples of intangible assets. Intangible assets must be amortized instead of depreciated.

interconnects Separate cable systems banding together to market local advertising as a single unit.

Internet A collection of linked computer networks used for exchanging text, graphics, video, audio, and other digital content.

inventory Advertising term used to denote the number of spots available for sale.

lead-in Program strategy in which the strongest program is placed at the beginning of the evening prime-time schedule.

liabilities Obligations to others, or what the firm owes.

liquidity ratios A set of tools used to measure the liquidity of an organization. Liquidity refers to the ability to quickly convert assets into cash.

localism Most important attribute of radio and television stations; many emphasize localism by presentation of local content such as news, sports, weather, and traffic.

local marketing agreement (LMA) Used in the broadcast industry; an LMA allows one station to take over marketing and programming of another station without taking control of ownership.

lower-level managers Those who mainly supervise others and monitor individual performance.

macroperspective Focusing on the whole; taking a macro perspective requires looking at the entire organization, as in systems theory.

makegood When advertising fails to meet expected audience ratings, companies provide free spots or *makegoods* to make up the difference.

management A process in which individuals work with and through other people to accomplish organizational objectives.

Management by Objectives (MBO) Developed by Peter Drucker; MBO involves the interaction of managers with individual employees.

market A place where consumers and sellers interact with one another to determine the price and quantity of the goods produced.

market structure The characteristics of a market define its structure; the concentration of buyers and sellers (producers) in the market, the differentiation among the various products offered, barriers to entry for new competitors, cost structures, and vertical integration.

Media Rating Council (MRC) A professional organization that examines the methodologies and procedures used in the collection of ratings data to ensure that the information is accurate and objective.

metro Used in audience research; the geographical area corresponding to the U.S. Office of Management and Budget's standard metropolitan statistical area (SMSA).

microperspective Focusing on individual units or people; a microperspective centers on the individual rather than the organization as a whole.

middle managers Those who typically plan and allocate resources and manage the performance of smaller groups.

mission statement Used by many electronic media organizations to communicate their purpose to internal and external publics.

monitoring Observing and evaluating performance of employees and the organization; an essential component of the process of management.

monopolistic competition Exists when there are many sellers offering products that are similar but not perfect substitutes for one another.

monopoly A market structure in which a product has only one seller.

motivators Theorized by Herzberg; involve aspects of the job itself, such as recognition, achievement, responsibility, and individual growth and development.

multiple ownership rules In the broadcast industry, refers to the limits imposed by the FCC on the number of stations in which an individual or group may hold ownership interests.

multiple system operator (MSO) A company that owns more than one cable system.

multipoint multichannel distribution services (MMDS) Also referred to as *wireless cable,* offers programming packages via microwave transmission.

must carry Regulations that require cable operators to carry all local broadcast stations.

national representative firm Or *Rep Firm;* works in conjunction with local stations in the sale of national advertising. Rep firms represent local stations in negotiating advertising.

national spot Category of media advertising.

near video on demand (NVOD) Type of system that allows programming to start at regular intervals (say every 30 minutes) from a program provider, but the user cannot stop or pause programming as in true video on demand.

network In the broadcast industry, term used to describe a service that provides programming to affiliates. Also refers to a category of advertising.

news package Term used to describe a reporter's coverage of a story or event; usually includes file footage as well as a "stand-up" of the reporter at the story location.

Nielsen families Households selected to participate in the national Nielsen sample; these households determine the national ratings for the broadcast networks.

noncompete clause Routinely found in talent contracts; a non-compete clause prevents an employee from jumping from one station to another without a designated waiting period, usually 6 months to 1 year. Some states have ruled these clauses unconstitutional.

nonprobability sample Type of sample; every member of the population does not have an equal chance of being selected.

oligopoly A market structure that features more than one seller of a product. Products offered by the sellers may be either homogeneous or differentiated.

on-air promotion Promotional spots and other tools used by an electronic media company to promote programming and other activities; a form of self-promotion.

O&O Broadcast stations owned and operated by a network; O & O stations represent the most valuable broadcast stations and are usually located in major markets.

operating statement Another name for an income statement.

other assets Includes intangible assets, goodwill, and prepaid items. Found on the balance sheet and used in financial management.

outputs From systems theory; refers to products, goods, and services.

outsourcing Describes having an outside vendor provide support services for an organization. Outsourcing often reduces expenses, but it also creates job loss.

overnight Term used to describe ratings information gathered from the previous night of viewing from metered households; used to determine viewing estimates for the national audience and the top local television markets.

owner's equity Or *net worth;* refers to the financial interest of the firm's owners.

PEG channels Public, educational, and governmental channels found on cable television systems; usually required by the franchising authority.

perfect competition A market structure characterized by many sellers in which the product is homogeneous and no single firm or group of firms dominates the market.

performance review Usually conducted on an annual basis; allows employer and employee the opportunity to exchange feedback on job performance, expectations, and other criteria. Serves as the basis for merit and promotion in many organizations.

place One of the four Ps of marketing; refers to where the products of electronic media companies are available to audiences.

podcasting Term used to describe the downloading of radio-like content and other audio programming for playback on an iPod or other MP3 device.

positioning A marketing strategy developed by Ries and Trout. In positioning, the product or service must be clearly presented to the consumer. Used in the electronic media to help establish difference between competitors.

postings The recording of accounting data; may be completed using either a computer software system or manual entry.

price One of the four Ps of marketing; the amount paid for a product such as electronic media advertising or cable television service.

price cap regulation A form of pricing structure used in setting rates in the telecommunications industry. In using price caps, telecommunication carriers can charge only up to a set price for services; profits are generated when the company can provide the service at a lower internal cost.

process A series of actions or events marked by change. Management is often considered a process because of its ongoing state of operation.

product One of the four Ps of marketing; in the electronic media, usually refers to programming.

product differentiation Refers to the subtle differences (either real or imagined, perceived by buyers) that exist among products produced by sellers.

production A common activity of electronic media firms; consists of the manufacture of both hardware and software for the electronic media.

production processes The conversion of inputs into some type of product.

profit and loss (P&L) statement Another name for an income statement.

promos On-air promotional spots.

promotion One of the four Ps of marketing; consists of all activities (including advertising) designed to raise awareness of electronic media companies and their activities.

psychographic Type of research that focuses on consumer and lifestyle information.

publicity Free time and space afforded by another medium (such as a newspaper) in the promotion and marketing of an electronic media organization.

publics Term used in public relations to identify the various groups an organization encounters on an internal and external basis. In the electronic media, audiences, advertisers, employees, and regulators are just a few of the publics that electronic media companies regularly interact with.

Public Utilities Commission (PUC) Or *Public Service Commission (PSC);* at the state level the PUC or PSC regulates rates for local exchange carriers and other utilities.

Persons using radio (PUR) term developed by Arbitron in radio measurement.

random sampling A type of probability sample; every member of the population has an equal chance of being selected.

rate-of-return (ROR) regulation A common way to regulate the rates of telecommunication companies for telephone services; ROR allows companies to earn a profitable rate of return as part of doing business.

rating An estimate of the number of people or households viewing or listening to a particular program, based on some universal estimate.

reach The number of different individuals reached in an advertising plan; a measure of media penetration.

regional Bell operating companies (RBOCs) The breakup of the Bell telephone system in 1984 created seven regional holding companies; over the years the number has been reduced to four companies.

retransmission consent The 1992 Cable Act gave broadcast stations the right to negotiate with cable operators for system carriage. This provision is known as retransmission consent, which means the cable operator can retransmit the broadcast signal only with the consent of the broadcaster, usually in return for some type of compensation.

revenues Money that flows into an organization through the sale of various products and services.

reverse compensation A new practice starting in the late 1990s in the TV industry; reverse compensation occurs when network affiliate stations pay the networks for their programming.

sample Audience research is based on a sample of the population; if the sample is chosen properly, the characteristics of the sample will reflect the larger population.

seamlessness Used in television programming, where the end of one program leads directly in to the next program; designed to hold viewers before they change channels. Also known as a "seamless transition."

segmentation Marketing strategy used to identify specific target audiences and develop products and services to meet their needs.

sellout rate An estimate (expressed as a percentage) of how much available inventory will be sold to advertisers. Most broadcasters use an estimate of 70 to 80 percent as a sellout rate.

share Measures the percentage of the viewing or listening audience, based on the total number of viewers or listeners tuned in.

software The content goods, including such products as television and radio programs, recordings, and advertising messages.

spot A category of media advertising; also refers to individual commercial units.

stacking Placing programs of the same genre back to back in a program schedule, usually for a period of 1 to 2 hours.

standard error All samples are subject to error because of several factors; ratings must be interpreted within a given range of error, expressed as a percentage.

statement of cash flows A common financial statement used by management.

strategic alliance An association designed to provide benefits for each of its members; types of strategic alliances include mergers and acquisitions, joint ventures, and both formal and informal cooperative agreements.

stunting Program strategy that in some way deviates from the regular presentation or schedule.

telecommunications Blanket term used to describe different components of the telephone industry; today the term is widely used to represent the integration of voice, data, and entertainment and informational materials.

teleological ethics Study of ethics concerned with actions or the consequences of making ethical decisions.

tent-poling Strategy used by programmers to place a strong program between two new or weaker programs.

Theory X Theorized by McGregor; managers use tactics such as control, threat, and coercion to motivate employees in a negative manner.

Theory Y Theorized by McGregor; managers integrate the individual needs of the workers and the needs of the organization. Employees exercise self-control and self-direction and develop their own sense of responsibility.

Theory Z Developed by William Ouchi; focuses on employee participation and individual development along with interpersonal relations between workers and managers. Management makes the key decisions in an organization, and a strong sense of authority must be maintained.

tiers Term used in the cable industry to denote different categories of service such as basic, expanded basic, and premium.

time spent listening (TSL) Estimates the amount of time the average person listens to radio.

traffic Department in an electronic media organization that handles the placement and execution of advertising messages. Works closely with sales and marketing personnel as well as accounting personnel.

turnover An estimate of how many times the audience completely changes during a particular time period.

V-chip Electronic device on future TV receivers allowing parents to block programs that contain excessive sex or violence.

vertical integration Occurs when a firm controls different aspects of production, distribution, and exhibition of its products.

VHF Very high frequency; denotes TV channels 2-13.

video compression Technology that allows compression of existing television signals to allow more expansion of channels; employs digital technology to compress signals.

video on demand (VOD) Delivering entertainment and information to users on demand; will work in conjunction with a set-top storage device to hold programming in memory for instant recall.

UHF Ultra high frequency; refers to TV channels 14 and higher.

user-generated content Blogs, podcasts, photos, and video content uploaded to web sites like YouTube and MySpace, and also refers to content shared with electronic media companies from individuals who are not employees.

Wi-Fi Term used to describe a wireless Internet network.

wireless The transmission of information without the use of wires; a growing method of distributing Internet content.

World Wide Web A part of the Internet of computer networks; allows for the integration of text, voice, and video data in the creation of web pages.

Index